Casey C. M. Mathewson

Architecture
today | heute | actuelle | actual

Feierabend

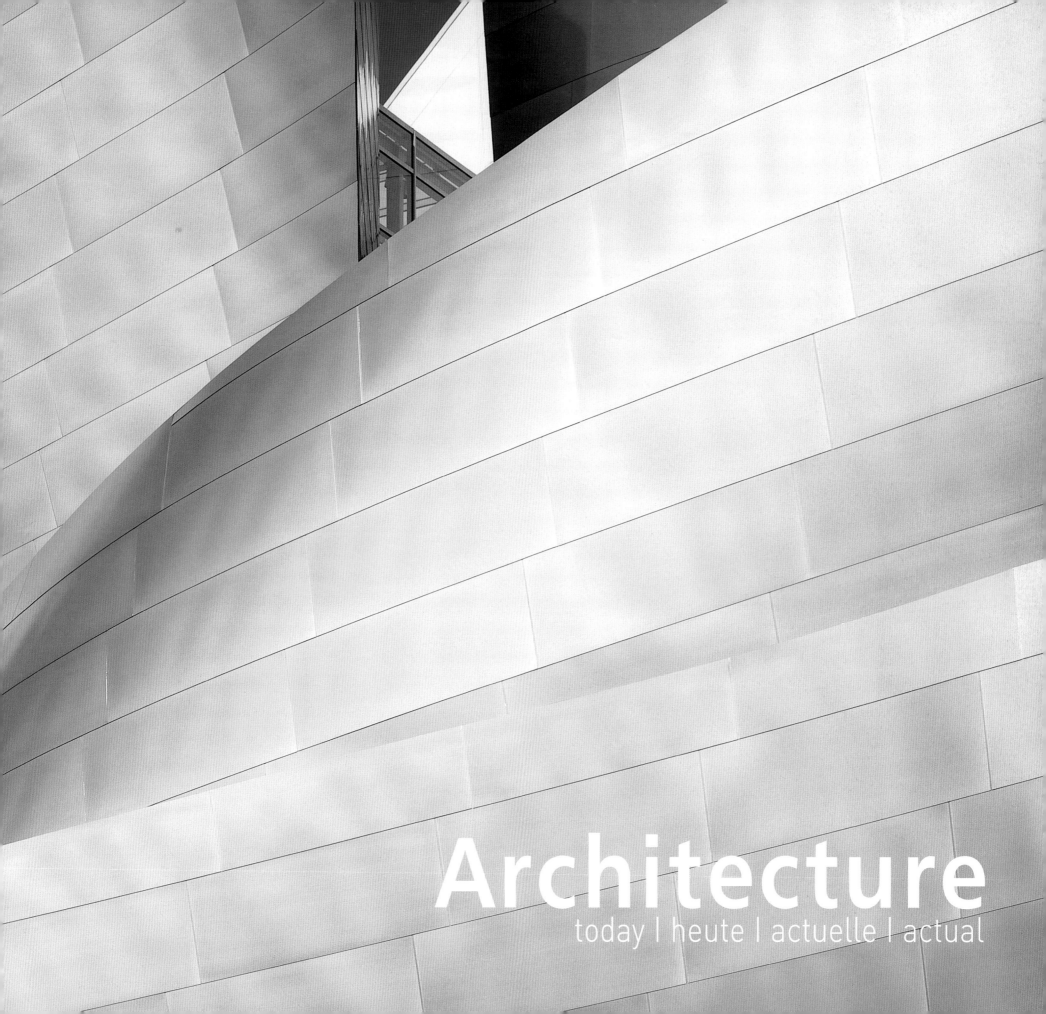

Architecture
today | heute | actuelle | actual

Contents
Inhalt
Sommaire
Contenido

© 2004 Feierabend Verlag oHG
Mommsenstr. 43, D-10629

Text English and German: Casey C. M. Mathewson
Translation into Spanish: Silvia Gómez de Antonio
Translation into French: Aline Weill
Proofreading: Marco Krämer, Nicole Weilacher
Production management: Stephanie Leifert
Layout & Typesetting: Roman Bold & Black, Cologne
Pictures: artur architekturbilder agentur gmbh, Cologne
Picture editing: Fabio Ricci
Lithography: LUP AG, Hürth

Idea and Concept: Peter Feierabend

Printing and Binding: Eurolitho s.p.a., Milan
Printed in Italy

ISBN 3-89985-049-1
40 02069 1

Foreword

Architecture is presently at a dynamic turning point. In the 1970s, harsh critique of monotonous Modernism provoked a complete rethinking in architecture. During the 1980s, tradition was rediscovered with Post-Modernism. By the early 1990s, the international avant garde had rediscovered Modernism and set about filling it with new life. Powerful new works have surfaced in the subsequent years. Their vivid "landmark architecture" revitalizes derelict city neighborhoods all across the globe. These works are future-oriented and innovative. Through thoughtful respect of human scale and integration with their specific surroundings, they correct the mistakes of relentless Late-Modernism with fresh new, holistic solutions.

In the 1920s, contrasting stances on architecture crystallized to become the driving forces in the striving to create inclusive architecture. Expressionism attempts to translate the laws of nature into organic forms. Rationalism, on the other hand, expresses new building technologies in a machine aesthetic. Today's architecture continues to be based on these contrary approaches.

Now, computer programs developed for use in aerospace technology enable the complex, organic building visions of early Expressionism to be built. At the same time, the stringent extreme is being explored in buildings which take the rationalist standpoint to new heights, producing poetic

Minimalism. And the advent of new, sustainable technologies generates new building forms: "green" architecture, which transcends its earthy granola and Birkenstock beginnings.

One of the most exciting facets of contemporary architecture is the pluralism of the solutions being explored. Contrary theories all seek to find innovative answers to the challenges facing the world today. This inventive, creative process results in epoch-making buildings which prove the thesis that Modernism's inherent potential has been far from fully explored. This is a supposition that this book, with striking images by leading architectural photographers, readily confirms.

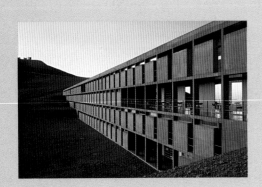

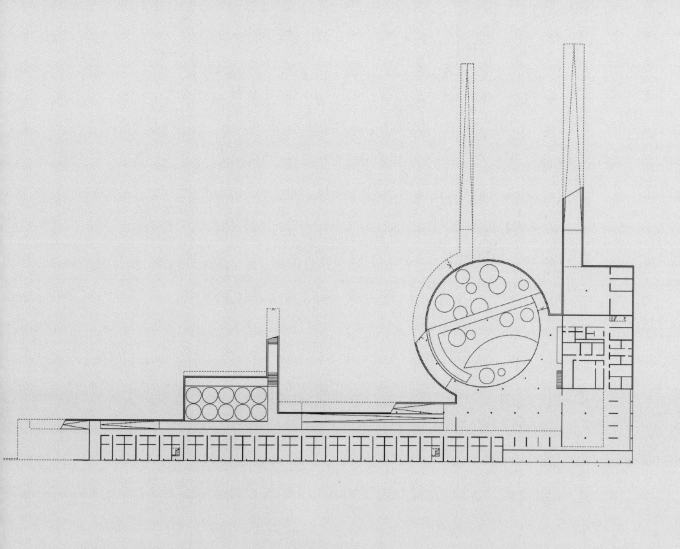

Vorwort

Die Architektur befindet sich weltweit an einem Wendepunkt. Bereits in den 1970er Jahren setzte eine harte Kritik gegen die Monotonie der modernen Architektur ein. In den 1980er Jahren entstand die Postmoderne als Rückbesinnung auf die Tradition. Aber seit Beginn der 1990er Jahre hat die Avantgarde die Moderne erneut entdeckt und sie mit neuem Leben gefüllt. Hierbei wird insbesondere die skulpturale Qualität der Bauten betont. Es entstehen Gebäude als Wahrzeichen, die zu wichtigen Wirtschaftsfaktoren ihrer Städte und Regionen werden. Die neuen Bauten sind zukunftsgerichtet und innovativ. Gerade indem sie den menschlichen Maßstab berücksichtigen und die spezifischen Eigenschaften ihrer Umgebung respektieren, sind sie rücksichtsvoller als die oft recht unsensiblen Bauten der Spätmoderne. Bereits in den 1920er Jahren kristallisierten sich unterschiedliche Tendenzen in der Architektur heraus. Der Expressionismus suchte in Formen der Natur eine neue Basis für die Baukunst. Der Rationalismus entwickelte als Ausdruck neuer technischer Möglichkeiten eine maschinelle Ästhetik. Noch heute bestimmen diese Ansätze die Architekturdiskussion weltweit.

Für die Raumfahrt entwickelte Computer-Programme lassen nunmehr die komplexen, organischen Bauformen der damaligen expressionistischen Utopien gebaute Wirklichkeit werden. Andererseits entstehen Bauten, die weiterhin den strengeren Weg des rationalen Minimalismus gehen. Hierbei werden auch neue Technologien eingesetzt, z. B. um eine optimierte ökologische Nachhaltigkeit zu erreichen.

Vor allem kennzeichnend für die neuen Bauten ist der Pluralismus der Ansätze. An entgegengesetzten Theorien und Standpunkten wird weltweit fieberhaft gearbeitet. Aber eins vereint sie alle: Sie suchen kreativ nach Antworten auf die Herausforderungen unserer Zeit. Eine Tendenz, die zu bahnbrechenden Resultaten führt und zeigt, dass die Potenziale der Moderne noch längst nicht ausgeschöpft sind. Eine Hypothese, die dieses Buch, illustriert durch Fotos von führenden Architekturfotografen, bestätigt.

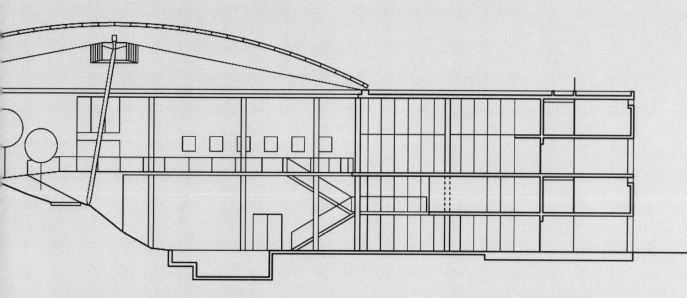

Préface

L'architecture se trouve aujourd'hui à un tournant dynamique. Dans les années 1970, une dure critique de la monotonie du modernisme a conduit à la repenser complètement. Au cours des années 1980, le post-modernisme a redécouvert la tradition, et au début des années 1990, l'avant-garde internationale a redécouvert le modernisme en lui insufflant une nouvelle vie. De nouvelles œuvres puissantes sont apparues dans les années suivantes. Leur « architecture monumentale » éclatante redonne vie aux vieux quartiers urbains du monde entier. Œuvres novatrices, elles corrigent les excès d'insensibilité de la fin du modernisme par de nouvelles solutions holistiques, en respectant l'échelle humaine dans un souci d'intégration dans leur environnement.

Au cours des années 1920, des positions architecturales très diverses se sont cristallisées pour promouvoir la tentative de création d'une architecture globale. L'expressionnisme a cherché à traduire les lois de la nature en formes organiques. Au contraire, le rationalisme a exprimé les nouvelles techniques de construction en une esthétique de la machine. L'architecture actuelle reste basée sur ces démarches opposées. Aujourd'hui, les programmes informatiques mis au point pour la technologie spatiale permettent la réalisation architecturale des visions organiques complexes du début de l'expressionnisme. Parallèlement, certains édifices explorent l'extrême inverse en poussant encore plus loin le point de vue rationaliste, créant un minimalisme

poétique. Et l'arrivée de nouvelles techniques de développement durable crée de nouvelles formes d'architecture « verte », transcendant les débuts de l'écologie.
Une des facettes les plus exaltantes de l'architecture contemporaine est le pluralisme des solutions proposées. Toutes les théories contraires tendent à trouver des réponses novatrices aux défis auxquels le monde est actuellement confronté. Ce processus inventif aboutit à la création d'édifices marquants, semblant prouver que le potentiel inhérent au modernisme est loin d'avoir été totalement exploré. Une hypothèse que ce livre, avec ses images saisissantes réalisées par d'éminents photographes, vient aisément confirmer.

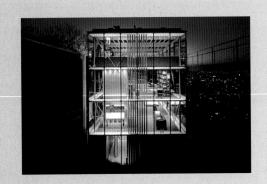

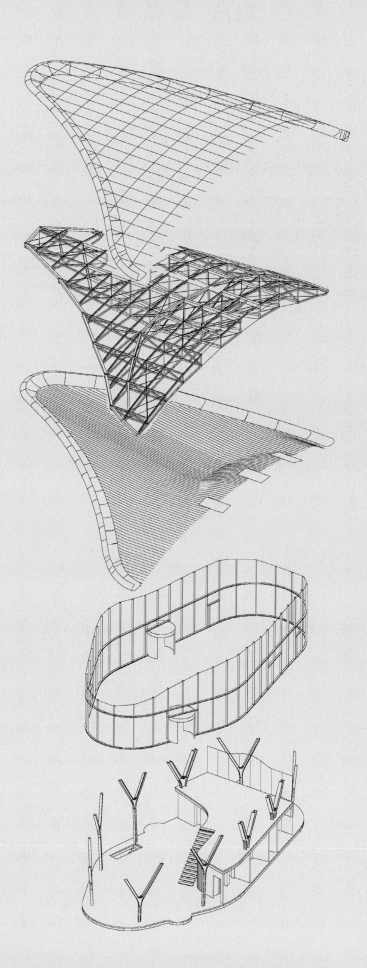

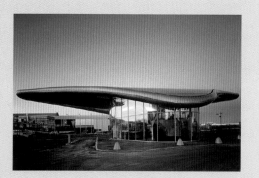

Prólogo

La arquitectura se encuentra en un punto de inflexión a nivel mundial. Ya en la década de 1970 empezó a criticarse fuertemente la monotonía de la arquitectura moderna. En los años ochenta surgió la posmodernidad como el regreso a la tradición. Sin embargo, al comenzar la década de 1990, la vanguardia redescubrió la modernidad dotándola de nueva vida. En este movimiento la cualidad escultural de los edificios recibe una especial importancia. Aparecen construcciones que asumen el papel de monumentos y que se convierten en importantes factores económicos de las ciudades y las regiones. Los rasgos característicos de estos nuevos edificios son su orientación hacia el futuro y su carácter innovador. En comparación con las construcciones frías e insensibles de la modernidad tardía, las construcciones actuales tienen en cuenta tanto las medidas humanas como las propiedades específicas de su entorno. En los años 1920 cristalizaron diferentes tendencias en la arquitectura. El expresionismo buscaba una nueva base para el arte de la construcción en las formas de la naturaleza. El racionalismo desarrolló una estética mecanizada como forma de expresión de las nuevas posibilidades técnicas. Hoy en día estas contribuciones continúan determinando las discusiones sobre arquitectura en todo el mundo. Ahora los programas informáticos diseñados para la astronáutica permiten convertir en realidad edificada las complejas formas orgánicas de las antiguas utopías expresionistas. Pero también aparecen edificios que continúan el estricto camino del minimalismo racional. Aquí también se utilizan las nuevas tecnologías, por ejemplo, para conseguir una sostenibilidad ecológica óptima de los edificios.

Especialmente característico de las nuevas construcciones es el pluralismo de las contribuciones. Por todo el mundo se sigue trabajando febrilmente en las teorías opuestas y en los principios. A pesar de esta diversidad, todas las ideas tienen algo en común que las une: la búsqueda creativa de respuestas a los retos de nuestro tiempo. Una tendencia que lleva a conseguir resultados revolucionarios y que pone de manifiesto que el potencial de la modernidad todavía no está agotado. Es una hipótesis que se confirma en este libro a través de las imágenes de los fotógrafos de arquitectura más destacados.

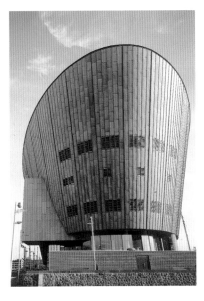

Amsterdam, The Netherlands,
Renzo Piano Building Workshop, 1997

Urban Ship

NeMo – National Center for Science and Technology

A new "ship" is at anchor in the port. From the slanting "upper deck", which acts as a public square augmenting the adjacent narrow streets, one enjoys a singular view of the historic city silhouette. The building extends the urban fabric but stands in marked contrast to the homogeneous old town as an autonomous object which strives more to be part of the port. The seemingly floating mass is wrapped on three sides with copper; the plinth in red brick incorporates a material typical of the city. The belly of the ship encloses an exhibition landscape where future-oriented themes of science and technology are presented.

Urbanes Schiff

NeMo – Nationales Zentrum für Wissenschaft und Technologie

Am Hafen ist ein „Schiff" vor Anker gegangen. Vom „Oberdeck" des schrägen Daches aus, das als öffentlicher Platz die dichten Gassen des Stadtkerns ergänzt, genießt man eine einmalige Aussicht auf die Stadtsilhouette. Der Bau ergänzt zwar das Stadtgebilde, steht diesem aber als ein Objekt am Hafen gegenüber. Auf dem Wasser scheinbar gleitend erhält er an drei Seiten eine Kupferverkleidung, der Sockel aus Klinkern setzt das prägende Material der Altstadt fort. Der Bauch des Schiffes dient als Ausstellungslandschaft, in der Themen rund um Mensch, Technik und Wissenschaft vermittelt werden.

Vaisseau urbain

NeMo – Centre national des sciences et des techniques

Un nouveau « bateau » est ancré dans le port. Du « pont supérieur » incliné, qui sert de place publique prolongeant les ruelles adjacentes, on jouit d'une vue singulière sur le site de la ville historique. L'édifice agrandit le tissu urbain, mais contraste nettement avec la vieille ville homogène, formant un objet autonome qui aspire davantage à faire partie du port. Cette masse apparemment flottante est enveloppée de cuivre sur trois côtés ; le socle en briques rouges intègre un matériau typique de la cité. Les entrailles du navire renferment un paysage d'exposition où sont présentés des thèmes scientifiques et techniques tournés vers le futur.

Barco Urbano

NeMo – Centro Nacional de Ciencia y Tecnología

En el puerto hay un nuevo «barco» anclado. Desde la «cubierta superior» del tejado inclinado, que al ser una plaza pública complementa las estrechas calles de los alrededores, se disfruta de una vista única de la silueta de la ciudad. A pesar de que el edificio forma parte de la ciudad, también se contrapone a ella como un objeto solo en el puerto. Su estructura, que parece flotar sobre el agua, está revestida en tres de sus lados con cobre, mientras que la base, de ladrillo recocido, utiliza el material típico del casco antiguo de la ciudad. La tripa del barco alberga las salas de exposiciones cuyos temas giran en torno al hombre, la técnica y la ciencia.

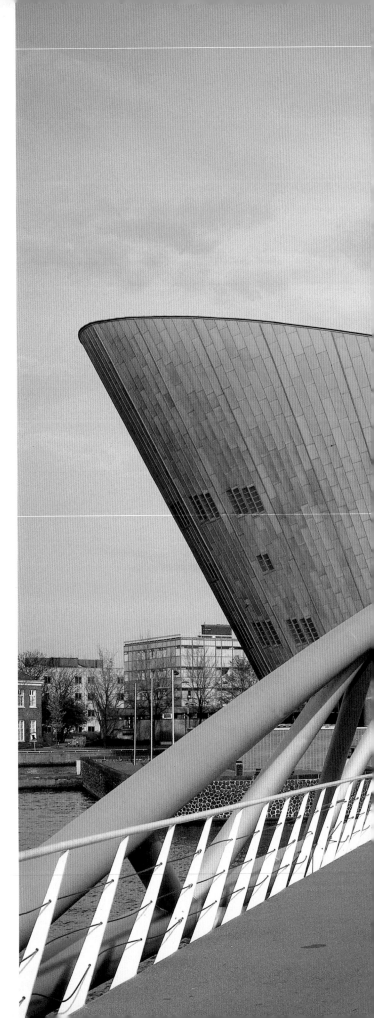

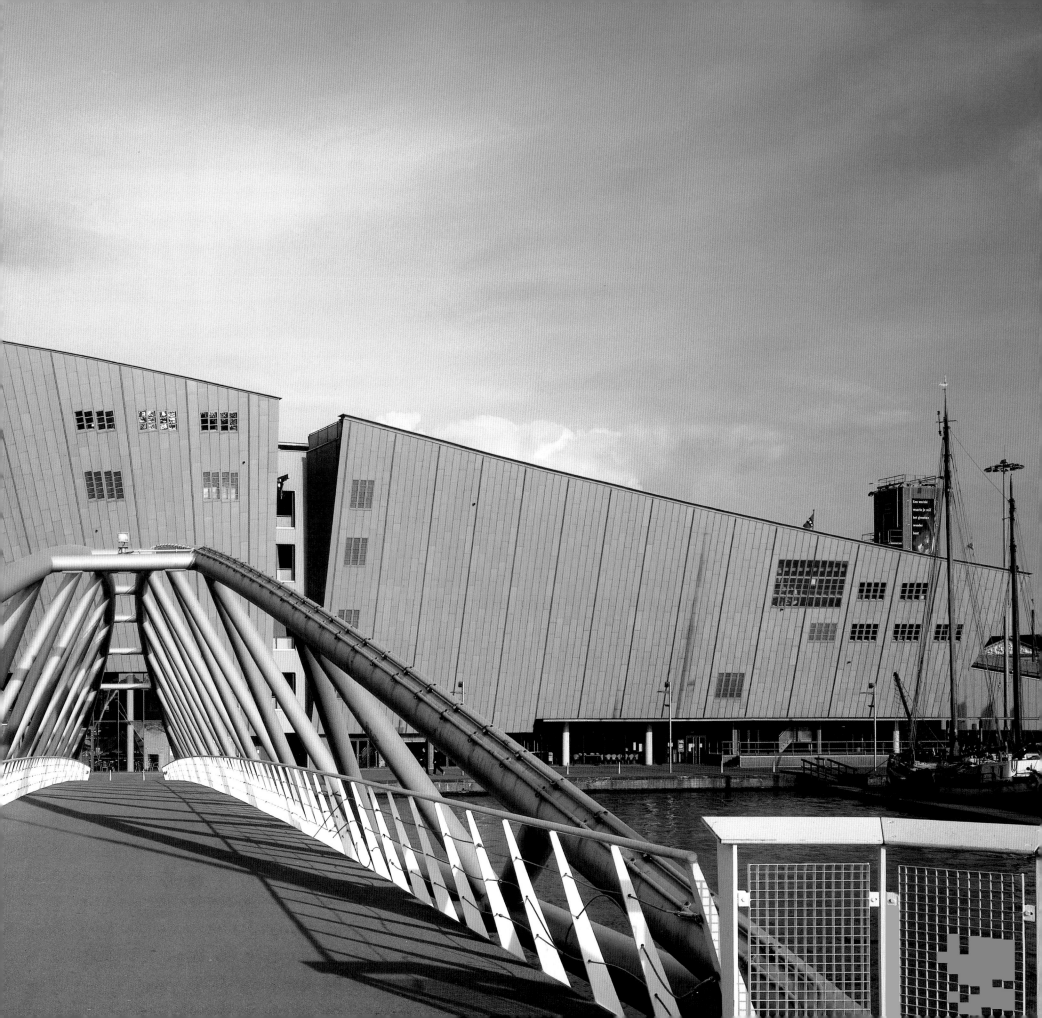

Stainless Steel Drum Set

National Center for Pop Music

The contributions of British musicians to pop culture are legendary. From the Beatles to Brit-Pop they've had tremendous influence on the development of a cultural form which changed the lives of countless people all around the globe. This complex, with its four turbine-like stainless steel pavilions, pays due tribute to them and creates a place where the history of the music can be presented. The building's forms recall the drum sets of unforgettable musicians like Keith Moon and John Bonham who, as "monsters of rock", shaped the music and died early in the turbulent era. Their spirit lives on here at live concerts, in the club and in the bar.

Edelstahl-Schlagzeug

Zentrum für Popmusik

Legendär sind sie, die Beiträge der britischen Musiker zur Popkultur. Von Beatles bis Brit-Pop übten sie großen Einfluss auf die Entwicklung einer nicht mehr wegzudenkenden Kultur aus und änderten das Leben unzähliger Menschen rund um den Globus. Um diese Leistungen zu würdigen und die Geschichte der Musik zu präsentieren, entstand dieser Komplex aus vier turbinenartigen Edelstahlkörpern. Sie erinnern an die Schlagzeuglandschaften der unvergesslichen Künstler wie Keith Moon oder John Bonham, die als „Monsters of Rock" die Musik prägten und im Trubel der Ära früh verstarben. Bei Live-Konzerten, im Club und an der Bar leben sie hier weiter.

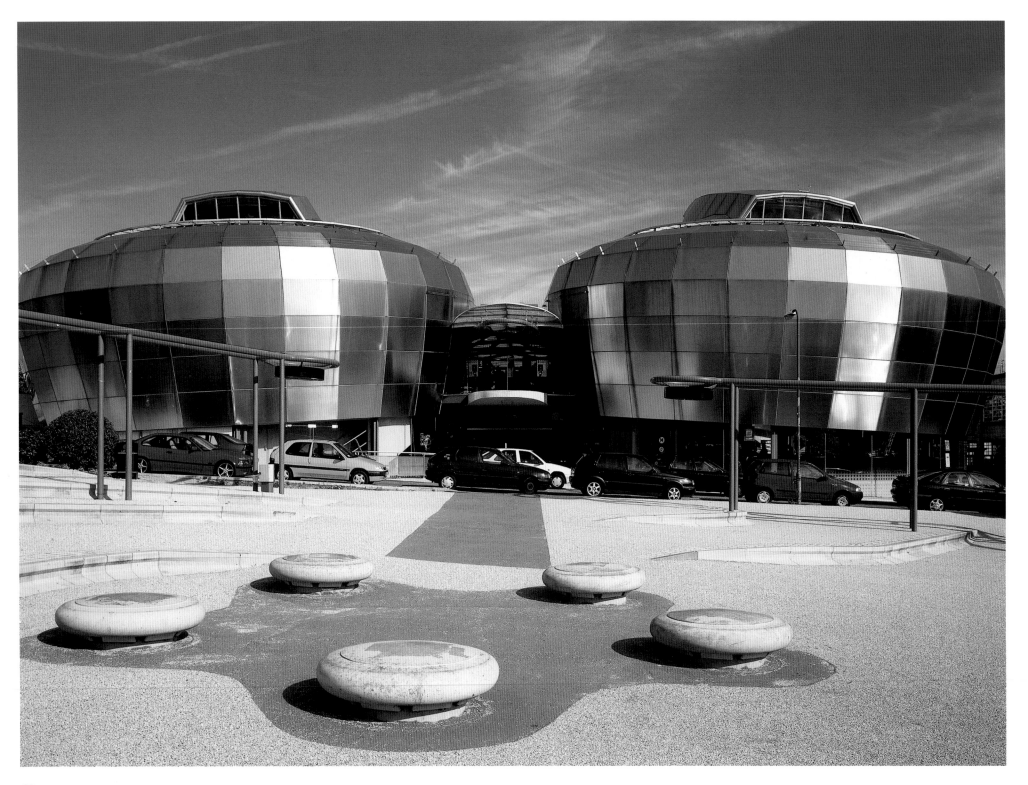

Batterie en inox

Centre de musique Pop

Les contributions des musiciens anglais à la culture pop sont légendaires. Des Beatles à la Brit Pop, ils ont eu une influence énorme sur le développement d'une forme culturelle qui a changé la vie de quantité de gens autour du globe. Ce complexe, avec ses quatre pavillons en inox pareils à des turbines, leur rend un hommage mérité et crée un endroit où l'histoire de la musique peut être présentée. Les formes du bâtiment rappellent les batteries de musiciens inoubliables comme John Bonham et Keith Moon, « géants du roc » qui ont façonné la musique et qui sont morts jeunes à l'époque dissipée. Leur esprit continue à vivre ici aux concerts live, dans le club et dans le bar.

Batería de Acero

Centro de Música Pop

Las contribuciones de los músicos británicos a la cultura pop son legendarias. Desde los Beatles hasta el Brit-Pop, estos artistas tuvieron una gran influencia en el desarrollo de una cultura que cambió la vida de innumerables personas en todo el mundo. En su honor y para presentar la historia de la música pop se creó este complejo de cuatro cuerpos de acero parecidos a unas turbinas. Los edificios se asemejan a las baterías de artistas inolvidables como Keith Moon o John Bonham, «monstruos del rock» que marcaron la música y murieron jóvenes en esta turbulenta era. Su espíritu sigue vivo en los conciertos en directo, en el club y en el bar.

Sheffield, Great Britain, Branson Coates Architects, 1999

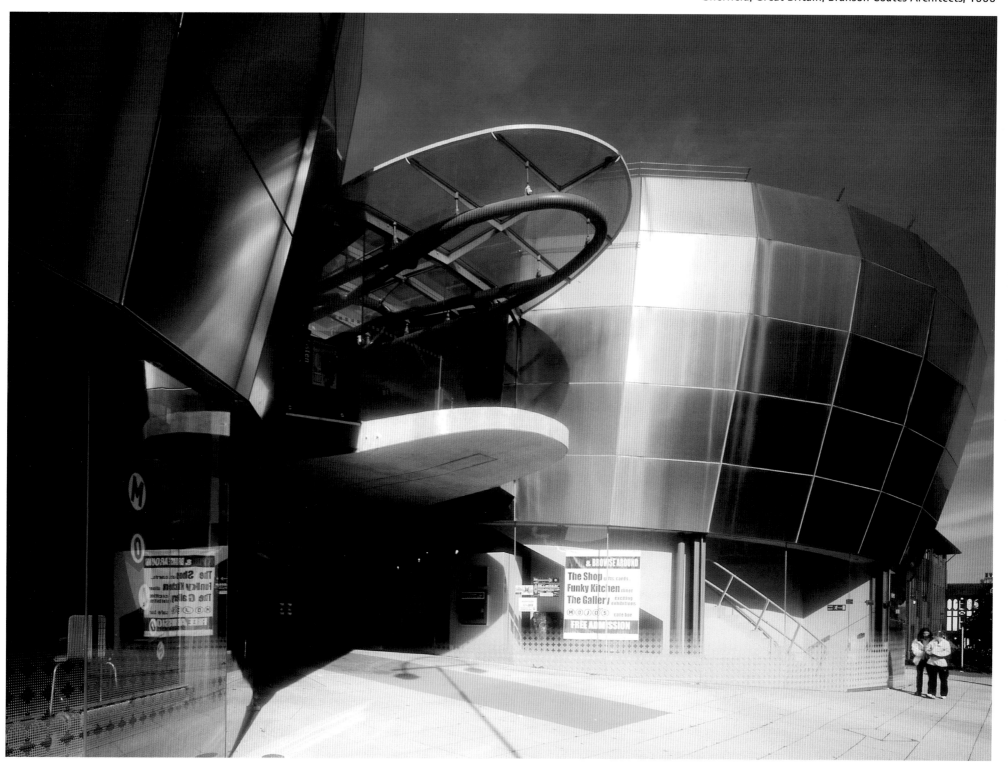

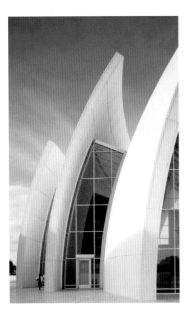

Rome, Italy, Richard Meier & Partners, 2003

Ethereal Presence

Jubilee Church

The Jubilee Church stands out from its bleak surroundings in Tor Tre Teste, a public housing project on Rome's periphery. Pristine, white concrete shell walls define the contemporary church as a luminous and inviting place. Of all the church walls only one reaches straight upward toward the heavens. The others rise to grand arches resembling white sails which appear to float as if they were made merely of tightly stretched white cloth. Inside the church, stone and wood complement the spectrum of materials utilized here, while abundant natural light enhances a space which seems at once sacred and progressive.

Ätherische Präsenz

Jubiläumskirche

Die Jubiläumskirche dominiert das Umfeld in Tor Tre Teste, einem Vorort an der östlichen Stadtperipherie Roms. Die gebogenen, weißen Betonschalen lassen die Bauplastik hell und freundlich als zeitgenössischer Kirchenbau wirken. Von den Wänden des Kirchenraumes streckt sich nur eine einzige kerzengerade nach oben, die anderen erheben sich zu Riesenbögen, die weißen Segeln ähneln. Im Inneren bestimmen Stein und Holz die Materialienpalette. Hier wirken die krummen Betonwände leicht: wie aus einem gespannten, weißen Stoff. Eine Fülle natürlichen Lichts schafft eine Sakralität, die zugleich archaisch und zukunftsgerichtet wirkt.

Présence éthérée

L'église du jubilé

L'église du jubilé se démarque de son morne environnement à Tor Tre Teste, un projet de logements publics à la périphérie de Rome. Des murs extérieurs en béton blanc immaculé font de cette église contemporaine un lieu accueillant et lumineux. De tous les murs de l'eglise, un seul s'élève droit vers le ciel. Les autres forment de grands arcs tels des voiles blanches, qui ont l'air de flotter comme des toiles tendues. Dans l'église, le bois et la pierre complètent la gamme des matériaux utilisés, et des flots de lumière naturelle rehaussent un espace qui paraît à la fois innovant et sacré.

Presencia Etérea

Iglesia del Jubileo

La Iglesia del Jubileo es el edificio dominante en el Tor Tre Teste, un suburbio en la periferia este de Roma. Las conchas blancas curvas de concreto hacen que la moderna iglesia parezca un lugar luminoso y agradable. Solo una de las paredes de la iglesia se yergue completamente vertical, las otras se levantan como gigantescos arcos parecidos a velas blancas. En el interior, la piedra y la madera son los elementos utilizados. Las inclinadas paredes de concreto parecen muy ligeras; como si fueran de tela blanca tensada. La abundante luz natural que inunda el espacio crea un ambiente de sacralidad que parece arcaico y progresista a la vez.

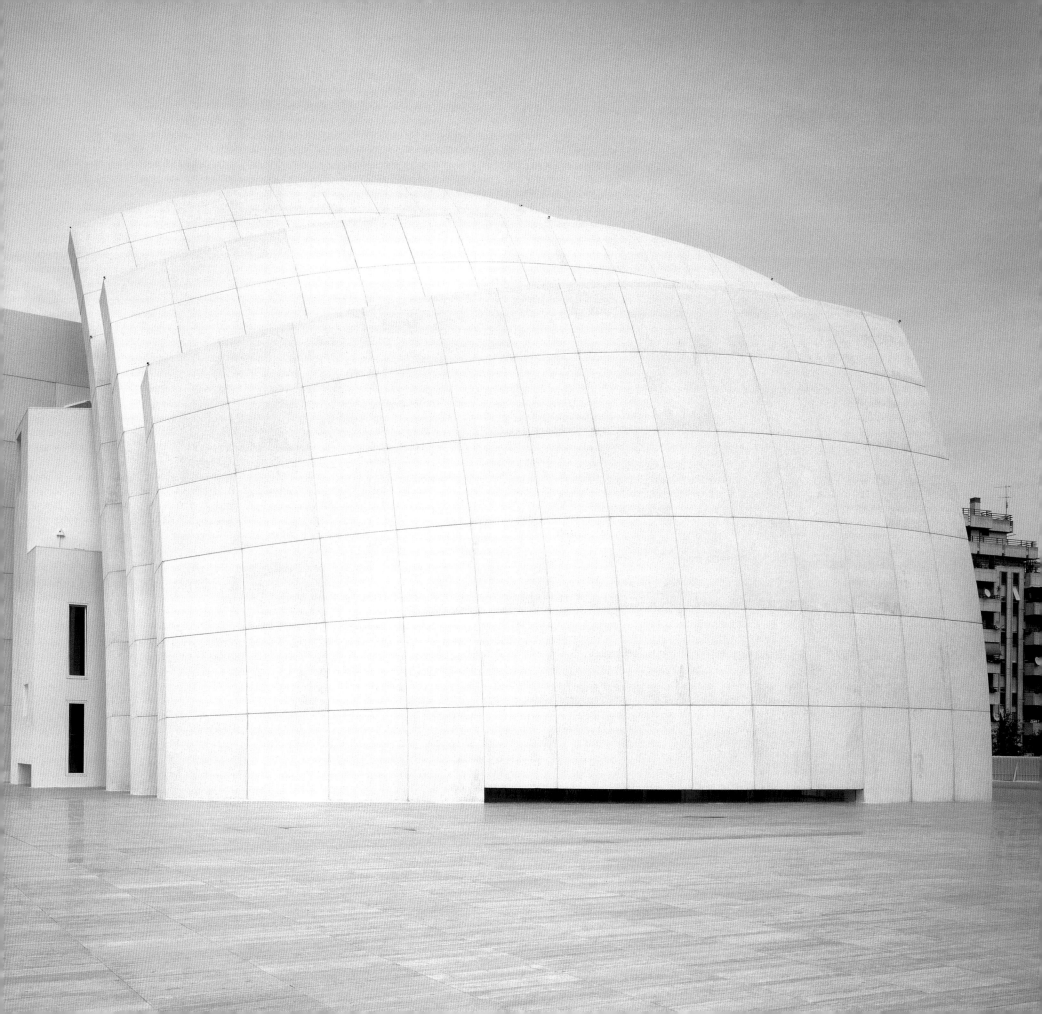

Ships of Culture

City of Arts and Sciences

This planetarium, science museum and culture palace complex brings life to a once desolate area on the edge of the city. As a reaction to the scorching summers of the region much of the site was envisioned with fountains and sculpture ponds. The skeletal buildings seem to float over them like ships at sea. The planetarium, as an eye to the skies, was designed in the form of a huge lens. Its water-facing facade can be completely opened to allow cooling breezes into the lobby. The science museum is housed in an arched structure which forms another spectacular focus for the cultural quarter.

Kulturschiffe

Stadt der Künste und Wissenschaft

Die Anlage aus Planetarium, Wissenschaftsmuseum und Kulturpalast dient als Motor der Stadtentwicklung auf einer vormals desolaten Stadtrandfläche. Als Reaktion auf das warme Klima werden große Teile des Areals als Wasserflächen ausgebildet. Wie Schiffe im Meer scheinen die weißen Gerippe dahinzugleiten. Das Planetarium, Auge zu den Sternen, gibt sich als riesige Linse. Seine Wasserfront lässt sich insgesamt wie ein Augenlid öffnen, um eine kühlende Brise in die Halle zu führen. Das Wissenschaftsmuseum ist in einem Bogen aus sichtbaren Tragelementen beherbergt und bildet einen weiteren, spektakulären Fokus der Anlage.

Vaisseaux de la culture

Cité des Arts et des Sciences

Ce complexe abritant un planétarium, un musée des sciences et un palais de la culture donne vie à une zone autrefois déserte en bordure de la ville. En réaction aux étés brûlants de la région, une grande partie du site comprend des bassins sculpturaux et des fontaines. Les bâtiments squelettiques semblent flotter au-dessus d'eux comme des navires sur la mer. Le planétarium, tel un œil vers le ciel, a la forme d'une immense lentille. Sa façade sur le plan d'eau peut être entièrement ouverte pour laisser les brises rafraîchir l'entrée. Le musée des sciences est situé dans une structure en voûte, formant un autre centre spectaculaire du quartier culturel.

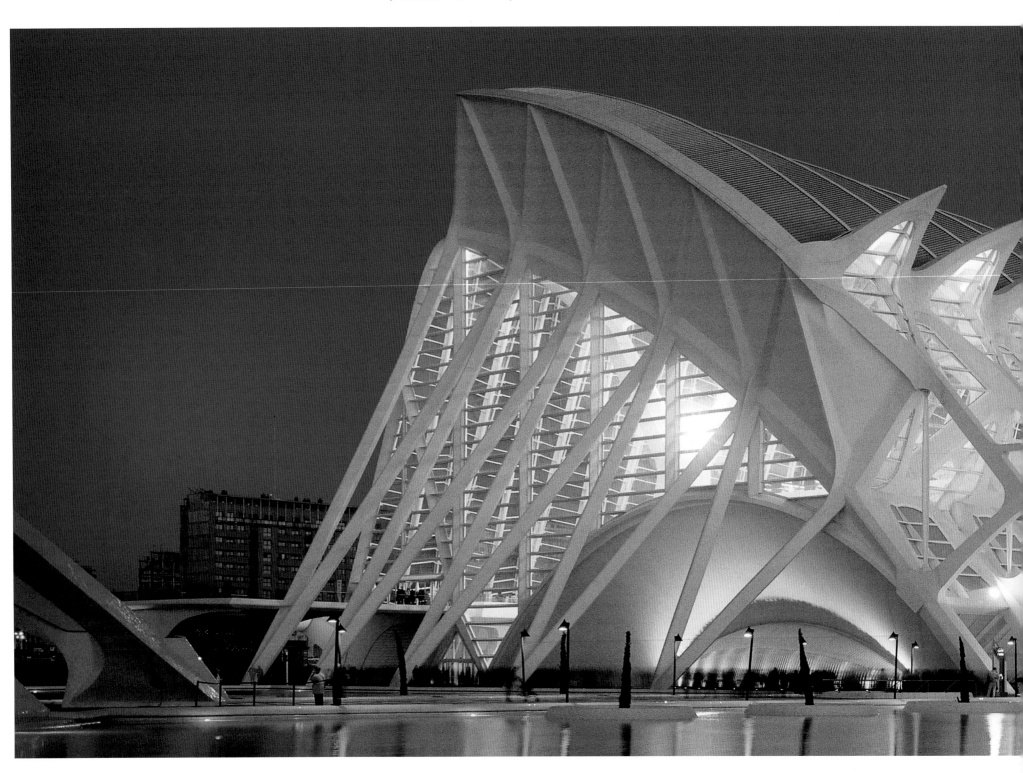

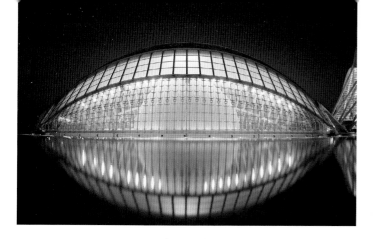

Barcos de Cultura

La Ciudad de las Artes y de las Ciencias

Esta instalación, compuesta por un planetario, un museo de ciencias y un palacio de la cultura, actúa como motor de desarrollo de un suburbio de la ciudad antes desolado. Como reacción al caluroso clima, gran parte del terreno se ha concebido como superficies de agua. Los armazones blancos parecen barcos que se deslizan por el agua. El planetario, el ojo a las estrellas, se levanta como una enorme lente. Su fachada revestida de agua puede abrirse completamente como un párpado permitiendo la entrada de una fresca brisa en el pabellón. El museo de ciencias está alojado en un arco de estructura visible y es otro espectacular centro de atención de la instalación.

Valencia, Spain, Santiago Calatrava, 2000

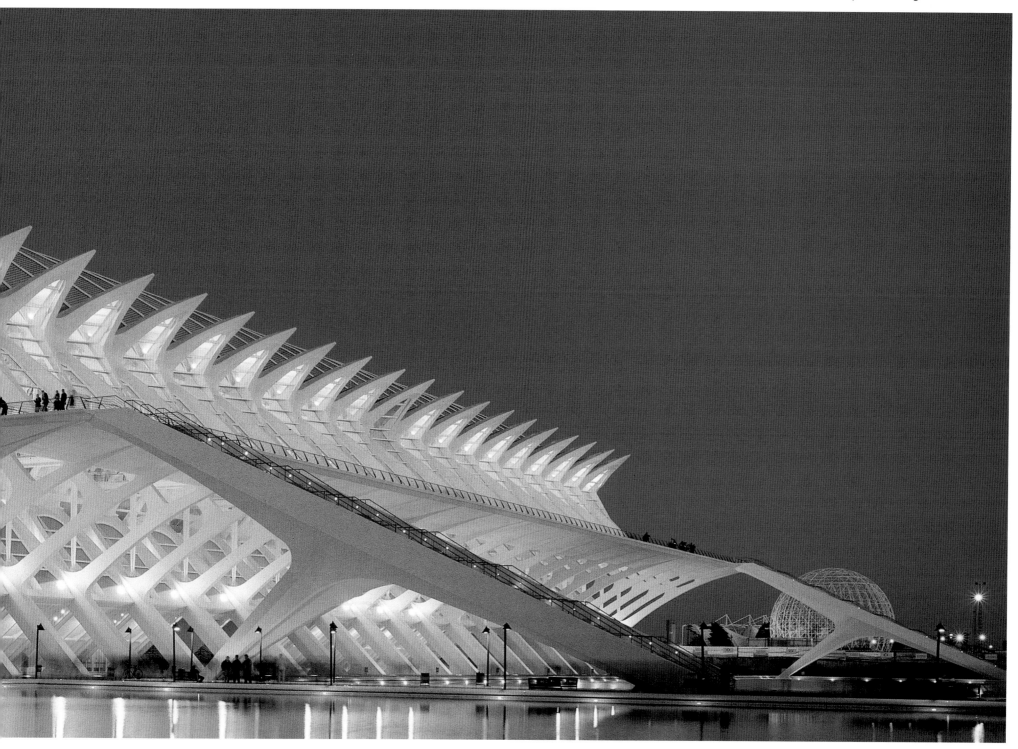

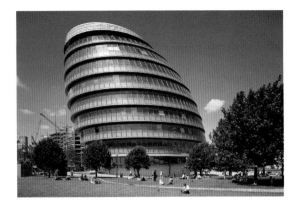

London, Great Britain,
Norman Foster and Partners, 2002

Leaning Tower

London City Hall

Directly adjacent to London Bridge and the Tower, this new building completes the historic ensemble with a bold approach. In order to convey the goals of the city government – transparency and sustainability – the complex was conceived in clear contrast to the neighboring monuments as an accessible public place with a landmark glass tower at it's center. A 500 meter long public ramp rises right through the assembly hall up to an observation deck at the top of the tower. Intelligent use of natural resources for heating and cooling reduce energy consumption to 25% of a conventional office building.

Schiefer Stadtturm

Rathaus London

In unmittelbarer Nachbarschaft zur London-Bridge und zum Tower komplettiert der gläserne Neubau das weltbekannte Ensemble mit einem gewagten Griff in die Trickkiste. Um die Ziele der Stadtverwaltung – Bürgernähe und Nachhaltigkeit – zum Ausdruck zu bringen, entstand im schroffen Kontrast zur historischen Umgebung ein offener Baukomplex um den transparenten Turm. Eine 500 m lange, öffentlich zugängliche Rampe führt durch den Sizungssaal der Stadtverordneten hindurch zur Aussichtsgalerie in der Turmspitze. Ökologische Maßnahmen reduzieren den Energieverbrauch auf ein Niveau von 25% eines konventionellen Bürohauses.

Une tour penchée

La mairie de Londres

Tout près du Pont et de la Tour de Londres, ce nouvel édifice complète l'ensemble historique par une approche hardie. Exprimant les objectifs de la municipalité – transparence et écologie – le complexe a été conçu par contraste avec les monuments voisins, comme un lieu accessible au public autour d'une grande tour de verre. Une passerelle longue de 500 m s'élève en plein milieu du hall de réunion jusqu'à une terrasse panoramique en haut de la tour. L'usage intelligent de ressources naturelles pour le chauffage et la climatisation réduisent la consommation d'énergie de 25% par rapport à un immeuble de bureau classique.

Torre Inclinada

Ayuntamiento de Londres

Situado muy cerca del Puente de Londres y de la Torre, esta construcción de cristal completa el mundialmente conocido conjunto con un atrevido truco. Para expresar los objetivos de la municipalidad, cercanía a los ciudadanos y sostenibilidad, se levantó un complejo abierto alrededor de la torre transparente y en claro contraste con los alrededores históricos. Una rampa abierta al público y de 500 m de longitud lleva a través de la sala de juntas de los concejales hasta la galería con el mirador en la parte superior de la torre. Gracias a las fuentes de energía naturales el consumo energético es del 25% de un edificio convencional de oficinas.

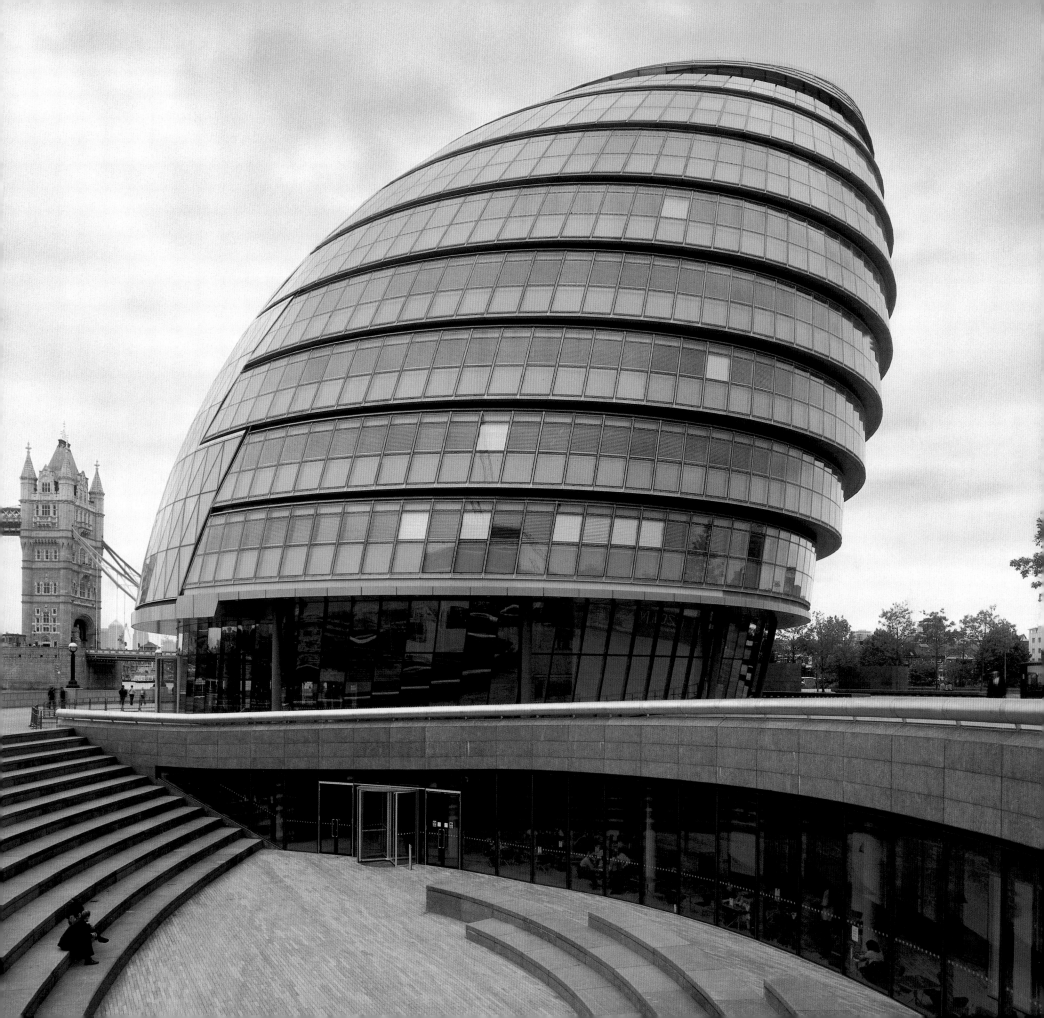

Soaring Hills

Miyagi Stadium

Sendai, a coastal city of one million located north of Tokyo, is bordered by rolling hills. The 49,000-seat stadium translates their circular motion into a dual set of asymmetrical roofs that blend with the landscape, enhancing the little-known city with a gracious landmark. Seen from the hills above, the gleaming metal covered roofs appear as juxtaposed sickles. They form a dynamic, soaring enclosure that protects from sun and rain, while framing dramatic views into the venerated Japanese landscape surrounding the city.

Aufstrebende Hügel

Miyagi Stadion

Sendai, eine Millionenstadt an der Küste nördlich von Tokio, grenzt an eine bukolische Hügellandschaft. Das 49 000 Sitzplätze umfassende Stadion überträgt die kreisenden Bewegungen der Topografie auf ein asymmetrisches Dächer-Paar, das sich in die Landschaft einfügt und die Stadt mit einem zeitgemäßen Wahrzeichen bereichert. Von den nahen Höhenzügen aus gesehen, zeigen sich die glänzenden Metalldächer als entgegengesetzte Sicheln. Sie definieren einen dynamischen Stadionraum, bieten Schutz vor Sonne und Regen und rahmen zugleich dramatische Ausblicke in die Landschaft der Umgebung ein.

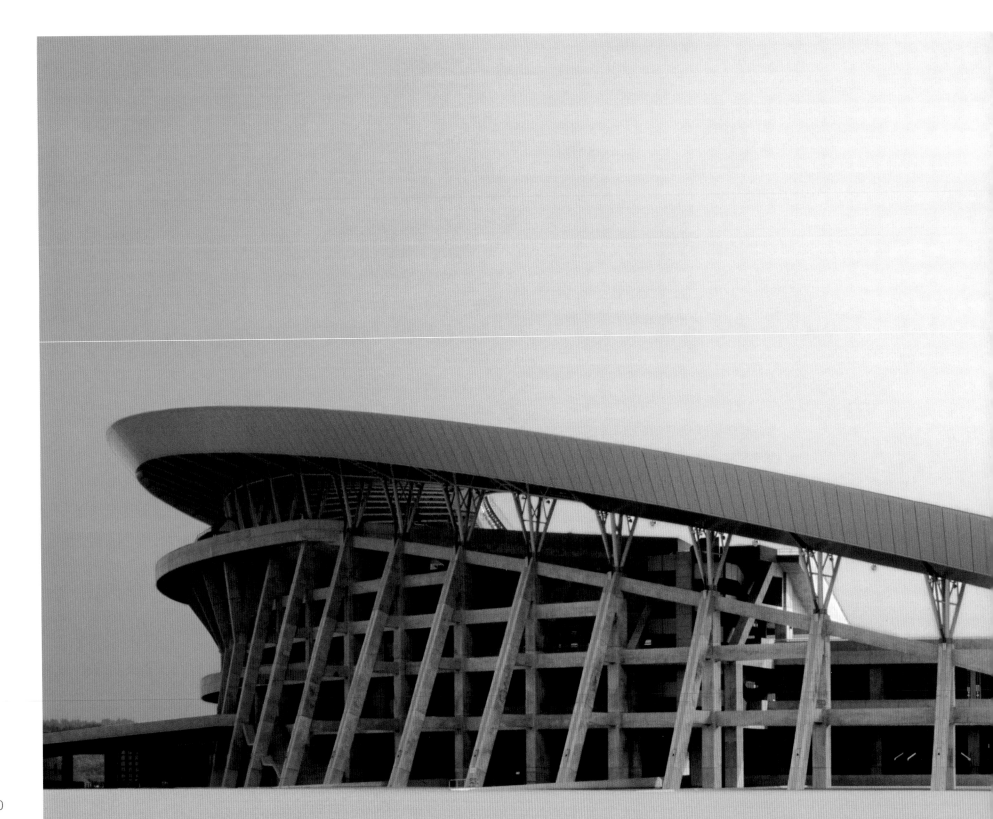

Des collines élancées

Le stade Miyagi

Sendai, ville côtière d'un million d'habitants au nord de Tokyo, est bordée de collines vallonnées. Le stade de 49 000 places traduit leur mouvement circulaire en une double série de toits asymétriques. En harmonie avec le paysage, ils créent un gracieux monument qui rehausse la ville peu connue. Vus des collines qui les dominent, les toits couverts de métal luisant ressemblent à des faucilles juxtaposées. Ils forment une enceinte dynamique élancée, protégeant de la pluie et du soleil tout en encadrant des vues spectaculaires sur le vénérable paysage japonais autour de la ville.

Colinas Ascendentes

Estadio Miyagi

Sendai, una ciudad costera con un millón de habitantes y situada al norte de Tokio, limita con un bucólico paisaje de colinas. El estadio, con capacidad para 49.000 asientos, traslada los movimientos circulares de la topografía a los dos tejados asimétricos, que se integran perfectamente en el paisaje y enriquecen la ciudad con un monumento contemporáneo. Observados desde las cercanas montañas, los tejados metálicos se ven como hoces opuestas. Son unos elementos dinámicos que al cerrarse protegen del sol y de la lluvia al mismo tiempo que enmarcan las conmovedoras vistas al venerado paisaje japonés de los alrededores.

Sendai, Japan, Atelier Hitoshi Abe, 2000

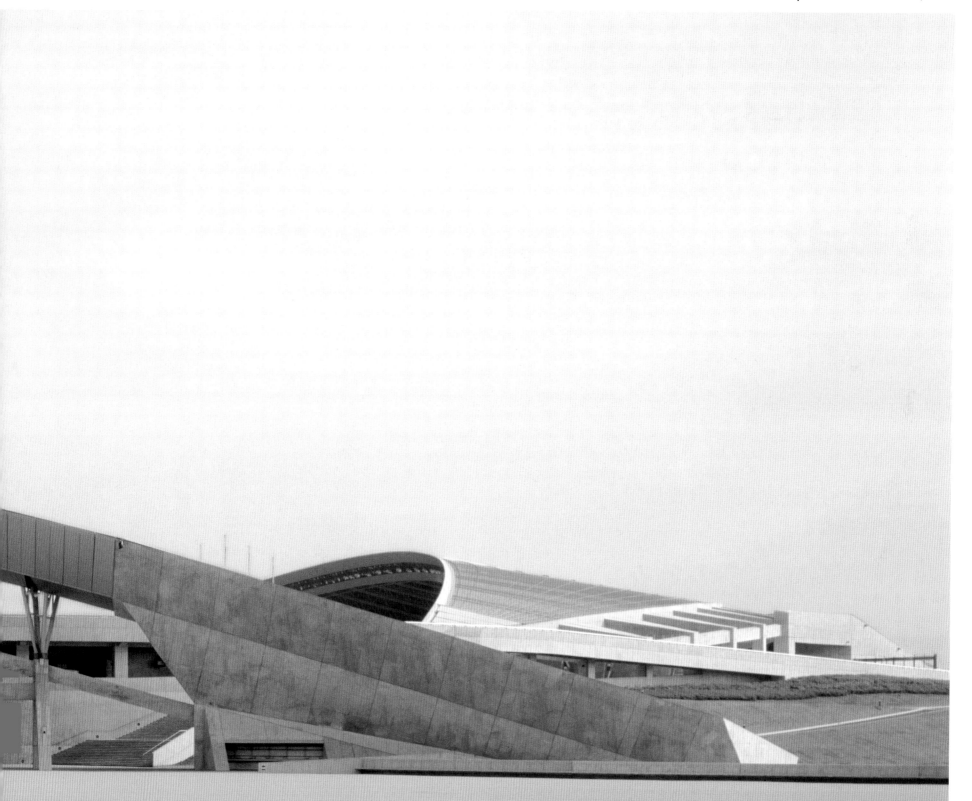

Graz, Austria, Peter Cook,
Colin Fournier, 2003

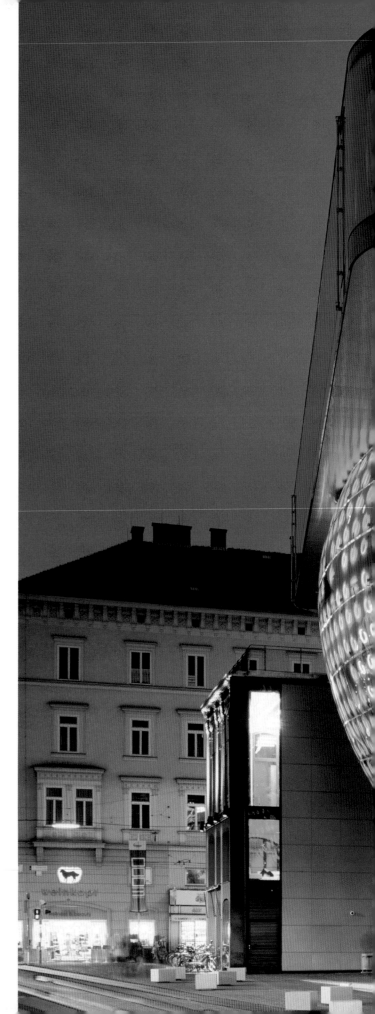

Return of the Blob

Kunsthaus Art Museum

One of the favorite architectural pastimes of the 1960s was the conception of futuristic utopias. The London-based Archigram group led by Peter Cook produced some of the most compelling with their visionary "walking cities". Back then the ideas were utopian. Today, software developed for space technology allows realization of complex, biomorphic forms. The "Bubble", composed of 1,280 Plexiglas panels, creates a blue shimmering spectacle in the historic city center and draws countless visitors, showing that Modernism's inherent potential has been far from fully explored.

Rückkehr der Amöbe

Kunsthaus Museum

Eines der beliebtesten Architektur-Faibles der 1960er Jahre bestand darin, sich futuristische Utopien auszudenken. Vor allem die Londoner Gruppe Archigram um Peter Cook war es, die damals mit ihren ungebauten Visionen für „walking cities" Furore machte. Damals blieben die Ideen Utopie. Heute lässt Software aus der Luft- und Raumfahrt solche Formen durchaus realisierbar werden. Die mit 1280 Plexiglasteilen verkleidete, blau schimmernde „Bubble" inmitten der Altstadt ergänzt diese um ein Spektakel, das zahlreiche Besucher in die Stadt lockt und zeigt, dass die Potenziale der Moderne noch längst nicht ausgeschöpft sind.

Le retour de la forme floue

Le musée d'art Kunsthaus

Un des passe-temps architecturaux favoris des années 1960 était la conception d'utopies futuristes. Le groupe londonien Archigram mené par Peter Cook a produit certaines des plus fascinantes d'entre elles avec ses « villes en marche » visionnaires. À l'époque, les idées étaient utopiques. Aujourd'hui, les logiciels mis au point pour la technologie spatiale permettent de réaliser des formes complexes biomorphiques. La « Bulle », composée de 1280 panneaux de plexiglas, crée un spectacle bleu chatoyant dans le centre historique de la ville. Elle attire d'innombrables visiteurs, montrant que le potentiel intrinsèque du modernisme est loin d'avoir été pleinement exploré.

El Regreso de la Ameba

Museo Kunsthaus

Una de las aficiones favoritas de la arquitectura durante la década de 1960 era imaginarse utopías futuristas. El grupo londinense Archigram, dirigido por Peter Cook, fue el que mayor furor causó con sus visionarias «walking cities». Por aquel entonces las ideas se quedaron en utopías. Hoy el software de la aeronáutica y la astronáutica permiten hacer realidad esas formas biomorfas. El «Bubble», compuesto por 1.280 paneles de Plexiglas y de color azul brillante, está en medio del casco antiguo de la ciudad y la complementa como un espectáculo que atrae a numerosos visitantes. Además demuestra que el potencial de la modernidad todavía no se ha agotado.

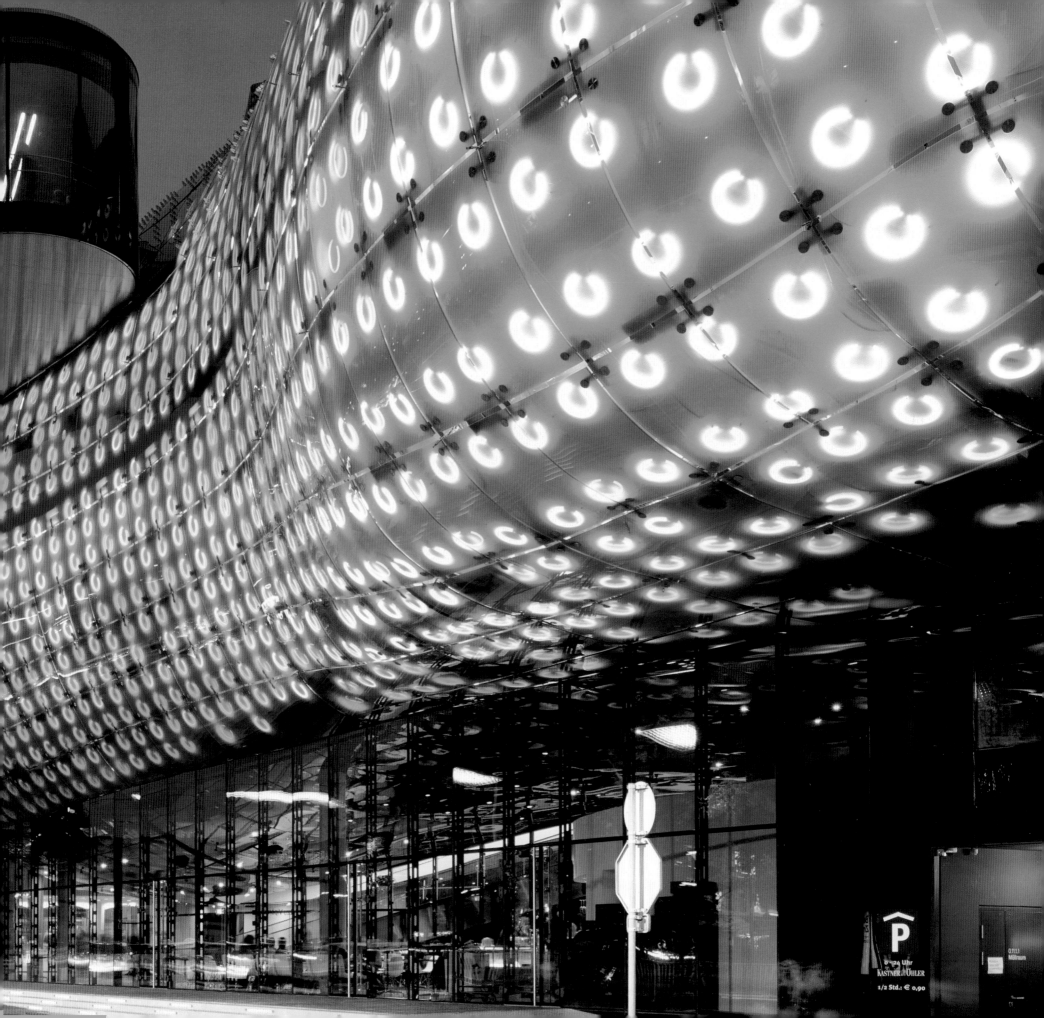

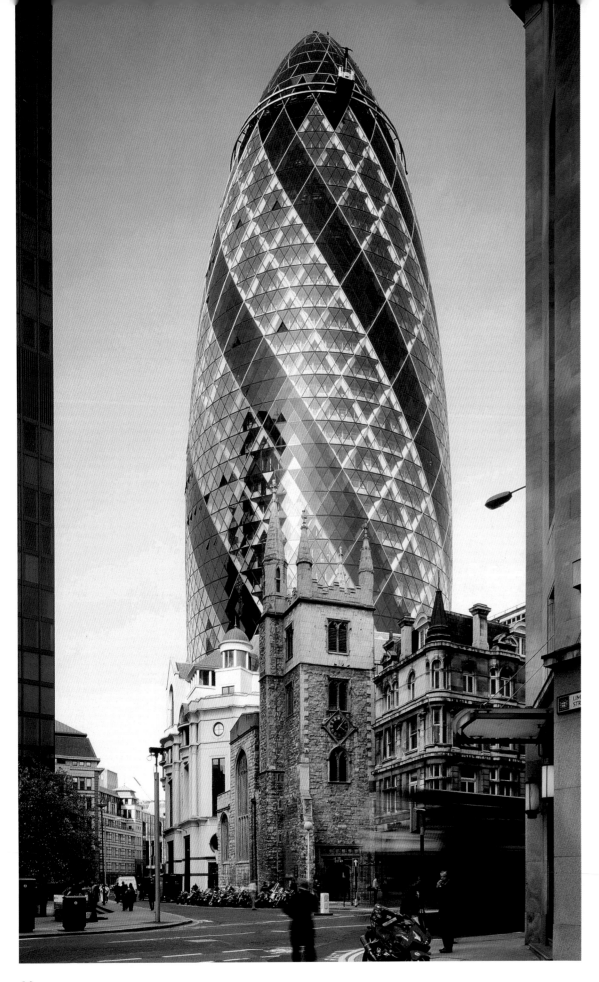

Zeppelin in the City

Swiss Re Headquarters Tower

High-rise buildings have been scorned in recent decades for their high energy consumption and aggressive urban presence. This criticism spawned the notion of the "sustainable" high-rise building. The aerodynamic form of the 180 meter high tower narrows at the base and the tip to create an elegant figure. The apparent reduction of the tower's size reduces horizontal wind loads and helps optimize the building structure. Vertical light wells around the building periphery provide natural lighting and ventilation for the office spaces and lower energy consumption 40 % below that of a conventional, mechanically air-conditioned high-rise.

Zeppelin in der City

Swiss Re Headquarters Tower

Lange Zeit galten Hochhäuser durch ihren extrem hohem Energieverbrauch als denkbar ungünstige ökologische Lösung. Die aerodynamisch motivierte Gebäudeform des 180 m hohen Turmes verschlankt sich nach unten und oben hin, um Leichtigkeit und Transparenz zu erzeugen. Die entstehende optische Verkleinerung lässt den Turm graziler und leichter erscheinen und reduziert die horizontalen Windlasten, was eine leichtere, effizientere Baustatik ermöglicht. Vertikale Lichtschächte an der Gebäudeperipherie erlauben eine natürliche Belüftung der Büros, wodurch der Energieverbrauch um 40 % gesenkt wird.

Un zeppelin dans la ville

Swiss Re Headquarters Tower

Les tours ont été méprisées ces dernières décennies à cause de leur grande consommation d'énergie et de leur présence urbaine agressive. Cette critique a fait naître la notion de tour « écologique ». La forme aérodynamique de cette tour de 180 m se resserre en haut et en bas pour créer une forme élégante. La réduction apparente de la taille de la tour diminue la pression des vents horizontaux et contribue à optimiser sa structure. Autour d'elle, des puits de lumière verticaux offrent une lumière et une ventilation naturelles aux espaces de bureaux avec une faible consommation d'énergie – 40 % de moins que celle d'une tour à la climatisation mécanique.

Zeppelin en la Ciudad

Swiss Re Headquarters Tower

Durante mucho tiempo, los rascacielos han estado considerados como una solución poco ecológica debido a su elevado consumo energético. La forma aerodinámica de la estructura de la torre, de 180 m de altura, se reduce en la base y en la parte superior para crear una sensación de levedad y de transparencia. La aparente reducción óptica resultante hace que la torre parezca grácil. Además se reduce la oposición horizontal al viento lo que posibilita una optimización de la estructura del edificio. Los pozos de luz verticales en la periferia del edificio permiten una ventilación natural de los despachos y un ahorro energético del 40 por ciento.

London, Great Britain, Norman Foster and Partners, 2003

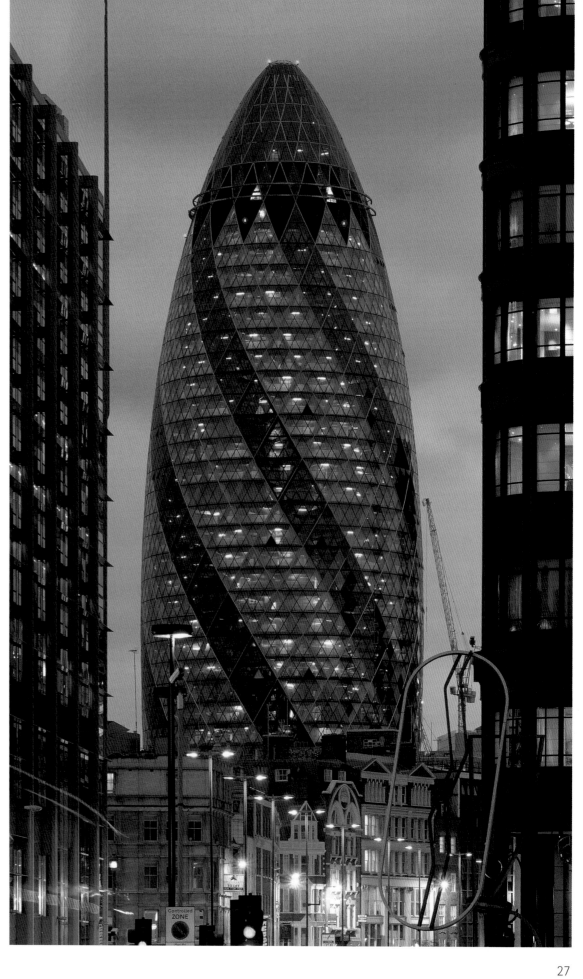

Umbrella Forest

Oriente Station

The station forms the radiant focus for a new urban quarter built on former military and industrial sites. The rail bed was raised onto a bridge-like structure to allow for maximum visual connection between the two neighborhoods on both sides of the tracks. This structure forms a plinth for the white steel umbrellas of the station roof which do more than simply provide shelter. Their memorable sculptural quality creates a special place of identification for the inhabitants of the new city. The daily act of transferring from rail to bus or tram, which both stop under palm-leaf shaped roofs on the square in front of the station, becomes an urban experience.

Ausgefahrene Stadtschirme

Oriente Bahnhof

Der Bahnhof bildet den strahlenden Fokus eines neuen Stadtteils, der auf ehemaligen Militär- und Industrieflächen entstanden ist. Um der trennenden Wirkung der Bahnschneise zwischen zwei Stadtteilen entgegenzuwirken wurde der Bahnkörper als räumlich durchlässige Brückenkonstruktion entworfen. Auf dem Brückenbauwerk stehen filigrane Stahlschirme, die nicht nur die Funktion der Überdachung erfüllen. Mit ihrer markanten Plastizität schaffen sie einen einprägsamen Ort der Identifikation. So wird der Akt des Umsteigens von der Bahn in die Tram oder den Bus, die beide unter den palmblattförmigen Dächern auf dem Vorplatz halten, zum urbanen Erlebnis.

Forêt de parasols

La gare Oriente

La gare forme le centre rayonnant d'un nouveau quartier urbain, construit sur d'anciens sites militaires et industriels. Les rails ont été montés sur une structure en forme de pont, pour ménager le plus de vues possibles entre les deux quartiers de chaque côté des voies. Cette structure forme le socle des parasols en acier blanc du toit, qui ne font pas seulement fonction d'abri. Leur aspect sculptural mémorable crée un lieu d'identification spécial pour les habitants de la nouvelle ville. Les correspondances quotidiennes entre les trains et les bus et les trams, qui s'arrêtent sur la place de la gare sous des auvents en forme de palmes, deviennent une expérience urbaine.

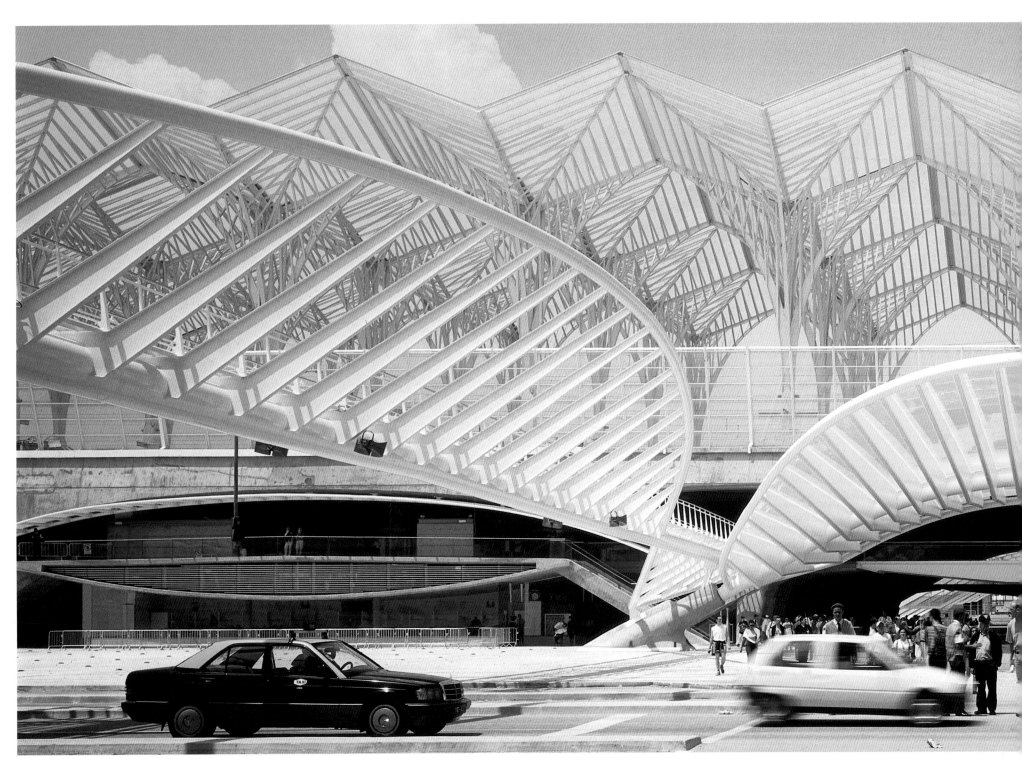

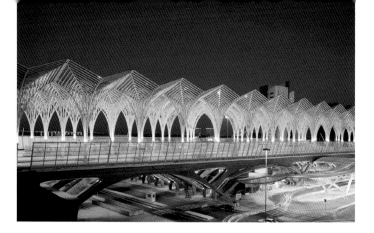

Sombrillas Desplegadas

Estación de Oriente

La estación ferroviaria es el nuevo y reluciente centro de un nuevo barrio de la ciudad levantado sobre antiguas áreas militares e industriales. Para evitar la sensación de separación que provoca la estación por su situación entre dos barrios, el edificio se diseñó como una estructura similar a un puente que permite la máxima conexión entre ambos lados. Sobre el edificio, una filigrana de sombrillas de acero no solo conforma el techo. Con su marcada plasticidad crean un lugar fácil de retener en la memoria y de identificación para los habitantes. Así, el trasbordo del tren al tranvía o al autobús, ambos bajo este techo, se convierte en toda una experiencia.

Lisbon, Portugal, Santiago Calatrava, 1998

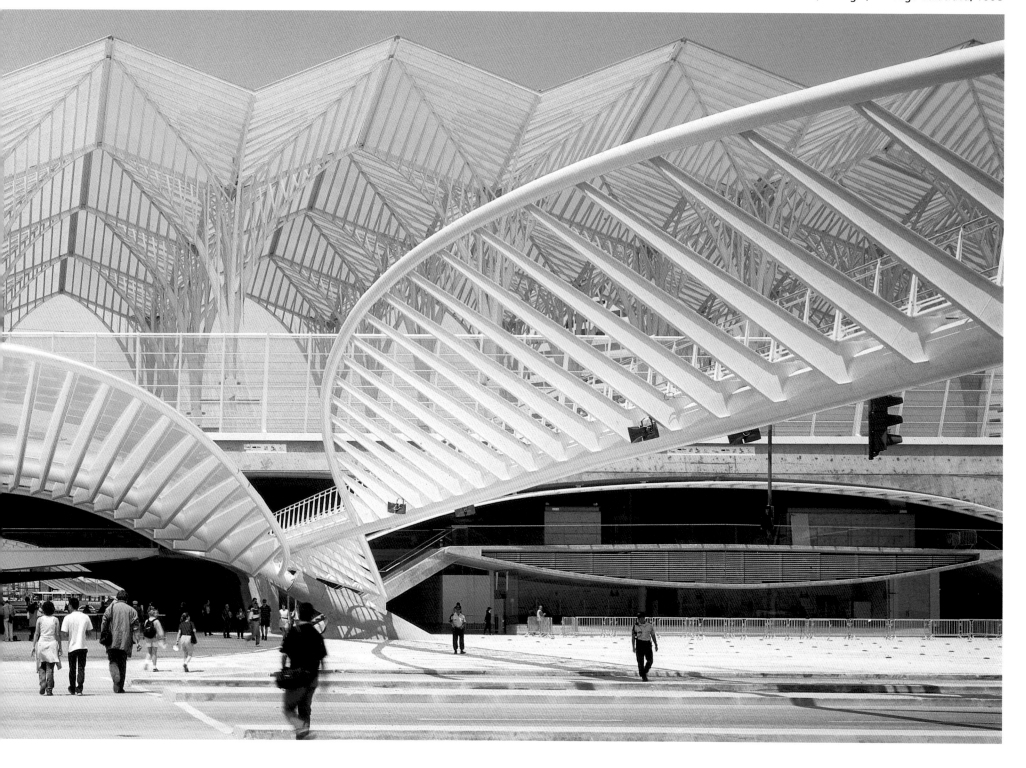

New Caledonia, South Pacific
Renzo Piano Building Workshop, 1998

Village of Culture

Tjibaou Culture Center

The South Pacific's tropical climate dictated the form of the traditional houses in the region – bamboo huts covered with palm mats to facilitate air circulation. This sustainable type was the model for the 10 "houses" of this village-like complex where history and contemporary themes regarding the islands are presented. The seamless integration into the seaside site is another local tradition that was respected. The conic pavilions are enclosed with renewable bamboo slats. They can be rotated according to prevailing winds and act as collectors to redirect cool air inside.

Kulturdorf am Pazifik

Tjibaou Kulturzentrum

Das tropische Klima im Südpazifik hat die traditionelle Hausform der Ureinwohner, Bambushütten mit luftdurch-lässigen Wänden aus Palmenmatten, entstehen lassen. Diese ökologisch sinnvolle Bauform übertrug man auf die zehn „Häuser" der dorfähnlichen Anlage, in der die Geschichte und Gegenwart der einheimischen Kultur präsentiert wird. Analog zur traditionellen Architektur der Inseln, wirken die direkt am Meer gelegenen Bauten im Einklang mit der Landschaft. Die konischen Pavillons sind mit Lamellen aus erneuerbaren Bambuslatten versehen. Sie können je nach Windrichtung gedreht werden, um kühlende Luft zu fangen und nach innen zu leiten.

Village culturel

Le centre culturel de Tjibaou

Le climat tropical du Pacifique Sud a dicté la forme des maisons traditionnelles de la région – des huttes de bam-bou couvertes de nattes de palmes pour faciliter la circulation de l'air. Cette forme écologique a été le modèle des 10 « maisons » de ce complexe bâti comme un village, où sont présentés l'histoire et les thèmes contemporains des îles. Une autre tradition locale a été respectée, l'intégration harmonieuse dans le site du littoral. Les pavillons coniques sont entourés de lattes de bambou renouvelables. Ils peuvent être tournés en fonction des vents domi-nants et servent de capteurs pour réorienter l'air frais vers l'intérieur.

Pueblo Cultural en el Pacífico

Centro Cultural Tjibaou

El clima tropical del Pacífico sur ha dictado la forma tradicional de las casas del lugar: chozas de bambú con paredes de esterillas de hojas de palma que permiten el paso del aire. Esta forma de construcción ecológica fue llevada a las diez «casas» de la instalación, que se parece a un pueblo y presenta la historia y el presente de la cultura indígena. El respeto a la arquitectura tradicional de la isla continúa en las construcciones a la orilla del mar. Los pabellones cónicos están rodeados de planchas hechas de tablas de bambú reciclables que pueden girarse dependiendo de la dirección del viento para captar el aire fresco y dirigirlo hacia el interior.

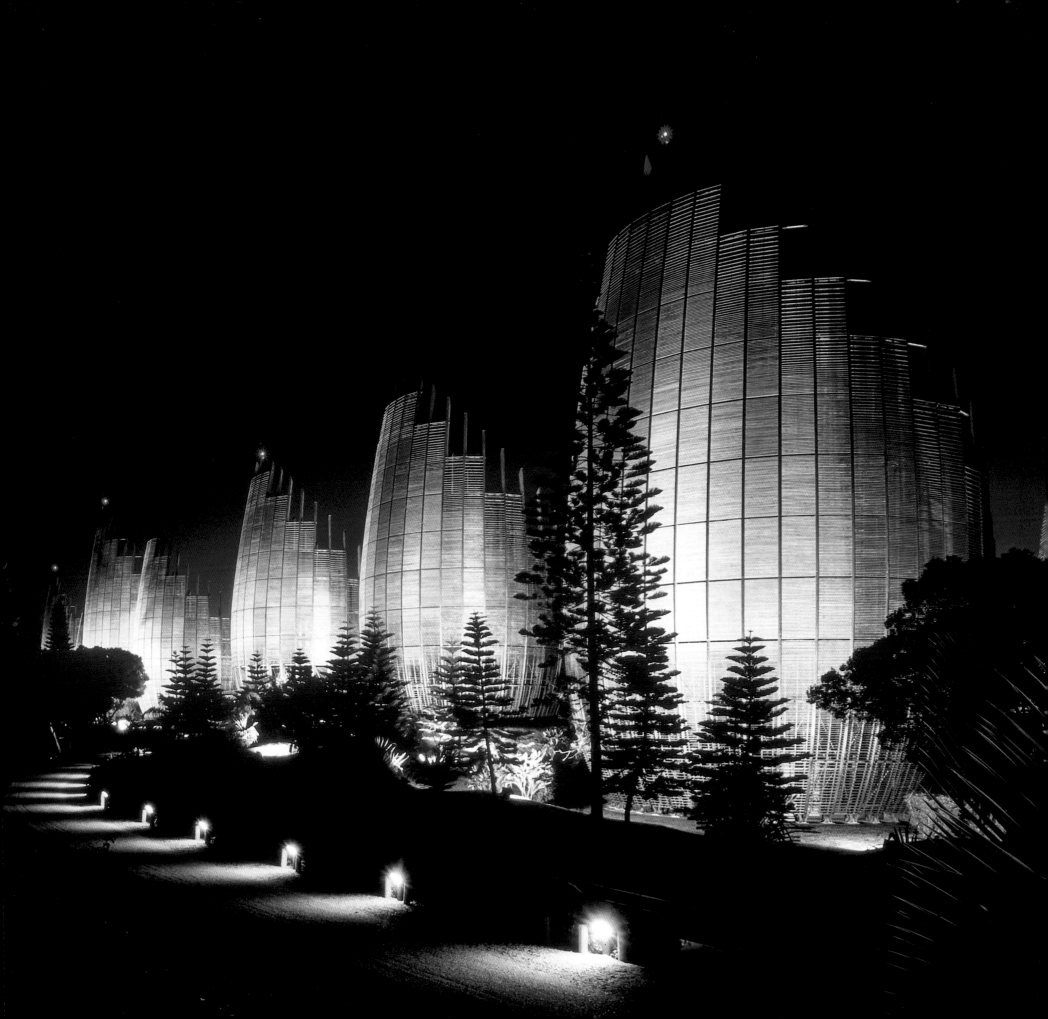

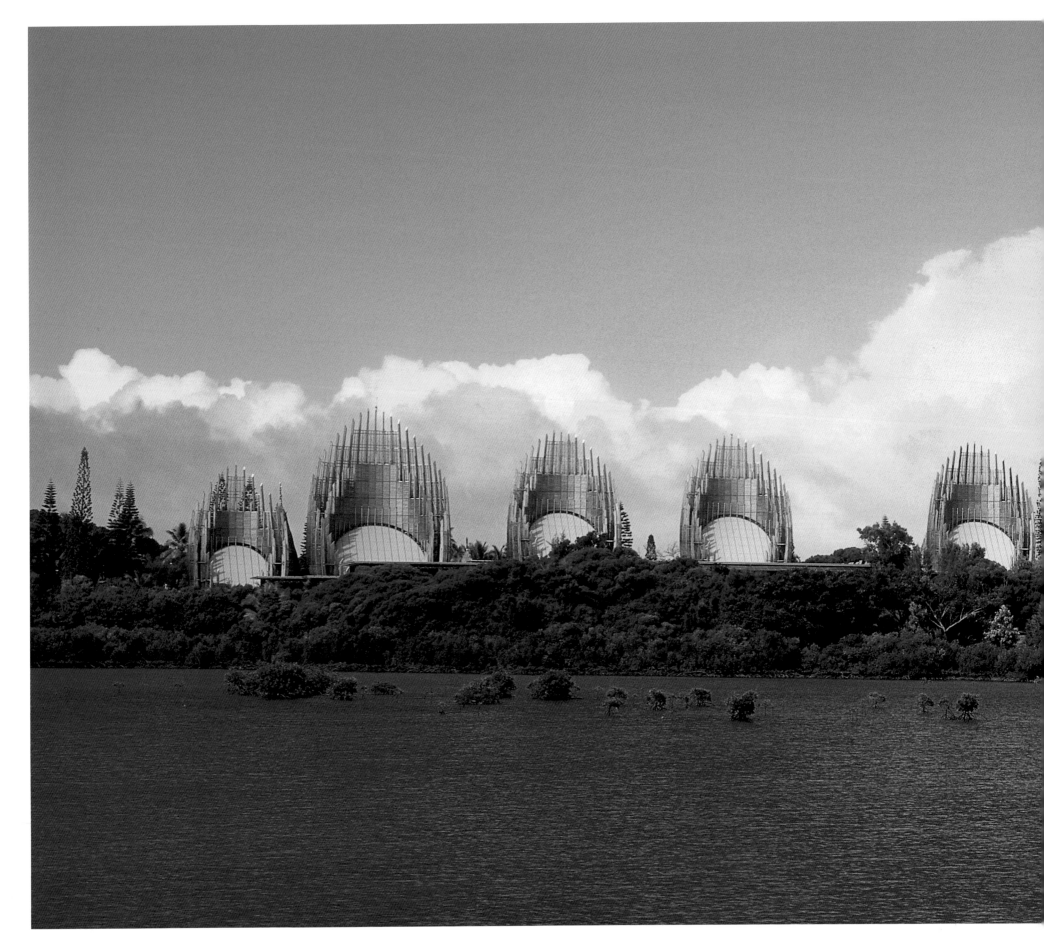

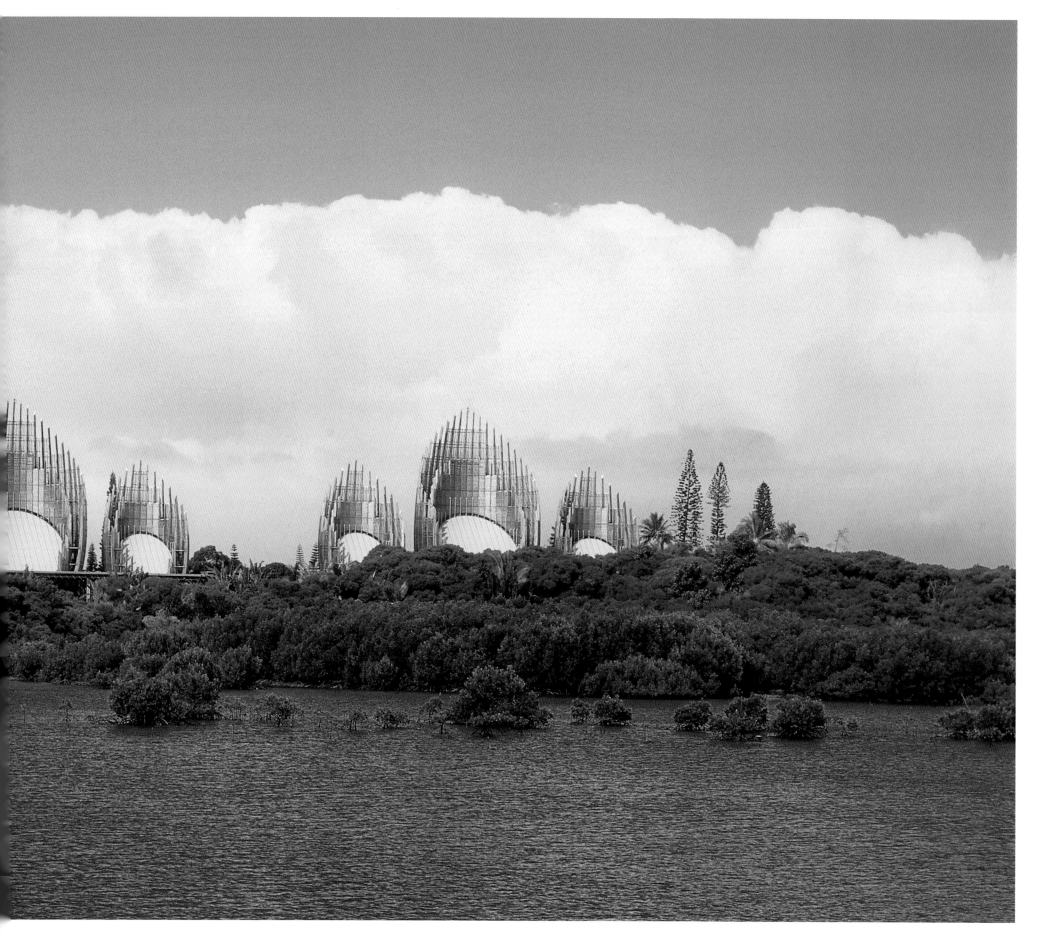

Dresden, Germany,
Wandel, Höfer, Lorch + Hirsch, 2001

United Polarities

Synagogue

The difficult challenge of creating a new synagogue on the site of the historic one burned down in the pogrom night in November 1938 was met with a reduction of forms as a contemporary interpretation of synagogue building theory. The congregation hall and synagogue are each housed in their own stone structure and stand in engaging spatial tension across from each other. The tilting walls of the synagogue transform it into an oscillating cube which transmits an archaic sacred quality. Softer textile materials inside stand in contrast to the hard stone of the massive buildings and evoke of the temple tent of Jewish tradition.

Vereinte Gegensatzpaare

Synagoge

Die schwierige Aufgabe: an der Stelle der in der Pogromnacht am 9. November 1938 niedergebrannten Synagoge einen Neubau zu errichten. Als zeitgemäße Interpretation der Theorie des Synagogenbaus reagierte man mit einer starken Reduktion der Formen. Gemeindehaus und Synagoge erhielten jeweils ein eigenes, massives Steinhaus. Durch Schrägstellung der Wände des Synagogenkörpers verwandelt er sich in einen oszillierenden Kubus, der eine archaische Sakralität ausstrahlt. In seinem Inneren bilden weiche Textilien einen Gegensatz zum harten Stein der Baukörper und erinnern an das Stiftszelt der jüdischen Tradition.

Réunion des polarités

Synagogue

Le défi de créer une nouvelle synagogue sur le site de l'ancienne, brûlée la nuit du pogrom de novembre 1938, a été relevé par une réduction des formes, interprétation moderne de la théorie de construction des synagogues. La salle de réception et la synagogue sont chacune abritées par une structure en pierre et dialoguent dans une agréable tension spatiale. Des murs inclinables transforment la synagogue en un cube oscillant, qui donne une impression de sacré archaïque. À l'intérieur, des matières textiles plus douces contrastent avec la pierre dure des bâtiments massifs, rappelant la tente du temple de la tradition juive.

La Unión de los Contrarios

Sinagoga

La difícil misión: Construir una nueva sinagoga en el lugar en el que se quemó antigua durante la noche de los pogromos, el 9 de noviembre de 1938. De acuerdo con la interpretación moderna de la teoría de la construcción de sinagogas se levantó un edificio con una fuerte reducción en las formas. La casa de la comunidad y la sinagoga recibieron cada una su propia construcción masiva de piedra. Las paredes inclinadas de la sinagoga convierten el edificio en un cubo oscilante que emana una arcaica sacralidad. En su interior, los suaves tejidos contrastan con la dura piedra de las construcciones y evocan la tienda del templo de la tradición judía.

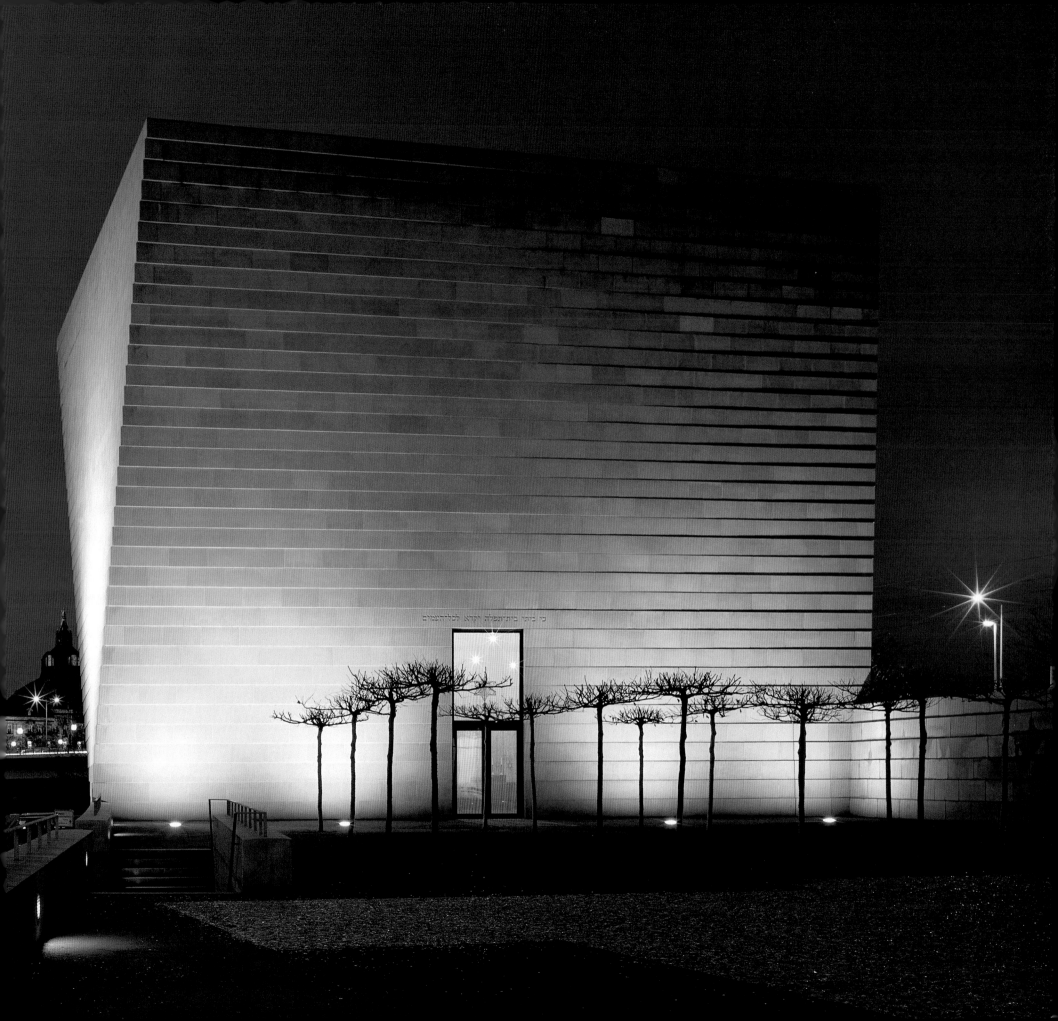

The Recyclable Building

Japanese Pavilion Expo 2000

In Japan, one of the most densely populated regions on the earth, one is confronted with the limits of nature daily. This building, designed for an exposition with the theme "humankind, nature and technology", explores new directions in sustainable architecture by utilizing solely recyclable materials. The roof's double-curved shell spans 34 meters and is the focus of the composition. A diagonally crossed latticework of paper hulls is hung below the wood trusses. To attain a watertight roof and meet fire code a roof membrane of paper and polymer-coated polyester sheeting was developed especially for use here.

Der recyclefähige Bau

Japanischer Pavillon Expo 2000

In Japan, einem der am dichtesten besiedelten Ländern, wird man tagtäglich mit den Grenzen der Natur konfrontiert. Um auf der Weltausstellung „Mensch, Natur, Technik" neue Wege vorzuzeigen beschloss man den Bau eines Pavillons aus ganz und gar wiederverwertbaren Materialien. Blickfang bildet die gekrümmte Gitterschale des 34 m überspannenden, hölzernen Dachtragwerkes mit seinem diagonal gekreuzten Netz aus Papierhülsen. Um eine wasserdichte Außenhaut herzustellen und die Auflagen des Brandschutzes zu erfüllen wurde speziell für diesen Bau eine Dachhaut aus Papier und polymerbeschichteten Polyestermembranen entwickelt.

Le bâtiment recyclable

Pavillon d'exposition japonais 2000

Le Japon, une des régions les plus densément peuplées de la terre, est quotidiennement confronté aux limites de la nature. Ce bâtiment, conçu pour une exposition sur le thème « humanité, nature et technologie », explore de nouvelles directions dans l'architecture écologique en utilisant uniquement des matériaux recyclables. Le toit à double courbe s'étend sur 34 m, formant le centre de la composition. Un treillis diagonal de coques en papier est suspendu sous des armatures en bois. Pour créer un toit étanche et ignifugé, une membrane formée de papier et de feuilles de polyester recouvertes de polymères a été spécialement conçue pour ce pavillon.

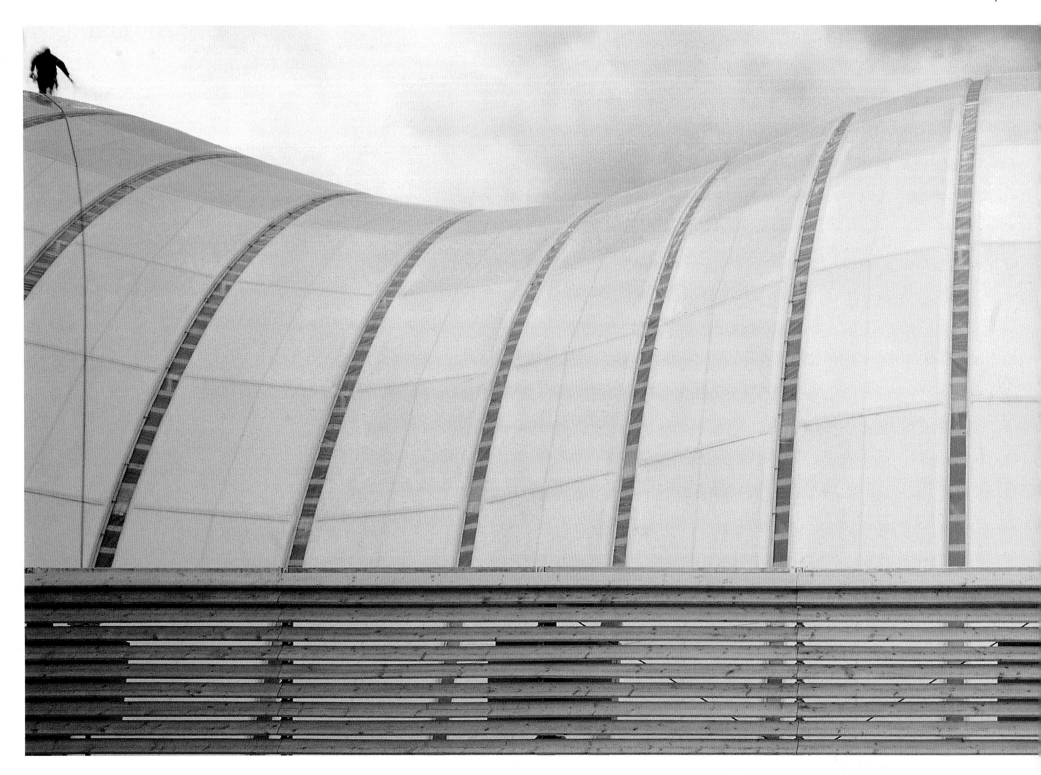

El Edificio Reciclable

Pabellón Japonés Expo 2000

En Japón, una de las regiones más densamente pobladas, se vive una confrontación diaria con los límites de la naturaleza. Para mostrar nuevos caminos en la exposición mundial de Hannover que tenía como lema «hombre, naturaleza y técnica», se decidió construir este pabellón a partir de materiales reciclados. El centro de atención es la malla curvada del esqueleto del techo, de 34 m de longitud y hecho de madera y con un enrejado de tubos de papel. Para conseguir una piel exterior resistente al agua y que cumpliera la normativa de incendios se desarrolló una membrana de papel para el techo y unas láminas de poliéster revestidas de polímero.

Hanover, Germany,
Shigeru Ban with Frei Otto, 2000

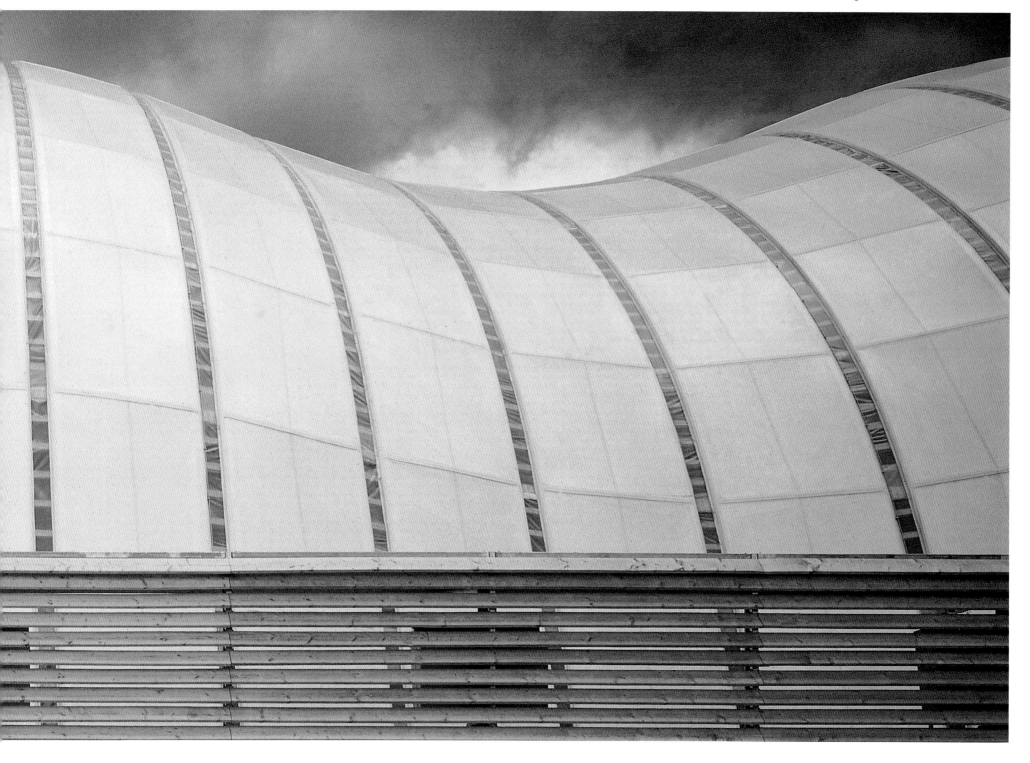

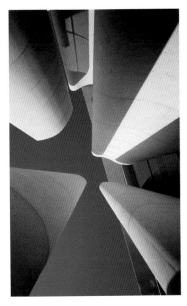

Berlin, Germany,
Axel Schultes, Charlotte Frank, 2001

Dignified Framework

Federal Chancellery

The new government buildings in Germany's capital are important symbols of the country's reunification. The goal was to create an architecture of representation while incorporating and respecting human scale. The central cube is conceived as a bridge-like structure symbolically connecting both halves of the country. The glass facade toward the entrance court is composed on a simple axis. A "forest" of curving white planes is arrayed before it to break the symmetry and soften the impression. The interiors, in contrast to the exteriors, are light and cheerful and create a working environment conducive to openness and communication.

Würdiger Rahmen

Bundeskanzleramt

Die neuen Regierungsbauten in Deutschlands Hauptstadt sind wichtige Symbole der Wiedervereinigung. Hier gilt es, dem Bedürfnis von Staat und Volk nach repräsentativen Bauten zu entsprechen, ohne den Bezug zum Einzelnen zu verlieren. Die Rahmenwirkung des zentralen Baukörpers suggeriert eine Brücke, die symbolisch beide Teile des Landes verbindet. Die gläserne Schauseite zum Hof ist symmetrisch auf die Mittelachse ausgerichtet. Ihr vorgelagert, stellt ein „Wald" aus krummen Scheiben den Bezug zum menschlichen Maßstab her. Innen gibt sich das Haus leicht und heiter als eine Arbeitswelt, die Offenheit fordert und Kommunikation erleichtert.

Un cadre empreint de dignité

La chancellerie fédérale

Les nouveaux bâtiments du gouvernement de la capitale allemande sont des symboles forts de la réunification du pays. Le but était de créer une architecture de représentation, tout en intégrant et en respectant l'échelle humaine. Le cube central est conçu comme un pont reliant symboliquement les deux moitiés du pays. La façade en verre de la cour d'entrée est formée sur un axe simple. Une « forêt » blanche de plans incurvés se déploie devant elle pour briser la symétrie et adoucir l'impression d'ensemble. L'intérieur, par contraste, est léger et gai, créant un environnement de travail propice à l'ouverture et à la communication.

Marco Digno

Cancillería Federal

Los nuevos edificios del Gobierno en la capital alemana son importantes símbolos de la reunificación. El objetivo era satisfacer el deseo del Estado y del pueblo de poseer edificios representativos pero sin perder la relación con las personas. El cubo central sugiere un puente que une simbólicamente las dos partes del país. La fachada de cristal que da al patio está dispuesta simétricamente sobre el eje central. Delante de ella, un «bosque» de planos curvos rompe la simetría y suaviza la impresión. Los interiores del edificio son luminosos y alegres y crean un ambiente de trabajo que exige un espíritu abierto y facilita la comunicación.

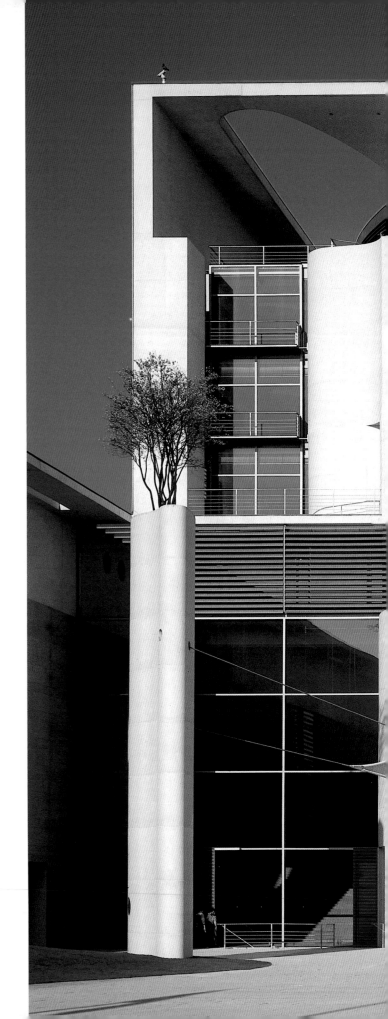

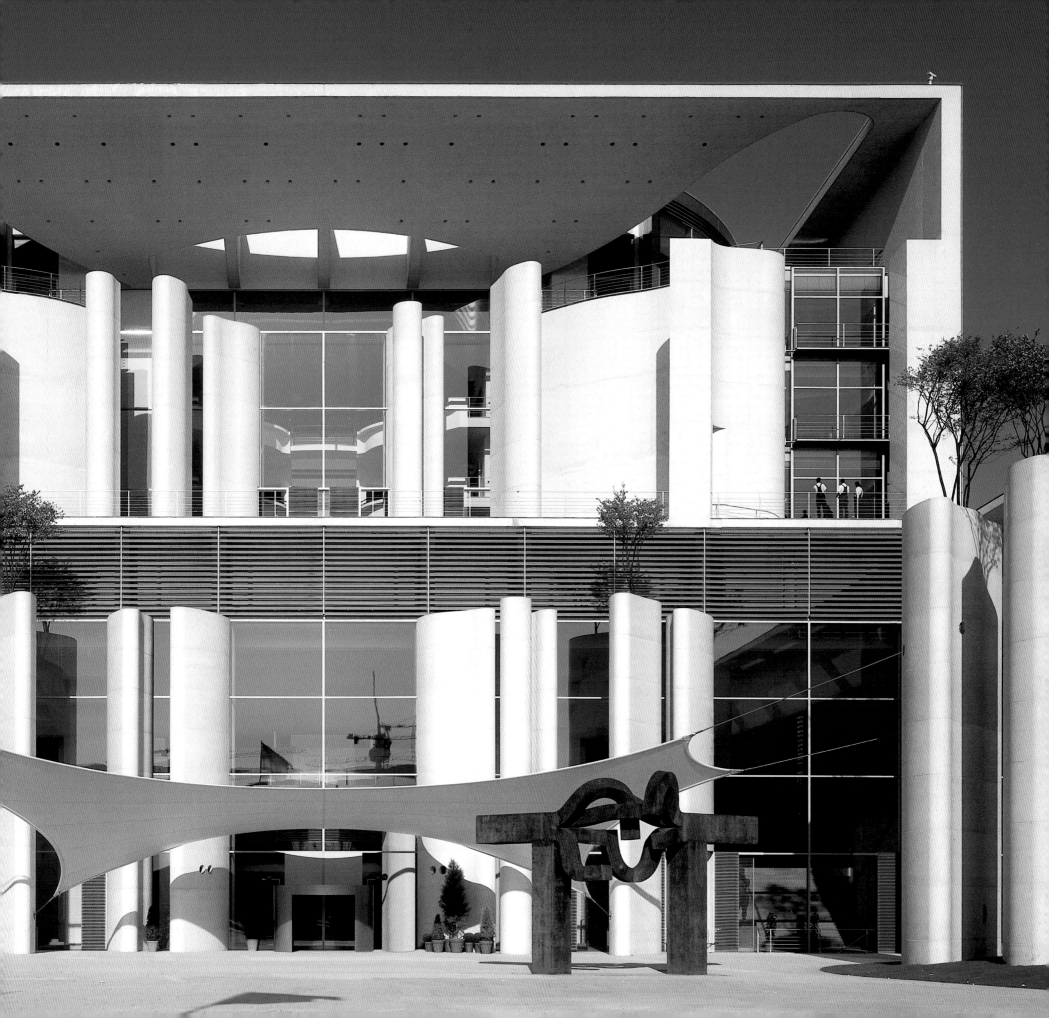

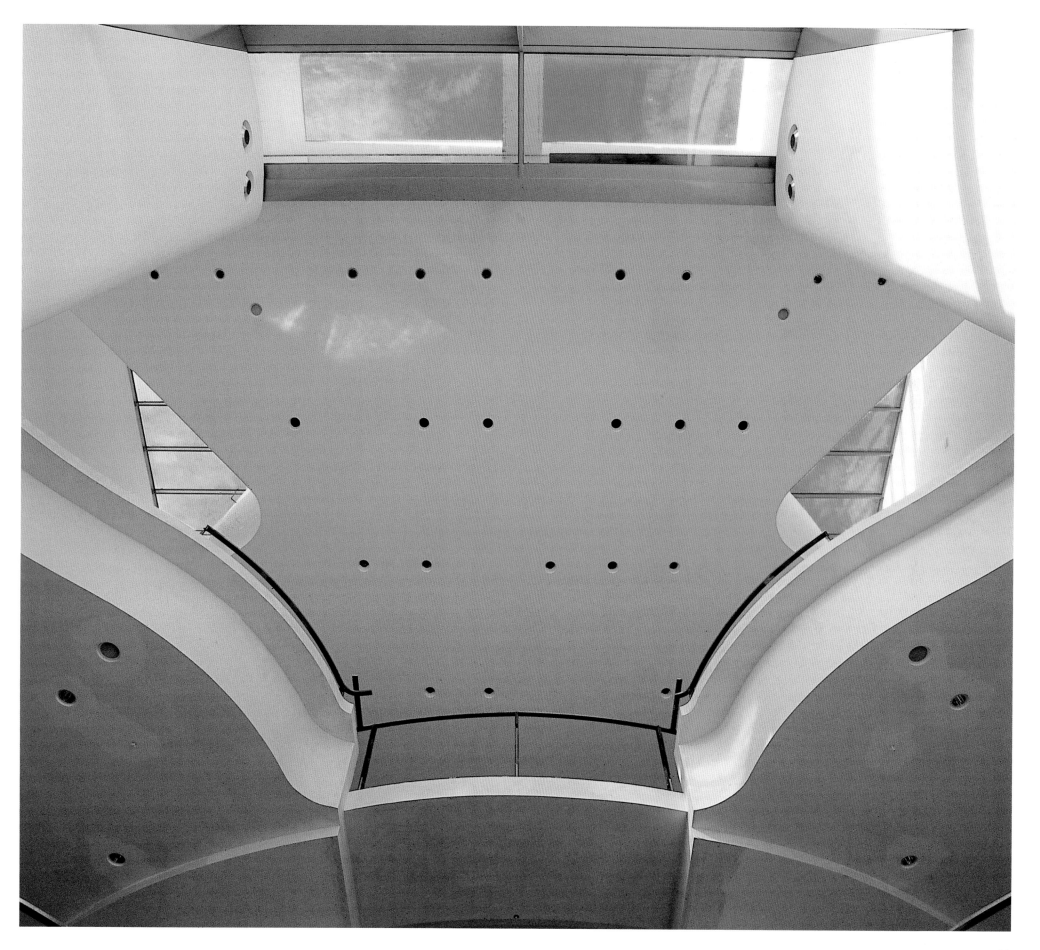

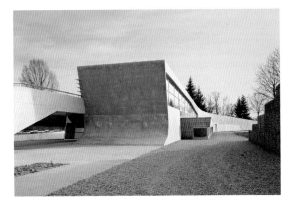

Weil am Rhein, Germany,
Zaha Hadid, 1999

Benchmark in Flux

LGS Pavilion

The bleak suburban context could be most anywhere, anyplace. In reaction to this arbitrariness the pavilion is a continuation of the site's specific terrain. The ground plane rises up the ramp-like building to an observation point. From here the composition is resolved by returning the virtual ground line back to the soil via a rounded base. Blank concrete walls and roof planes strengthen the sense of synthesis with the surroundings. By softening the borders between building and landscape, and sensitively extending the colors and textures of the adjoining paths and terraces a balanced harmony between nature and building is achieved.

Fließender Festpunkt

LGS Pavillon

Die öde Vorstadtlandschaft der Umgebung wirkt wie nirgendwo und überall. Auf diese Willkür bezieht sich der Pavillon als Fortentwicklung der Geländeoberfläche auf diesen speziellen Ort. Aus ihr heraus steigt der Gebäude-rücken als Rampe bis zum Aussichtspunkt empor, um dann sanft an der Stirnseite über eine gekrümmte Rundung zurück zur Basisebene geführt zu werden. Die skulpturalen Baukörper aus Sichtbeton verstärken die Synthese mit der Umgebung und setzen die Farbigkeit und Texturen der umgebenden Wegeflächen im Gebäude fort. Eine Figur im Einklang mit der Natur, die die Grenzen zwischen Landschaft und Gebautem fließend werden läßt.

Repère changeant

Pavillon LGS

Ce morne quartier de banlieue pourrait être presque n'importe où. En réaction à cet arbitraire, le pavillon est une continuation du terrain spécifique du site. Le sol s'élève le long du bâtiment en forme de rampe jusqu'à un point de vue. De là, la composition est résolue en ramenant la ligne du sol virtuelle vers la terre par une base arrondie. Des murs aveugles en béton et des toits plats renforcent l'impression de synthèse avec l'environnement. En réduisant les limites entre paysage et bâtiment et en prolongeant délicatement les couleurs et les textures des terre-pleins et des sentiers voisins, on atteint à une harmonie équilibrée entre nature et bâtiment.

Punto de Referencia en Movimiento

LGS Pavilion

Este desolado paisaje suburbano de los alrededores podría estar en ningún lugar y en todos los sitios. El pabellón se refiere a esta arbitrariedad al presentarse como la prolongación de la superficie de este lugar. El plano del suelo se levanta como una rampa hasta convertirse en un mirador, para bajar después en una suave curvatura por el lado frontal hasta llegar nuevamente al plano de la base. El cuerpo escultural de hormigón liso refuerza la síntesis con el entorno y continúa el colorido y las texturas de la superficie de los caminos lo rodean. Una figura en armonía con la naturaleza que difumina los límites entre paisaje y construcción.

Really Sustainable

The Eden Project

Trend-setting greenhouses are a long-standing tradition in England. When built in 1848, the Palm House in London's Kew Gardens was the largest glass building on earth. Here, on the site of a former pit mine, eight "Biomes" compose the largest greenhouse in the world. To help save our dwindling natural ressources a new symbiosis of humankind, technology and nature is documented and presented to the public. Held by the structure of 625 hexagonal steel frames, giant plastic cushions allow light through but retain heat. Their minimal weight allows 100 meter wide, free-spanning spaces in which three of the world's major climates are simulated.

Wirklich Nachhaltig

Das Eden Project

Zukunftsweisende Gewächshäuser haben in England Tradition. 1848 war das Palmhaus im Londoner Kew Gardens das größte Glasgebäude der Welt. Das Eden Project aus acht „Biomen" renaturiert einen durch Tagebau entstandenen Krater und ist heute das weltweit größte Pflanzenhaus. Angesichts schwindender Ressourcen wird hier eine neue Symbiose von Mensch, Technik und Natur einem breiten Publikum vermittelt. 625 hexagonförmige Stahlrahmen bilden das Tragwerk für riesige, lichtdurchlässige Plastikkissen. Ihr geringes Gewicht ließ 110 Meter breite, stützenfreie Räume entstehen, in denen drei Haupt-Klimazonen der Welt zur Schau gestellt werden.

Vraiment écologique

Le projet Eden

Les serres innovantes sont une vieille tradition anglaise. À sa construction, en 1848, la Palm House du Kew Gardens de Londres était le plus grand bâtiment en verre du monde. Ici, sur le site d'une ancienne mine, une serre cultivant huit « biomes » détient aujourd'hui ce titre. Pour aider à sauver nos ressources naturelles en déclin, une nouvelle symbiose de l'humanité, de la nature et de la technique y est présentée au public. Soutenus par 625 armatures hexagonales en acier, des coussins en plastique géants laissent entrer la lumière, mais retiennent la chaleur. Leur légèreté permet des espaces de cent mètres de large, où trois des grands climats du monde sont simulés.

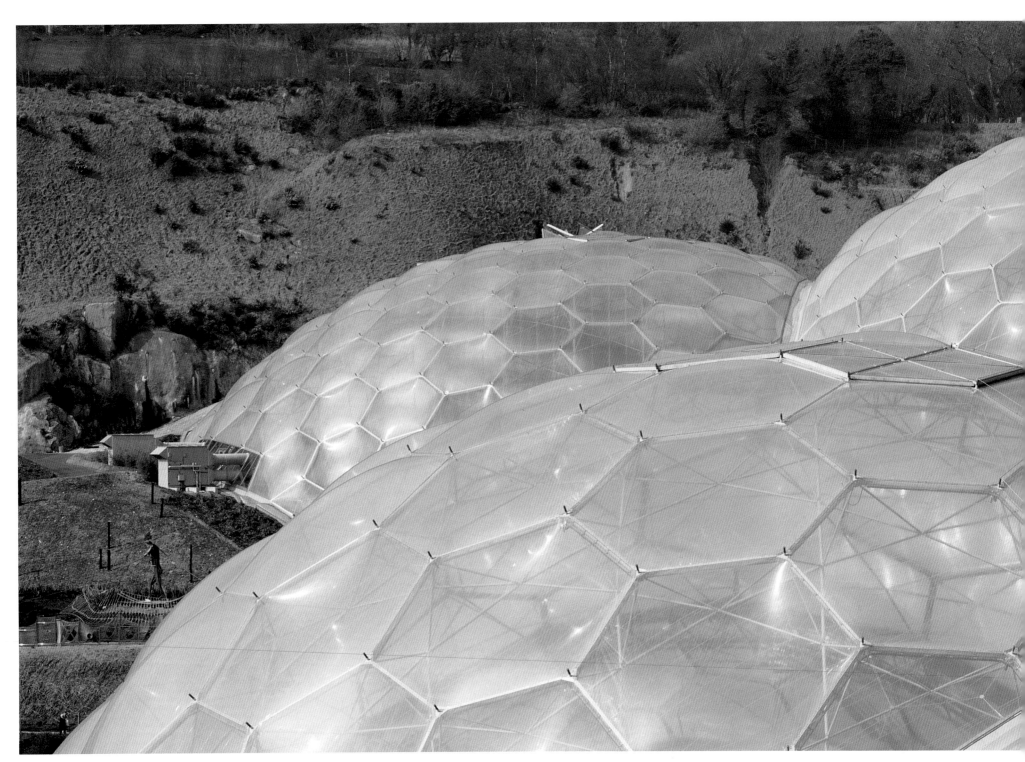

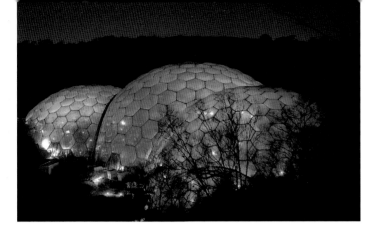

Realmente Sostenible

El Proyecto Edén

Los invernaderos futuristas tienen una larga tradición en Inglaterra.
En 1848 se levantó la mayor casa de cristal del mundo, la Palm House,
en el Kew Garden de Londres. El Proyecto Edén, compuesto por ocho
biodomos, repuebla una cantera y es el mayor invernadero del mundo.
La disminución de los recursos ha llevado a presentar al gran público
esta obra, una nueva simbiosis entre el hombre, la técnica y la natura-
leza. El esqueleto está formado por 625 hexágonos de acero y aguanta
enormes almohadillas de plástico transparentes. Su mínimo peso per-
mite espacios de 110 m de ancho y sin apoyos donde se recrean las
tres mayores zonas climáticas del mundo.

Cornwall, Great Britain,
Nicholas Grimshaw and Partners, 2001

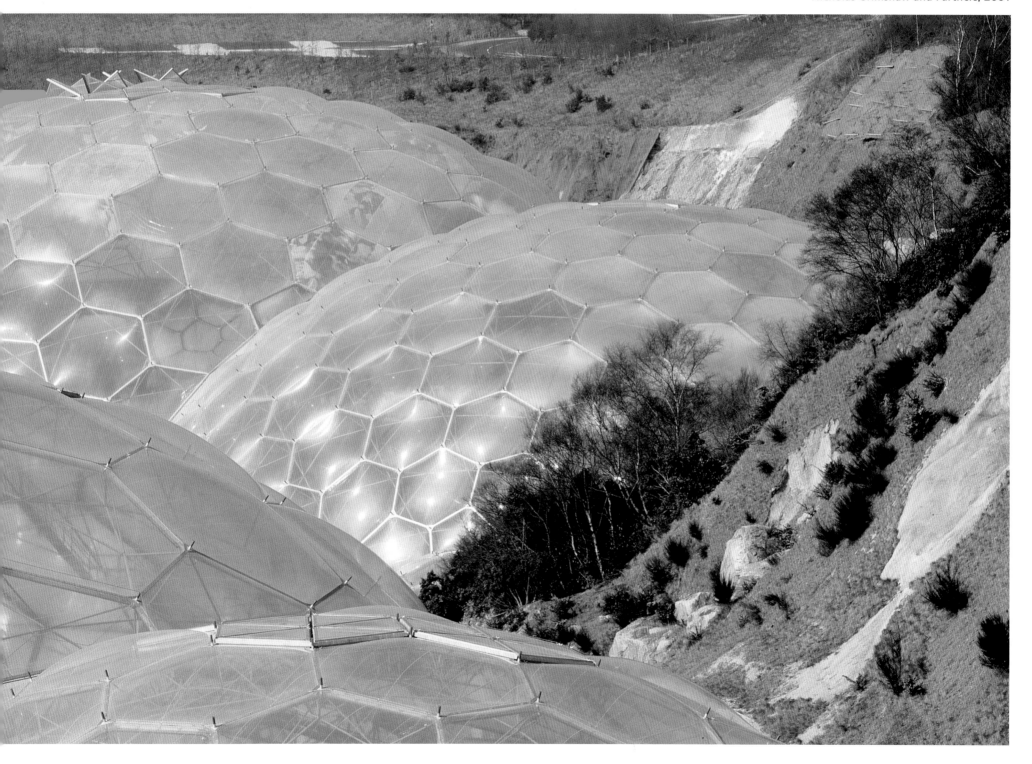

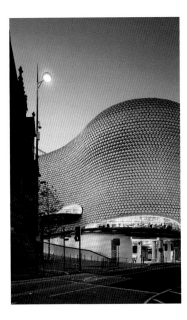

Birmingham, Great Britain, Future Systems, 2003

No Daily Routine

Selfridges Department Store

Fifteen thousand slightly concave aluminum plates cover this building's undulating surface. Their shimmering ambience varies as the light changes throughout the day. In sunlight they seem to glow, on cloudy days they blend with the gray sky behind. The new focus building for a run-down city center, it strikes up a lively conversation with the neighboring neo-gothic church. The unique shopping experience doesn't end at the flashy facades. A kidney-shaped, light-flooded atrium inside forms the heart of a cave-like shopping universe that is oriented not only inward, but strives to create an urban image making its presence known far beyond the city limits.

Keine Alltagsroutine

Kaufhaus Selfridges

15 000 leicht konvexe Aluminiumplatten zeichnen matt schimmernd die Wellen des Bauvolumens nach. Je nach Tageszeit changierende Lichtreflexe lassen den Bau glühen oder unwirklich gegen den Himmel verschwinden. Als strahlender Fokus eines heruntergekommenen Stadtteils harmoniert er mit der benachbarten neogotischen Kirche. Das einmalige Einkaufserlebnis endet aber nicht bei der Gestaltung der auffälligen Außenhülle. Ein lichtdurchflutetes, nierenförmiges Atrium bildet das Herz des höhlenähnlichen Shopping-Universums, das jedoch nicht nur nach Innen gerichtet ist, sondern als Wahrzeichen weit über die Stadtgrenzen hinaus wirkt.

Pas de routine quotidienne

Le grand magasin Selfridges

Quinze mille tôles concaves en aluminium tapissent la surface de ce bâtiment. Leur aspect miroitant varie avec les changements de lumière. Au soleil, elles semblent briller, et se fondent par temps couvert avec le ciel gris. Cet édifice neuf dans un centre ville décrépit dialogue joyeusement avec l'église néo-gothique voisine. La rencontre avec ce magasin exceptionnel ne s'arrête pas aux façades tape-à-l'œil. Un hall central en forme de rein, inondé de lumière, est le cœur de cet univers commercial aux allures de grotte. Axé non seulement sur l'intérieur, il tend à créer une image urbaine qui fasse connaître sa présence bien au-delà des limites de la ville.

Sin Rutina Diaria

Grandes Almacenes Selfridges

15.000 placas de aluminio ligeramente convexas forman la superficie ondulada y mate de esta construcción. Según el momento del día, los reflejos de la luz hacen que el edificio parezca estar al rojo vivo o que desaparezca de forma irreal en el cielo. Es el nuevo y brillante centro de un barrio venido a menos y que armoniza con la vecina iglesia neogótica. Esta experiencia comercial única no acaba en la llamativa fachada. Un atrio con forma de riñón e inundado de luz es el corazón de este universo de las compras, similar a una cueva, que no sólo está orientado hacia el interior sino que, además, su silueta destaca más allá de los límites de la ciudad como un símbolo distintivo.

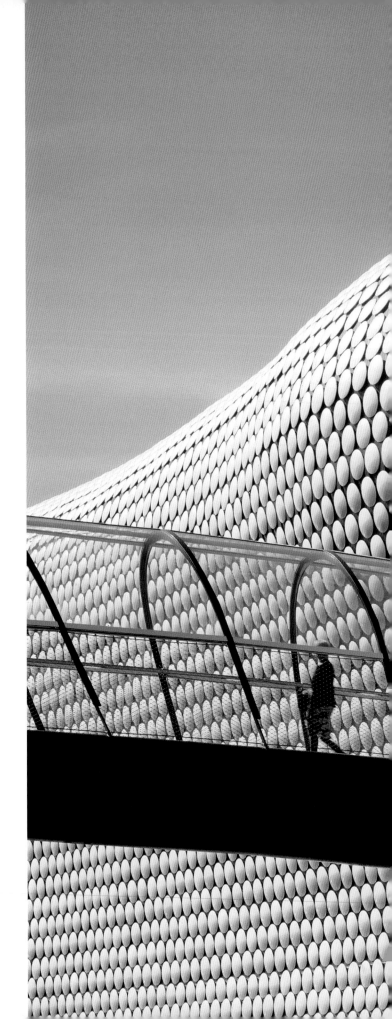

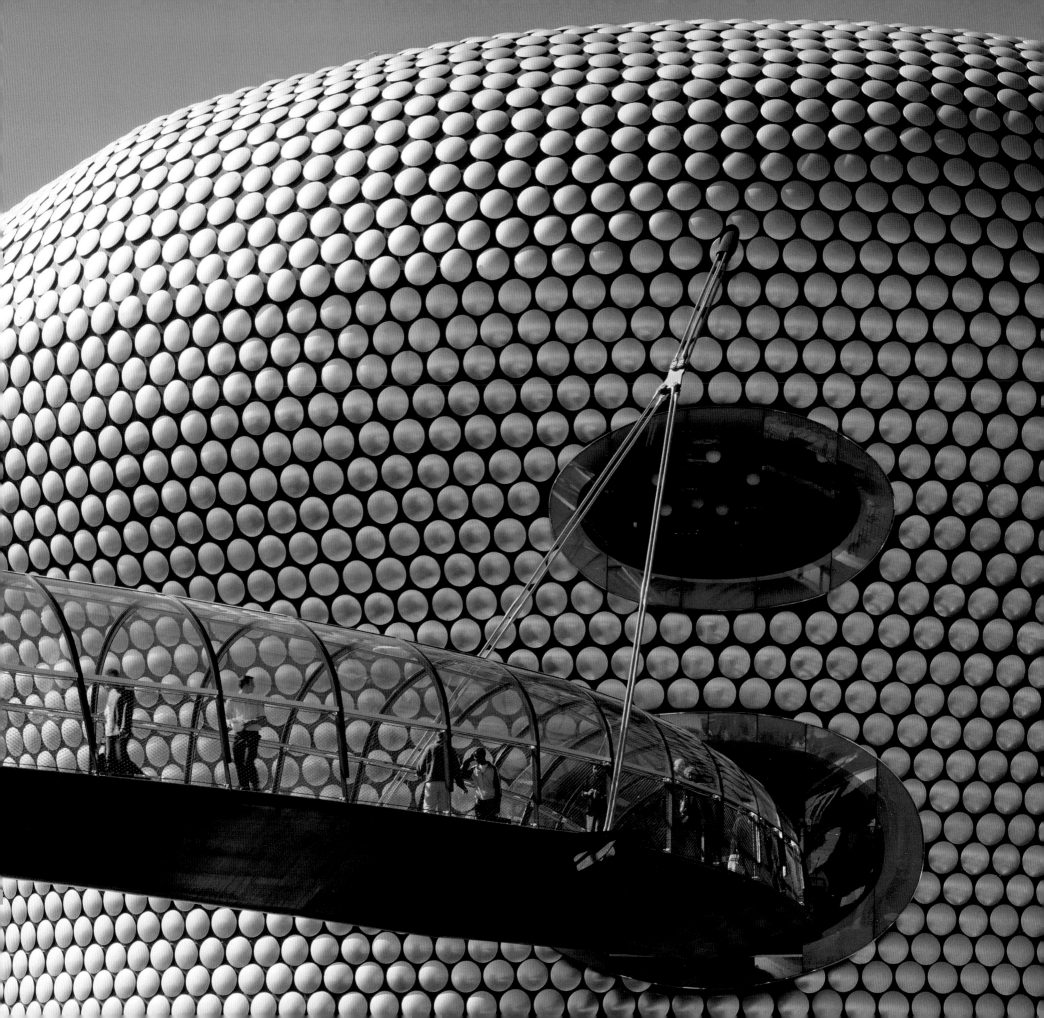

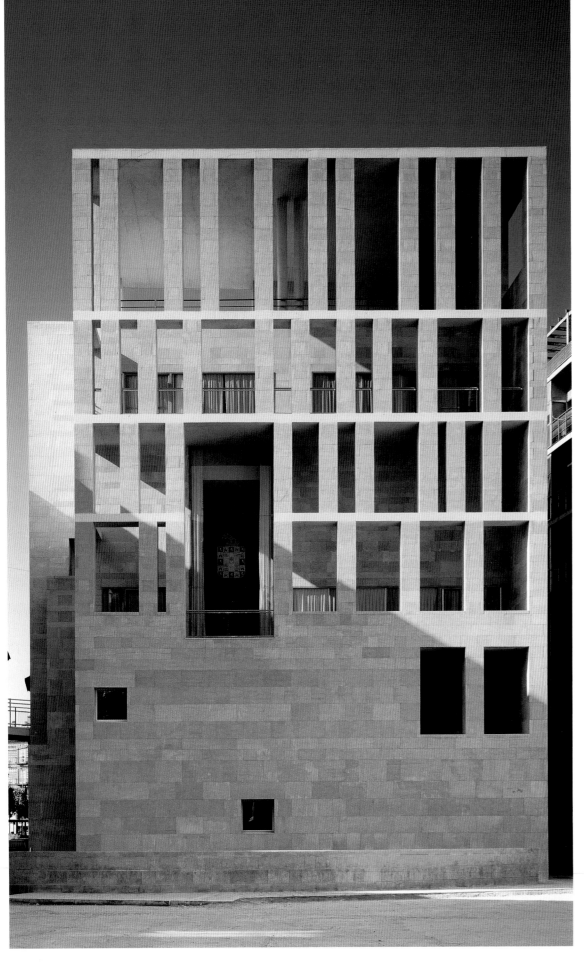

New Kid on the Plaza

City Hall Annex in Murcia

The Plaza Cardenal Belluga is a like a forest clearing surrounded by the narrow alleys of the medieval town. The new city hall takes a step back and lets the baroque Santa Maria Cathedral play the leading part. The main front on the plaza, clad in pink Cavila limestone, begins as a massive plinth and is increasingly perforated as the building rises. The sculptural play with deep recesses and loggias translates the cathedral's rich vocabulary into new forms that recognize the delicate scale of the plaza without replicating it – a stance respectful of history's lessons yet striving for a better future.

Zukunftsgerichtete Geschichte

Rathausanbau in Murcia

Im Dickicht der engen Gassen des mittelalterlichen Stadtkerns öffnet sich die Plaza Cardenal Belluga wie eine lichte Wiese. Die plastisch gestaltete Rathausfront tritt gegenüber der barocken Kathedrale Santa Maria gestalterisch zurück. Die mit rosafarbenem Muschelkalk aus Cavila verkleideten Mauern geben sich unten burgartig massiv und öffnen sich dann in den oberen Geschossen. Der Bau deutet dabei die Säulen und Skulpturen der Kathedrale in Pfeiler um, die den feingliedrigen Maßstab der Umgebung aufnehmen, ohne sich historisierend anzubiedern. Eine Haltung, die die Lehren der Geschichte respektiert, ohne den Blick für die Zukunft zu verlieren.

Un sang nouveau sur la grand-place

Annexe de la mairie de Murcie

La Plaza Cardenal Belluga est comme une clairière dans un bois, entourée par les ruelles étroites de la ville médiévale. La nouvelle mairie est un peu en retrait pour laisser la cathédrale baroque Santa Maria jouer le rôle central. Sur la plaza, la façade principale, revêtue de calcaire rose de Cavila, débute comme un socle massif, pour être de plus en plus percée vers le haut de l'édifice. Le jeu sculptural entre les renfoncements et les loggias traduit en formes nouvelles le riche vocabulaire de la cathédrale, reconnaissant l'échelle délicate de la plaza sans la reproduire — une position respectueuse des leçons de l'histoire, tout en recherchant le meilleur de l'innovation.

Un Nuevo Niño en la Plaza

Anexo del Ayuntamiento en Murcia

En medio de la maraña de estrechos callejones del centro medieval de la ciudad se abre la Plaza Cardenal Belluga como un luminoso claro. El frente del ayuntamiento, creado de una forma escultural, da un paso atrás ante la catedral barroca de Santa María. Los muros, cubiertos de piedra caliza rosada de Cavila, son en su base un zócalo macizo que después se abren en los pisos superiores. La construcción es una interpretación nueva de las columnas y las esculturas de la catedral en pilares que reconocen sin imitar las delicadas proporciones de la plaza. Una postura respetuosa con la enseñanza de la historia pero que mantiene su mirada en el futuro.

Murcia, Spain, José Rafael Moneo, 1998

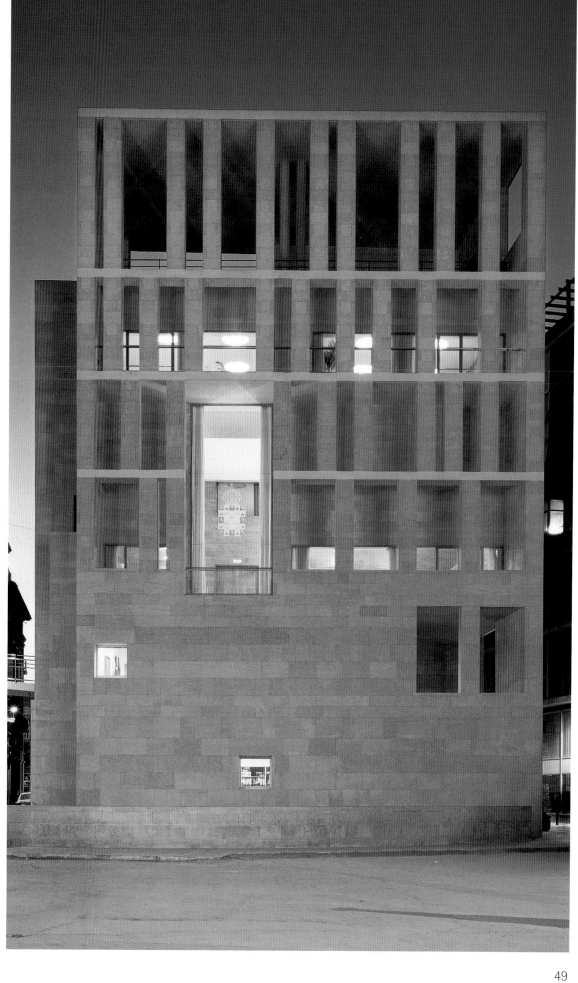

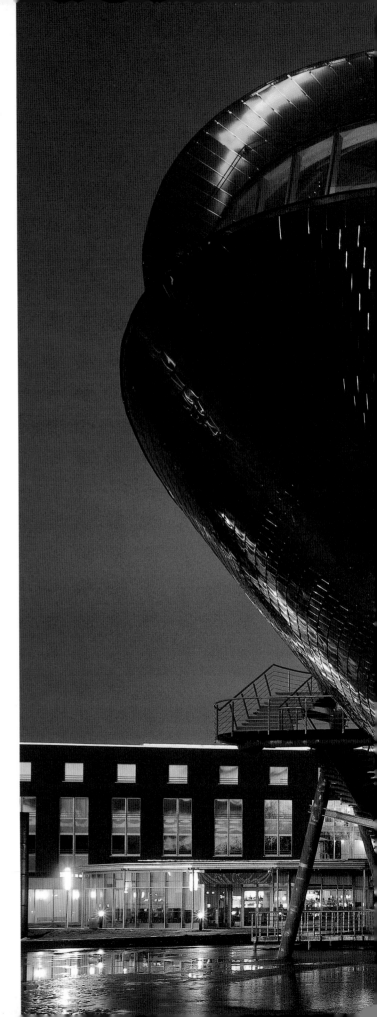

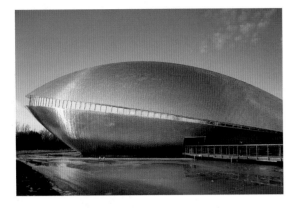

Bremen, Germany,
Thomas Klumpp, 2001

In the Whale's Belly

Universum® Science Center

Humankind cannot survive without nature. True to this motto, this science center is a place where new, sustainable thinking is relayed to a broad public. The resultant organic form creates interior and exterior spaces that rouse curiosity. A curved wooden skeleton supports the gleaming building hull. The skin of countless reflective stainless steel scales reflects light and mirrors the surroundings during the day, and radiates a futuristic, UFO-like quality at night. The interior spaces, bathed in mysterious blue light, create a thought-provoking atmosphere which effectively communicates the center's mission.

Im Bauch des Wals

Universum® Science Center

Ohne die Natur kann der Mensch nicht überleben. Treu dieser Devise werden im Science Center nachhaltige Lösungsansätze einem breiten Publikum vermittelt. Die dieser Aufgabe entsprechende, organische Bauform schafft Innen- und Außenräume, die Neugierde wecken. Getragen wird die schimmernde Hülle durch ein gebogenes Holzskelett. Darauf wurden die unzähligen, schimmernden Schuppen aus Edelstahl befestigt, die zu jeder Tageszeit ein ganz eigenes Ambiente erzeugen. Im Inneren angelangt, regen die geheimnisvollen, in blaues Licht gehüllten Räume zur kurzweiligen Auseinandersetzung mit der Wissenschaft an.

Dans le ventre de la baleine

Universum® Centre scientifique

L'humanité ne peut survivre sans la nature. Fidèle à cette devise, ce centre scientifique est un lieu où la pensée nouvelle est transmise à un large public. Dans ce but, sa forme organique crée des espaces intérieurs et extérieurs suscitant la curiosité. Une charpente en bois courbe soutient la carcasse brillante de l'édifice. Le revêtement, formé d'innombrables écailles en inox, refléchit la lumière et reflète les environs dans la journée, avant de rayonner la nuit d'un éclat d'OVNI futuriste. L'intérieur, baigné d'une mystérieuse lumière bleue, crée une atmosphère propice à la pensée qui communique de façon frappante la mission du centre.

En la Barriga de la Ballena

Universum® Science Center

El ser humano no puede sobrevivir sin la naturaleza. Fiel a esta divisa, este centro de ciencias es un lugar en el que se transmite un pensamiento nuevo y sostenible a un amplio público. De acuerdo con este propósito, la forma orgánica de la construcción crea unos espacios interiores y exteriores que despiertan la curiosidad. La brillante cubierta es soportada por un esqueleto de madera curvado. Sobre él se han fijado innumerables escamas de acero inoxidable que dependiendo del momento del día crean una atmósfera diferente. En el interior, los espacios, bañados en una misteriosa luz azul, invitan a interesarse de una forma divertida por la ciencia.

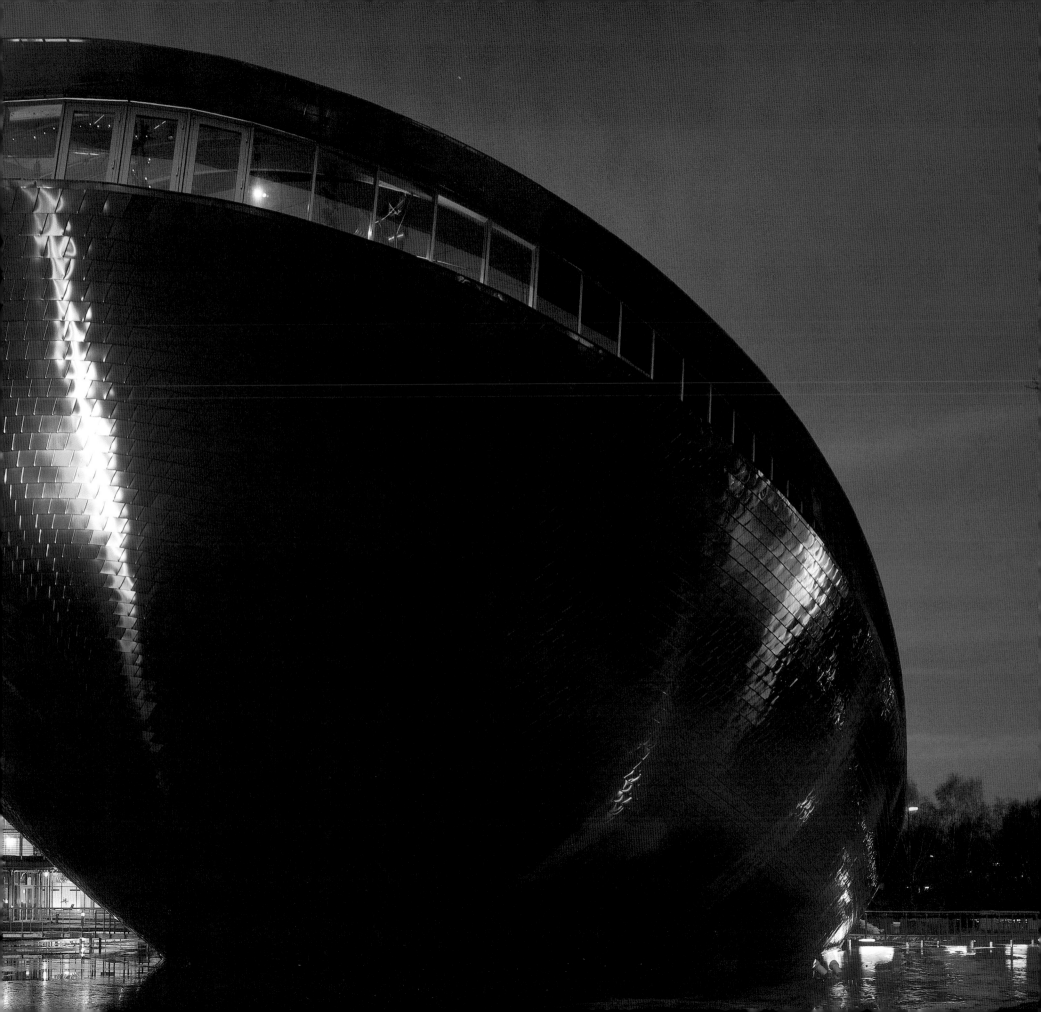

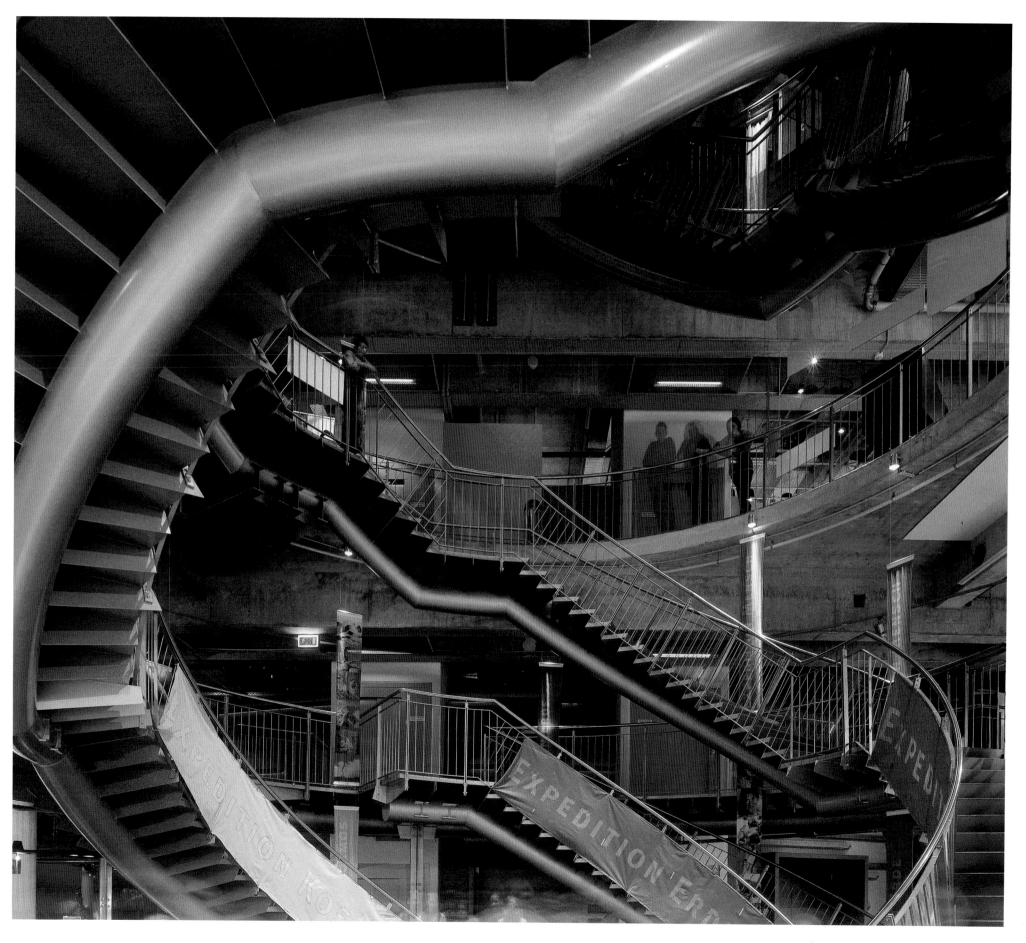

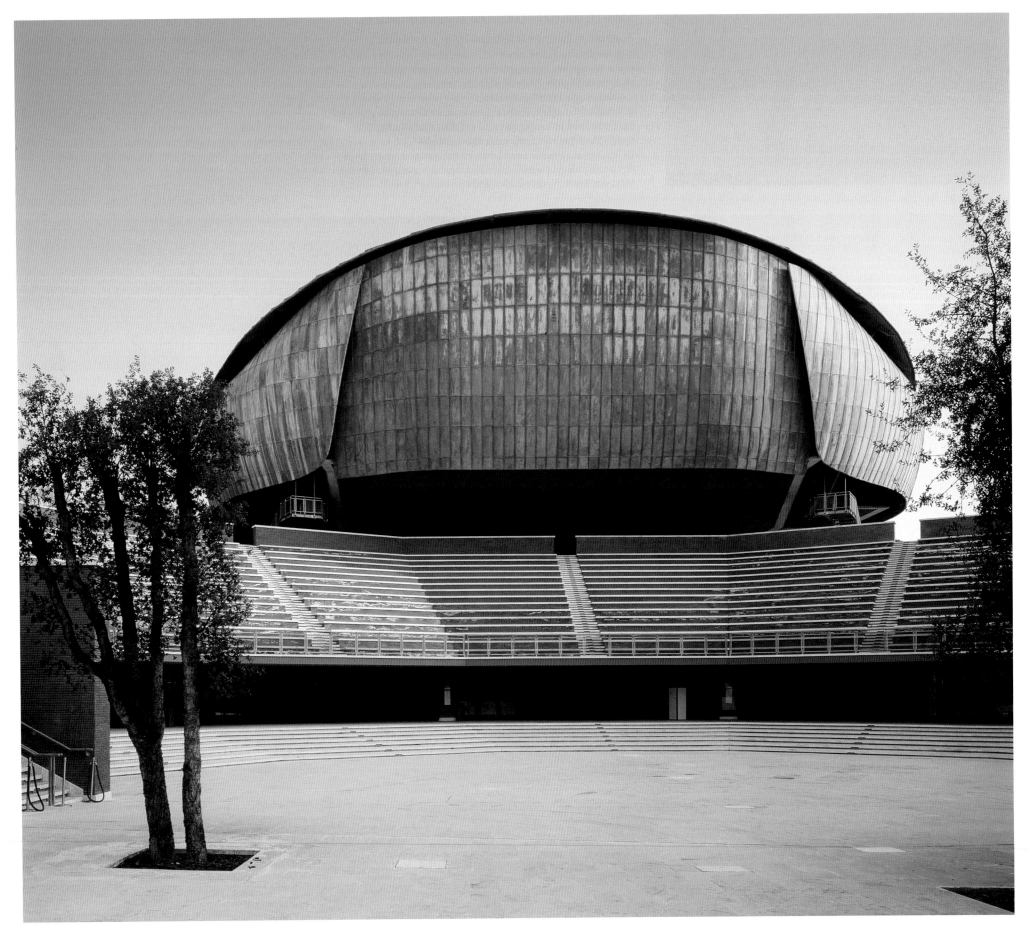

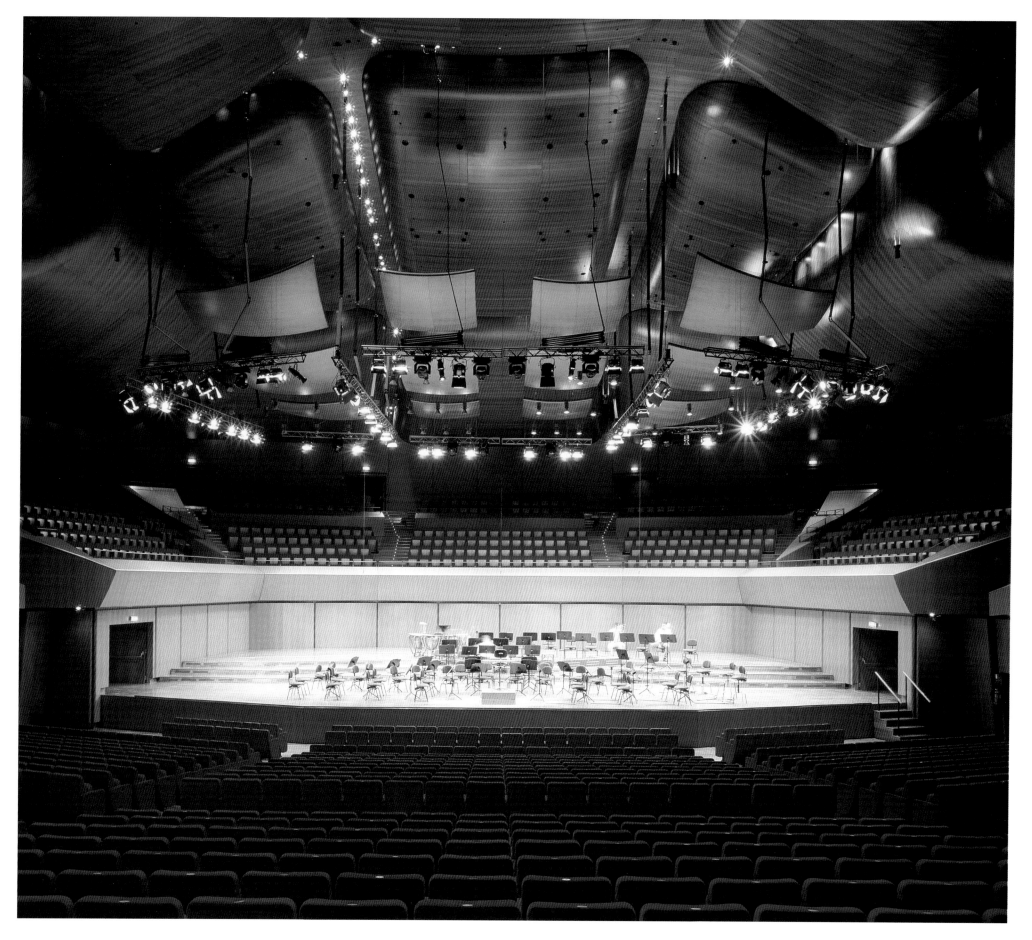

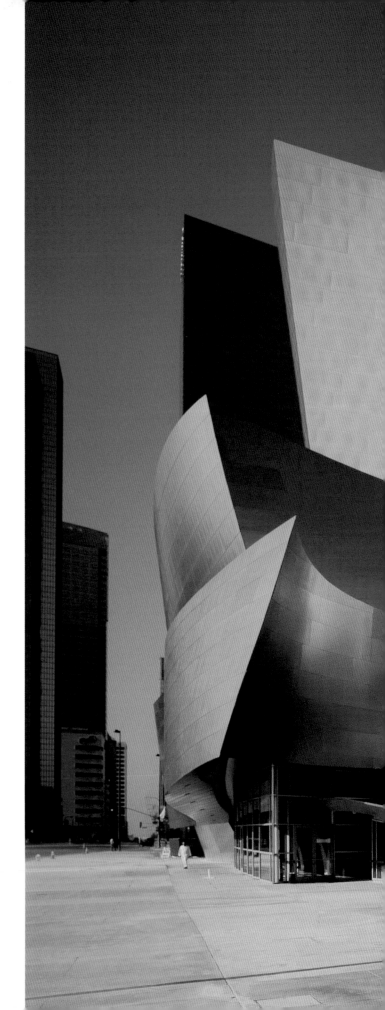

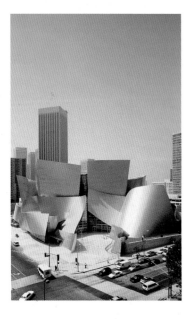

Los Angeles, USA, Frank O. Gehry, 2003

Pulsating Music

Disney Concert Hall

For decades, downtown Los Angeles has been the city's neglected problem child. It took 30,000 drawings and 16 years of planning and construction to complete the cultural complex, the pulsating focus for a new urban quarter. The shiny titanium skin of the building catches the Southern California sunlight and reflects it into the cool shade in the park at the base of the towering sculptures. The 2265-seat main hall was designed first, with the rest of the building conceived to surround it. Praised even by the demanding musicians of the La Philharmonic orchestra, the hall, paneled on all surfaces in vibrant Douglas fir, boasts exceptional acoustics.

Pulsierende Musik

Disney Concert Hall

Downtown Los Angeles ist seit Jahrzehnten das verwahrloste Sorgenkind der Stadt. Nach Anfertigung von 30 000 Zeichnungen und 16 Jahren Planungs- und Bauzeit vollendete man den Kulturkomplex als das pulsierende Zentrum eines neuen Stadtviertels. Aufgelöste Baukörper, in Titanstahl gekleidet, fangen die Sonne Südkaliforniens ein und reflektieren diese in die kühlen Schatten des Parks zu Füßen der sich auftürmenden Metallkörper. Der 2.265 Sitzplätze umfassende Saal wurde zu allererst konzipiert. Der vollständig mit Douglas-Tanne verkleidete Raum verfügt über eine bisher selten erreichte Akustik, die nicht nur Philharmoniker begeistert.

Musique trépidante

La salle de concert Disney

Durant des décennies, le centre de Los Angeles a été le canard boiteux de la ville. Il a fallu 30 000 dessins et 16 ans de construction et d'urbanisme pour achever le complexe culturel, le cœur trépidant d'un nouveau quartier urbain. Le revêtement en titane brillant du bâtiment capte le soleil du sud californien et le renvoie dans l'ombre fraîche du parc au pied des sculptures imposantes. La grande salle de 2265 sièges a été créée en premier, et le reste du bâtiment a été conçu autour d'elle. Cette salle très réputée, même parmi les musiciens exigeants de la philarmonie de LA, est entièrement lambrissée de sapin Douglas et jouit d'une acoustique exceptionnelle.

Música Vibrante

Disney Concert Hall

El centro de Los Ángeles ha sido durante décadas el niño problemático y abandonado de la ciudad. Fueron necesarios 30.000 dibujos y 16 años de planificación y construcción para completar el complejo cultural, centro palpitante de un nuevo barrio. La brillante piel de titanio de los cuerpos del edificio atrapa el sol de California del Sur y lo refleja en la fría sombra del parque en la base de los altos cuerpos metálicos. La sala, con 2.265 asientos, fue lo primero en diseñarse y a su alrededor se concibió el resto del edificio. Toda la superficie está recubierta con madera de pino Douglas y tiene una excepcional acústica que no sólo entusiasma a los filarmónicos.

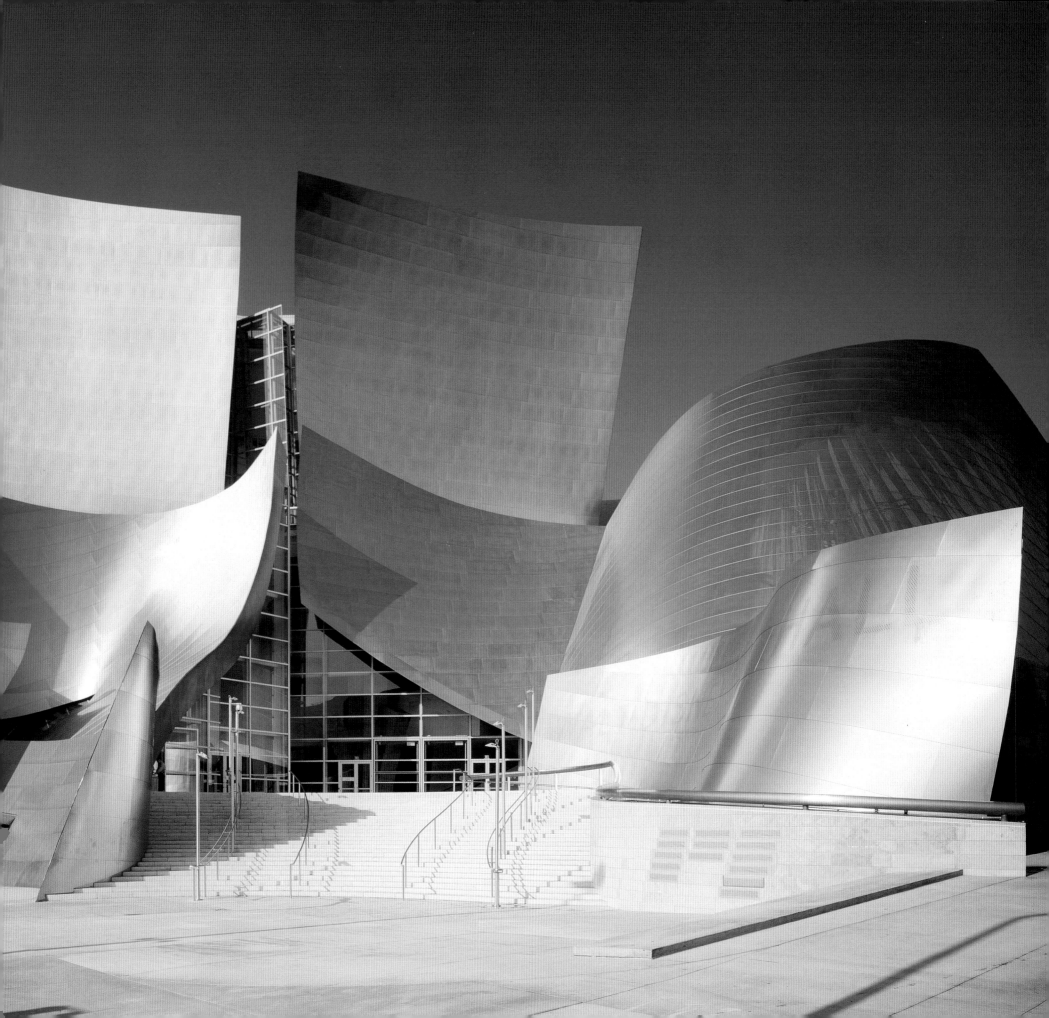

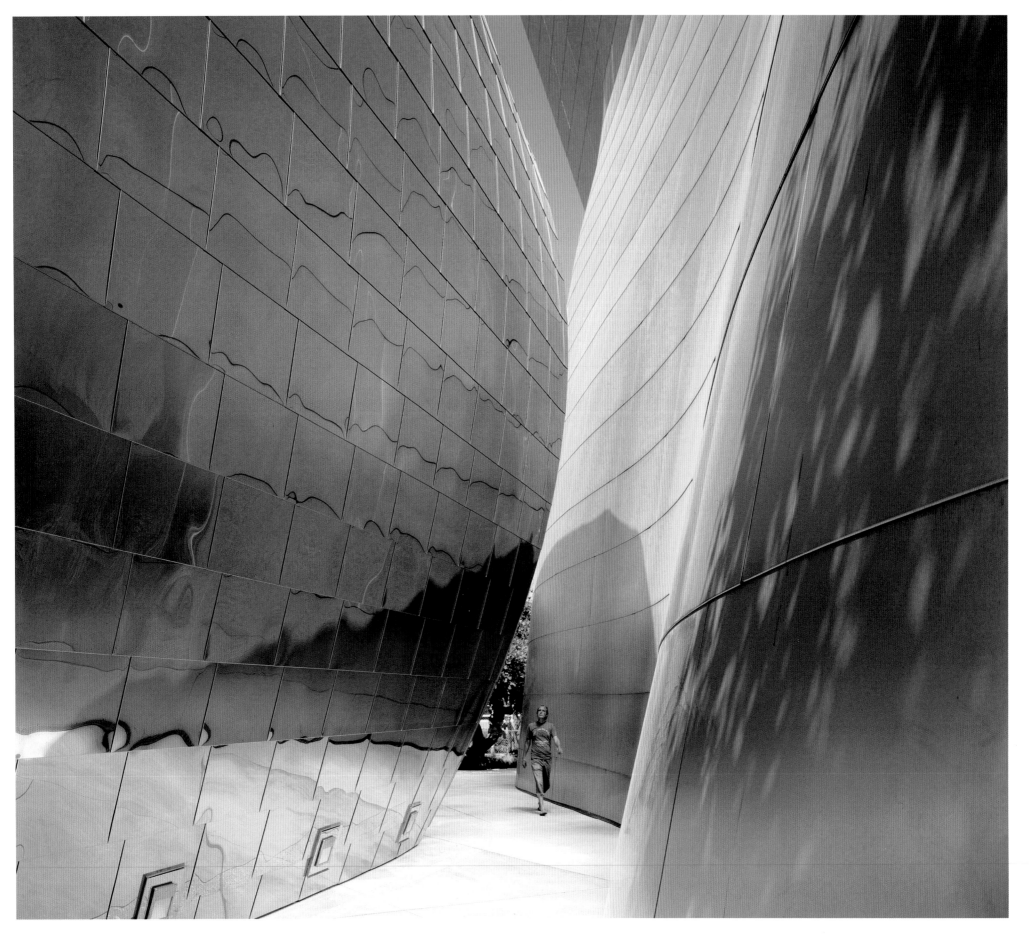

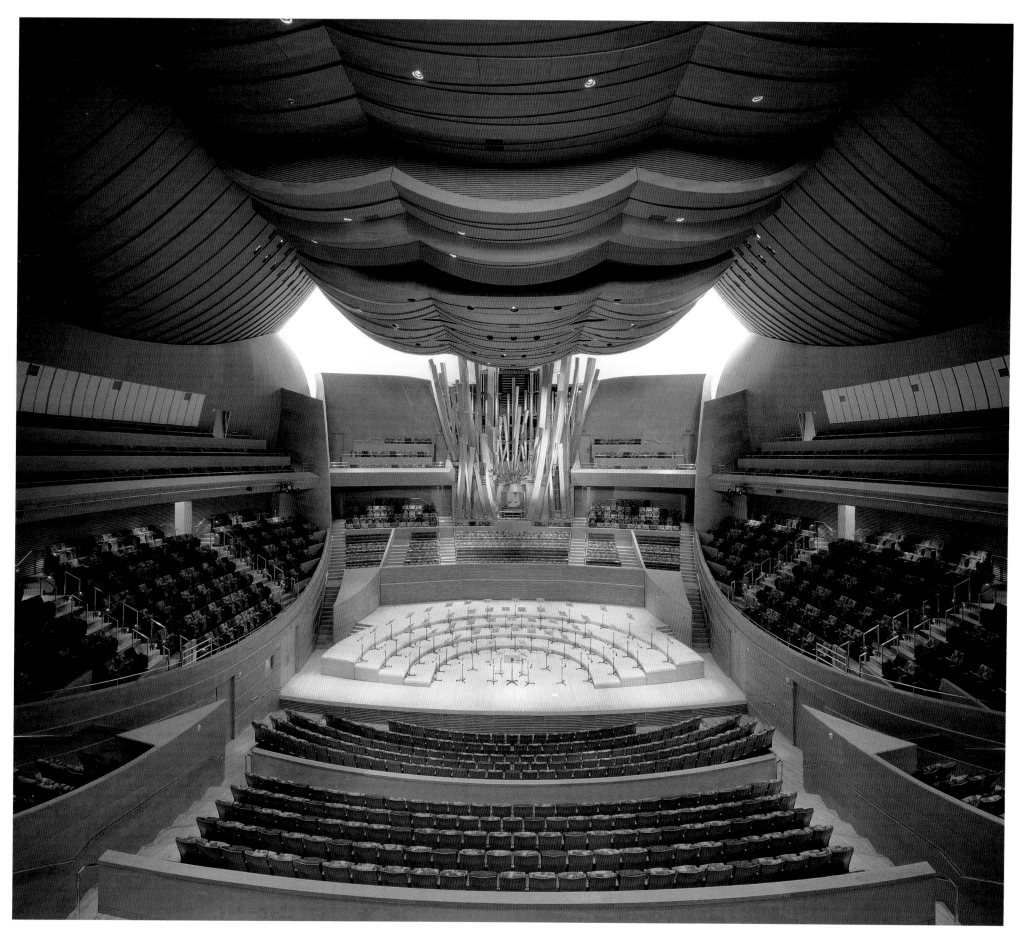

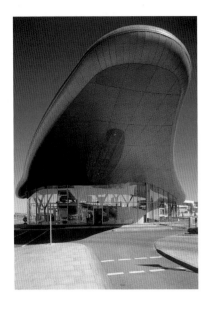

Hamburg, Germany, Renner Hainke Wirth, 2000

UFO or Jumbo Jet?

Lufthansa Reception Building

As a marketing tool in the battle to win and retain quality-conscious passengers, established airlines are increasingly utilizing future-oriented design. The Lufthansa Reception Building is a striking interpretation of high-tech aero-technology. The resilient steel of the lightweight structural frame allows the far-reaching cantilever roof to provide cover for the passenger drop-off point. The two-story waiting space inside includes a quiet upper gallery level with comfortable pilot seats. Here the traveler is invited to relax and maybe even to leave the laptop closed and enjoy the view out over the busy airfield.

UFO oder Airbus?

Lufthansa Empfangsgebäude

Im Kampf der Airlines um die wählerischen Passagiere locken etablierte Carrier mit Komfort und gezielt eingesetztem, zukunftsweisendem Design. Das Lufthansa Empfangsgebäude besticht durch eine bauliche Interpretation der hochentwickelten Luftfahrttechnologie. Stahl als Trageskelett ermöglicht die weiten Auskragungen des schwebenden Flugdaches. So entsteht eine überdachte Auffahrt, von der aus man die luftige, zweigeschossige Halle erreicht. Die bequemen Pilotensitze auf der Wartegalerie bieten vornehme Ruhe und reizen dazu, den Laptop auch mal zugeklappt zu lassen und die Aussicht auf das Rollfeld zu genießen.

UFO ou Airbus ?

Réception de la Lufthansa

Dans une optique commerciale pour attirer et conserver des passagers exigeants, les compagnies aériennes emploient de plus en plus de concepts futuristes. Le bâtiment de réception de la Lufthansa est une interprétation frappante de la technologie aérienne avancée. Grâce à l'acier résistant de la structure légère, le vaste toit en porte-à-faux offre un abri au point d'arrivée des passagers. À l'intérieur, les salles d'attente sur deux niveaux comprennent une galerie à l'étage, dotée de sièges pilotes confortables. Ici, le passager est invité à se détendre et peut-être à délaisser son ordinateur portable pour jouir de la vue sur l'aéroport animé.

¿OVNI o Aerobús?

Edificio de Recepción de Lufthansa

En la lucha de las aerolíneas por atraer a los exigentes viajeros, las compañías establecidas apuestan cada vez más por el confort y por un diseño orientado hacia el futuro. El edificio de recepción de Lufthansa es una magnífica interpretación de la tecnología aérea avanzada. El acero de la estructura de soporte permite los anchos voladizos del tejado flotante. De este modo se crea una salida cubierta desde la que se accede a la diáfana entrada de dos plantas. Los cómodos asientos de piloto que hay dispuestos en la galería de espera son una elegante posibilidad para descansar e invitan a dejar cerrado el ordenador portátil para disfrutar de las vistas al aeródromo.

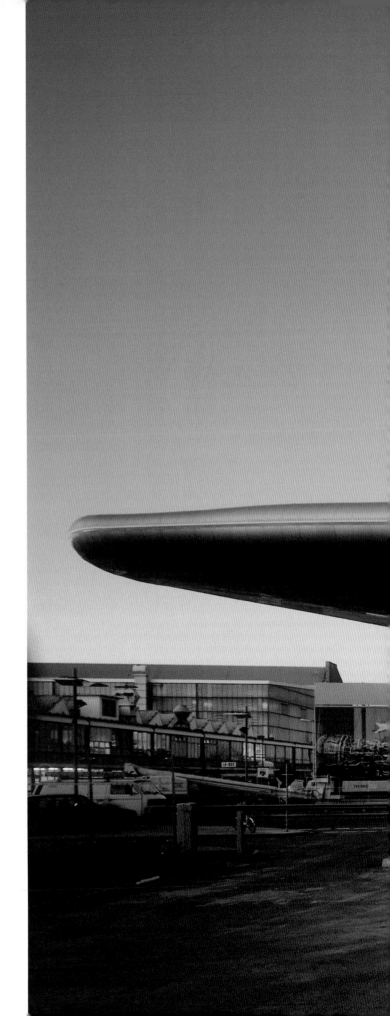

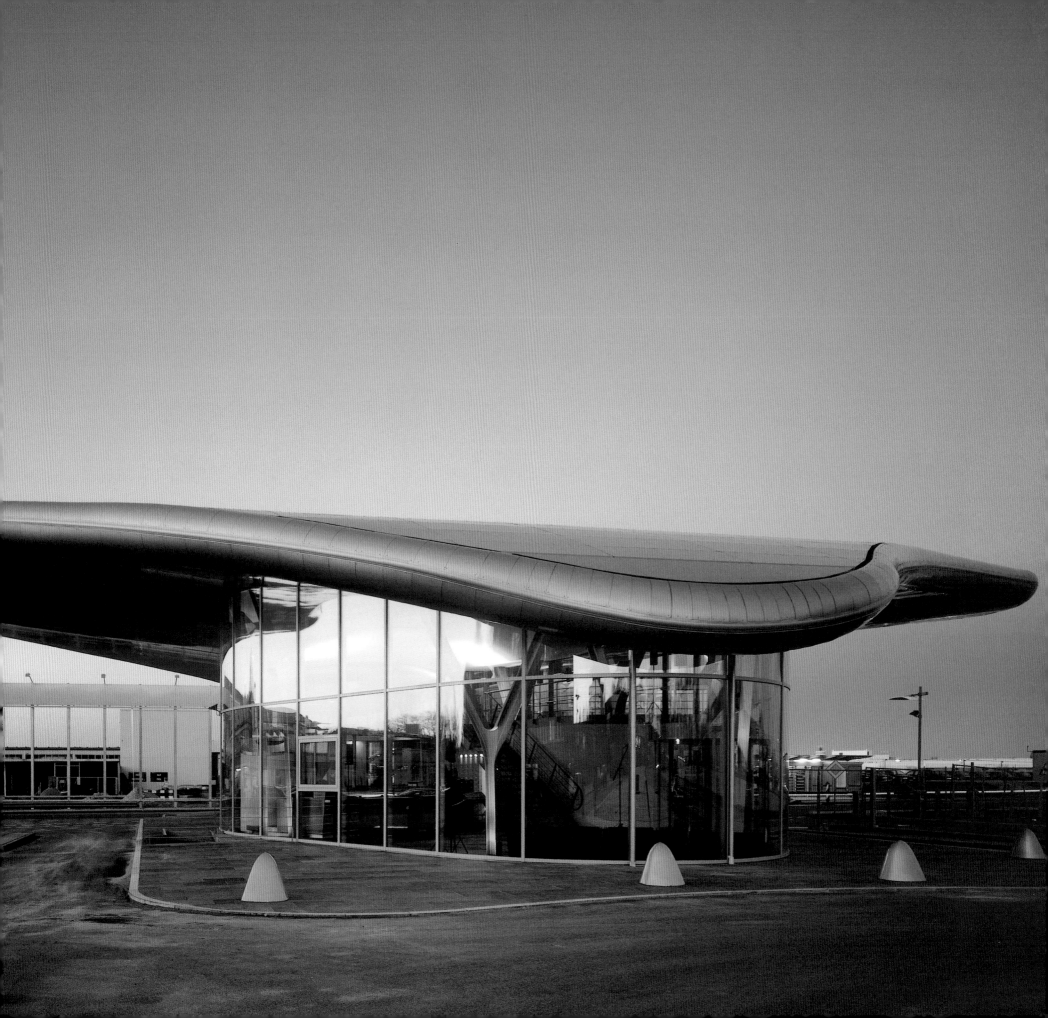

P+R Poetry

Interchange Terminal Hoenheim-Nord

There's nothing like a piece of built poetry to help against dreary park and ride complexes. As a place of transfer from one means of transport to another everything is in dynamic motion here. The tilted light columns atop the parking garage slant as if they were under hurricane winds. The meandering tram station roof continues the ground plane right up to the roof surface. It consciously dissolves the boundaries between ground plane, wall and roof and questions our conventional understanding of space and time. This is a place that all but incites one to miss the connecting tram.

P+R Poesie

Park und Ride Terminal

Ein Stück Baupoesie hilft gegen die oft lieblos gestalteten P+R Anlagen sehr. Als Ort des Wechsels der Transportmittel ist hier alles in dynamischer Bewegung begriffen. Lichtsäulen auf der schrägen Ebene des Parkhauses neigen sich wie vom Orkan verweht. Die mäandernde Bahnsteigüberdachung aus Beton entwickelt sich als ansteigende Fortsetzung der Bodenebene. Sie lässt die Grenzen zwischen Boden, Wand und Decke bewusst verschmelzen und stellt unser Verständnis von Raum und Zeit provokativ in Frage. Ein Ort, der dazu animiert, die Anschlusstram zu verpassen.

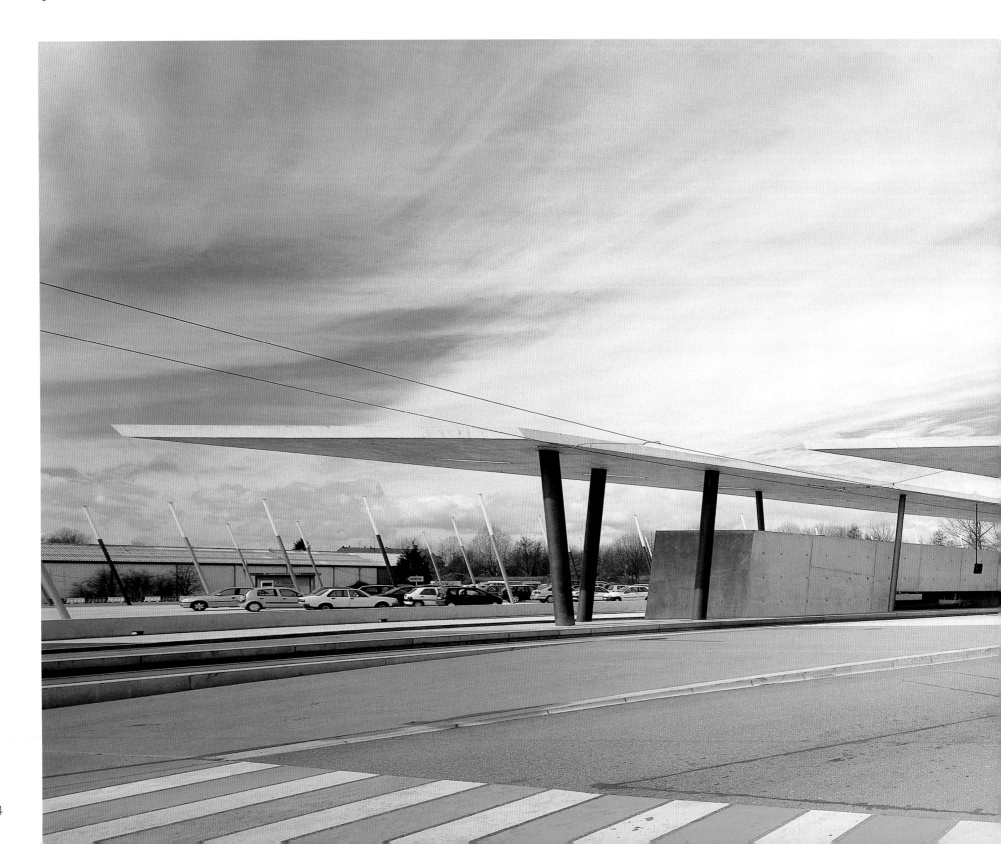

Poésie P+R

Parking périphérique

Rien n'aide plus à oublier l'ennui des complexes de transport et de stationnement que la poésie des bâtiments. Dans ce lieu de correspondance entre plusieurs moyens de transport, tout obéit à la dynamique du mouvement. Les colonnes légères penchées au-dessus du parking ont l'air d'être courbées par un ouragan. Le toit sinueux de la station de tramway prolonge le niveau du sol jusqu'à la surface de l'auvent. Il dissout consciemment les limites entre sol, mur et toit et interroge notre compréhension classique de l'espace et du temps. C'est un lieu qui inciterait presque à rater sa correspondance...

Poesía P+R

Estacionamiento «Park and Ride»

Un poco de poesía en la construcción a menudo ayuda contra las aburridas instalaciones de P+R. Como intercambiador de medios de transporte, en este lugar es todo movimiento y dinamismo. Las farolas sobre el techo del aparcamiento se inclinan como si fueran empujadas por la fuerza de un huracán. Parece como si el serpenteante tejado de hormigón de la estación del tranvía fuera la continuación del suelo. Con él se eliminan conscientemente los límites entre el suelo, la pared y el tejado y se cuestiona nuestra comprensión convencional de espacio y tiempo. Es un lugar que provoca que el viajero pierda el tranvía de enlace.

Strasbourg, France, Zaha Hadid, 2002

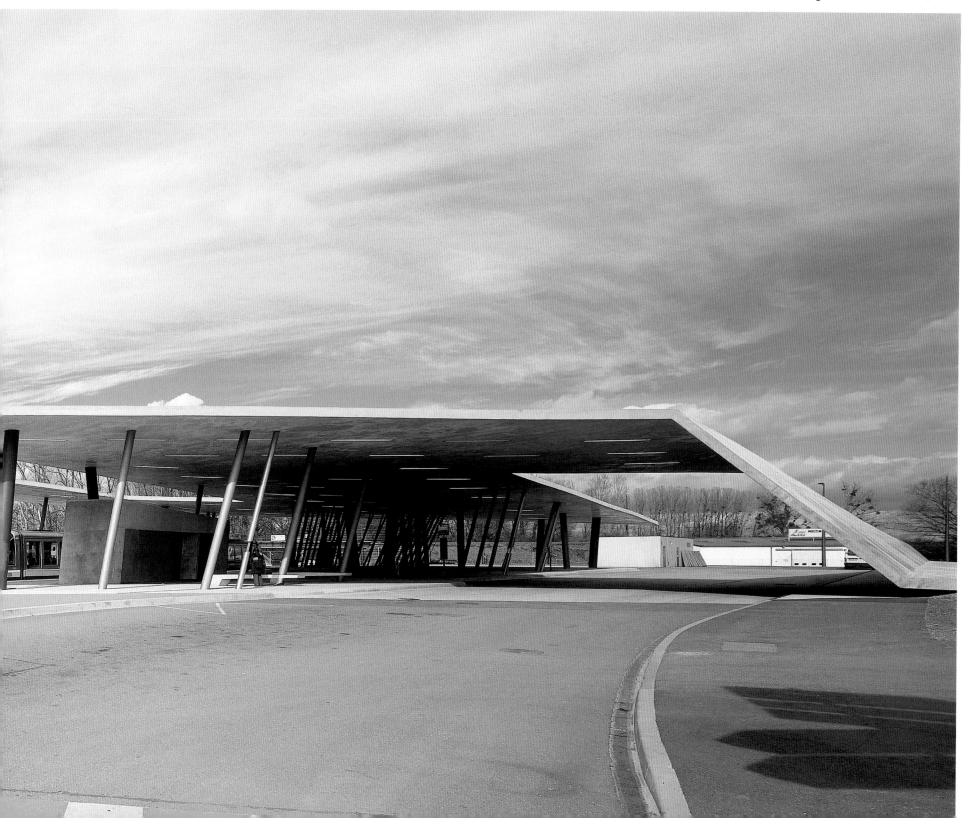

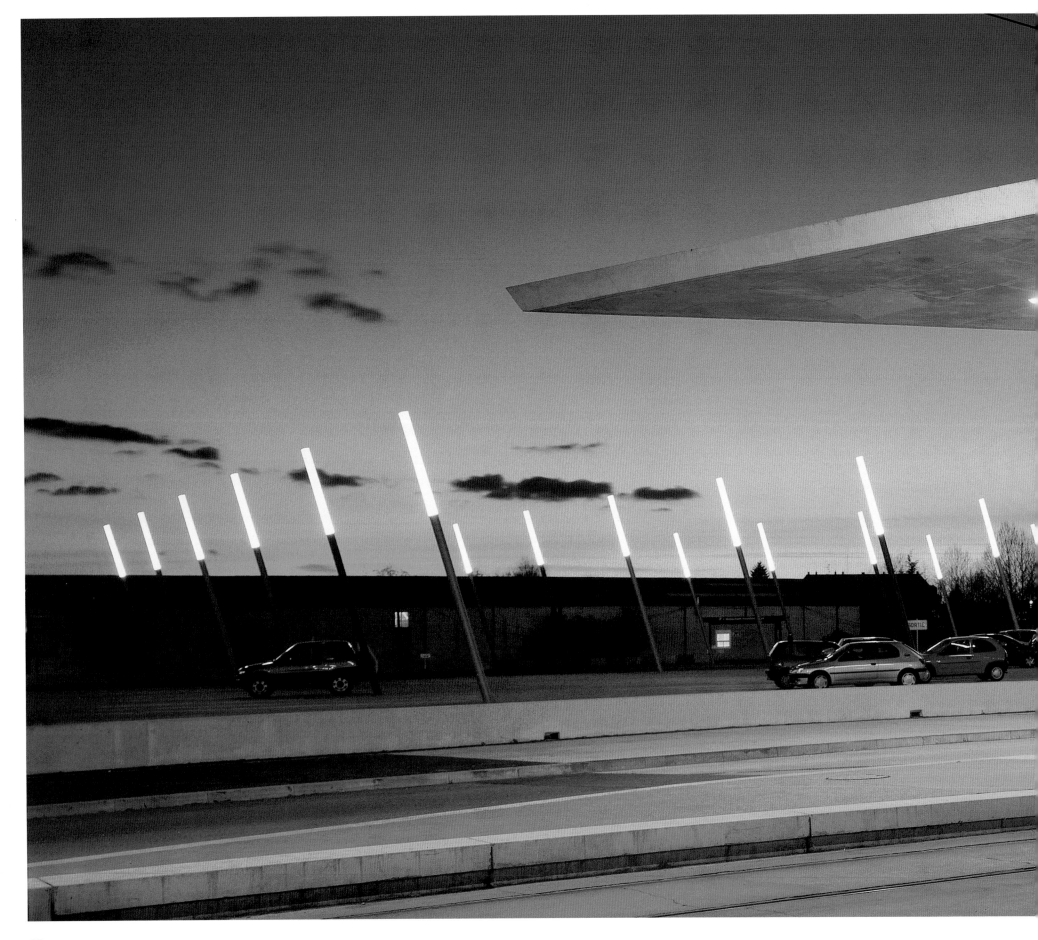

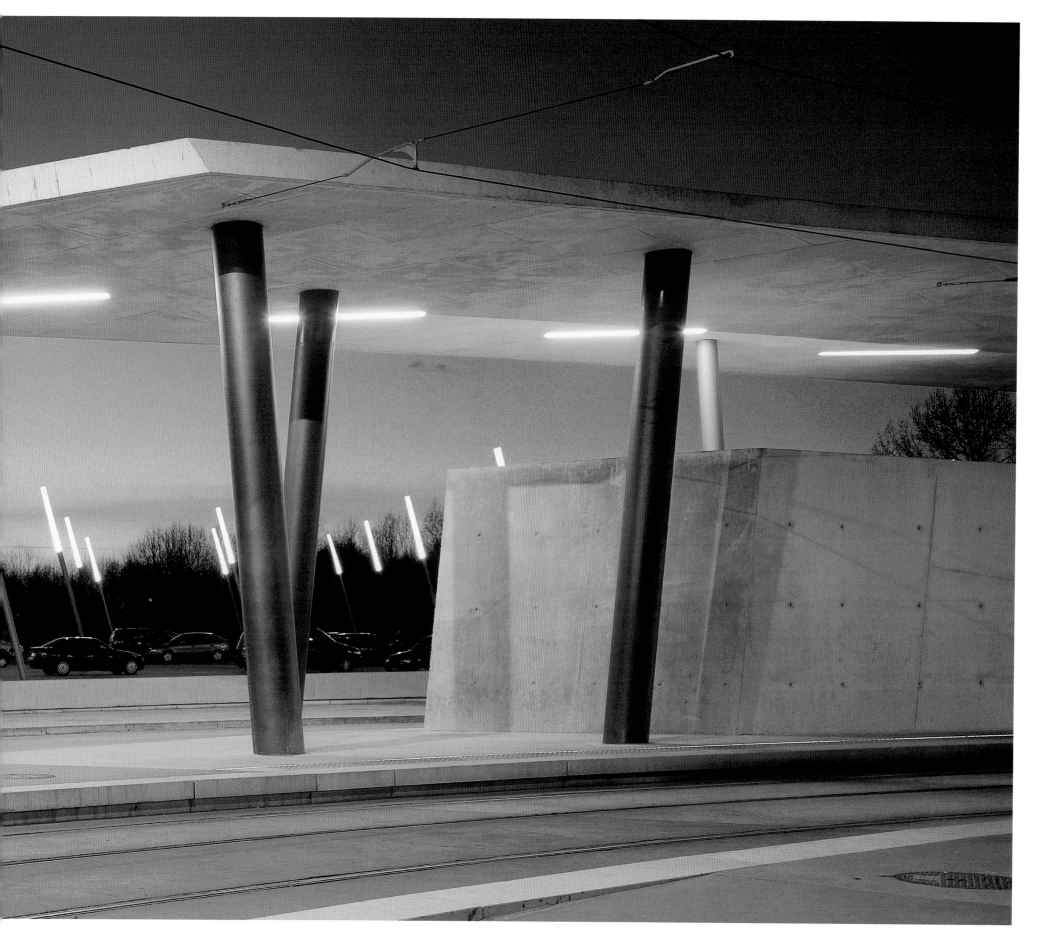

Innsbruck, Austria, Zaha Hadid, 2002

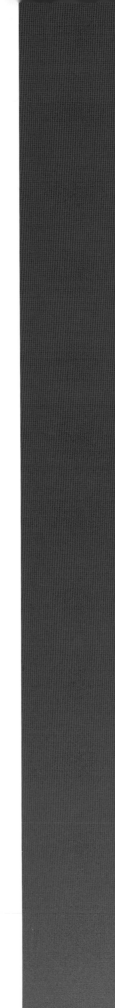

Organic Hybrid

Ski Jump Berg Isel

An homage to the natural setting on sacrosanct Bergisel Mountain is rendered here high above Innsbruck. The ski jump ramp and tower structure are virtually melded together to create a unique new form. The ski jump ramp is wrapped up the structure, wandering from the horizontal ramp plane all the way up to the vertical wall and roof terrace at the top of the 43 meter high tower. The cafeteria above the jump off point has its own elevator so the public can reach separately. The steel structure seats 150 and offers a breathtaking panorama of the Austrian Alps.

Organische Hybride

Sprungschanze Berg Isel

Der exponierten Lage am Bergisel, einem Heiligtum des Landes, wurde durch eine Bauskulptur gehuldigt. Elegant wurden Anlauframpe und Turm zu einer neuen Form verschmolzen. Die Rampe schlängelt sich um den Turmkopf, verformt sich aus der Waagerechten zur senkrechten Außenwand des Schanzenkopfes und setzt sich weiter bis zur Dachterrasse des 43 m hohen Turmes fort. Dominierender Abschluss über dem Startplateau der Athleten ist die separat erreichbare Cafeteria mit 150 Plätzen. Sie ist in Stahl konstruiert, um eine durchgehende Fensterfront mit Panoramablick auf die Tiroler Alpen zu ermöglichen.

Hybride organique

Le tremplin de ski de Berg Isel

Très haut au-dessus d'Innsbruck, ce bâtiment rend hommage au cadre naturel sur le sacro-saint Bergisel. La rampe du tremplin de ski et la tour de l'édifice se fondent quasiment pour créer une nouvelle forme exceptionnelle. La première enveloppe la structure, montant du plan horizontal jusqu'au mur vertical et à la terrasse du toit de la tour de 43 mètres. La cafétéria, au dessus du point de départ, a son propre ascenseur pour permettre un accès indépendant au public. La structure en acier comprend 150 sièges et offre un panorama étourdissant sur les Alpes autrichiennes.

Híbrido Orgánico

Rampa de Esquí Berg Isel

Este visible lugar en Bergisel, un santuario del país, fue homenajeado con una escultura arquitectónica. La rampa de saltos y la torre fueron elegantemente fusionadas para conseguir una forma nueva y única. La rampa de salto se enrosca alrededor de la cabeza de la torre y abandona después el plano horizontal para convertirse en la pared inclinada de la terraza y continuar así hasta la parte superior de esta torre de 43 metros. El final dominante sobre la línea de salida de los atletas es la cafetería, con 150 asientos y a la que se llega por otro lado. Está construida de acero para permitir una estructura frontal de cristal con vistas panorámicas de los Alpes.

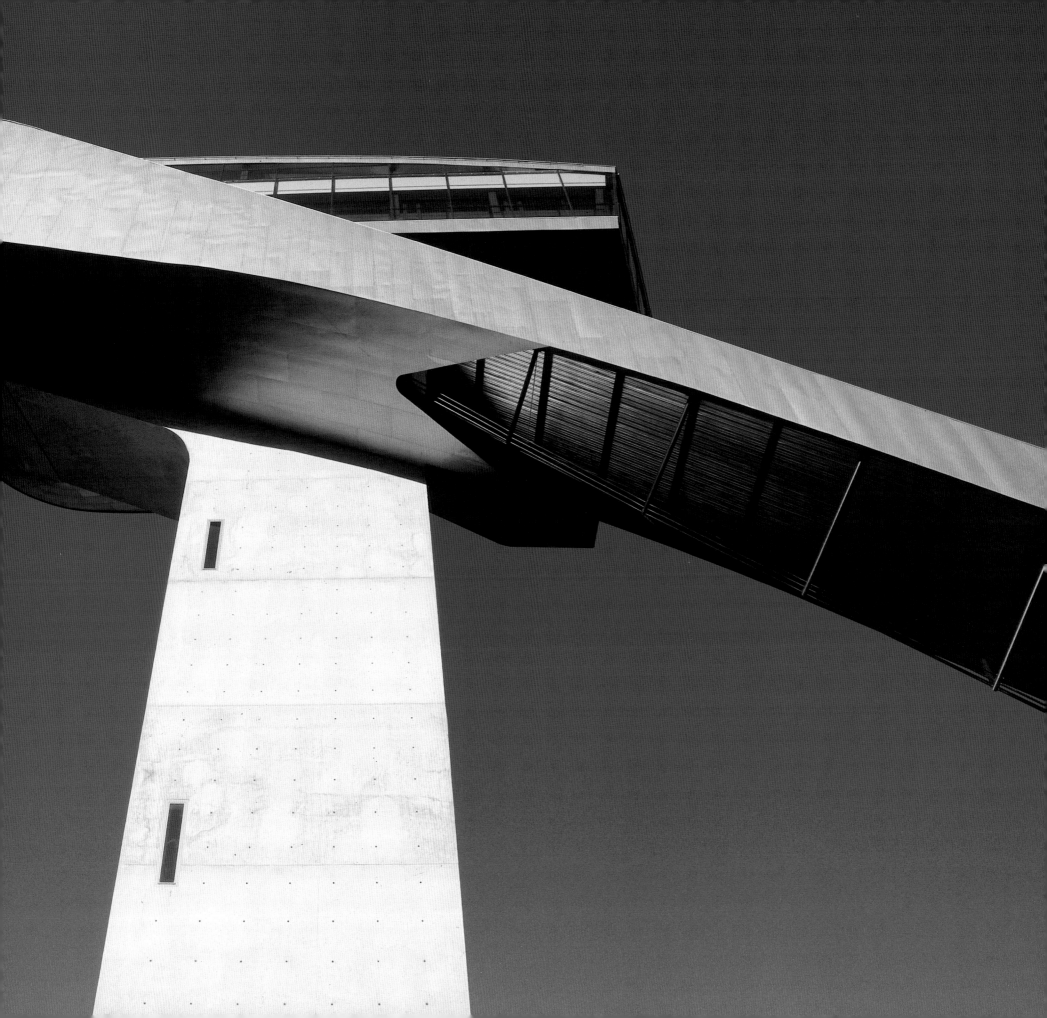

Corporate Identity

MPreis Supermarket

Who isn't dismayed by the scourge of interchangeable supermarkets plaguing cities worldwide? MPreis markets employ site-specific architecture and inventive design to create stores that are anything but anonymous boxes. Here glass is the prevailing material – its transparency allows views in and out, linking the shop with the surroundings. The orthogonal structural grid is shifted to accommodate an undulating garden of firs, which extends the Alpine scenery into the building. A crystalline opulence is achieved through the use of sun-protective glass with built-in blinds. Shopping here, with a view of the Alps, becomes an unforgettable experience.

Corporate Identity

MPreis Supermarkt

Wer ärgert sich nicht über die weltweite Ausbreitung gesichtsloser Supermarktkisten? Das Unternehmen MPreis setzt, geradezu als Markenzeichen, intelligent gebaute Märkte emphatisch dagegen. Wichtig dabei ist die Herstellung von Transparenz, um Blicke von außen nach innen und umgekehrt zu ermöglichen. Die orthogonale Grundstruktur wird durch einen biomorphen Kieferngarten gestört, der die alpine Landschaft in das Gebäude holt. Der Kristalleffekt der Fassaden kommt durch die Verwendung von Sonnenschutzglas mit integrierten Lamellen zustande. Ein Einkaufserlebnis mit Blick auf die Alpen, bei dem Tante Emma noch grüßen läßt.

L'identité des sociétés

Supermarché MPreis

Qui ne s'irrite pas du fléau des supermarchés interchangeables qui frappe les villes du monde entier ? La société MPreis allie esthétique inventive et architecture personnalisée pour créer des magasins qui sont tout, sauf des boîtes anonymes. Ici, le verre domine – offrant des vues intérieures et extérieures, reliant le magasin à son environnement. Le réseau orthogonal de l'édifice est modulé pour accueillir une petite sapinière sinueuse, prolongeant le paysage alpin à l'intérieur du bâtiment. Une baie vitrée pare-soleil, avec des stores intégrés, crée une opulence cristalline. Acheter ici, avec une vue sur les Alpes, devient une expérience inoubliable.

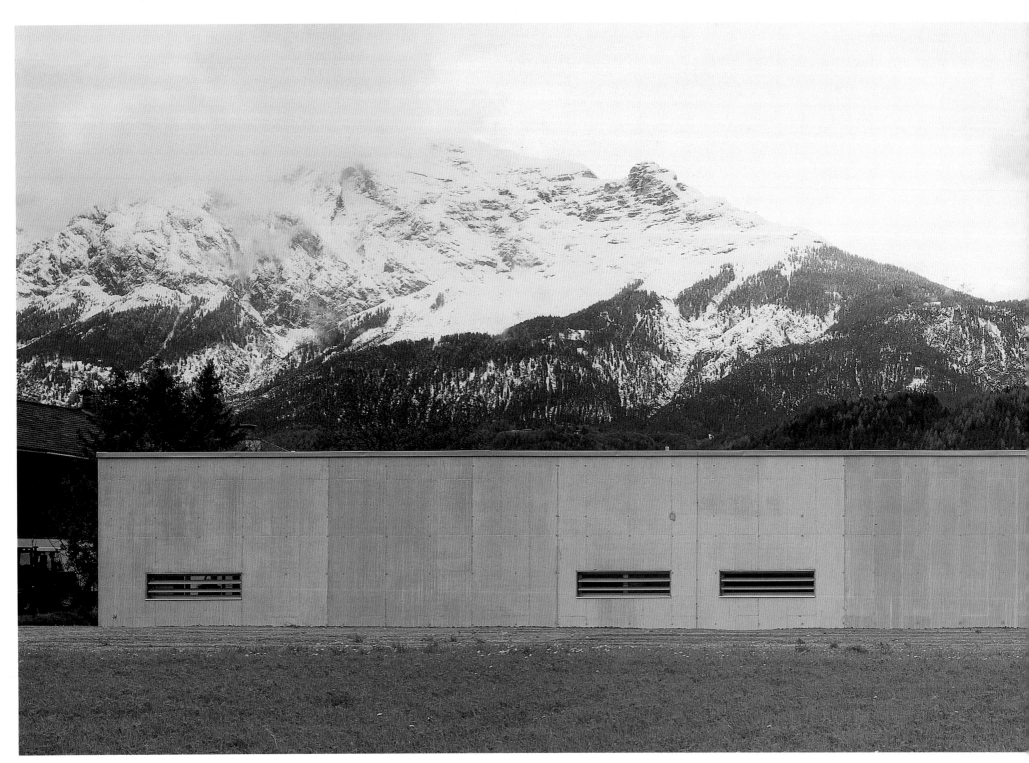

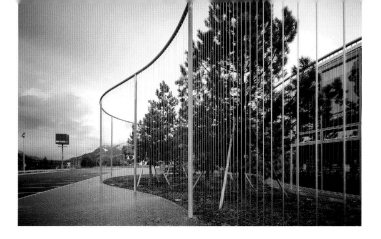

Identidad Empresarial

Supermercado MPreis

¿Quién no está cansado de la proliferación de supermercados sin identidad por todas las ciudades del mundo? La empresa MPreis se opone a esta tendencia y utiliza como marca distintiva supermercados construidos de forma inteligente. En estos edificios lo importante es la transparencia, que permite mirar hacia afuera y hacia adentro. La planta ortogonal se ha alterado para alojar un jardín ondulado de abetos que prolonga el paisaje alpino hasta el edificio. El efecto cristalino de la fachada se consigue gracias a la utilización de cristal de protección solar con persianas integradas. La vista a los Alpes convierte la compra una experiencia.

Wattens, Austria, Dominique Perrault, 2001

Gate to the Clouds

Petronas Towers

Cutting-edge engineering and age-old elements of Islamic culture combine, culminating in 88-story twin spires that presently hold the title of world's tallest building. The floor plans are the result of the superimposition of two squares with circular appendages. These geometric shapes symbolize unity, stability and rationality – important fundamentals of Islamic culture. The sky lobby on the 41st floor serves as an intermediate stop on the way up to the tops of the towers. The connecting bridge here joins the soaring spires to form a lofty gate that serves as a commanding landmark for the entire region.

Wolken-Tor

Petronas Towers

Als Synthese einer hochentwickelten Technik mit Gestaltungselementen der traditionellen islamischen Kultur Malaysiens gelten die 88-geschossigen Zwillingstürme derzeit als höchstes Gebäude der Welt. Die Turmgrundrisse resultieren aus der Überlagerung zweier Quadrate mit kreisförmigen Ausbuchtungen. Diese geometrischen Figuren symbolisieren Einheit, Stabilität und Rationalität, allesamt wichtige Prinzipien des Islams. Zwischenstation auf dem Weg in die Turmspitzen bildet die Sky Lobby im 41. Geschoss, wo eine Brücke die Türme verbindet und ein überdimensionales Tor entstehen läßt, das zur Landmark einer ganzen, aufstrebenden Weltregion wird.

La Porte des nuages

Petronas Towers

Associant des techniques de pointe à des aspects séculaires de la culture islamique, ces deux flèches jumelles de 88 étages détiennent aujourd'hui le titre de plus haut bâtiment du monde. Les plans de niveau résultent de la superposition de deux carrés, dotés d'appendices circulaires. Ces formes géométriques symbolisent l'unité, la stabilité et la rationalité – des fondamentaux importants de la culture islamique. La galerie du 41ème étage sert d'arrêt intermédiaire vers les sommets des tours. Ici, le pont communiquant réunit les flèches élancées pour former un portail imposant, qui sert de repère à la région toute entière.

Puerta a las Nubes

Petronas Towers

Estas torres gemelas de 88 pisos de altura son los edificios más altos del mundo y en ellas se combina una técnica altamente desarrollada con elementos de la cultura islámica tradicional de Malasia. El trazado de las plantas resulta de la superposición de dos cuadrados con anexos circulares. Estas figuras geométricas simbolizan la unidad, la estabilidad y la racionalidad, importantes fundamentos de la cultura islámica. El Sky Lobby en el piso 41 es un alto en el camino hacia la parte superior de las torres. Aquí, un puente une los dos edificios y crea una puerta de enormes dimensiones que se ha convertido en el punto de referencia de toda una floreciente región.

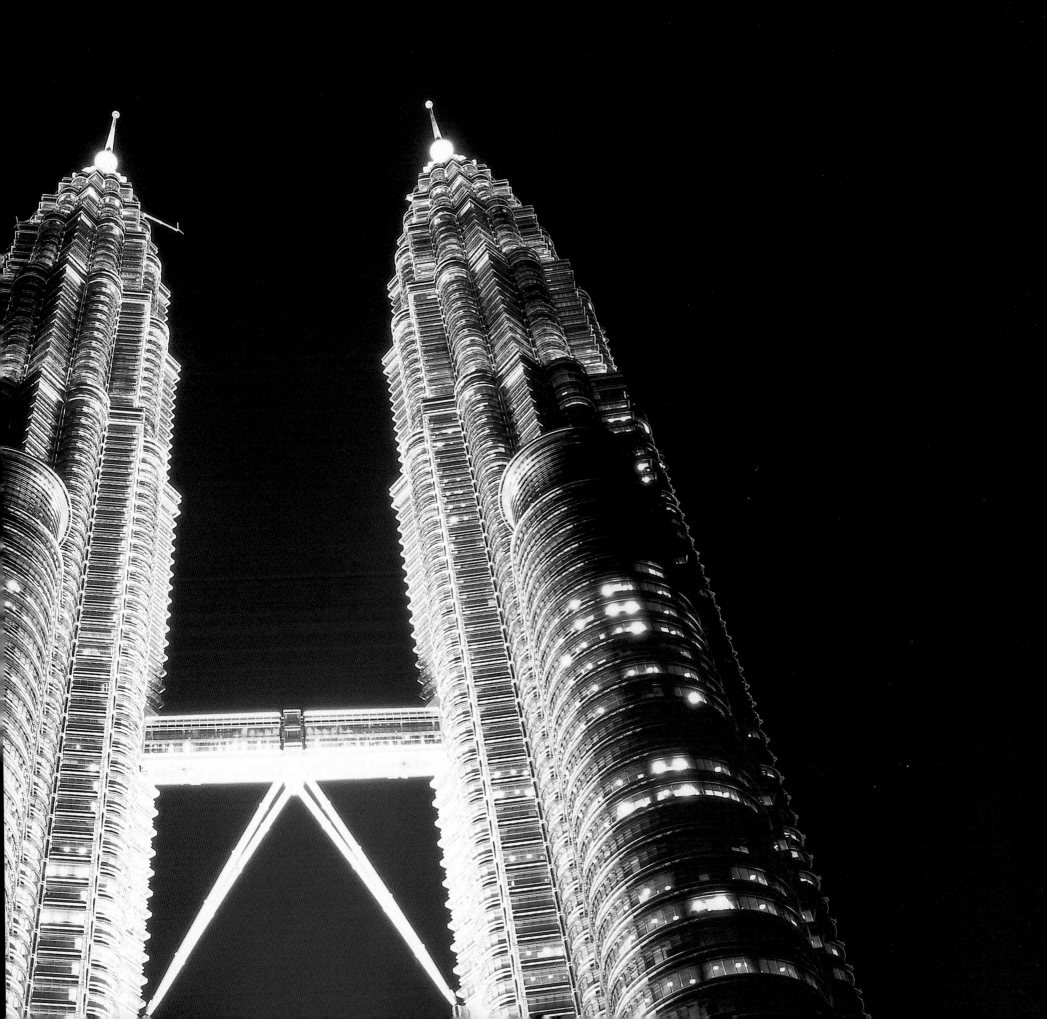

Urban Metaphor

Guggenheim Museum

The once decaying industrial city took on new verve with this stunning building. It drew 1.3 million visitors in its first year and spawned countless imitators worldwide. All of them sought to emulate its popularity, aptly dubbed the "Bilbao effect". The museum mirrors the heavens where urban wasteland once blighted the old town. Nineteen exhibition spaces are connected by an atrium, the pivotal focus of the composition. Ten of the galleries are housed in rectangular limestone structures. The remaining galleries are sheathed in shiny titanium panels and serve as surprisingly flexible spaces for changing exhibitions.

Stadtmetapher

Guggenheim Museum

Die alternde Industriestadt erhielt mit diesem Bau einen geballten Schuss Elan. Bereits im ersten Jahr zog er 1,3 Mio. Besucher an und verführte Städte weltweit dazu, den „Bilbao Effekt" mit imageträchtigen Neubauten nach-zuahmen. Auf einer einstigen Stadtbrache spiegelt sich der Himmel in einer glänzenden Stadtlandschaft aus skulp-turalen Bauformen. Im Inneren angelangt, besticht die vielfältige Gestalt des Atriums, an dem 19 Ausstellungssäle liegen. Von diesen wurden 10 in rechteckigen, mit Kalkstein verkleideten Baukörpern untergebracht. Titanstahl veredelt die anderen Säle, deren eigenwillige Formen doch überraschend flexible Ausstellungen ermöglichen.

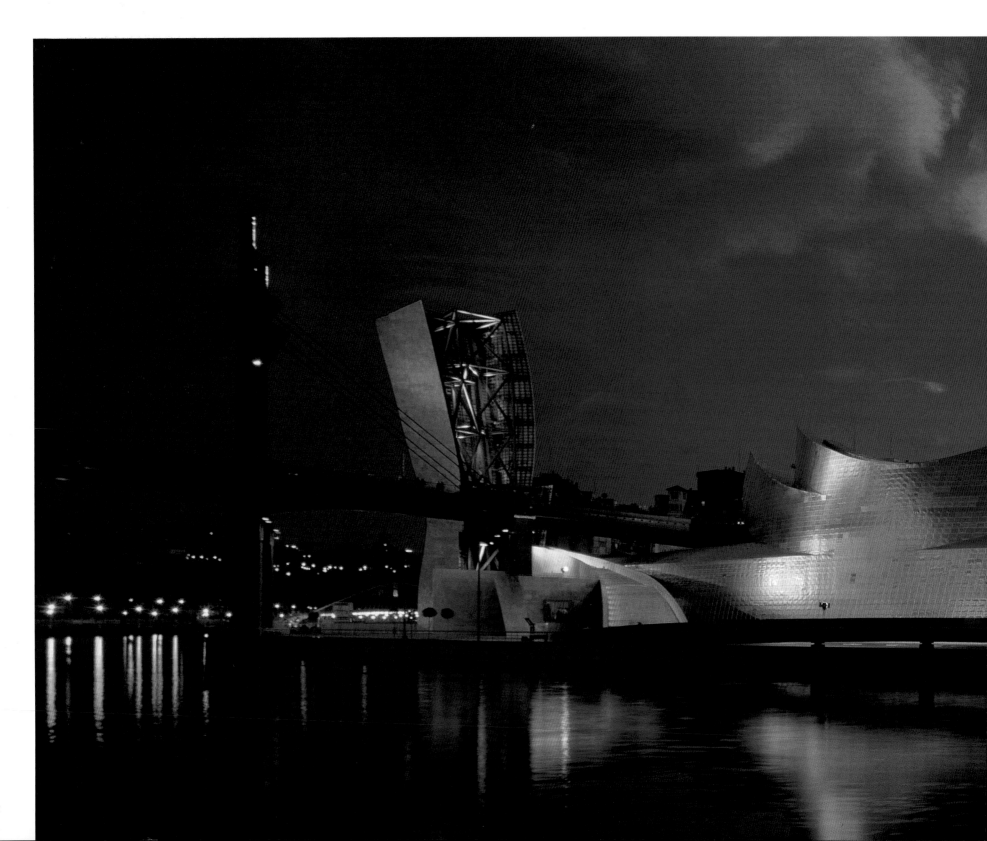

Métaphore urbaine

Le musée Guggenheim

La ville industrielle jadis sur le déclin a pris un nouvel essor avec ce bâtiment splendide. Il a attiré 1 300 000 visiteurs la première année et suscité d'innombrables imitations dans le monde entier. Toutes ont recherché la même popularité, nommée à juste titre l'« Effet Bilbao ». Le musée reflète le ciel à l'endroit où les terrains vagues enlaidissaient naguère la vieille ville. Dix-neuf espaces d'exposition sont reliés par un hall central, pivot de la composition. Dix des galeries se trouvent dans des structures calcaires rectangulaires. Les autres sont gainées de panneaux brillants en titane et servent d'espaces étonnamment souples à des expositions temporaires.

Metáfora Urbana

Museo Guggenheim

La ciudad industrial otrora en decadencia recibió un fuerte impulso con este edificio. En el primer año atrajo a 1,3 millones de visitantes y llevó a muchas ciudades del mundo a imitar el «efecto Bilbao» con construcciones similares. El cielo sobre lo que antes era un yermo terreno urbano se refleja ahora en un brillante paisaje de edificios esculturales. Un atrio, el punto central de la composición, une las diecinueve salas de exposiciones. Diez de ellas se alojan en estructuras rectangulares de piedra caliza. Las demás están revestidas con paneles de titanio y sus caprichosas formas permiten exposiciones muy flexibles.

Bilbao, Spain, Frank O. Gehry, 1997

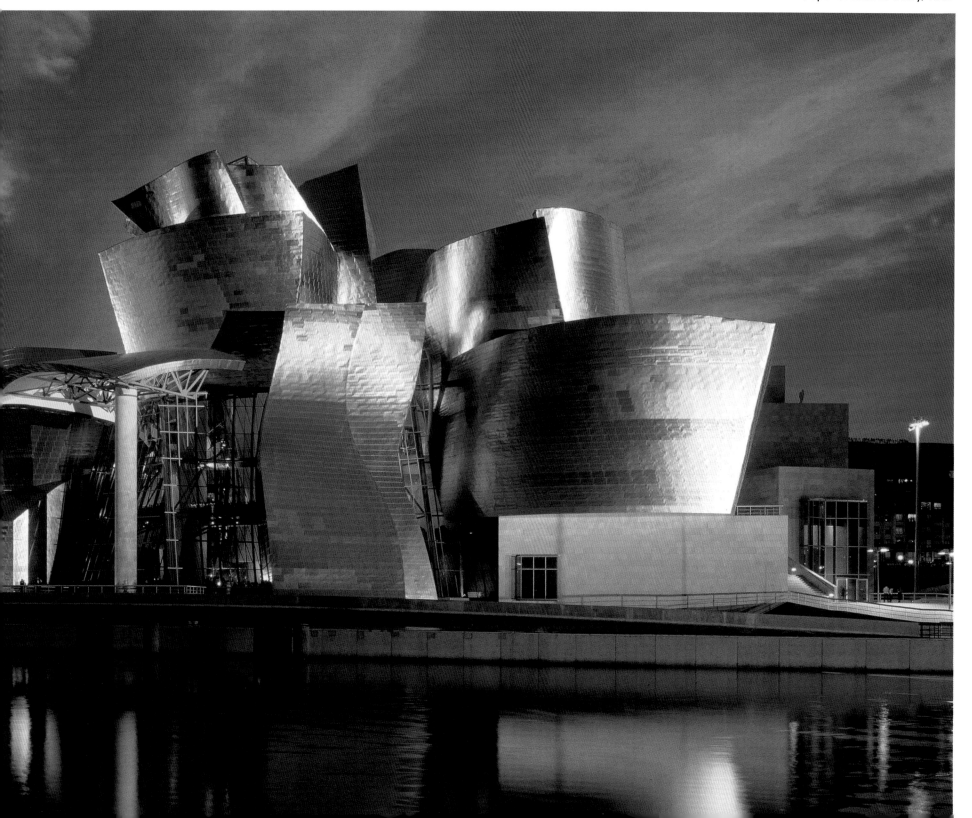

Manchester, Great Britain,
Daniel Libeskind, 2002

Ground, Sea, Air

Imperial War Museum

Three aggressive spatial shards, meant to signify ground, sea and air warfare, house the museum, which documents
the horror of war and its effects on individual human lives. The towering hollow structure of the "air shard",
sheathed in silver aluminum, creates a dramatic entrance space. The dark interior of the exhibition hall is housed
in the curved hump of the "ground shard". The museum restaurant is located in the "water shard" with a view out
to the Manchester Ship Canal. Altogether, the building defines a vocabulary of sharp edges and threatening forms
which are intended to provoke and demand one to reflect on the futility of war.

Boden, Wasser, Luft

Kriegsmuseum

Die drei aggressiven Scherbenkörper des Museums, in dem die Schrecken des Krieges und ihre Auswirkungen auf
die Schicksale einzelner Menschen dokumentiert werden sollen, verkörpern den Boden-, Wasser- und Luftkrieg.
Der Zutritt erfolgt über den mit silbernen Aluminiumplatten verkleideten Hohlraum der „Luftscherbe". Ausstellungs-
flächen sind im gekrümmten Korpus der „Bodenscherbe", das Museumsrestaurant in der zum Manchester Ship
Canal hin orientierten „Wasserscherbe" untergebracht. Der Besucher erlebt ein Vokabular scharfer Kanten und
bedrohlicher Formen, die zum Nachdenken über den „Sinn" des Krieges auffordern.

Terre, Mer, Air

Musée Imperial de la Guerre

Trois vastes tessons agressifs, censés représenter les conflits maritimes, terrestres et aériens, abritent le musée, qui
décrit les horreurs de la guerre et ses effets sur la vie des hommes. L'imposante structure creuse du « tesson aérien »,
gainée d'aluminium argenté, crée une entrée spectaculaire. Le sombre intérieur du hall d'exposition est situé dans
la bosse incurvée du « tesson terrestre ». Le restaurant du musée se trouve dans le « tesson maritime », avec une vue
sur le Canal de Manchester. Dans l'ensemble, le bâtiment constitue un vocabulaire de formes menaçantes et de
bords tranchants, conçus pour provoquer la réflexion sur la vanité de la guerre.

Terra, Mar, Aire

Museo Imperial de la Guerra

Los tres agresivos cuerpos del museo, con forma de fragmentos, representan la guerra por tierra, mar y aire y en
ellos se documentan el horror de la guerra y sus efectos sobre el destino de cada ser humano. La entrada se alcanza
atravesando la estructura hueca del «fragmento del aire», recubierta con placas plateadas. Las superficies destina-
das a las exposiciones se encuentran en el «fragmento de la tierra» y el restaurante en el del mar, que está orientado
hacia el Manchester Ship Canal. El visitante experimenta un incisivo vocabulario y unas formas amenazantes que
invitan a reflexionar sobre el sentido de la guerra.

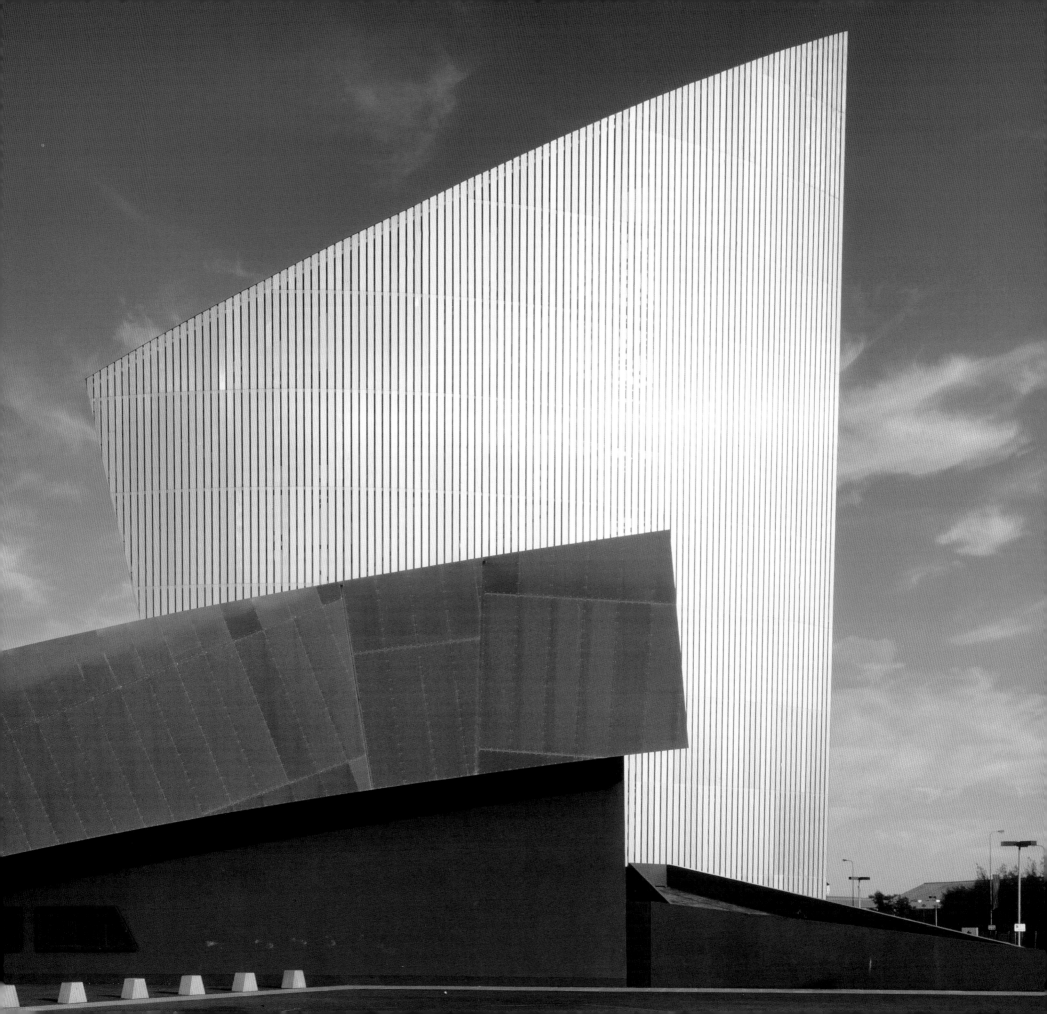

From Light to Darkness

León City Auditorium

On the edge of town a sculpture-like building in white concrete, bathed in clear Castilian sunshine, invites with a remarkable play of shadow and light. Passing through this facade one reaches the entrance courtyard, which accesses both wings of the building. Ramps and stairs lead up behind the thick recessed openings to the exhibition space facing the plaza. Behind it, the main building in Roman travertine houses the concert hall. Its interior is vast and dark, like the belly of a giant. The black-stained, hovering wood panels can be adjusted to calibrate perfect acoustics. This is a space where one is induced to concentrate on the music, not on flamboyant architecture.

Vom Hellen ins Dunkle

Auditorium der Stadt León

Am Rande der Innenstadt lockt eine plastische Platzfront aus weißem Beton im gleißenden Sonnenlicht Kastiliens mit einem unverwechselbaren Schattenspiel. Diese durchschreitend geht es zum Eingangshof, der beide Flügel des Baus erschließt. Über schiefe Ebenen und Treppen führt der Weg im Inneren hinter den ausgehöhlten Löchern der Platzfront zum Ausstellungssaal hinauf. Im mit römischem Travertin verkleideten Hauptbau dahinter betritt man den großen Saal wie den Bauch eines Riesen. Schwarzgebeizte, schwebende Holzpanelle ermöglichen die reine Akustik. Die Konzentration gilt hier der Musik, die Architektur tritt dahinter vornehm zurück.

De la lumière à l'ombre

L'auditorium de la ville de León

En bordure de la ville, un édifice sculptural en béton blanc, baigné par la luminosité castillane, séduit par un jeu remarquable d'ombre et de lumière. Cette façade donne accès à la cour d'entrée, qui dessert les deux ailes du bâtiment. Passerelles et escaliers montent derrière des ouvertures encastrées, jusqu'à l'espace d'exposition face à la place. Derrière lui, le bâtiment principal en travertin abrite la salle de concert. Son intérieur est vaste et sombre, comme les entrailles d'un géant. Des panneaux de bois suspendus peuvent être réglés pour donner une acoustique parfaite. Un espace qui invite à se concentrer sur la musique, pas sur l'architecture flamboyante.

De la Luz a la Oscuridad

Auditorio de la ciudad de León

Al borde de la ciudad, un edificio escultural en concreto blanco bañado por la luz de Castilla atrae nuestra atención con su inconfundible juego de sombras. Atravesando la fachada se llega hasta el patio de la entrada, al que se abren las dos alas del edificio. Las rampas y las escaleras conducen a la sala de exposiciones del interior, al otro lado de los gruesos vanos de la fachada. Detrás, el edificio principal de piedra romana travertina alberga la sala de conciertos, vasta y oscura. Los paneles de madera flotantes y negros permiten una acústica pura. Aquí se invita a la concentración en la música, mientras que la arquitectura pasa a un segundo plano.

León, Spain, Emilio Tuñón and Luis Moreno Mansilla, 2002

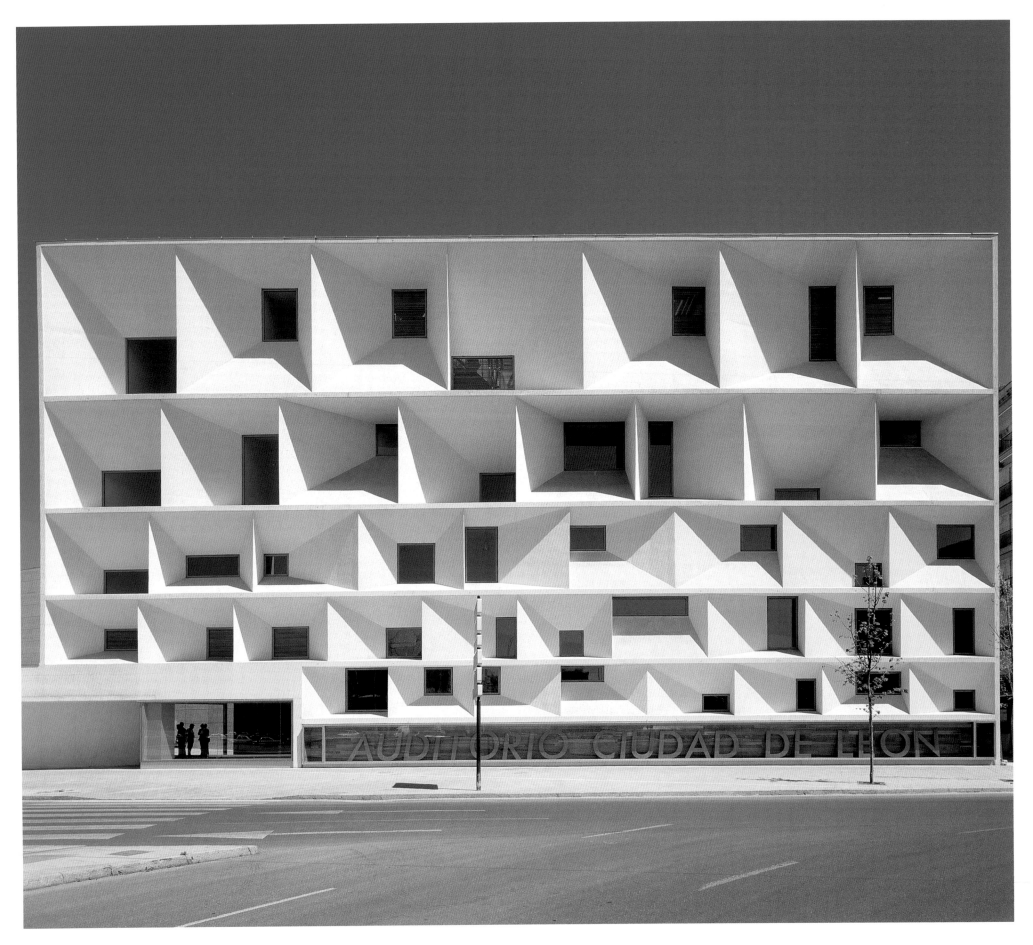

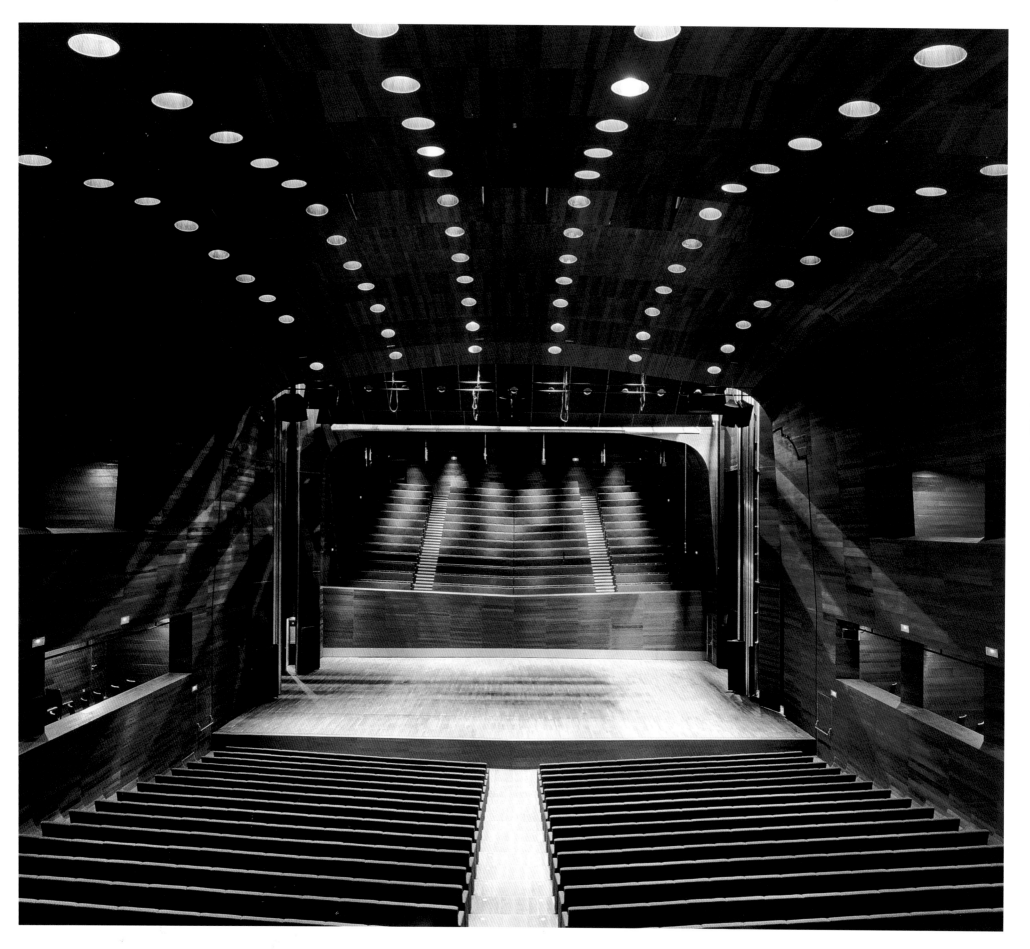

Cincinnati, USA, Zaha Hadid, 2003

3D Puzzle

CAC Contemporary Arts Center

A dense urban site inspired the building's complex vertical spatial composition. The ground plane curves right up the white concrete back wall of the atrium and connects all levels from ground to roof. In contrast to its polished texture, the hull of the exhibition galleries is roughly hewn, seemingly chiseled out of a single block of concrete. The cumbersome mass appears to float above the glass enclosed lobby. The equivocal shifting composition of the exhibition halls is expressed in the sculpted relief of the Walnut Street facade. As such the building actually provokes the creation of new art and is the ideal home for the city's newest museum.

3D Puzzle

CAC Contemporary Arts Center

Der knappe Bauplatz im Stadtzentrum birgt die Chance der vertikalen Organisation mit komplexen Raumdurchdringungen. Als verbindendes Element wird der Lobbyboden als Sichtbeton-Rückwand der Halle in die Höhe geführt. Kontrastierend zu deren polierter Oberfläche sind die Ausstellungssäle in rauhen, scheinbar aus einem massiven Betonblock gehauenen, Körpern untergebracht. Diese schweben transzendental über dem Glaskorpus der Lobby. Die reliefartige Ostseite in der Walnut Street lässt die versetzte Anordnung der Säle nach außen sichtbar werden. Räume, die die Entstehung neuer Kunst geradezu provokativ herausfordern.

Puzzle en 3 dimensions

Le Contemporary Arts Center

La densité du site urbain a inspiré la composition verticale complexe du bâtiment. Le plan incliné s'incurve le long du mur arrière blanc du hall central, reliant tous les niveaux du sol au plafond. Par contraste avec sa structure polie, le revêtement des galeries d'exposition est plus grossier, apparemment taillé dans un bloc de béton. La lourde masse paraît flotter au-dessus de l'entrée aux murs de verre. La composition changeante des salles d'exposition s'exprime dans le relief sculpté de la façade de Walnut Street. Le bâtiment provoque ainsi vraiment la création d'un art nouveau et il est le foyer idéal du plus récent musée de la ville.

Puzle en 3D

CAC Contemporary Arts Center

El reducido solar en el centro de la ciudad inspiró la compleja composición vertical de este espacio. El suelo del vestíbulo actúa como elemento de unión al elevarse hasta el techo como una pared trasera de hormigón visto. Contrastando con su pulida superficie, las salas están alojadas en cuerpos ásperos que parecen estar tallados en un bloque de hormigón masivo y que dan la impresión de flotar metafísicamente sobre el cuerpo de cristal del vestíbulo. Los relieves visibles en la fachada este, en la Walnut Street, dejan reconocer desde el exterior la distribución desplazada de las salas, que provocativamente desafían la creación de un nuevo arte.

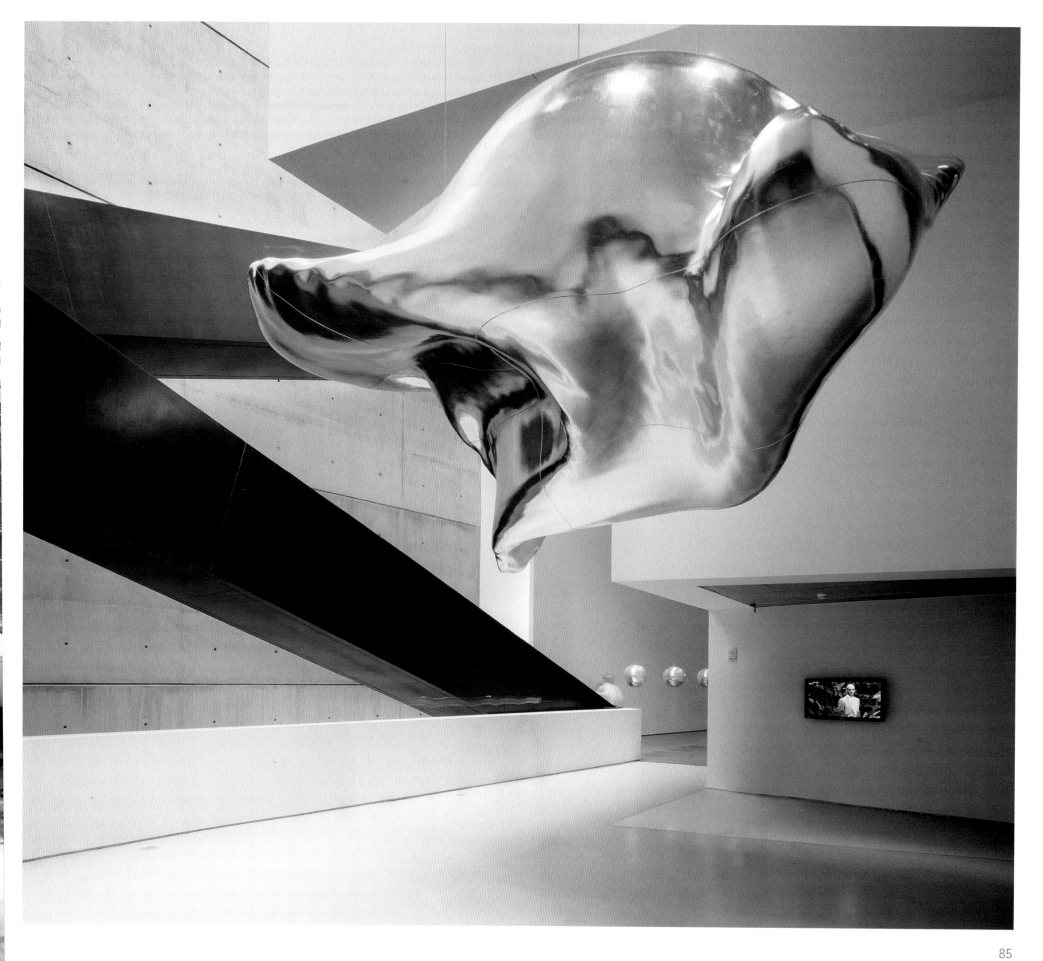

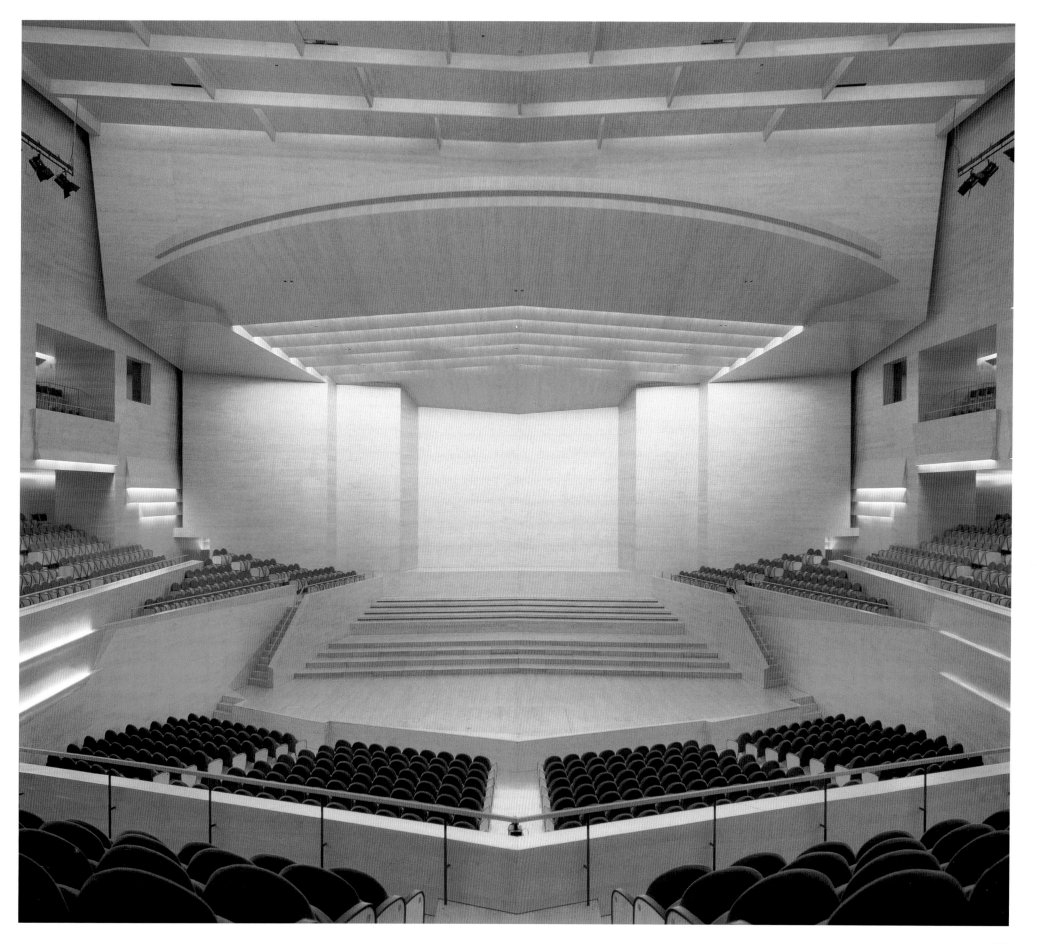

Minimalist Contrast

Navarra Convention Center and Auditorium

Ernest Hemingway was beguiled by Pamplona and elevated the city to cult status with his vivid account of the yearly bull run. Now, striding beyond tradition, the city provides new impetus for the future. This cultural complex forms an urban square that enriches the neighborhood. Mirroring the disparate natural landscape of the area, with its arid plains and forested mountains, a contrasting palette of materials was chosen. Warm, soft wood plays off cool and hard stone surfaces. The exterior's wood-framed windows contrast stone facades. Inside, warmth emanated from the wood-paneled concert halls counters the cool understatement of the foyer spaces.

Minimalistisches Wechselbad

Kongresszentrum

Bereits Ernest Hemingway war von der kargen Ursprünglichkeit Pamplonas fasziniert. Doch jenseits des jährlichen Stierrennens bemüht man sich hier auch um Zukunftsweisendes. Der Bau bildet einen Vorplatz, der das Quartier bereichert. Analog zur Landschaft der Umgebung mit ihren trockenen Steppen und waldreichen Bergen wird bei der Materialienwahl auf Kontrast gesetzt. Warmes, weiches Holz wird kühlen, harten Steinflächen entgegengesetzt. Ein Mittel, das bereits außen bei den Holzfenstern der steinernen Bauten das Bild prägt. Innen setzt sich das Prinzip fort. Die Säle kontern hier die Sachlichkeit der Foyers mit einem warmen, einladenden Ambiente.

Contraste minimaliste

Palais des Congrès

Ernest Hemingway a été captivé par Pampelune et a fait de la cité une ville-culte par sa description vivante de ses corridas. Aujourd'hui, en dépassant la tradition, la ville donne un nouvel élan à l'avenir. Ce complexe culturel forme un espace urbain qui enrichit les environs. Reflètant le paysage naturel disparate de la région, avec ses plaines arides et ses montagnes boisées, il est composé d'une palette de matériaux contrastés. Des bois tendres et chauds équilibrent les surfaces de pierre dure et froide. Les fenêtres extérieures en bois contrastent avec les façades de pierre. À l'intérieur, la chaleur émanant des salles de concert lambrissées neutralise la froide discrétion du foyer.

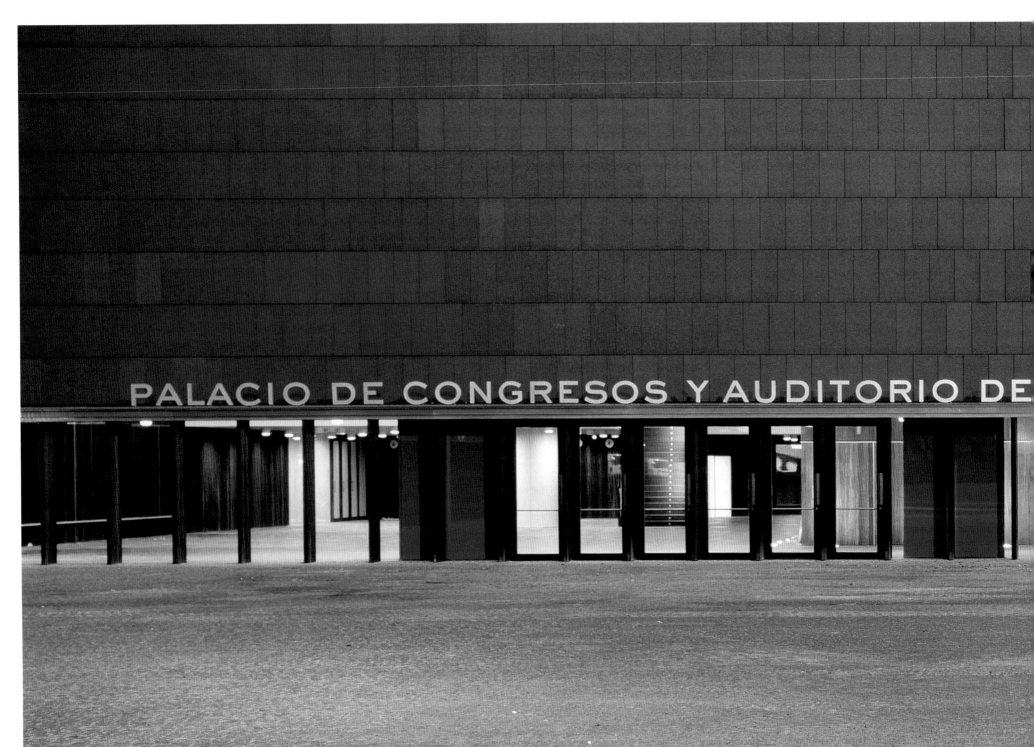

Contraste Minimalista

Palacio de Congresos

El rudo carácter de Pamplona fascinó a Ernest Hemingway. Sin embargo, más allá de los encierros anuales, la ciudad se esfuerza por proyectar el futuro. Este complejo cultural da lugar a una plaza urbana que enriquece el barrio. Queriendo reflejar el paisaje de los alrededores, arboladas montañas y áridas estepas, se apostó también por los contrastes en la elección de los materiales. Una madera cálida y suave se contrapone a las superficies de fría y dura piedra. En el exterior, los marcos de madera de las ventanas contrastan con las fachadas de piedra. En el interior, la calidez que emana de los paneles de madera de las salas se opone a la sobriedad del vestíbulo.

Pamplona, Spain,
Francisco José Mangado Asociados
and Alfonso Alzugaray, 2003

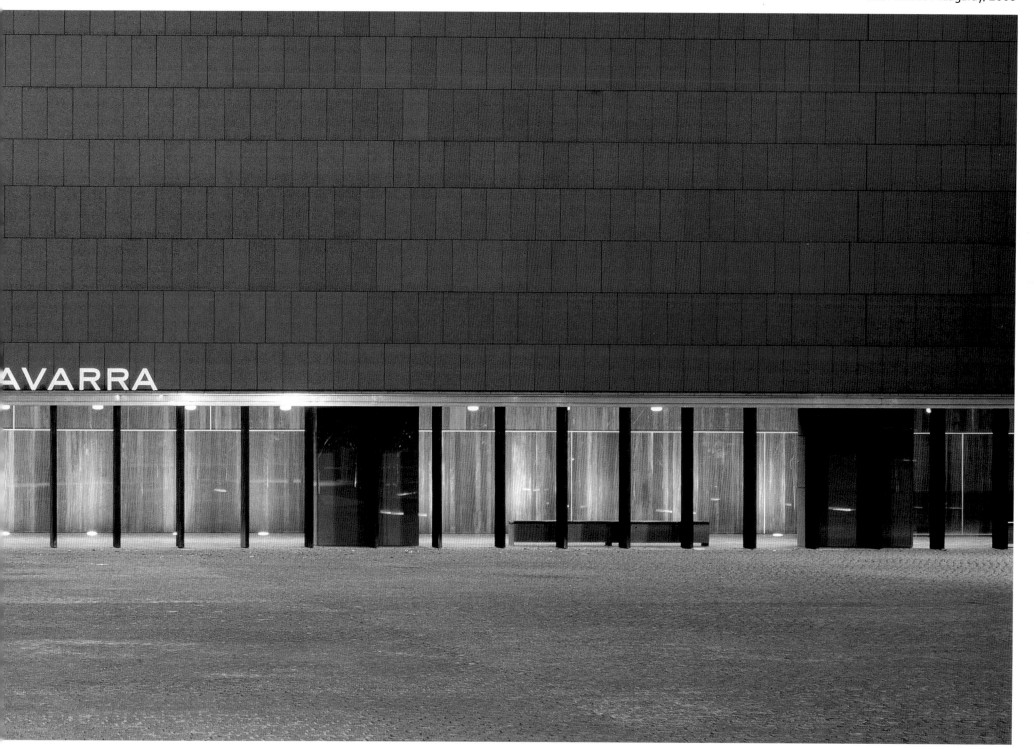

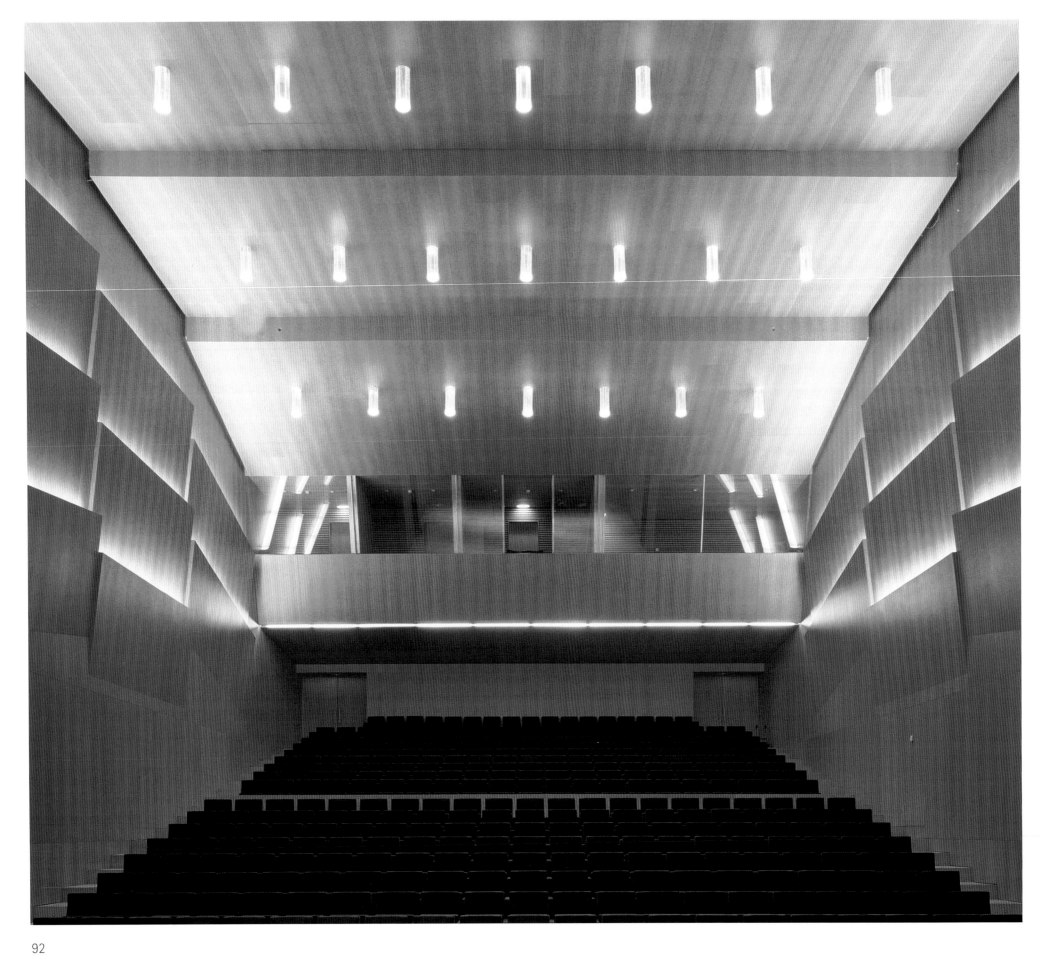

Urban Gesture

Moscone West Convention Center

The increasing rivalry between the world's great cities to create competitive convention centers inspired this new approach. The center isn't located somewhere out on the edge of town but rather at the heart of the city. The architects reacted to the urban location with an open, transparent complex featuring a 34 meter high glazed curtain wall; a technical accomplishment considering the acute danger of earthquakes. Views into the inner life of the center aren't only possible, they are welcomed. The interior spaces, usually dark and hardly inviting, are flooded with natural light and accommodate varied and flexible uses.

Urbane Geste

Moscone West Kongresszentrum

Im Wettstreit der Weltstädte um den attraktivsten Messestandort verfolgt die Stadt am Pazifik einen innovativen Ansatz. Das neue Kongresszentrum liegt nicht am Stadtrand, sondern mitten in der Stadt. Die Architekten reagierten auf diesen urbanen Standort mit einem offenen, transparenten Komplex um eine 34 Meter hohe, vorgehängte Glasfront. Angesichts der akuten Erdbebengefahr eine technische Meisterleistung. Einblicke ins Innenleben des Komplexes sind damit möglich und erwünscht. Die Innenräume, bei Kongresszentren oft wenig einladend, sind hier von sanftem Licht durchflutet und laden zur vielfältigen, flexiblen Nutzung ein.

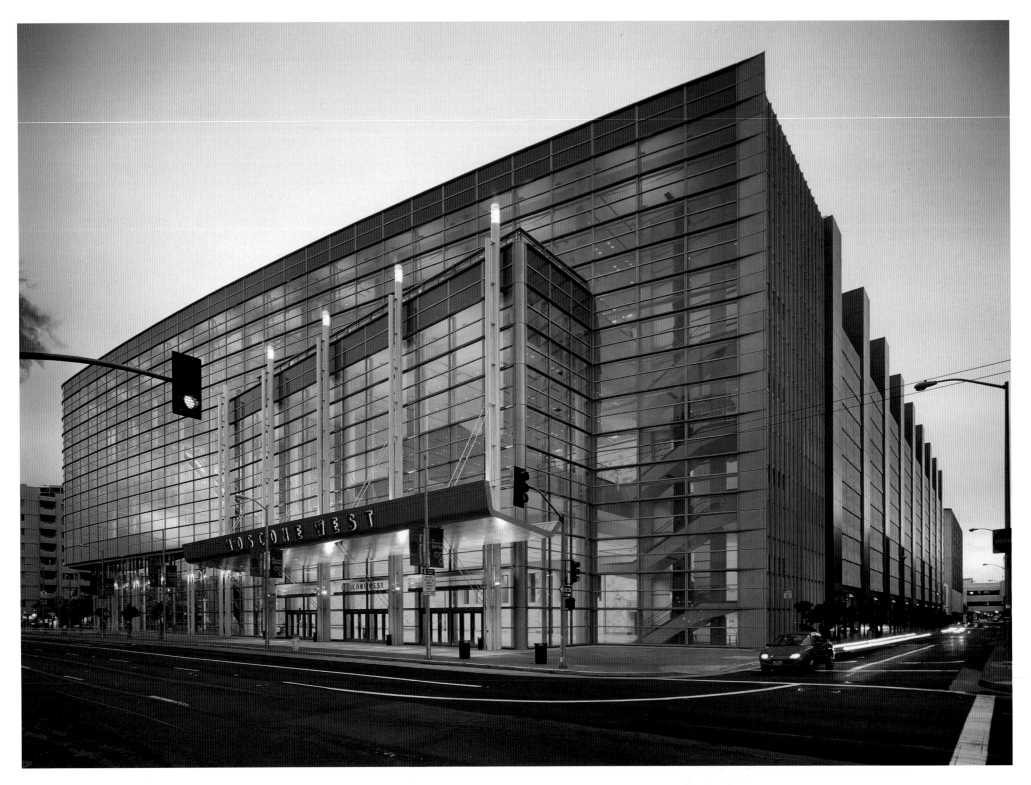

Geste urbain

Palais des Congrès Moscone West

La rivalité croissante entre les plus grandes villes du monde pour créer des palais des congrès compétitifs a inspiré cette nouvelle structure. Le centre n'est pas situé en bordure de la ville, mais au cœur de la cité. Les architectes ont réagi à cette situation urbaine en créant un complexe ouvert, transparent, pourvu d'un rideau vitré haut de 34 m ; une prouesse technique, compte tenu des graves dangers de tremblements de terre. Des vues sur la vie interne du centre sont non seulement possibles, mais souhaitées. Les espaces intérieurs, d'ordinaire sombres et peu accueillants, sont ici inondés de lumière naturelle et permettent des utilisations souples et variées.

Gesto Urbano

Centro de Convenciones Moscone West

La creciente rivalidad entre las grandes ciudades del mundo por crear los mejores centros de convenciones ha inspirado esta nueva propuesta. El edificio no está ubicado en las afueras de la ciudad sino en su centro. Los arquitectos reaccionaron ante esta ubicación urbana con un complejo abierto y transparente rodeado de una cortina de cristal de 34 metros de altura; un logro técnico considerando el alto riesgo de terremotos. Esta estructura no sólo permite la mirada hacia la vida interior del edificio sino que además la busca. Los espacios interiores, a menudo poco atractivos, están aquí invadidos de una suave luz e invitan a un uso flexible y variado.

San Francisco, USA, Gensler, 2003

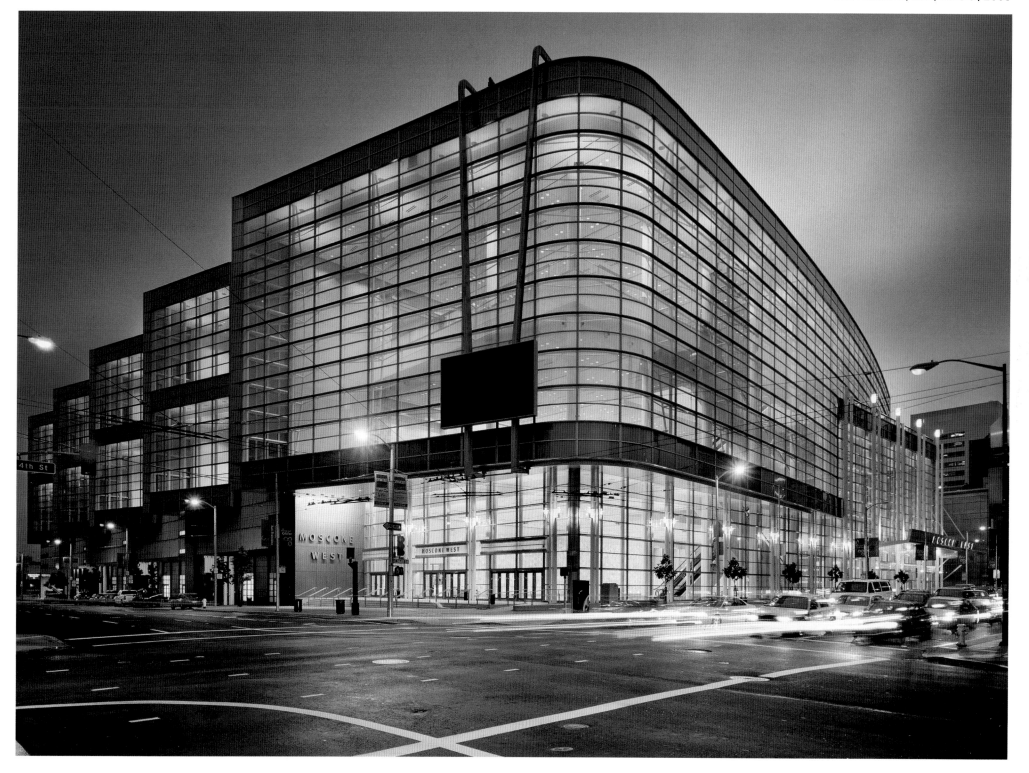

Melbourne, Australia,
Wood Marsh Pty Ltd, 2002

Red Monolith

ACCA Australian Center for Contemporary Art

Evoking the old warehouses originally spread throughout the area, weathered steel gives the distorted Euclidean shapes a light, tight-skin effect. The steel oxidizes to an orange-red tone that blends well with the old brick facades along the street. The composition creates a sculptural, seamless whole, the discreet placement of windows preserving the planar quality of the facade. The building, built directly over a major tunnel ramp, incorporates a 50 meter ventilation stack as a totem-like landmark tower. An entrance courtyard leads to four galleries, rehearsal rooms, and a set-building workshop providing vital spaces for Melbourne's lively cultural scene.

Roter Monolith

ACCA Zentrum für Gegenwartskunst

Den Lagerhallen der Umgebung ähnlich, verleiht verrosteter Stahl dem Bau ein rauhes, industrielles Ambiente. Mit der Zeit oxidiert der Stahl und nimmt eine orange-rote Tönung an, die mit den Backsteinbauten der Straße harmoniert. Die Komposition schafft ein betont skupturales Ganzes, ein Eindruck, der durch die fast fensterlosen Flächen verstärkt wird. Erbaut auf Neuland über einen Tunnelneubau, integrierte man seinen 50 m hohen Lüftungsturm als totem-ähnliches Wahrzeichen. Der Vorplatz erschließt Ausstellungssäle, Probesäle und Bühnenbildwerkstatt, die vitale Räume für die lebendige Kulturszene der Stadt schaffen.

Monolithe rouge

Le centre d'Art Contemporain ACCA

Rappelant les anciens entrepôts des environs, l'acier rouillé donne à ce bâtiment un sévère aspect industriel. Le métal oxydé prend un ton rouge-orangé qui se marie bien avec les vieilles façades en briques de la rue. La composition crée un ensemble sculptural homogène, où des fenêtres discrètes préservent la continuité de la façade. Le bâtiment, construit au-dessus d'un tunnel, intègre une cheminée de ventilation de 50 m, formant une tour monumentale pareille à un totem. Une cour d'entrée dessert quatre galeries, des salles de répétition et un atelier de décors de théâtre, offrant des espaces essentiels à la scène culturelle animée de Melbourne.

Monolito Rojo

ACCA Centro de Arte Contemporáneo

El acero oxidado le da al edificio el aspecto tranquilo e industrial de los almacenes cercanos. El acero se oxida con el tiempo y adquiere un tono rojo-anaranjado que combina con los edificios de ladrillo cocido de la calle. La composición crea un todo uniforme y escultórico, impresión que es reforzada por la casi total ausencia de ventanas en las paredes. El centro, levantado en tierra virgen y sobre un túnel, tiene una torre de ventilación de 50 m de altura similar a un tótem que se ha convertido en su elemento característico. El patio lleva a las salas de exposiciones, a las de ensayo y al taller de decorados, espacios vitales de la animada vida cultural de la ciudad.

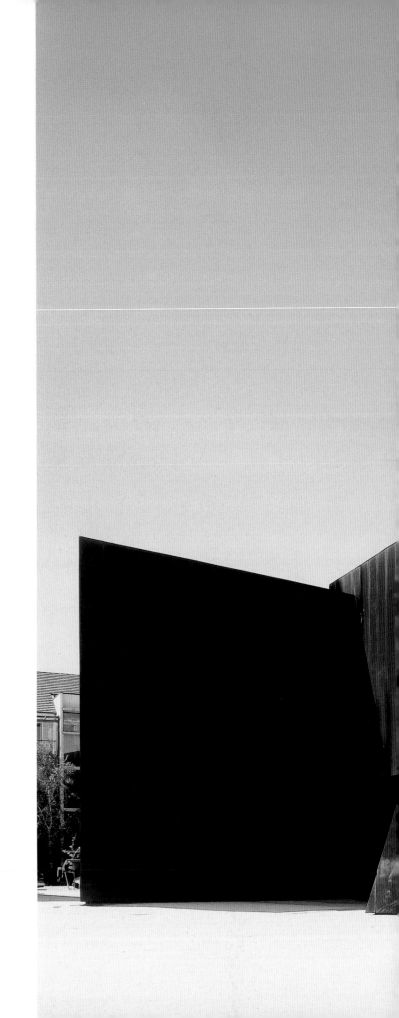

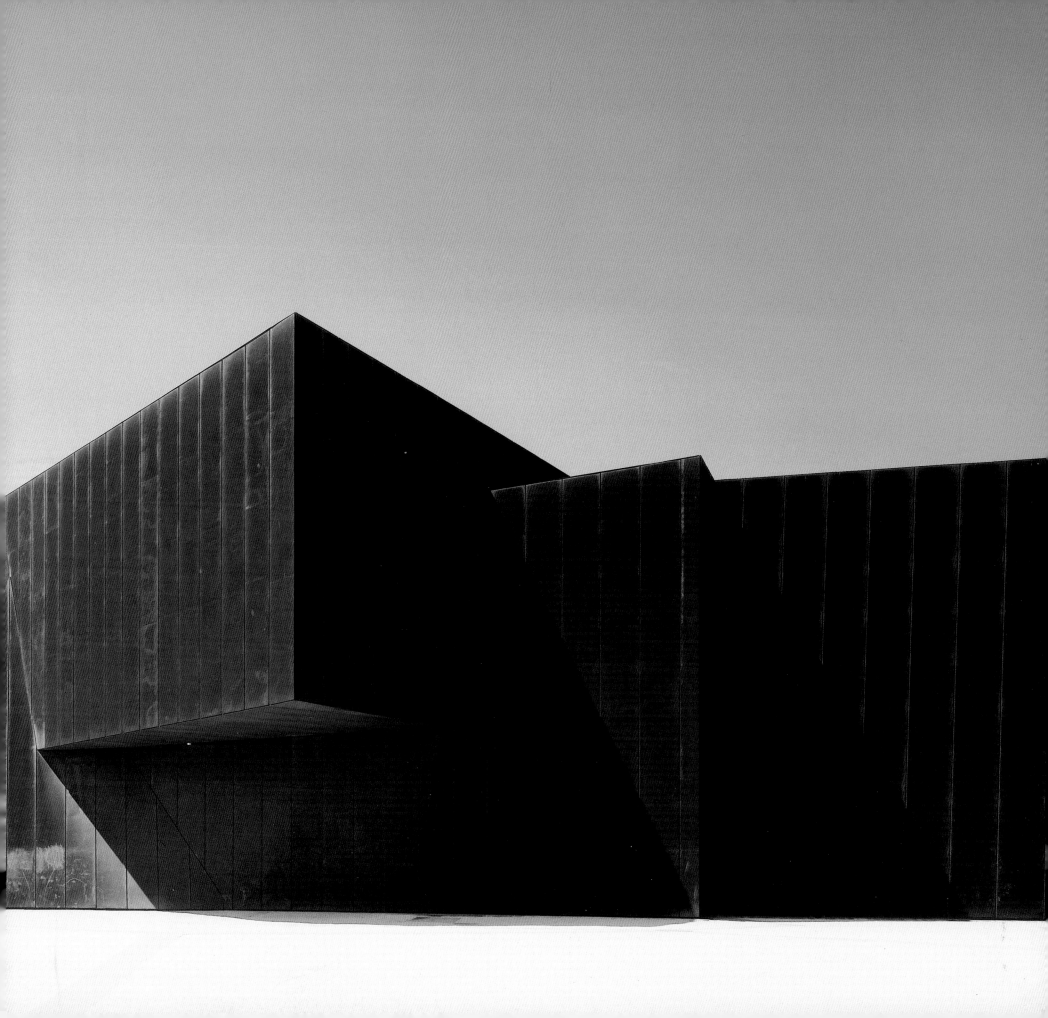

Art in Motion

Laban Dance Centre, London

Deptford Creek, the site of the first Royal docks in 1513, is an oily ditch today. This building rejuvenated the run-down neighborhood overnight. The Center, a world-renowned dance school, consists of four performance areas and thirteen dance studios bathed in restrained colors. The common spaces contrast these in bright magenta, green and tourquise tones. The exterior is completely glazed. Opaque glass panels sheathe the massive outer walls and serve as solar collectors. Strewn in irregular rhythm, the windows translate the kind of spontaneous movement that is the celebrated school's trademark into dynamic architecture.

Kunst in Bewegung

Laban Dance Centre, London

Heute ist der Quai am Deptford Creek, 1513 Standort der ersten königlichen Häfen Londons, eine ölige Schleife. Doch dieser Bau hat die heruntergekommene Gegend über Nacht verwandelt. Die renommierte Tanzschule beherbergt vier Vorführungssäle und dreizehn Tanzstudios, die in neutralen Farben gehalten werden. Die Flure leuchten kontrastierend dazu in knalligen Tönen. Außen ist der Bau komplett verglast. Opake Glaspaneele bilden eine zweite Haut, hinter der solare Wärme gespeichert wird. Unregelmäßig verstreut, übertragen die großen Fensterlöcher die spontanen Bewegungen der Tänzer auf den Rhythmus der Architektur.

L'art en mouvement

Le Laban Dance Centre, à Londres

Site des premiers docks royaux en 1513, Deptford Creek est aujourd'hui un fossé graisseux, un quartier décrépit que ce bâtiment a prestement rajeuni. École de danse réputée dans le monde entier, il est formé de quatre salles de spectacle et de treize ateliers de danse aux couleurs sobres, contrastant avec les espaces collectifs aux vives tonalités vertes, magenta et turquoise. Des panneaux de verre opaque tapissent les murs extérieurs massifs entièrement vitrés et servent de capteurs solaires. Dispersées en rythme irrégulier, les fenêtres traduisent en architecture dynamique le mouvement spontané qui est la marque célèbre de l'école.

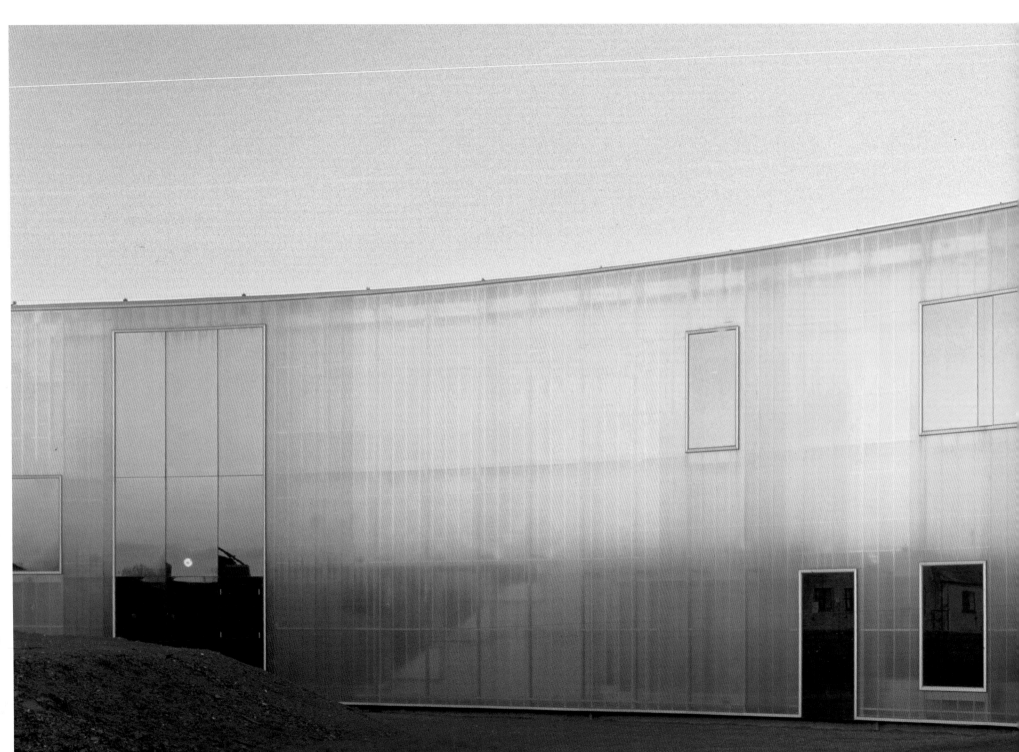

Arte en Movimiento

Laban Dance Centre, Londres

El muelle de Deptford Creek, que en 1513 fue el primer puerto real de Londres, es hoy un lugar grasiento. El edificio, sin embargo, ha transformado del día a la noche esta deprimida zona. La renombrada escuela de baile alberga cuatro escenarios y trece estudios de baile, todos ellos decorados en colores neutrales. Los pasillos, en cambio, contrastan con sus llamativos tonos. En la parte exterior el edificio está totalmente encristalado. Los paneles de cristal opaco forman una segunda piel detrás de la que se acumula el calor solar. La distribución irregular de las grandes ventanas reflejan los movimientos espontáneos de los bailarines.

London, Great Britain, Herzog & de Meuron, 2003

Santa Cruz de Tenerife, Spain,
Santiago Calatrava, 2003

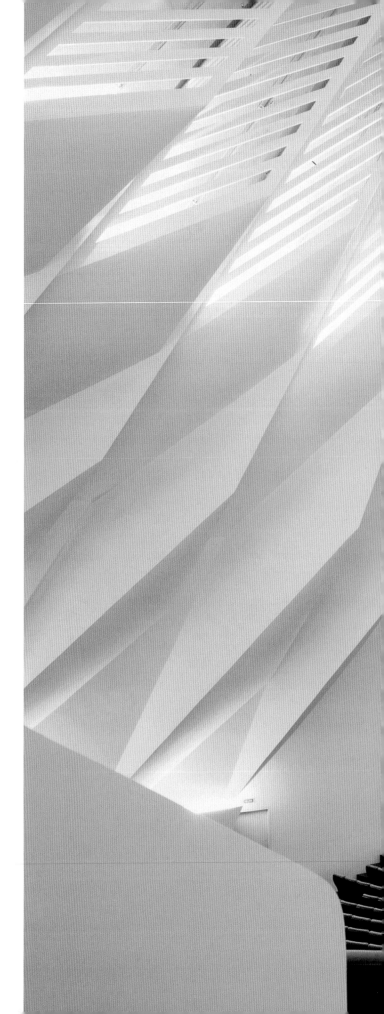

Shell of the Mollusk

Tenerife Opera House

Rather than create a building as a collage of wanton forms, the approach here is firmly rooted in the discipline of engineering. Calatrava's early sculptures – intense studies of structural forces – led to the dramatic, symmetrical form of this complex, his first concert hall. Sited beside the Atlantic Ocean, the concrete and stone building seems to rise up and over itself like a wave. The towering swell crests above two auditoriums that seat over 2000. Acoustically, the spaces can be adapted to accommodate varied needs. This flexibility allows use by the opera company, the symphonic orchestra and theater groups, as well as serving as multifunctional lecture hall.

Schale der Molluske

Opernhaus Teneriffa

Abweichend von dem Trend, Bauten als auffällige Collagen der Form willen zu entwerfen, basiert dieser Komplex auf den Gesetzen des Ingenieurbaus. Calatravas frühe Skulpturen, Studien in statischen Kräften, dienten als Modell für die dramatische, symmetrische Gestalt dieses Baus, seine erste Konzerthalle. Direkt am atlantischen Ozean gelegen, schwellt das Gebäude – einer Welle ähnlich – in die Höhe. Der Wellenkamm aus Beton und Stein markiert die beiden Auditorien mit insgesamt 2000 Sitzplätzen. Diese lassen sich flexibel für Opern, Konzerte, Theatervorführungen oder Vorträge nutzen.

La coquille du mollusque

L'Opéra de Tenerife

Loin de créer un édifice comme un collage de formes gratuites, la démarche est ici fermement ancrée dans le génie civil. Les premières sculptures de Calatrava – des études fouillées de forces structurelles – ont abouti à cette forme symétrique spectaculaire, sa première salle de concert. Au bord de l'Atlantique, ce complexe de béton et de pierre paraît se dresser sur lui-même comme une énorme vague, couronnant deux auditoriums de plus de 2000 places, adaptables à des acoustiques diverses. Cette souplesse permet d'accueillir l'orchestre symphonique, la troupe de l'opéra et des compagnies théâtrales, et de servir de salle de conférences polyvalente.

La Concha del Molusco

Ópera de Tenerife

Alejándose de la tendencia de crear edificios como llamativos collages, esta obra se basa, sobre todo, en las leyes de la ingeniería. Las esculturas tempranas de Calatrava, estudios sobre las fuerzas estáticas, sirvieron de modelo para la dramática y simétrica forma de este edificio que, a la vez, es su primera sala de conciertos. La construcción está situada junto al océano Atlántico y parece elevarse sobre sí misma como una ola. Su cresta, de hormigón y piedra, cubre los dos auditorios, que tienen cabida para un total de 2.000 asientos. Estas salas son flexibles y pueden utilizarse para la ópera, el teatro o para dar conferencias.

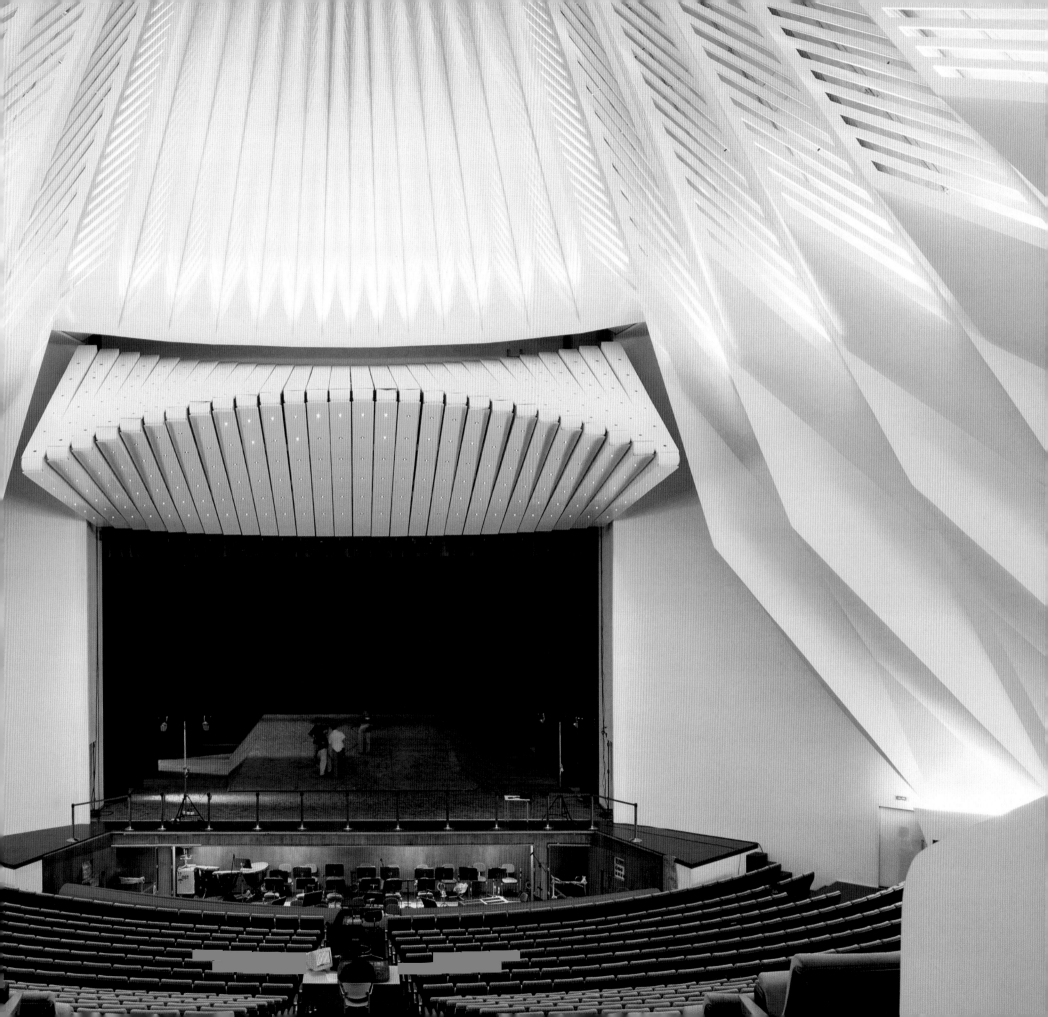

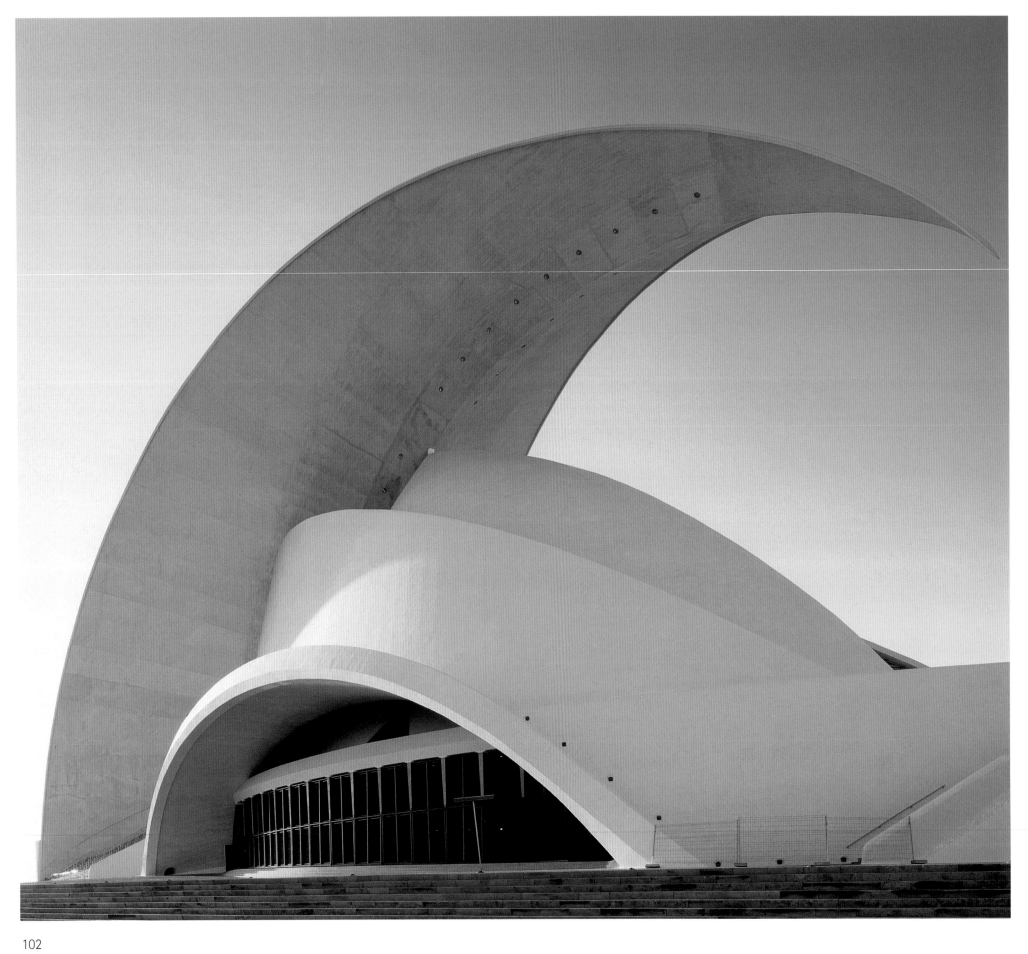

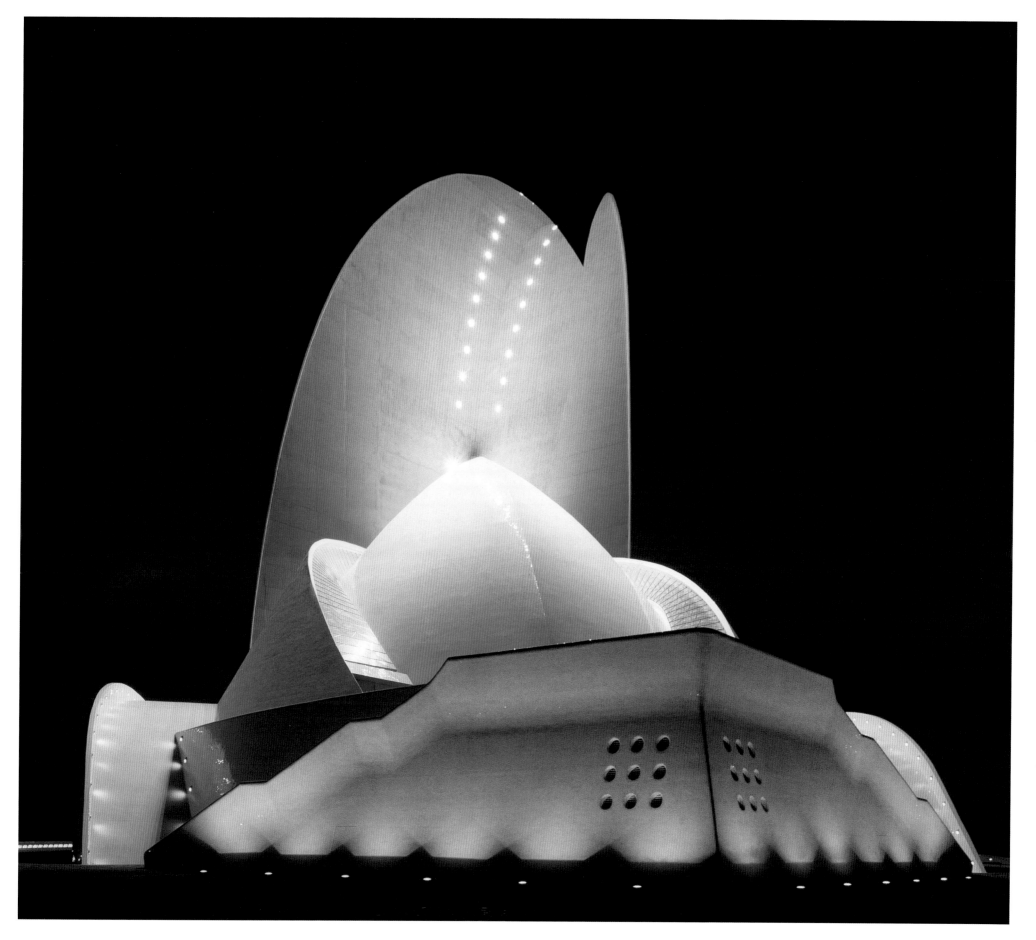

Annandale, New York, USA, Frank O. Gehry, 2003

Confetti Landscape

Fisher Center for the Performing Arts at Bard College

Already touted as the cultural nucleus of the Hudson Valley, the Center draws attention to a scenic region known up until now more for the landscape painters of the Hudson River School, which immortalized it in the 1800's, than for provocative architecture. Two theaters, four rehearsal studios for dance, theater, and music and professional support facilities comprise the facility. The 900-seat theater includes an orchestra pit for opera and an acoustic shell designed by Yasuhisa Toyota, that also enhances chamber and symphonic music. This new facility is home to teaching and college events during the academic year and is used as a public performing arts facility in summer.

Konfettilandschaft

Bard College Theater

Bereits jetzt wird der Bau als der kulturelle Kernpunkt des Hudson Valleys gehandelt. Eine Gegend, die im 19. Jhdt. durch die Landschaftsmaler der Hudson Valley School verewigt wurde, jedoch bis heute kaum an provokative Architektur denken ließ. Zwei Theatersäle, vier Probestudios für Tanz, Theater und Musik und Medienräume wurden virtuos unter kulissenartigen Titanstahlschalen angeordnet. Der große Saal mit 900 Sitzplätzen und Orchestergraben erhielt eine Akustikschale von Yasuhisa Toyota, die Kammermusik- und Orchesternutzung ermöglicht. Primär für die College-Nutzung konzipiert, finden hier in den Sommermonaten internationale Festivals statt.

Paysage de confettis

Le Bard College Theater

Déjà très vanté comme le noyau culturel de l'Hudson Valley, ce bâtiment rehausse une région pittoresque jusqu'alors plus connue pour avoir été immortalisée par les paysagistes du 19ème siècle que pour son architecture provocante. Il est formé de 2 théâtres, 4 ateliers de répétitions musicales, théâtrales et chorégraphiques, et d'infrastructures professionnelles. Le théâtre de 900 places contient une fosse d'orchestre d'opéra et une coquille acoustique conçue par Yasushisa Toyota, qui se prête aussi bien à la musique de chambre et symphonique. Lieu d'enseignement et d'examens dans l'année, ce centre offre des spectacles publics durant l'été.

Paisaje de Confeti

Bard College Theater

La construcción está considerada como el centro cultural del Hudson Valley. Este lugar fue inmortalizado en el siglo XIX por el pintor paisajístico del Hudson Valley School y hasta hoy aquí no parecía haber sitio para la arquitectura provocativa. Estas teatrales placas de titanio albergan magistralmente las dos salas de teatro, los cuatro estudios de ensayo para la danza, el teatro y la música y las instalaciones con equipos profesionales. Yasuhisa Toyota diseñó el recubrimiento acústico de la sala más grande, de 900 asientos y con una fosa para la orquesta, y permite la interpretación de música de cámara y sinfónica. Las salas se utilizan en verano para los festivales internacionales.

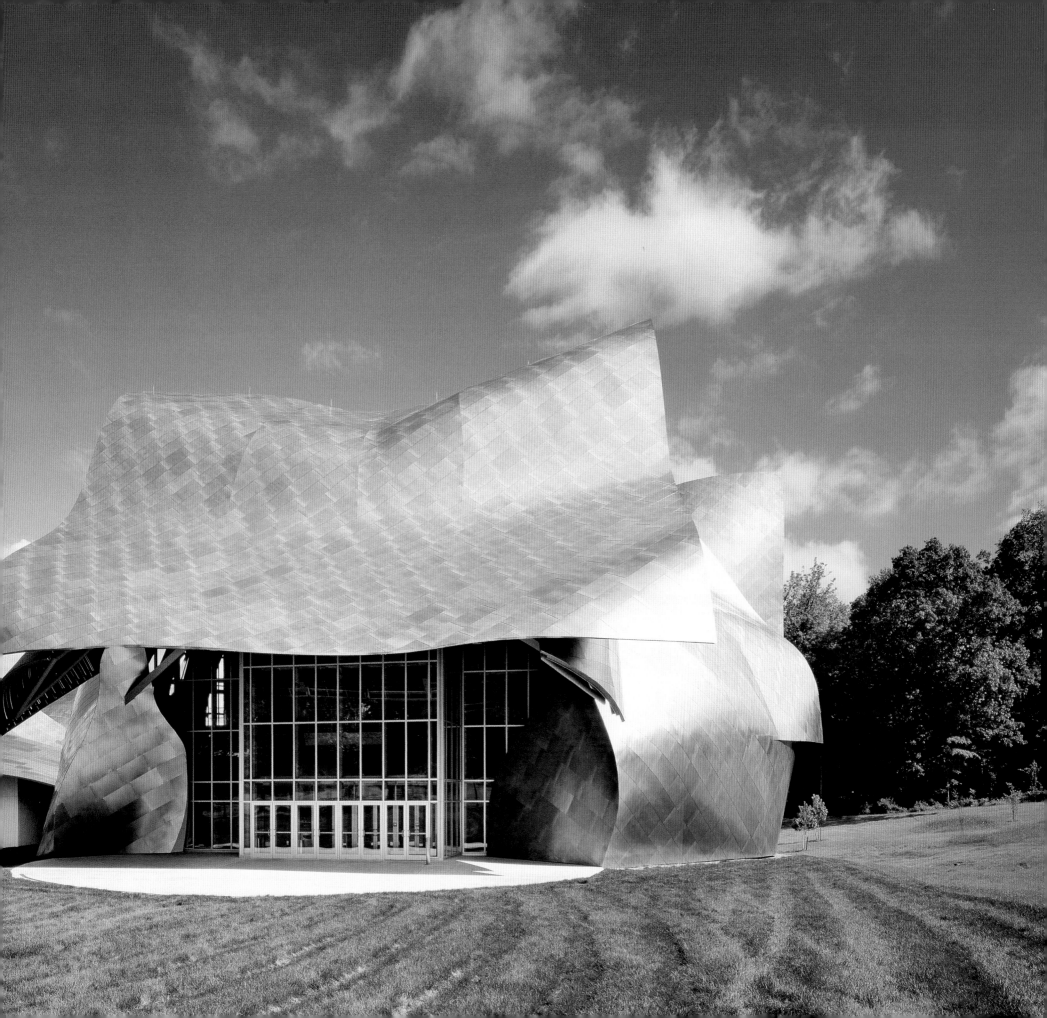

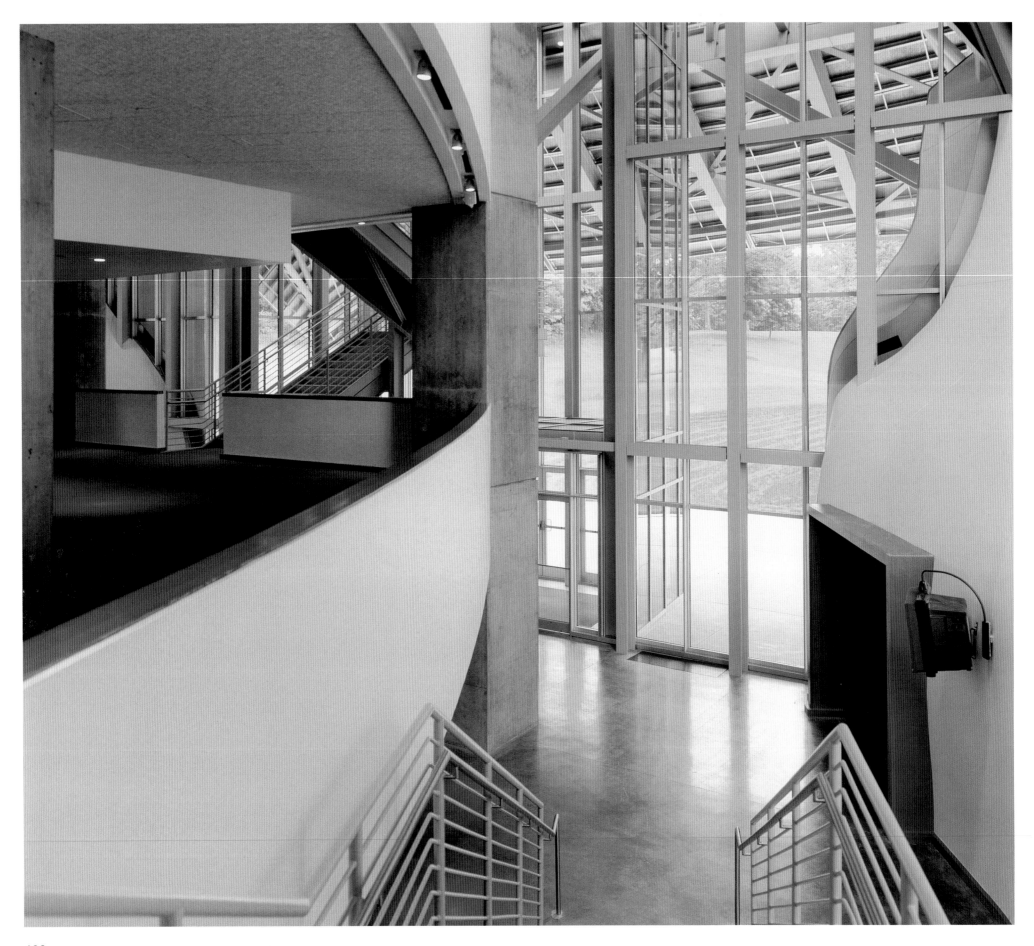

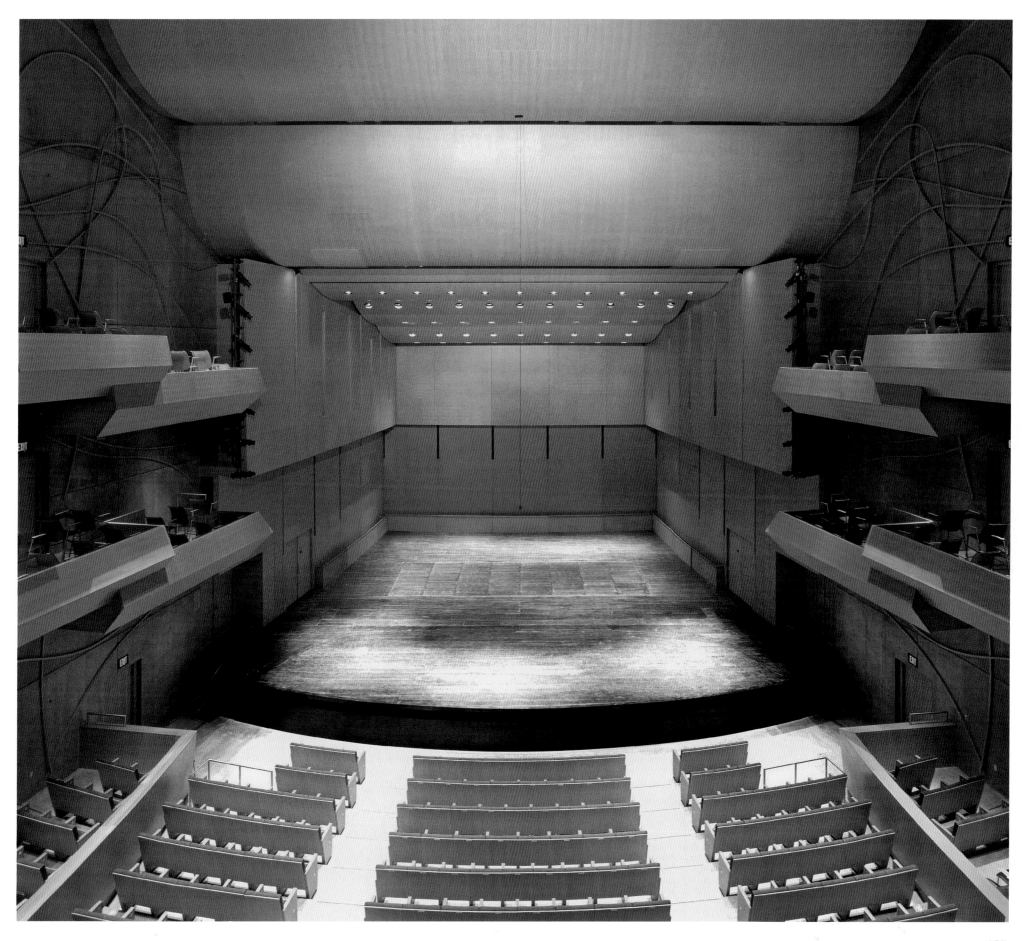

Dome of Light

Millennium Dome

A long derelict industrial area on the banks of the Thames was revitalized with an exhibition hall to celebrate the new millennium and at the same time create a modern landmark for the metropolis. The circular, 100,000 square meter space is spanned by a bold dome construction as a future-oriented alternative to conventional exhibition buildings. Twelve striking, 100 meter high steel masts, supported by 70 kilometers of high strength cable, form an unforgettable skyline. Additional cables hung from these masts support an extremely light roof membrane made of Teflon coated glass fiber.

Lichtdom

Millennium Dome

Auf dem seit über 20 Jahren vernachlässigten Industrieareal entstand zur Feier des neuen Millenniums eine Ausstellungshalle der Superlative, ein neues Wahrzeichen an der Themse. Als zukunftsweisende Alternative zu konventionellen Hallentypen wählte man eine gewagte Hängekonstruktion für die 100 000 qm große, kreisrunde Halle. Zwölf markante, 100 m hohe Stahlmasten, die durch 70 km Kabel gehalten werden, schaffen eine einmalige Skyline und tragen die Dachkonstruktion aus radial angeordneten Stahlkabeln, an denen die leichte Dachhaut aus teflonbeschichteten Glasfasern befestigt wird.

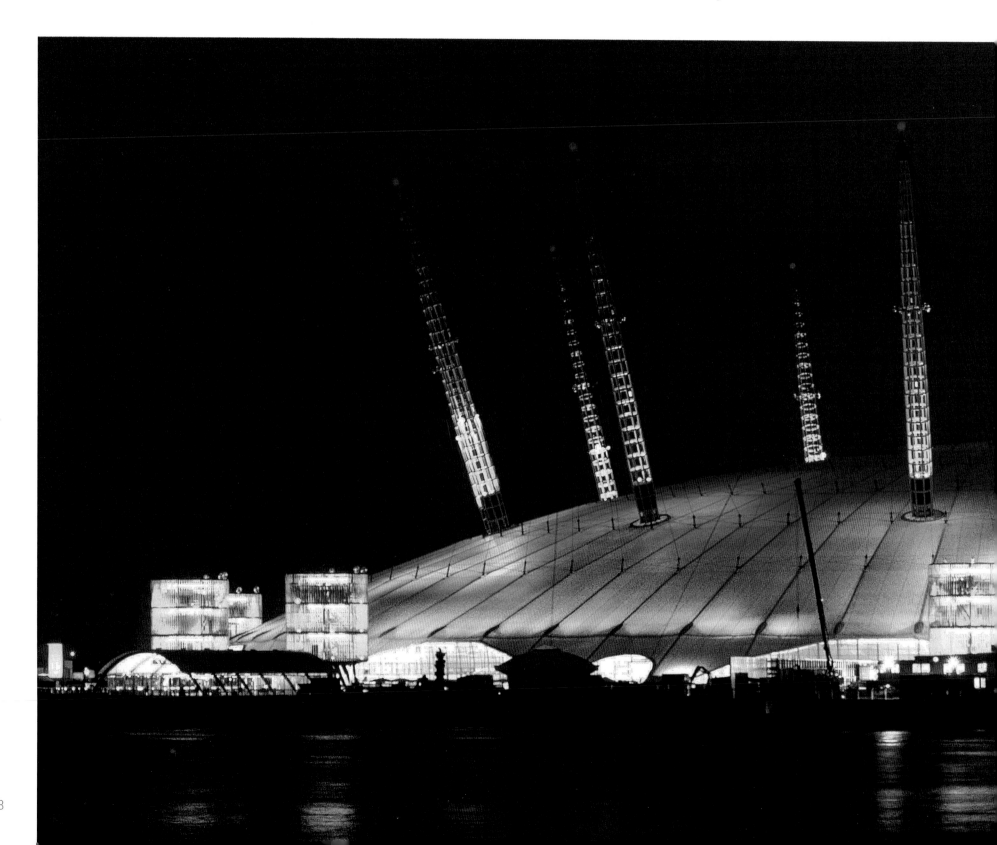

Dôme de lumière

Le dôme du millénaire

Une zone industrielle longtemps à l'abandon sur les rives de la Tamise a été ranimée par un hall d'exposition, pour célébrer le nouveau millénaire et créer un monument moderne dans la métropole. L'espace circulaire de 100 000 m² est couvert par une construction audacieuse en forme de dôme, alternative futuriste aux bâtiments d'exposition classiques. Douze saisissants pylônes en acier de 100 m de haut, soutenus par 70 kilomètres de câbles très résistants, forment une ligne d'horizon inoubliable. Des câbles additionnels, suspendus à ces pylônes, supportent la membrane d'un toit extrêmement léger, en fibre de verre garnie de téflon.

Cúpula de Luz

La Cúpula del Milenio

En este área industrial, abandonada desde hacía más de 20 años, se levantó un espectacular pabellón de exposiciones para celebrar el nuevo milenio que se convirtió en un nuevo monumento a orillas del Támesis. Para este espacio circular de 100.000 m² se eligió una atrevida construcción como una alternativa orientada al futuro frente a los pabellones de exposiciones convencionales. Doce impresionantes mástiles de acero de 100 m de altura están sujetados por 70 km de cable y crean un inolvidable perfil en el horizonte. Cables de acero radiales sujetan la construcción del ligero techo, que está hecho de una membrana de fibra de vidrio revestida en teflón.

London, Great Britain, Richard Rogers Partnership, 1999

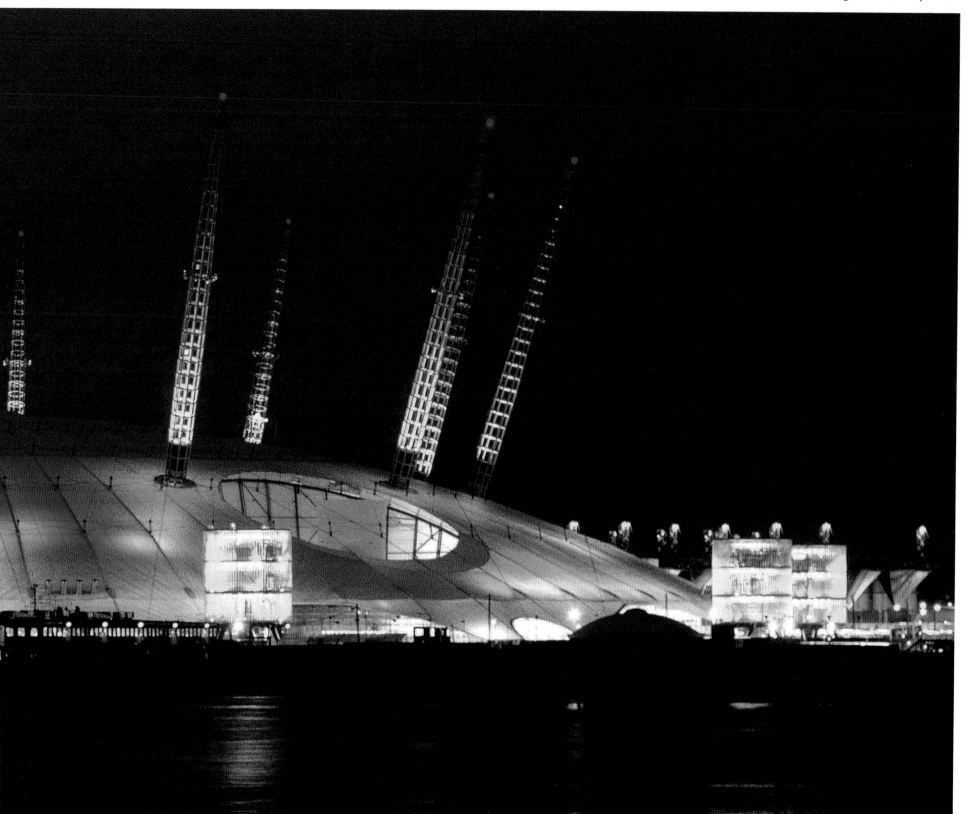

109

Berlin, Germany,
Daniel Libeskind, 1999

Axes

Jewish Museum Berlin

Askew, tin-sheathed shapes create a queasy setting. Jagged angles stand in marked contrast to the historic building next door where the main entry lies. A gray concrete staircase leads underground to the new building. At its base, three paths originate: the Axis of the Holocaust, the Axis of Exile, and the Axis of Continuity. The Axis of the Holocaust ends in a bare, unheated, concrete tower. An unsettling "garden" culminates the Axis of Exile. A pomegranate tree, a symbol of fertility in Jewish tradition, forms a more optimistic climax for the Axis of Continuity. Arrayed around these paths, the museum's galleries portray the story of Jews in Germany since medieval times.

Achsen

Jüdisches Museum Berlin

Schräge, metallene Körper strahlen Dissonanz aus. Messerscharfe Kanten stehen im Kontrast zum Altbau nebenan, der den Eingang beherbergt. Eine graue Betontreppe führt nach unten in den Neubau. Hier stehen drei Wege zur Wahl: die Achse des Holocausts, die Achse des Exils und die Achse der Kontinuität. Die Achse des Holocausts endet in einem kalten Turmraum. Ein beunruhigender Garten schließt die Achse des Exils ab. Ein Granatapfelbaum, Fruchtbarkeitssymbol der jüdischen Tradition, schafft den optimistischeren Endpunkt der Achse der Kontinuität. Um diese Achsen herum wird die Geschichte der Juden in Deutschland seit dem Mittelalter präsentiert.

Axes

Le musée juif de Berlin

Des formes de guingois, couvertes de fer-blanc, provoquent le malaise. Des angles déchiquetés contrastent nettement avec le bâtiment historique d'à côté, qui abrite l'entrée principale. Un escalier en béton gris s'enfonce vers le nouveau bâtiment en sous-sol. Trois axes partent de sa base : l'Axe de l'Holocauste, de l'Exil et de la Continuité. Le premier monte vers une tour de béton nue, non chauffée. Le second aboutit à un « jardin » dérangeant. Un grenadier, symbole de fertilité dans la tradition juive, achève le troisième de façon plus optimiste. Autour de ces axes, les galeries du musée présentent l'histoire des Juifs d'Allemagne depuis le moyen-âge.

Ejes

Museo Judío de Berlín

Los cuerpos metálicos inclinados irradian disonancia. Los bordes extremadamente afilados contrastan con el edificio histórico de al lado que alberga la entrada. Unas escaleras grises de hormigón conducen hacia abajo, al edificio nuevo. Aquí pueden escogerse tres caminos: el Eje del Holocausto, el Eje del Exilio y el Eje de la Continuidad. El Eje del Holocausto termina en una fría y desnuda torre. Un inquietante jardín es el final del Eje del Exilio, mientras que el final, más optimista, del Eje de la Continuidad es un granado, símbolo de la fecundidad en la tradición judía. Alrededor de estos ejes se presenta la historia de los judíos en Alemania desde la Edad Media.

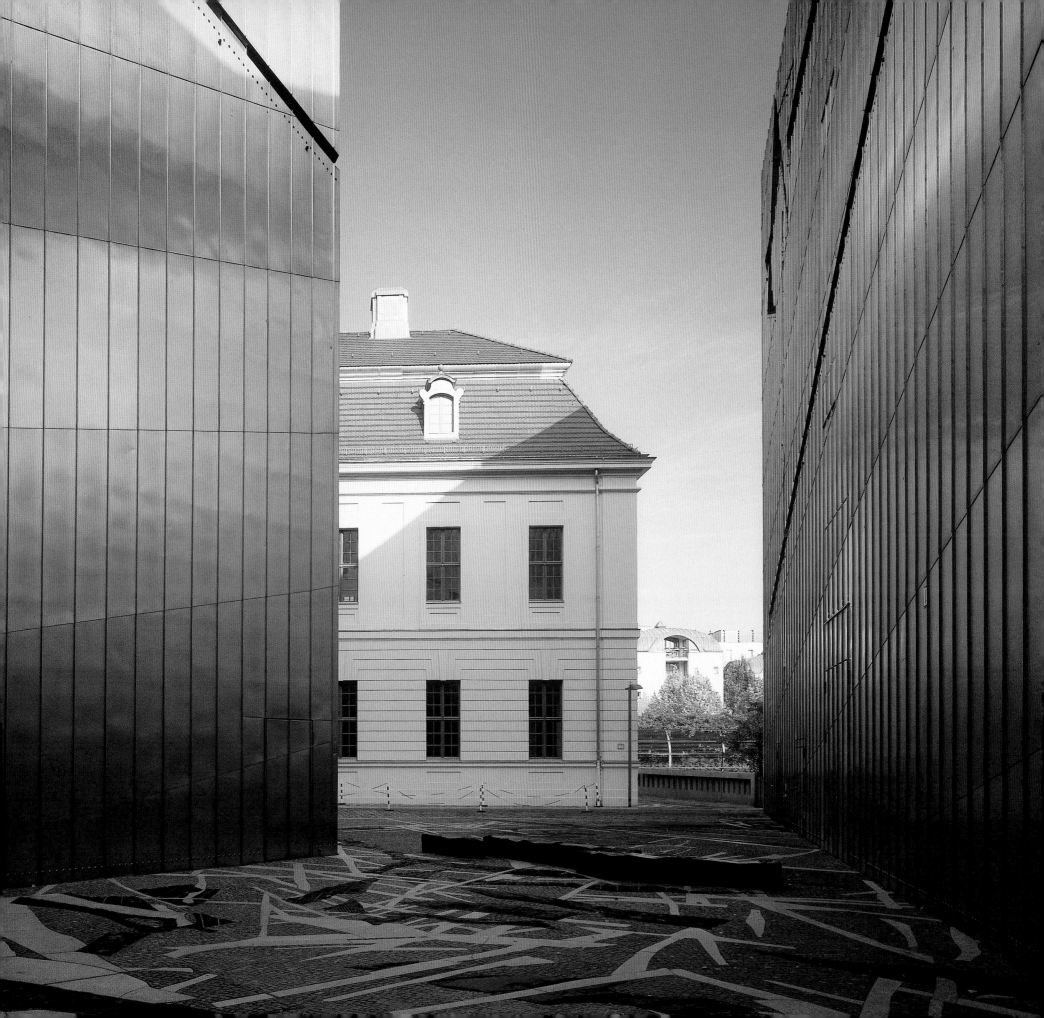

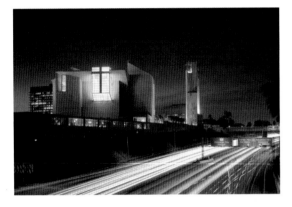

Los Angeles, USA,
José Rafael Moneo, 2003

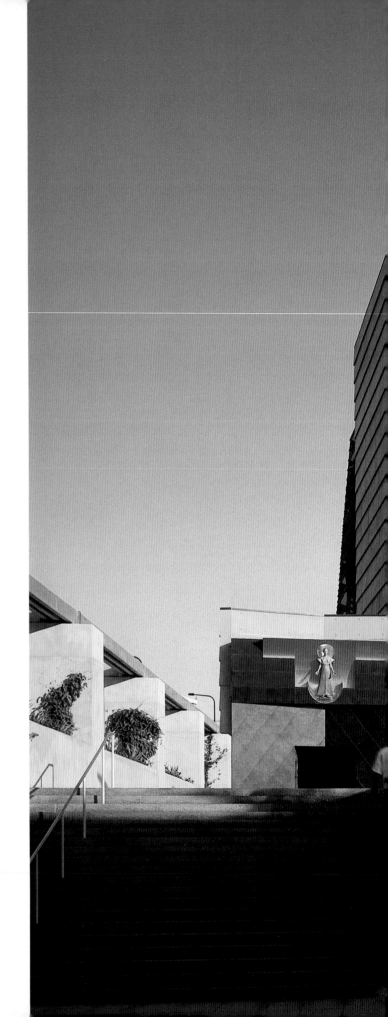

Roadside Redemption

Our Lady of the Angels Cathedral, Los Angeles

The site for one of the world's largest cathedrals rises above the traffic on the Hollywood freeway. The expressive angular structure strikes up a quietly self-assured conversation with the chaotic billboard landscape of the city. The sanctuary inside is imbued with a mystical sense. Light is skillfully directed inside through semi-transparent Spanish alabaster panes to define varie-gated spatial realms. The cavernous main hall relates a sense of monumental magnitude and accentuates the cohesion of the congregation. Ten chapels create more intimate niches for introverted reflection far removed from the hectic metropolis outside.

Erlösung an der Autobahn

Kathedrale in Los Angeles

Dicht neben dem starkbefahrenen Hollywood Freeway erhebt sich eine der größten Kathedralen der Welt. Nach außen wirkt der Bau, der fast keine rechten Winkel aufweist, wie eine in sich ruhende Antwort auf die auftrumpfenden Werbetafeln der Umgebung. Im Kirchenraum entsteht ein mystisches Ambiente. Durch gezielte Lichtführung über Öffnungen mit halb-transparentem spanischen Alabaster entstehen unterschiedliche Raumzonen. Der stattliche Hallenraum vermittelt betont den Zusammenhalt der Gemeinde. Zehn Kapellen schaffen intimere Raumzonen der introvertierten Reflektion weit jenseits der Hektik der Metropole.

Rédemption au bord de la route

La cathédrale de Los Angeles

Le site d'une des plus grandes cathédrales du monde s'élève au-dessus du trafic de l'autoroute de Hollywood. Cette structure anguleuse et expressive engage une conversation sereine avec le paysage chaotique des panneaux de la ville. Une atmosphère mystique imprègne l'intérieur du sanctuaire. La lumière y est adroitement dirigée par des panneaux d'albâtre espagnol semi-transparents pour définir des espaces variés. La nef immense donne une impression monumentale et souligne la cohésion de la communauté. Dix chapelles créent des niches plus intimes pour la méditation, loin de la métropole trépidante au dehors.

Redención en la Autopista

Catedral en Los Ángeles

Al lado de la concurrida autopista de Hollywood se levanta una de las mayores catedrales del mundo. Hacia fuera, el edificio, que apenas presenta ángulos rectos, parece erguirse como una respuesta al caótico paisaje de carteles de la ciudad. Una sensación de misticismo inunda el interior de la iglesia. La entrada controlada de la luz a través de paneles de alabastro español semitransparente define los diferentes espacios. La enorme nave principal transmite una sensación de grandeza monumental y acentúa la unión de la comunidad. Diez capillas crean lugares más recogidos para la meditación interior, lejos del bullicio de la ciudad.

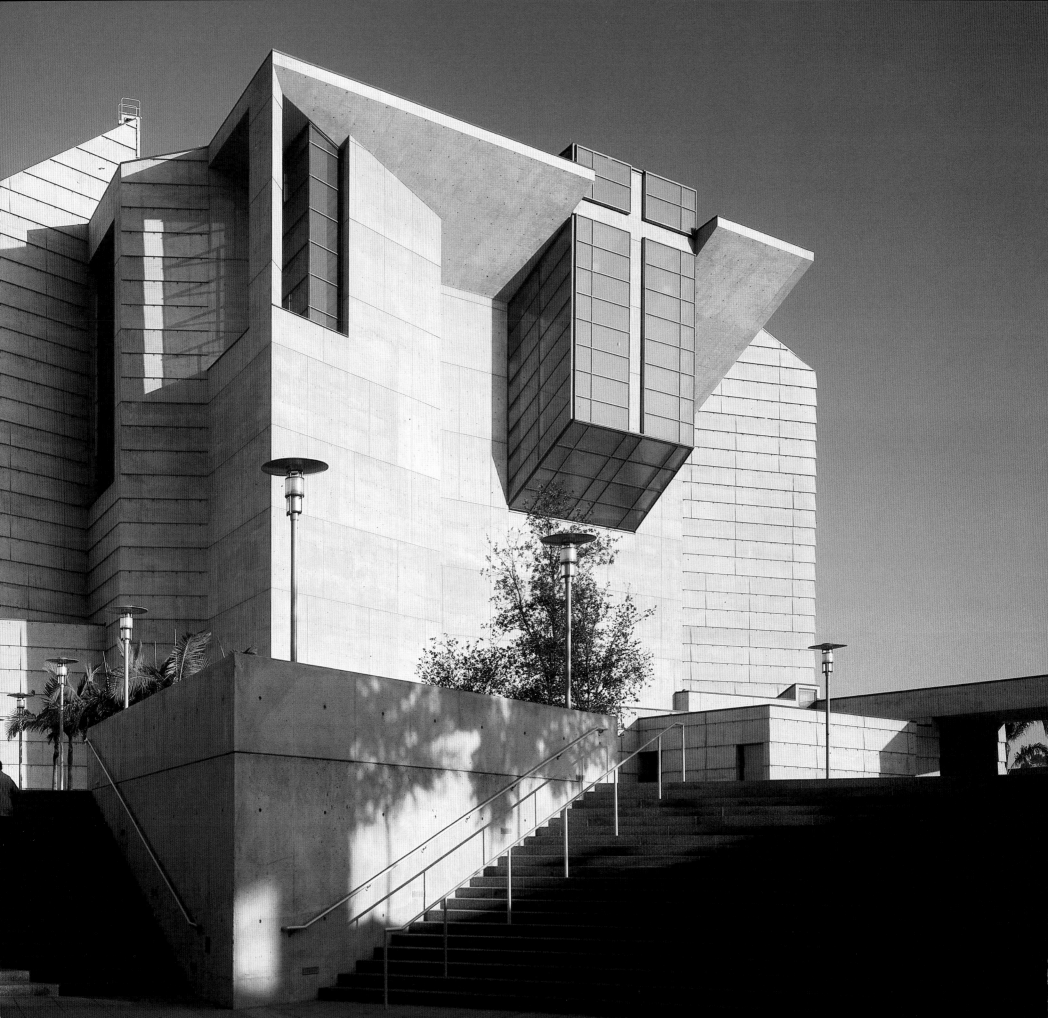

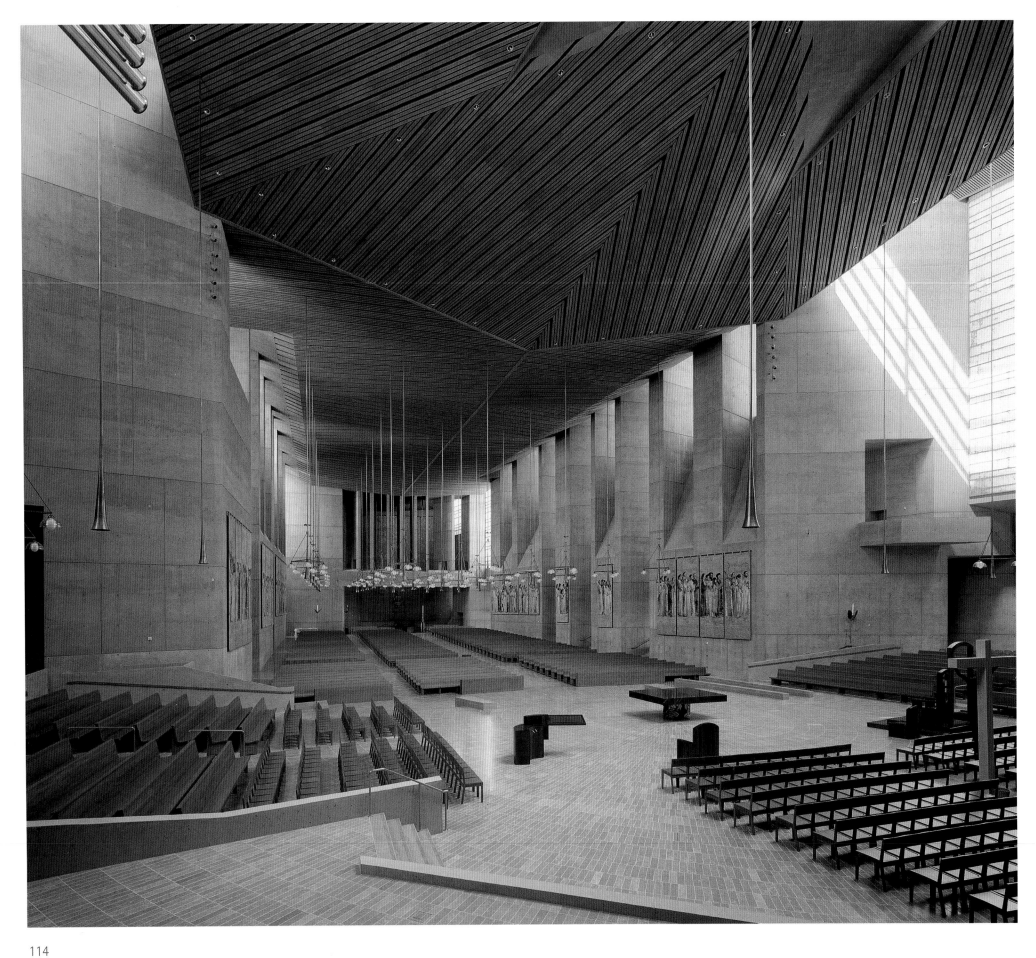

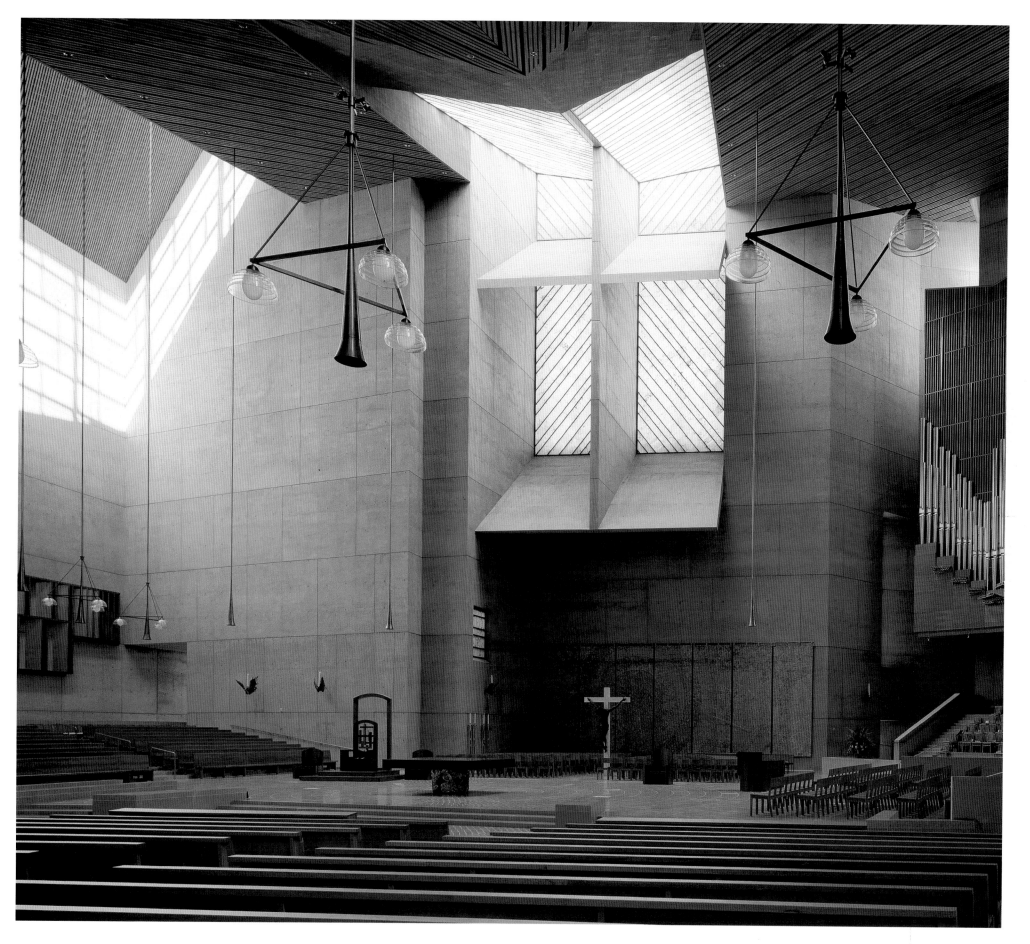

Monte Tamaro, Switzerland,
Mario Botta, 1996

The Path is the Goal

Chapel of Santa Maria degli Angeli

Access to this mountain chapel commences via an arrow straight axis. Roman aqueducts and Egyptian monumental architecture served as formal images for the horizontal composition, which crowns a remote ridge. The next station on the path toward the chapel interior is the observation platform at the end of the axis, which offers a commanding overview of the Alpine landscape. Turning back toward the mountain, the path continues down the steps of the chapel roof. A last flight of steps underscores the symmetry pervasive throughout, which is relentlessly pursued down to the last detail of the circular chapel space.

Der Weg ist das Ziel

Kappelle Santa Maria degli Angeli

Schnurgerade streckt sich der Zugangsweg zur Kapelle hin. Römische Aquädukte und ägyptische Monumentalarchitektur dienten als Vorbilder einer Anlage, die horizontal auf dem Bergrücken lagert. Die Aussichtskanzel am Ende des Viaduktes, mit weitem Ausblick auf die Schweizer Berglandschaft, ist eine Zwischenstation auf dem Weg zum Kirchenraum. Von hier aus wendet sich der Besucher zum Berg hin und schreitet die Stufen des Kapellendaches hinab. Die letzte Treppe vor dem Eingang unterstreicht die alles beherrschende Symmetrie, die sich im Inneren der kreisförmigen Kapelle bis ins letzte Detail fortsetzt.

La voie est le but

La chapelle Santa Maria degli Angeli

L'accès à cette chapelle de montagne commence par un axe fléché en ligne droite. Les aqueducs romains et l'architecture égyptienne monumentale ont servi de modèles à la construction horizontale, couronnant une crête lointaine. La station suivante sur la voie de l'intérieur de la chapelle est la terrasse panoramique au bout de l'axe, offrant une vue imposante sur le paysage alpin. En se retournant vers la montagne, la voie continue au bas des marches du toit. Un dernier escalier souligne la symétrie omniprésente, poursuivie jusqu'au dernier détail de l'espace circulaire de la chapelle.

El Camino es la Meta

Iglesia de Santa Maria degli Angeli

El camino de acceso a esta iglesia se extiende en línea recta. Los acueductos romanos y la arquitectura monumental egipcia sirvieron de modelo para esta instalación que se levanta de forma horizontal sobre la cresta de la montaña. La plataforma de observación que se encuentra al final del viaducto es la última parada antes de llegar a la iglesia. Desde aquí el visitante se gira hacia la montaña y desciende por los peldaños del tejado de la iglesia. El último tramo de escaleras antes de alcanzar la entrada acentúa la simetría dominante en todo el complejo y que continúa en el interior del espacio circular de la iglesia hasta el último detalle.

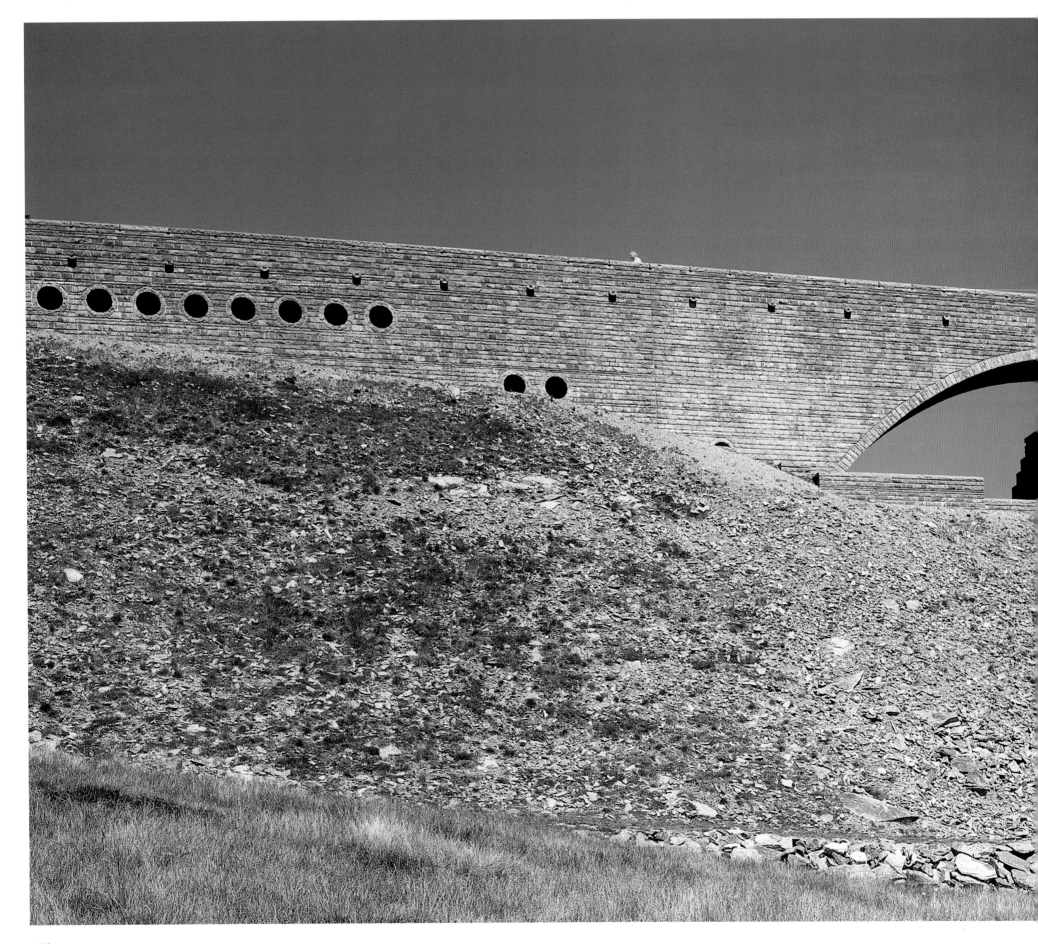

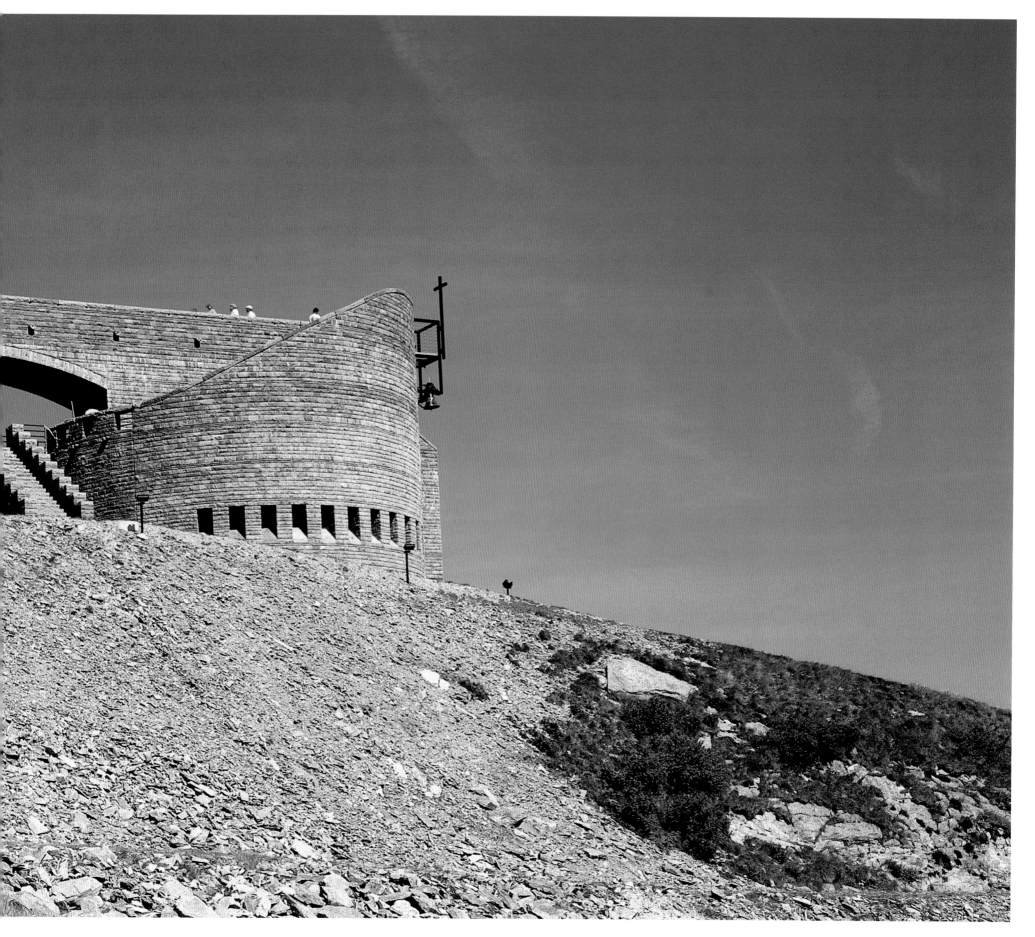

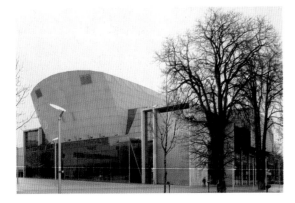

St. Pölten, Austria, Klaus Kada, 1997

Architectural Highlight

Concert Hall

The entrance facade of the Concert Hall, which forms the focal point of a new governmental quarter, presents itself as a composition of variegated glass surfaces. The sculpted mass of the hall, clad in shimmering green glass, soars above the transparent foyer. During the day, both surfaces reflect the surroundings and form opaque, solid spatial planes. At night, when they are back-lit, the foyer lights up like an aquarium and the hall emanates a mysterious glow from within like a huge block of ice. Inside the concert auditorium a softer palette of materials complement the cool, hard surfaces on the exterior.

Glanzlicht im Regierungsviertel

Festspielhaus

Glas in Glas zeigt sich die Eingangsseite des Konzerthauses, das als Kulturbau die Verwaltungskomplexe des neuen Regierungsviertels abrundet. Über der transparenten Foyerfront kragt der mit schimmernd grünen Mattglas-Paneelen verkleidete Korpus des Saals aus. Tagsüber reflektieren beide Körper die Umgebung und wirken wie geschlossene Flächen. Nachts werden sie von hinten beleuchtet. Das Foyer wirkt dabei völlig transparent wie ein Aquarium, der Saal darüber strahlt geheimnisvoll von innen wie ein überdimensionaler Eisblock. Erst im Saalraum bilden weichere Materialien einen Kontrast zu den harten, kühlen Oberflächen des Exteriers.

Architecture de lumière

Salle de concert

La façade de la salle de concert, qui forme le point central d'un nouveau quartier gouvernemental, se présente comme une construction de différentes surfaces de verre. La masse sculptée de la grande salle, garnie de carreaux verts miroitants, se dresse au-dessus du foyer transparent. Le jour, les deux surfaces réflètent les alentours et forment des espaces massifs et opaques. La nuit, quand elles sont rétro-éclairées, le foyer s'illumine comme un aquarium et la grande salle rayonne d'un mystérieux éclat interne, tel un énorme bloc de glace. À l'intérieur de l'auditorium, une palette de matériaux plus doux complète les surfaces dures et froides de l'extérieur.

Destellos en el Barrio Gubernamental

Sala de Conciertos

El lado de la entrada de esta sala de conciertos está totalmente encristalado y el edificio completa, con su función cultural, el nuevo barrio gubernamental. Sobre el frente transparente del vestíbulo se eleva el cuerpo de la sala, recubierto con paneles de brillante cristal verde opaco. Durante el día, los cuerpos reflejan el entorno y parecen planos espaciales cerrados. Por la noche se iluminan desde dentro. El vestíbulo parece totalmente transparente, como un acuario, y la sala encima de él brilla desde el interior de forma misteriosa, como un gigantesco bloque de hielo. En la sala, los materiales suaves contrastan con las superficies duras y frías del exterior.

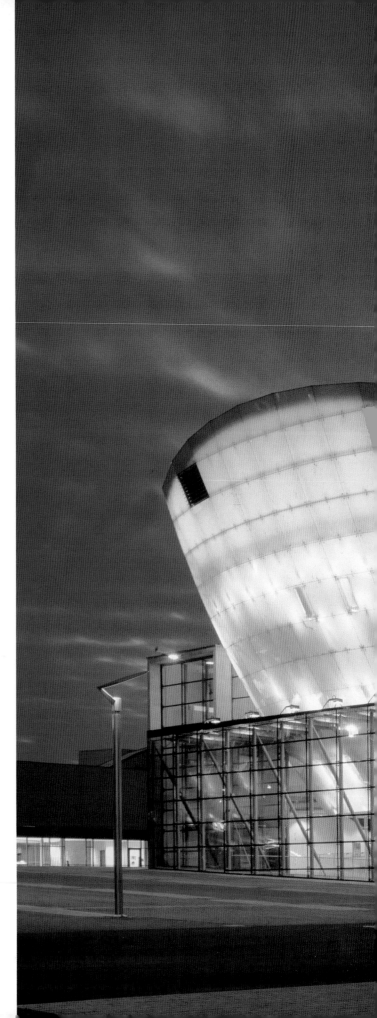

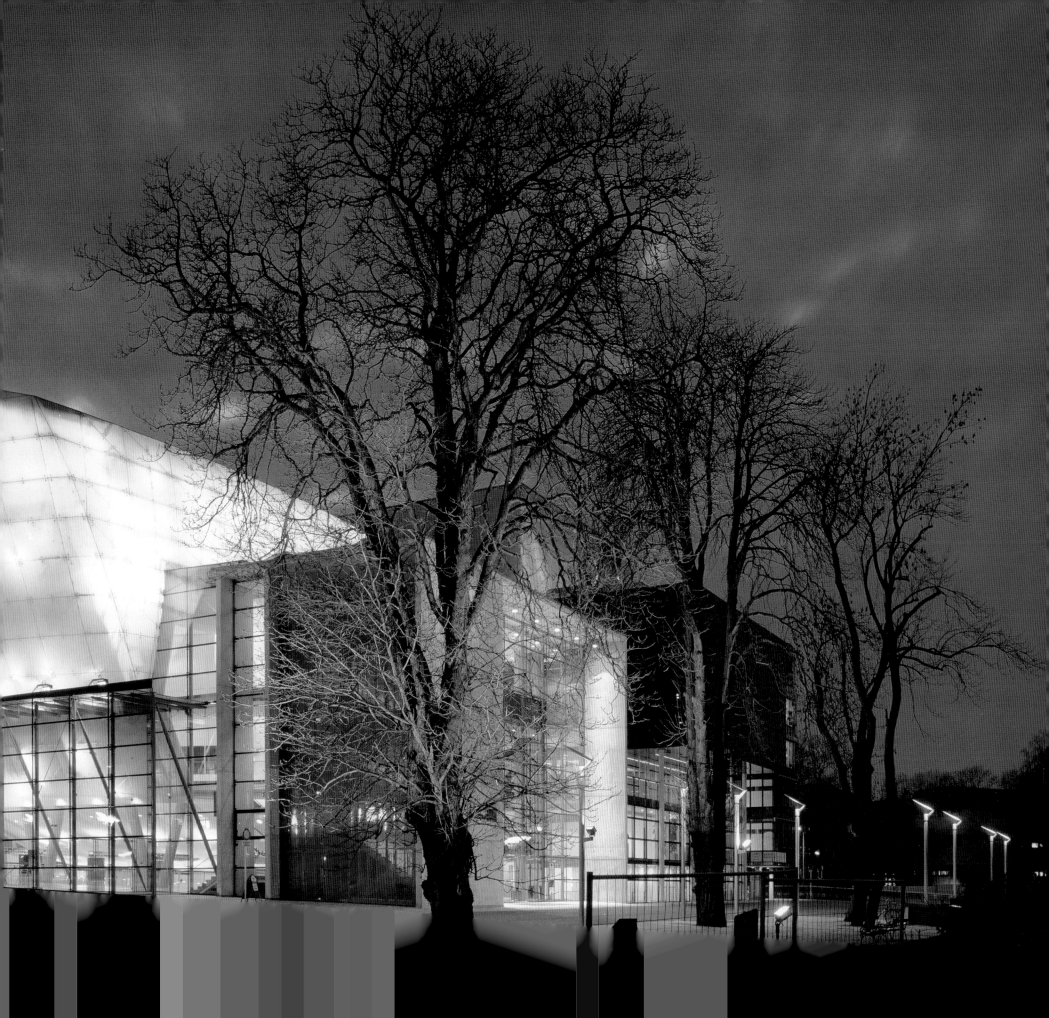

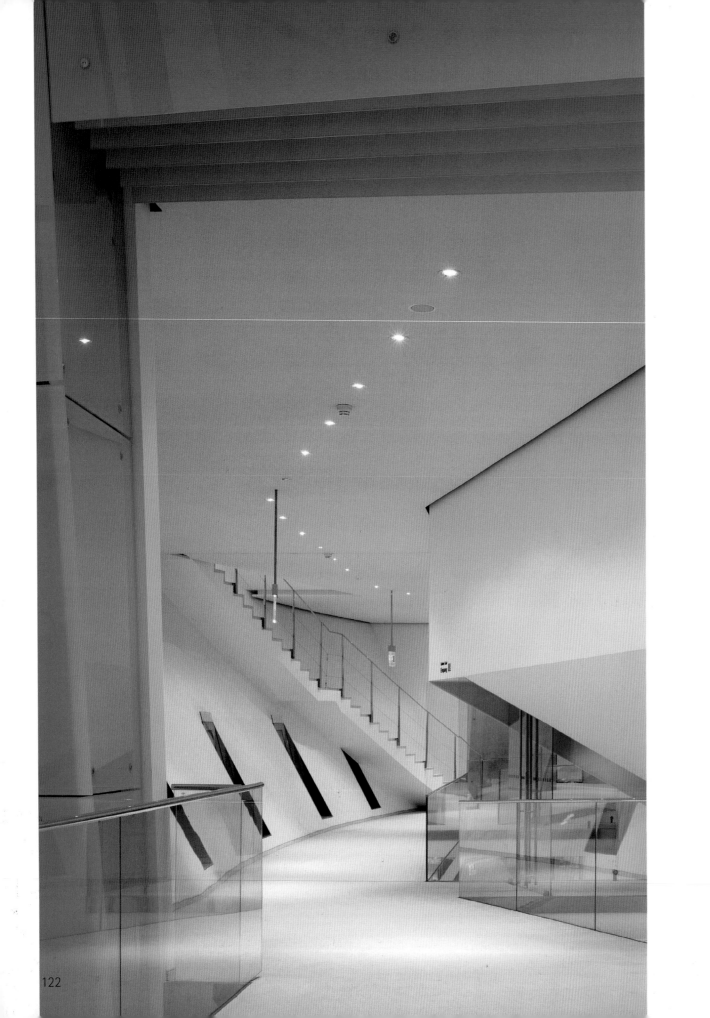

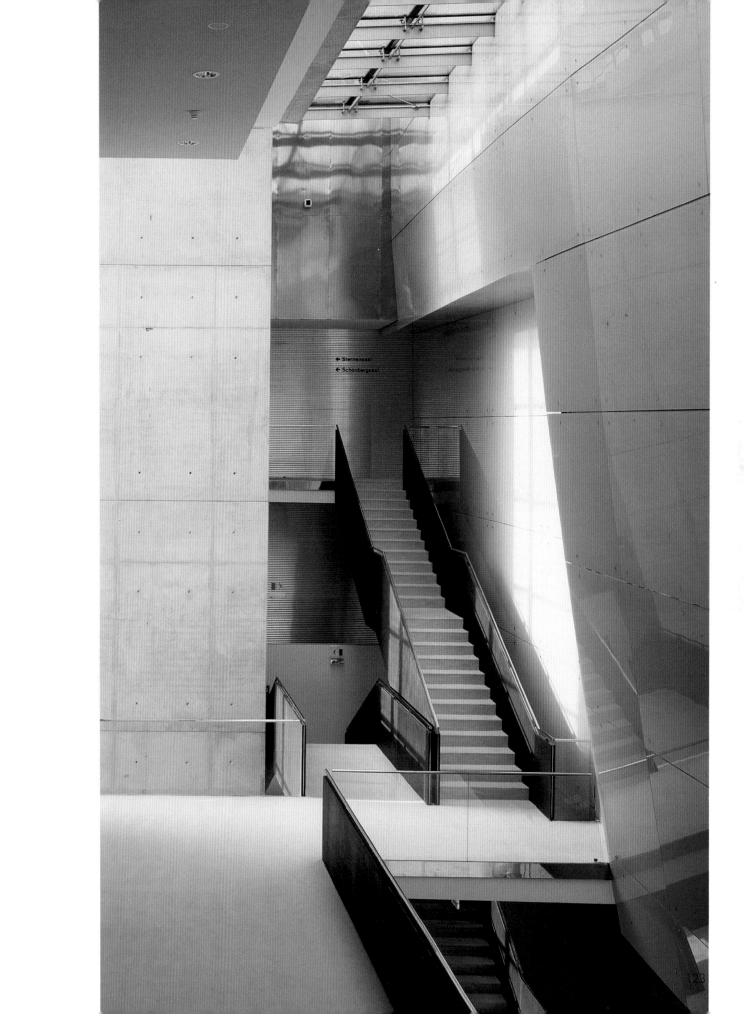

← Sternensaal
← Schönbergsaal

Berlin, Germany,
Norman Foster and Partners, 1999

Accessible Parliament

Reichstag Berlin

A synthesis of old and new, the Reichstag Parliament was revitalized with the future in mind. The old walls, burnt and scarred by dictatorship and war, and still bearing the Cyrillic graffiti Russian soldiers scrawled on them at the close of World War II, were retained as a massive hull surrounding the new plenar hall at the heart of the building. The mirror-clad tower at the center of the glass dome above reflects sunlight into the hall and acts as a natural ventilation chimney. A public panorama ramp wraps up around the glass dome to the popular observation platform high above the city.

Begehbares Parlament

Reichstag Berlin

Als Synthese aus Neu und Alt, aus Geschichte und Gegenwart entstand ein Parlamentsneubau mit Blick in die Zukunft. Die alten Gemäuer, vielfach verbrannt durch Diktatur und Krieg, wurden, mitsamt der kyrillischen Inschriften der russischen Soldaten, die sie gegen Kriegsende besetzten, als Hülle erhalten. Von diesen massiven Mauern geschützt liegt der Parlamentssaal im Herzen des Gebäudes. Der trichterförmige, mit beweglichen Spiegeln behängte, Turm in der gläsernen Kuppel führt Licht in den Saal und fungiert zugleich als natürlicher Entlüftungskamin. Um ihn herum schraubt sich die öffentliche Rampe zur beliebten Aussichtsplattform über der Stadt hoch.

Un parlement accessible

Le Reichstag de Berlin

Synthèse de l'ancien et du nouveau, le Reichstag a été rénové dans un esprit tourné vers le futur. Portant toujours les graffitis en cyrillique gribouillés par les soldats russes à la fin de la dernière guerre, les vieux murs, brûlés et marqués par le conflit et la dictature, forment une carcasse massive autour de la nouvelle salle plénière au cœur du bâtiment. La tour couverte de miroirs, au centre du dôme de verre de la coupole, réfléchit le soleil dans la salle et sert de cheminée de ventilation naturelle. Une rampe publique panoramique s'élève autour du dôme de verre, jusqu'au point de vue très prisé de la terrasse au-dessus de la ville.

Parlamento Accesible

Reichstag de Berlín

Este edificio del parlamento se creó con la mirada puesta en el futuro, como síntesis entre lo viejo y lo nuevo, entre la historia y el presente. Como cubierta se han conservado los viejos muros, quemados varias veces durante la dictadura y la guerra, y las inscripciones en escritura cirílica de los soldados rusos que ocuparon la ciudad durante el fin de la guerra. Estos muros protegen la sala del Parlamento, en el corazón del edificio. En la cúpula encristalada, la torre con forma de embudo y cubierta de espejos móviles conduce la luz hacia la sala y actúa también como chimenea de ventilación. La rampa pública asciende alrededor de la torre hasta el concurrido mirador.

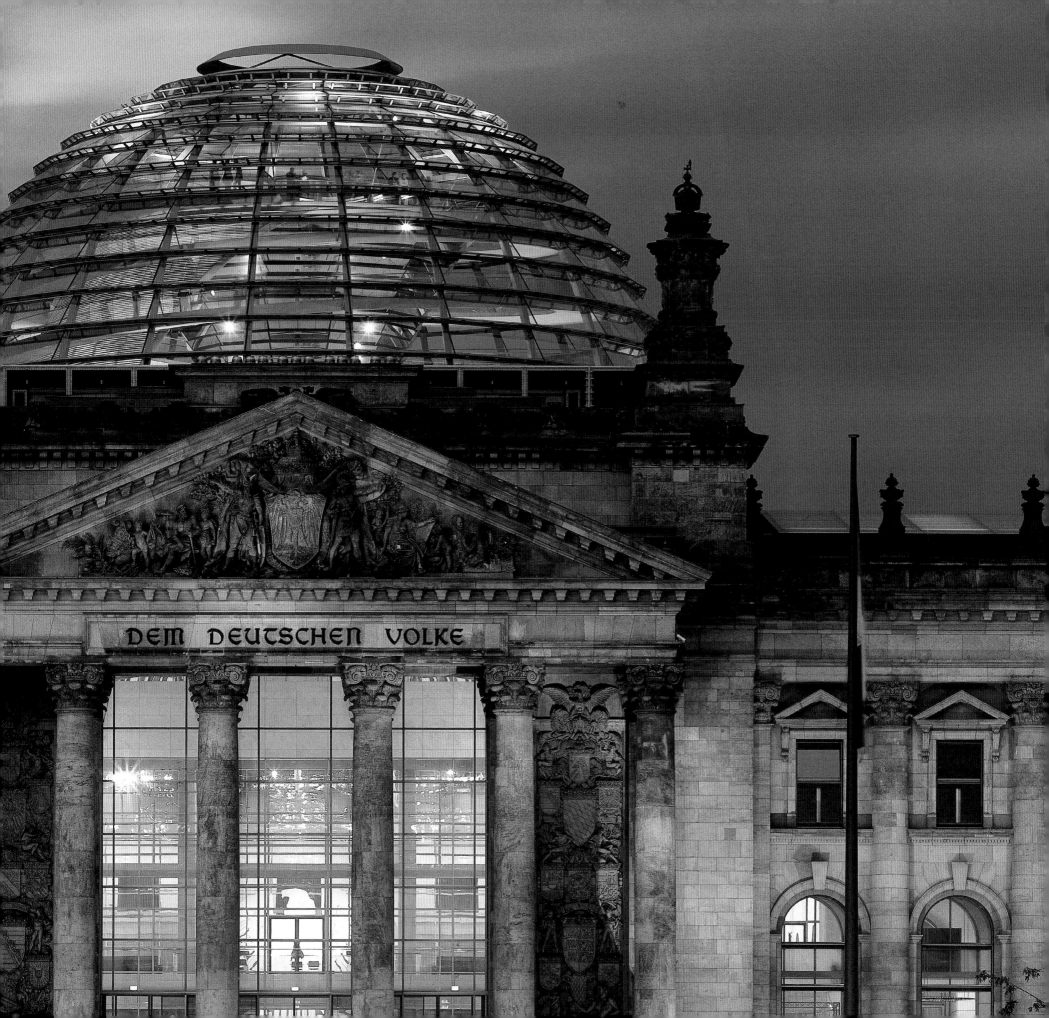

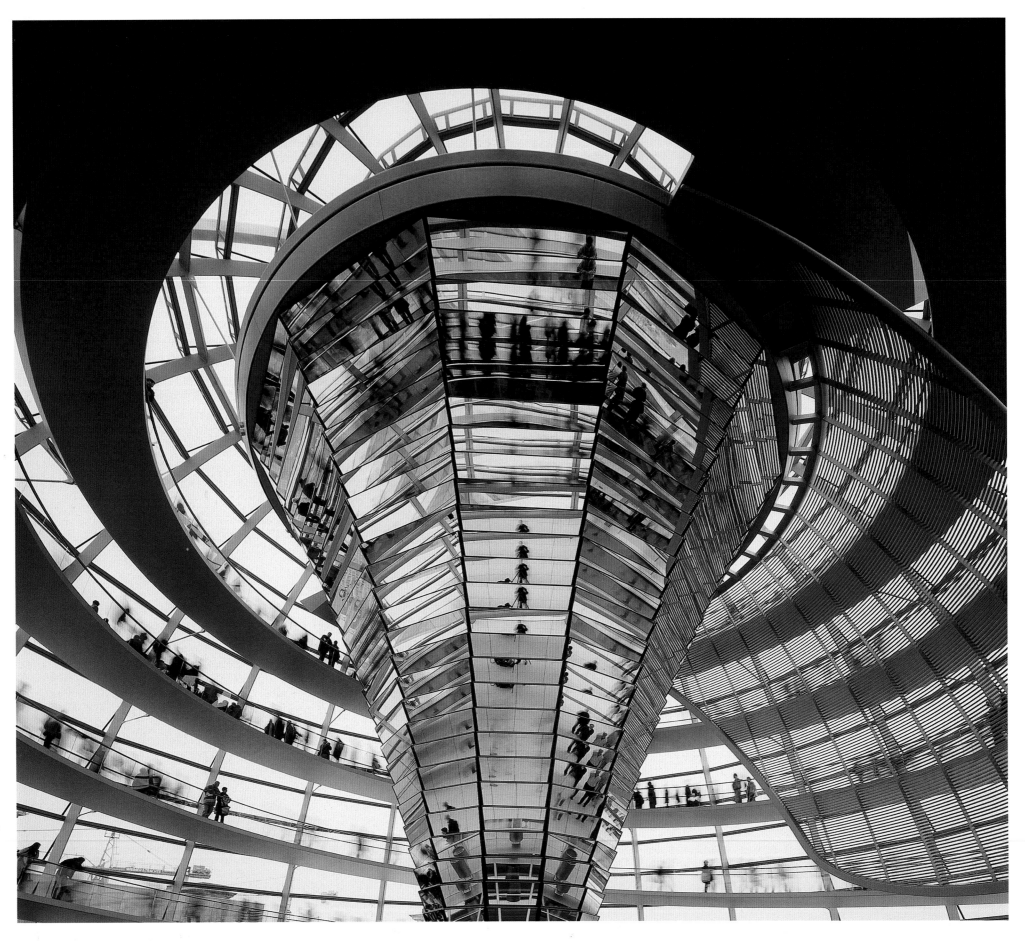

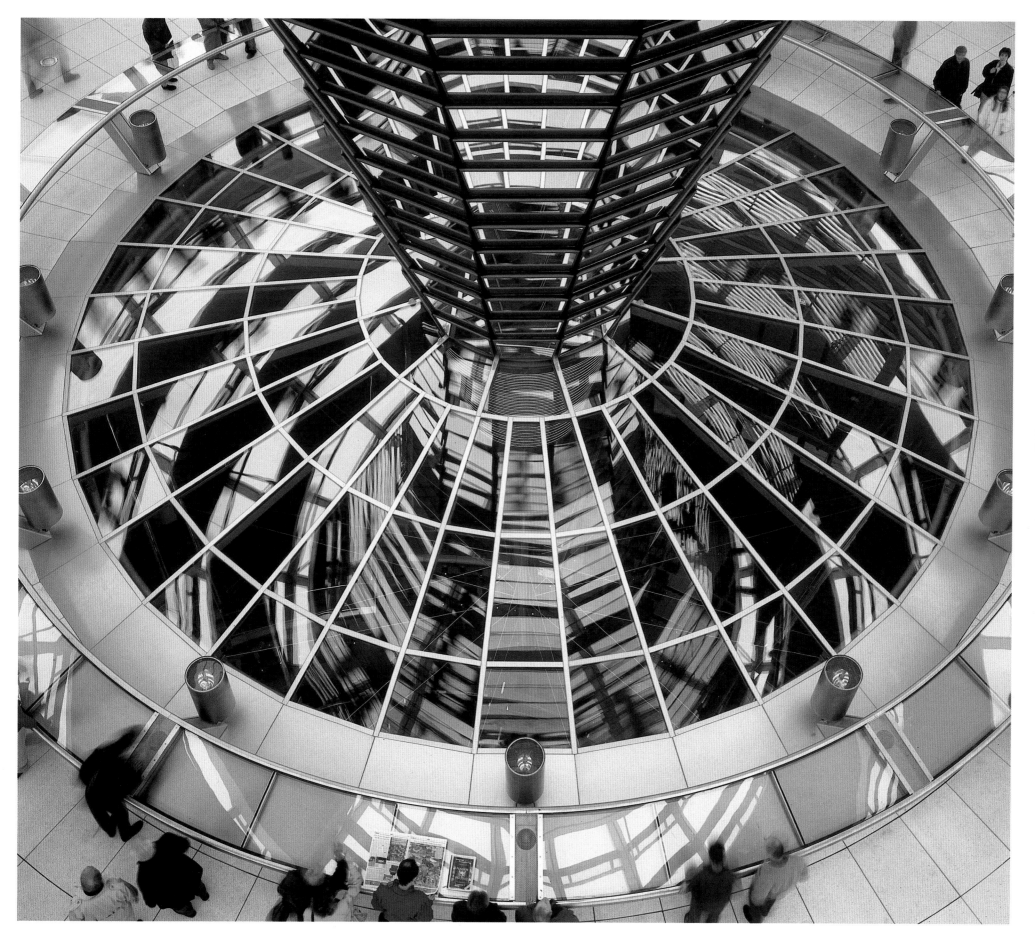

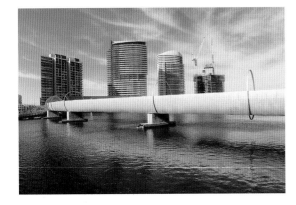

Melbourne, Australia,
Denton Corker Marshall,
Artist: Robert Owen, 2003

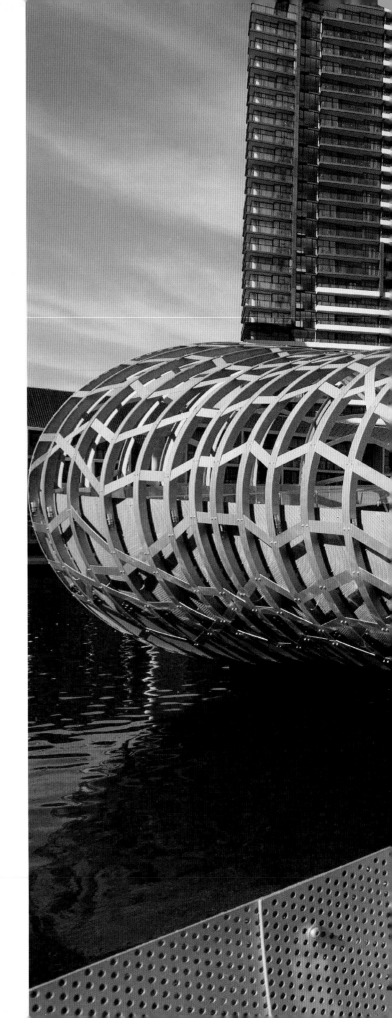

More than a Bridge

Webb Bridge

Melbourne's Docklands once ranked among the premier ports in the South Pacific. Their relocation allows the creation of a seaside extension of the city center. To ensure success for the new neighborhoods, much attention has been given to the bridges which connect the area with the vibrant downtown nearby. This project serves therefore not only as a mere urban connector for bikers and pedestrians, but as a place to meet others and to take a break from the daily routine. An existing rail bridge remnant was preserved, covered in metal, and integrated into the scheme. A new connecting segment winds its way to the bank like an eel.

Mehr als eine Brücke

Webb Bridge

Melbournes Docklands zählten einst zu den bedeutendsten Häfen im Südpazifik. Durch ihre Verlagerung wird in direkter Nachbarschaft zum Stadtzentrum Platz frei für ein neues Stadtquartier am Meer. Um das Gebiet für moderne Stadtbewohner attraktiv zu gestalten scheut man bei der Gestaltung der Verkehrsbauten keine Mühen. Diese Brücke fungiert nicht nur als Verbindungsweg für Fußgänger und Radfahrer, sondern auch als urbaner Treffpunkt und Aufenthaltsort. Das bestehende Fragment einer Eisenbahnbrücke wurde erhalten und in Metall eingehüllt. Das neue Verbindungssegment schlängelt sich aalförmig zum neuen Ufer.

Plus qu'un pont

Le Webb Bridge

Les docks de Melbourne comptaient jadis parmi les premiers ports du Pacifique Sud. Leur déménagement permet la création d'une extension du centre ville en bord de mer. Pour garantir le succès des nouveaux quartiers, une grande attention a été portée aux ponts qui relient cette zone au cœur trépidant de la ville. Ce projet sert ainsi non seulement de voie urbaine pour les piétons et les cyclistes, mais aussi de lieu de rencontre et de détente. Les vestiges d'un ancien pont ont été conservés, couverts de métal et intégrés dans le complexe. Une nouvelle bretelle de raccordement serpente comme une anguille vers le rivage.

Más que un Puente

Webb Bridge

Los Docklands de Melbourne eran antiguamente uno de los puertos más importantes del Pacífico sur. Su traslado deja libre un espacio cerca del centro de la ciudad que permitirá la construcción de un barrio a orillas del mar. Para atraer a los ciudadanos se ha puesto mucha atención en el diseño de los puentes que conectan este área con el vibrante y cercano centro. Estas construcciones no son sólo caminos para los peatones y las bicicletas, también actúan como punto de encuentro urbano y lugar de descanso. Se conservó un trozo del puente ferroviario todavía existente y se cubrió con metal. El nuevo puente serpentea hasta la nueva orilla como una anguila.

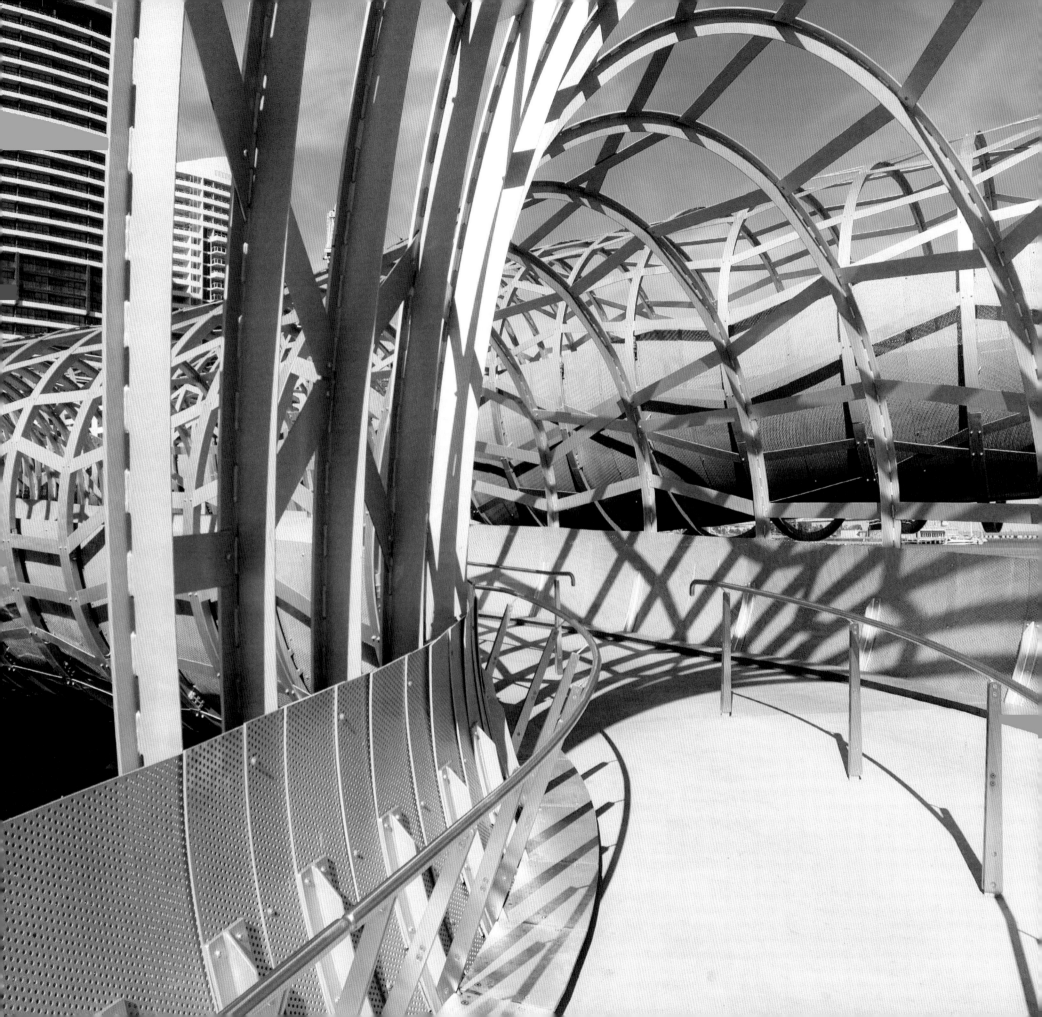

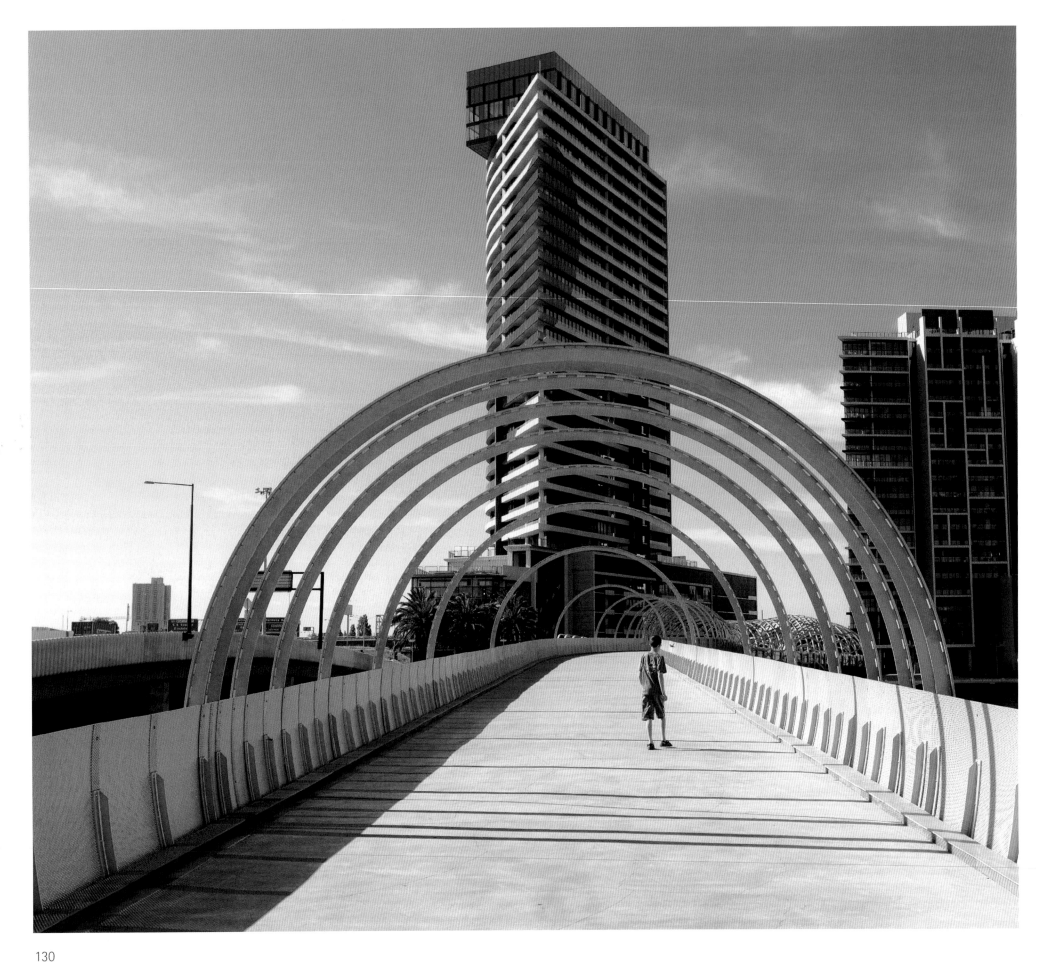

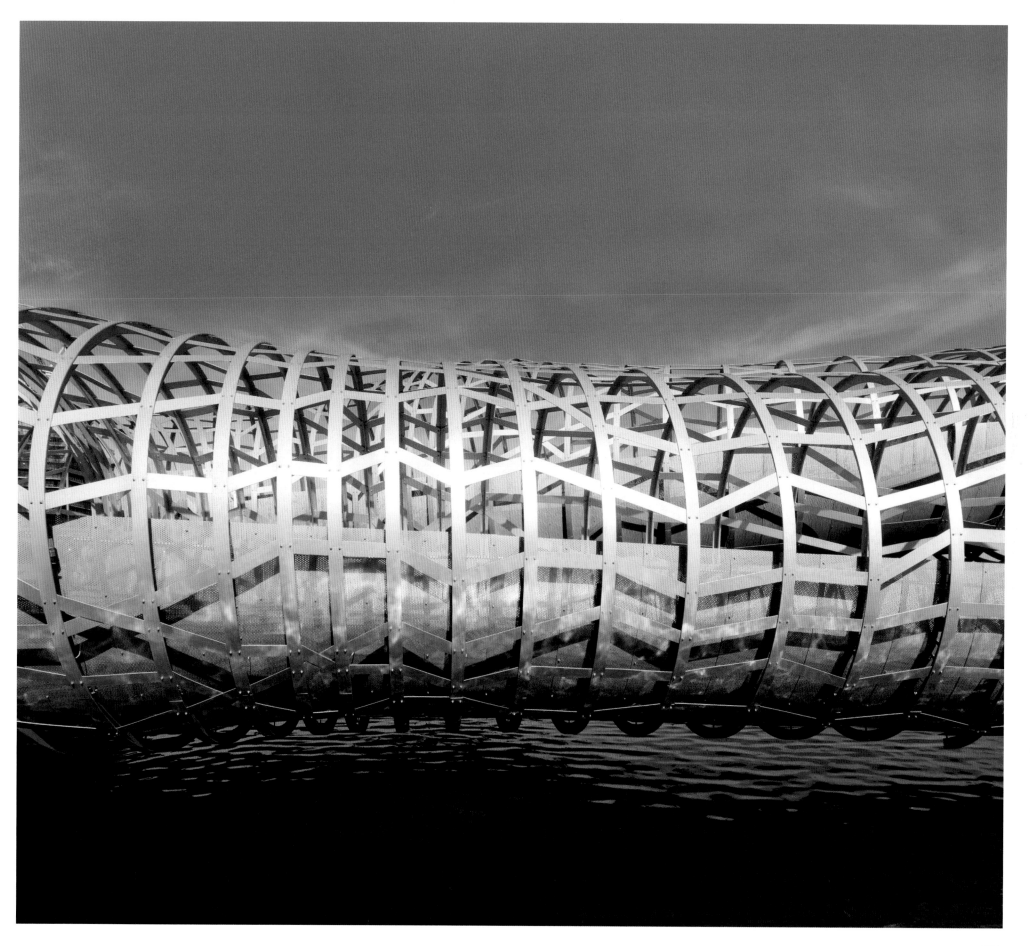

Laguardia, Alava, Spain,
Santiago Calatrava, 2001

Mountains on the Plain

Winery Complex

This singular site, on a vast plain at the foot of a mountain range, inspired the building composition which translates the landscape into architectural form. Emulating the nearby mountains, the undulating, wooden clad walls of the building rise from the ground plane while the shiny metal roofs mirror the snow-covered ridges beyond. The side wings of the complex contain storage areas where the wine ages in oak casks. The articulated central hall celebrates the main space where wine tasting occurs. The building is at one with the landscape and at the same time creates a striking landmark for the successful winery.

Gebirgskette in der Ebene

Weingut

Die einmalige Lage – eine weite Ebene zu Füßen einer Bergkette – inspirierte zu einer Bauplastik, die die Landschaft in Architektur übersetzt. Gleich einem Höhenzug erhebt sich der Bau aus der Erdoberfläche. Gewellte Holzwände setzen die erdige Farbigkeit des Geländes um. Die metallenen Dächer hingegen spiegeln die schneebedeckte Gipfelkette wider. In den seitlichen Flügeln wird der Wein in Eichenfässern gelagert. Das erhöhte Mittelresalit markiert einen öffentlichen Innenraum und zelebriert den Akt der Weinprobe. Ein Bau, der sich in die Landschaft integriert und zugleich zum markanten Wahrzeichen wird.

Montagnes sur la plaine

Complexe vinicole

Ce site original, dans une vaste plaine située au pied d'une chaîne de montagnes, a inspiré la composition du bâtiment, qui traduit le paysage en une forme architecturale. Imitant les montagnes voisines, ses murs ondulants tapissés de bois s'élèvent du niveau du sol, tandis que les toits de métal brillant reflètent les crêtes enneigées. Les ailes latérales du complexe contiennent des entrepôts où le vin vieillit en fûts de chêne. Le hall central articulé met en valeur l'espace principal où l'on goûte le vin. Le bâtiment est en harmonie avec le paysage tout en créant un splendide monument dans la florissante entreprise vinicole.

Cadena Montañosa en la Llanura

Explotación Vitivinícola

Esta localización única, una extensa llanura a los pies de una cadena montañosa, inspiró la construcción de este complejo que traduce el paisaje en arquitectura. Las paredes onduladas de madera continúan el colorido terroso del paisaje. Los tejados metálicos, en cambio, reflejan las cumbres nevadas de las montañas. En las alas laterales se almacena el vino en barricas de roble. El elevado cuerpo central aloja un espacio interior público y en él se celebra la cata de los vinos. Una construcción integrada en el paisaje pero que, al mismo tiempo, se ha convertido en una destacada referencia en la producción del vino.

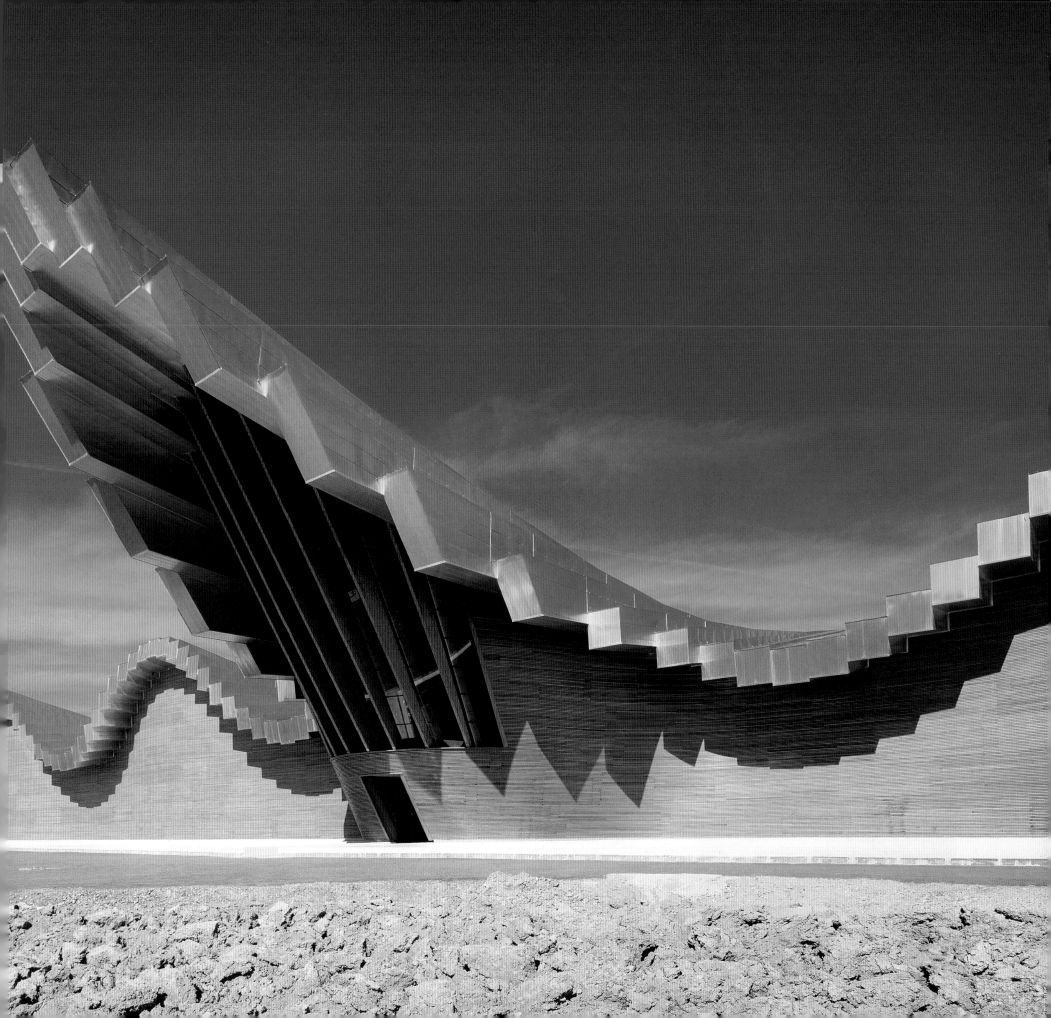

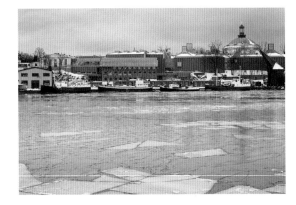

Stockholm, Sweden,
José Rafael Moneo, 1998

Tradition and Modernism

Moderna Museet

To weave the building mass into the historic city fabric the program was dispersed into individual, connected houses". Their characteristic pyramid shaped metal roofs skillfully direct natural light into the exhibition spaces while complementing the domes and spires of the old-town skyline. In another effort to integrate with the historic surroundings, stucco was chosen for all the wall surfaces. The warm terracotta tone on the exterior forms a striking contrast to the radiant white interior exhibition spaces, where one of the world's most significant collections of modern art is displayed.

Tradition und Moderne

Moderna Museet

Aus Respekt vor der historischen Innenstadt wurde die Baumasse in miteinander verbundenen Einzelbaukörpern untergebracht. Als charakteristisches Merkmal sind diese mit pyramidenförmigen Metalldächern versehen, deren Laternen das natürliche Licht von oben in die Ausstellungssäle leiten und die Stadtsilhouette mit ihren Kuppeln und Turmspitzen nahtlos ergänzen. Als weitere Referenz zur Bautradition der Stadt wurde der Bau mit Putz versehen. Der warme Terrakottaton der Außenfronten kontrastiert wirkungsvoll mit dem leuchtenden Weiß der Säle, in denen eine der bedeutendsten Sammlungen moderner Kunst präsentiert wird.

Tradition et Modernité

Moderna Museet

Pour intégrer la masse du bâtiment dans le tissu de la ville historique, le projet a été dispersé en « maisons » individuelles communicantes. Leurs toits métalliques, à la forme pyramidale caractéristique, attirent adroitement la lumière vers les espaces d'exposition, tout en agrémentant les dômes et les flèches de la ligne des toits de la vieille ville. Pour parachever l'intégration dans le quartier historique, chaque mur est revêtu de stuc. La chaude tonalité terracotta de l'extérieur forme un contraste saisissant avec les espaces d'exposition intérieurs d'un blanc éclatant, abritant une des plus grandes collections d'art moderne du monde.

Tradición y Modernidad

Moderna Museet

Para respetar el centro histórico de la ciudad, el cuerpo de la construcción se dispuso en cuerpos individuales unidos entre sí. El rasgo característico son los tejados metálicos con forma piramidal y acabados en linternas que dirigen la luz natural desde arriba hasta las salas de exposiciones. Estos edificios, con sus cúpulas y terminaciones en forma de torres, complementan la silueta de la ciudad. Otra referencia a la tradición constructora de la ciudad es el revoque de los edificios. El cálido color terracota de los frentes exteriores contrasta de forma llamativa con el blanco reluciente de las salas, en las que se muestra una de las más importantes colecciones de arte moderno.

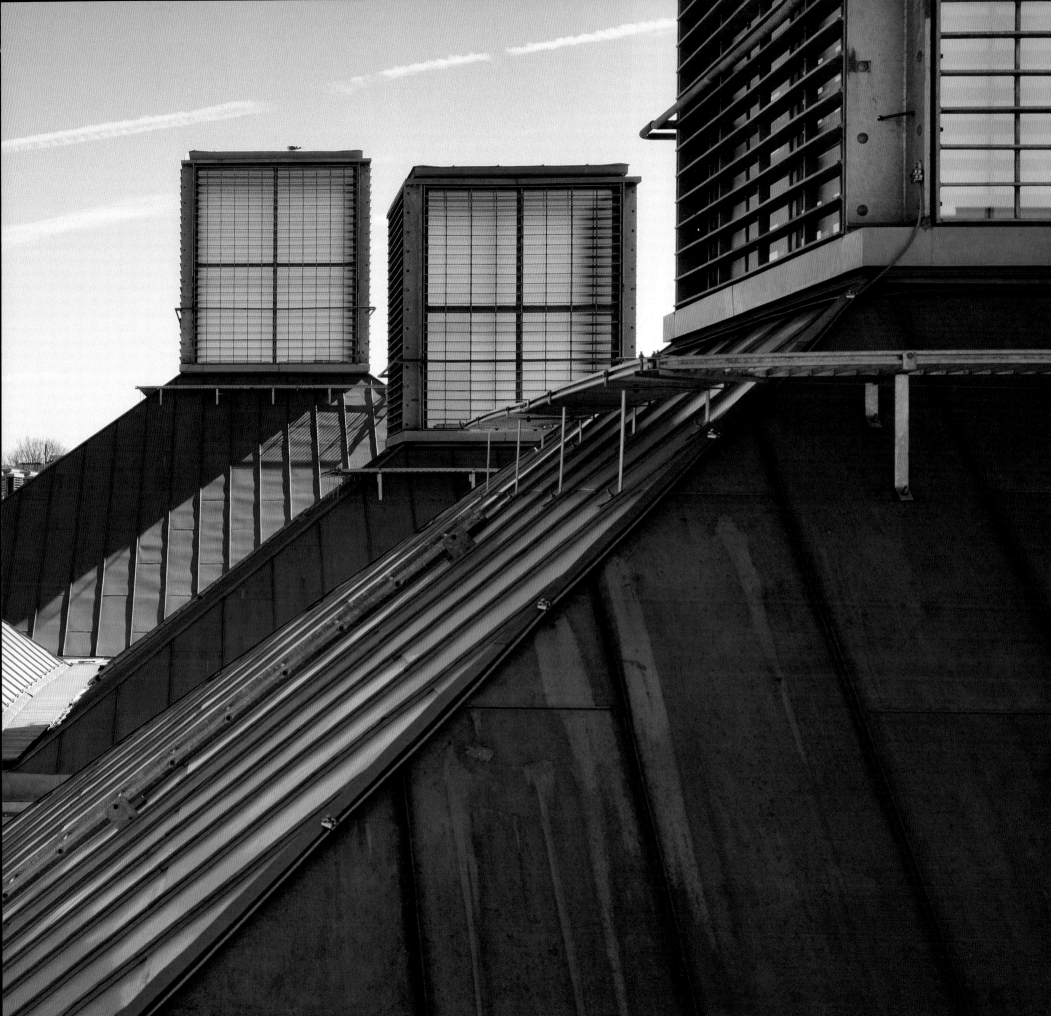

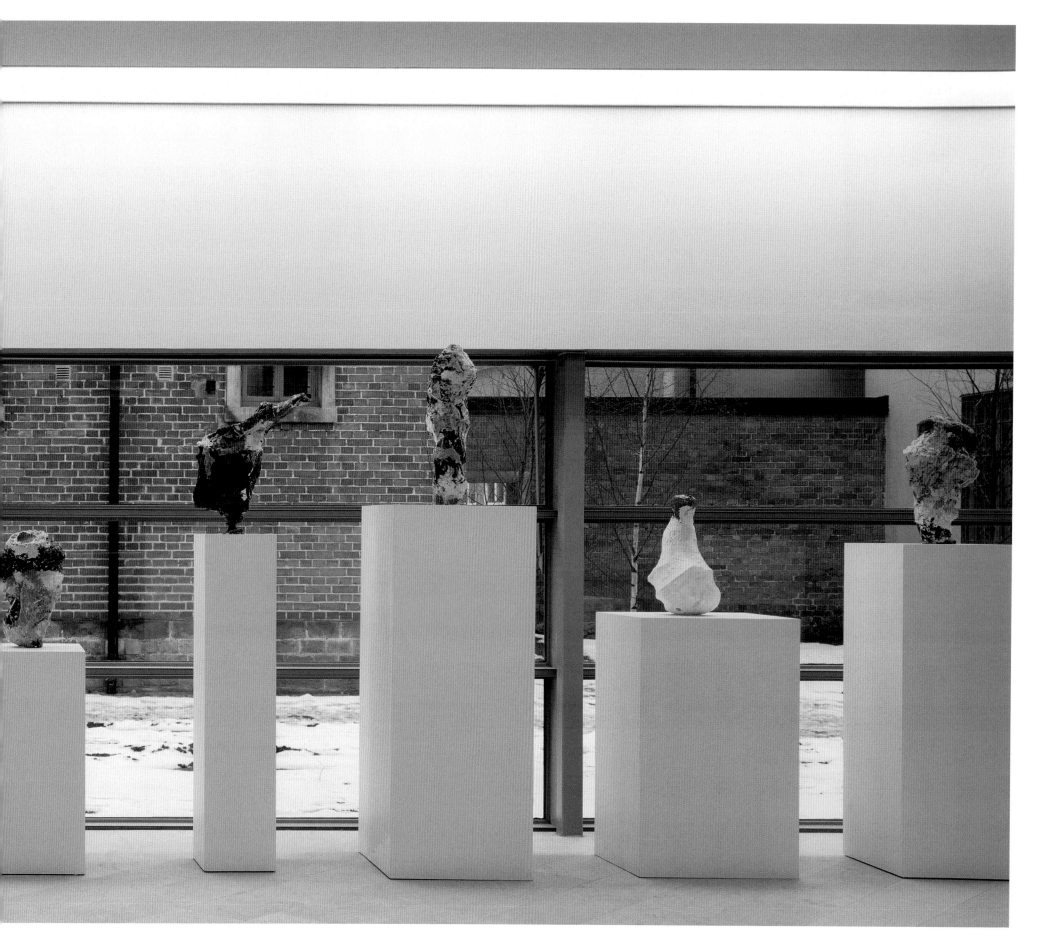

Tokyo, Japan,
Renzo Piano Building Workshop, 2001

Glass Slab

Hermès Building

The Ginza, Tokyo's top shopping district, has always been a place to marvel and take in the newest attractions. In marked contrast to its flashy neon surroundings the Hermès flagship store is an exercise in understatement. A building-high, earthquake-resistant, cloak of glass block creates a mysteriously glowing hull that, like the make-up of a Geisha, conceals and at the same time provokes to discover what lies hidden behind. At night, the 11-story glass tower turns into a glowing urban lantern reminiscent of the paper lanterns found all around Japan.

Gläserne Scheibe

Hermès-Firmengebäude

Die Ginza, Tokios vornehmes Einkaufsviertel, war immer schon ein Ort des Staunens und der Attraktionen. Als Gegenbild zur Neonflut der Umgebung versah man den Flagship-Store von Hermès gebäudehoch mit einer erdbebensicheren Hülle aus Glasbausteinen. Das feine Raster der Steine und die optische Verzerrung schaffen eine mysteriöse Hülle, die ähnlich der Schminke einer Geisha vieles verbirgt, aber auf das Verborgene neugierig macht. Bei Einbruch der Dunkelheit verwandelt sich die 11-geschossige, gläserne Scheibe in eine leuchtende Stadtlaterne, die Assoziationen an die in Japan allerorts präsenten Papierlaternen weckt.

Bloc de verre

Le bâtiment Hermès

Le Ginza, le quartier commercial principal de Tokyo, a toujours été un endroit étonnant, adoptant les dernières attractions. Contrastant nettement avec les bâtiments environnants aux néons clinquants, la boutique-phare d'Hermès est un modèle de discrétion. Un bloc de verre, résistant aux tremblements de terre et couvrant la hauteur du bâtiment, crée un mystérieux revêtement brillant. Tel le maquillage d'une geisha, il dissimule tout en incitant à découvrir ce qui se cache derrière. La nuit, les onze étages de la tour de verre se changent en lanterne urbaine incandescente, rappelant les lanternes de papier omniprésentes au Japon.

Losa de Cristal

Edificio de la Empresa Hermès

Ginza, el barrio de compras más elegante de Tokio, siempre ha sido un lugar para el asombro y las atracciones. En contraste con las luces de neón de su entorno, el edificio bandera de Hermès ha sido dotado en su totalidad de una cubierta de ladrillos de vidrio resistentes a los terremotos. La fina trama de los ladrillos y la deformación óptica crean una envoltura misteriosa que, como el maquillaje de una geisha, esconde muchas cosas a la vez que despierta la curiosidad por lo ocultado. Con la oscuridad, esta losa encristalada de once pisos se convierte en un farol urbano, reminiscencia de los siempre presentes farolillos de papel japoneses.

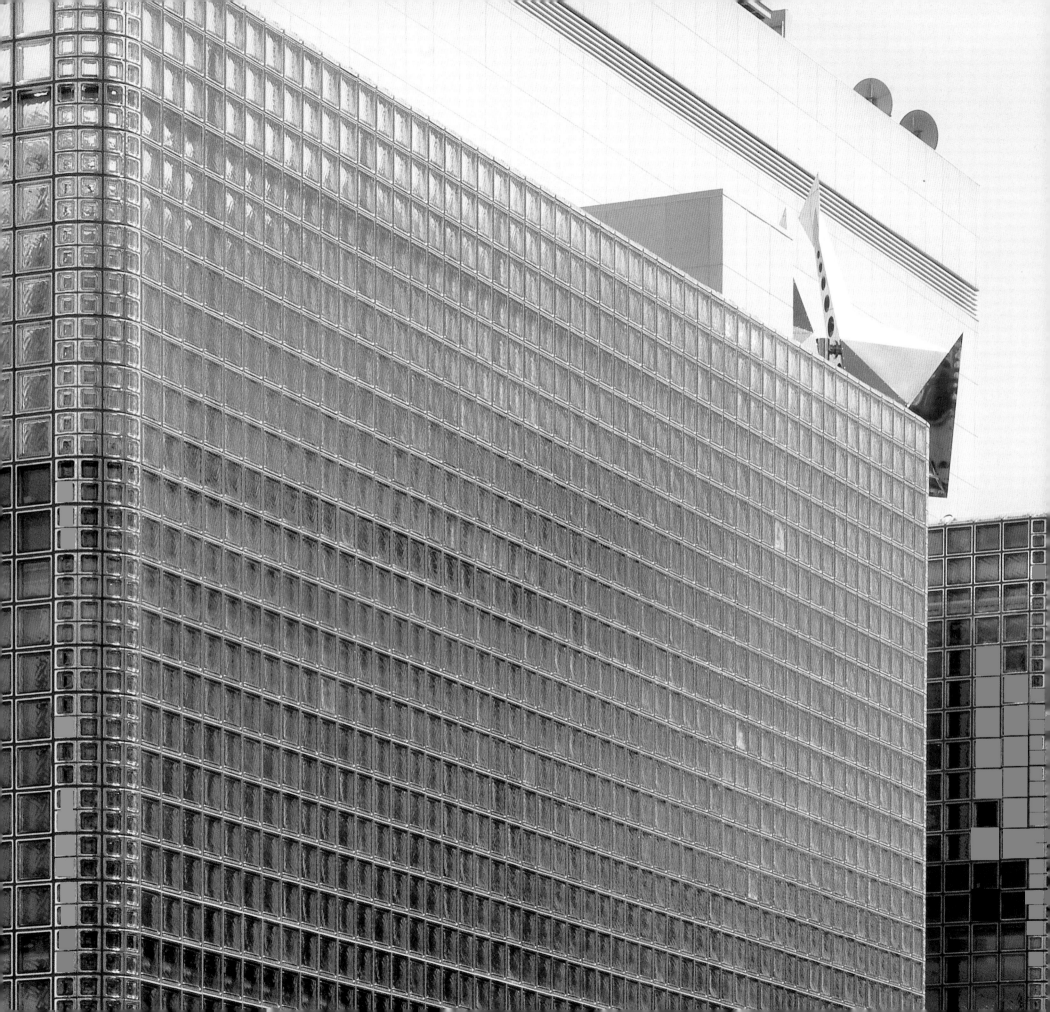

The Art of Collecting

Schaulager® – Emanuel-Hoffmann-Stiftung

New building types are rarely developed. But the idea of creating accessible storage for 650 works from the overflowing Basel Museum of Contemporary Art produced this exciting one. The building hulk makes its stand at the edge of town. The white entrance side shines invitingly, a house-like pavilion marks the entrance and extends the scale of the neighborhood into the museum. Inside, the 28 meter high atrium is a dramatic spatial surprise. The lower two floors are open to the public and contain changing exhibitions. The upper floors are for permanent storage and are accessible to staff and art historians. The structure is a contemporary monument to art collecting.

Kunst des Sammelns

Schaulager® der Emanuel-Hoffmann-Stiftung

Selten wird ein neuer Bautypus erfunden. Umsomehr überrascht die Idee, die 650 Kunstwerke, die im Stammhaus des Baseler Museums für Gegenwartskunst keinen Platz mehr finden, offen zu deponieren. Der wuchtige Korpus stellt sich zunächst als erdiges Solitär an der Stadt-Peripherie auf. Die Eingangsseite strahlt in Weiß, davor greift ein Steinhaus die Siedlungshäuser der Umgebung auf. Überwältigend öffnet sich über einem das 28 m hohe Atrium. Im öffentlichen Erd- und Untergeschoss finden Wechselausstellungen statt. Auf den drei, Fachpersonal zugänglichen, Obergeschossen lagert die Kunst. Ein zeitgenössisches Monument des Kunstsammelns.

L'art de la collection

L'entrepôt de l' Emanuel-Hoffmann-Stiftung

Il est rare de construire de nouveaux types de bâtiment. Mais l'idée de créer un entrepôt pour 650 œuvres du Musée d'Art Contemporain saturé de Bâle a fait naître cet édifice passionnant en bordure de la ville. Un pavillon, tel une petite maison, marque l'entrée, prolongeant l'échelle du quartier dans le musée. À l'intérieur, la pièce centrale de 28 m de haut est une surprise spatiale spectaculaire. Les deux premiers niveaux, accessibles au public, accueillent des expositions temporaires. Les niveaux supérieurs, abritant l'entrepôt, sont réservés aux historiens d'art et au personnel. L'édifice est un monument contemporain à la collection des œuvres d'art.

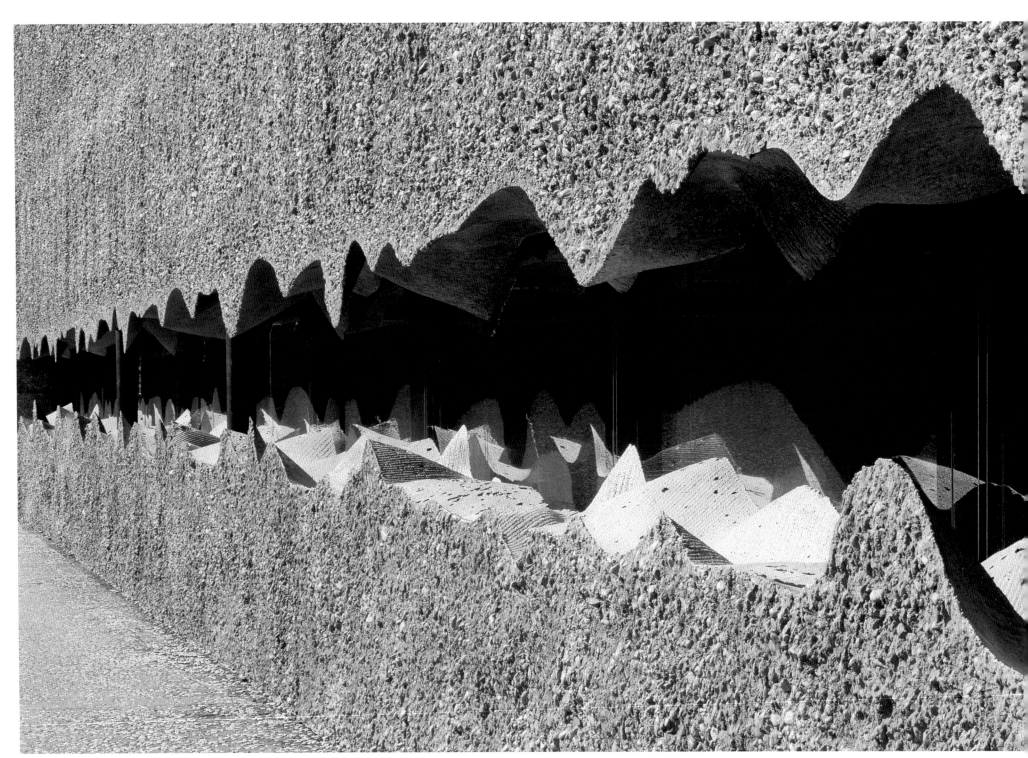

El Arte del Coleccionismo

Depósito de la Emanuel Hoffmann Stiftung

Raramente se inventan nuevos tipos de edificios. Por eso sorprendió la idea de crear un depósito abierto al público con las 650 obras de arte que no cabían en el Museo de Arte Contemporáneo de Basilea. El macizo edificio marrón está sólo en la periferia de la ciudad. El blanco brilla en el lado de la entrada y, ante él, una casa de piedra imita las de las urbanizaciones colindantes. Dentro, el atrio resulta abrumador con sus 28 m de altura. Las dos primeras plantas están abiertas al público y albergan las exposiciones temporales. A los tres pisos superiores, donde se almacenan las obras, sólo tiene acceso el personal. Un monumento actual del arte del coleccionismo.

Basel, Switzerland, Herzog & de Meuron, 2003

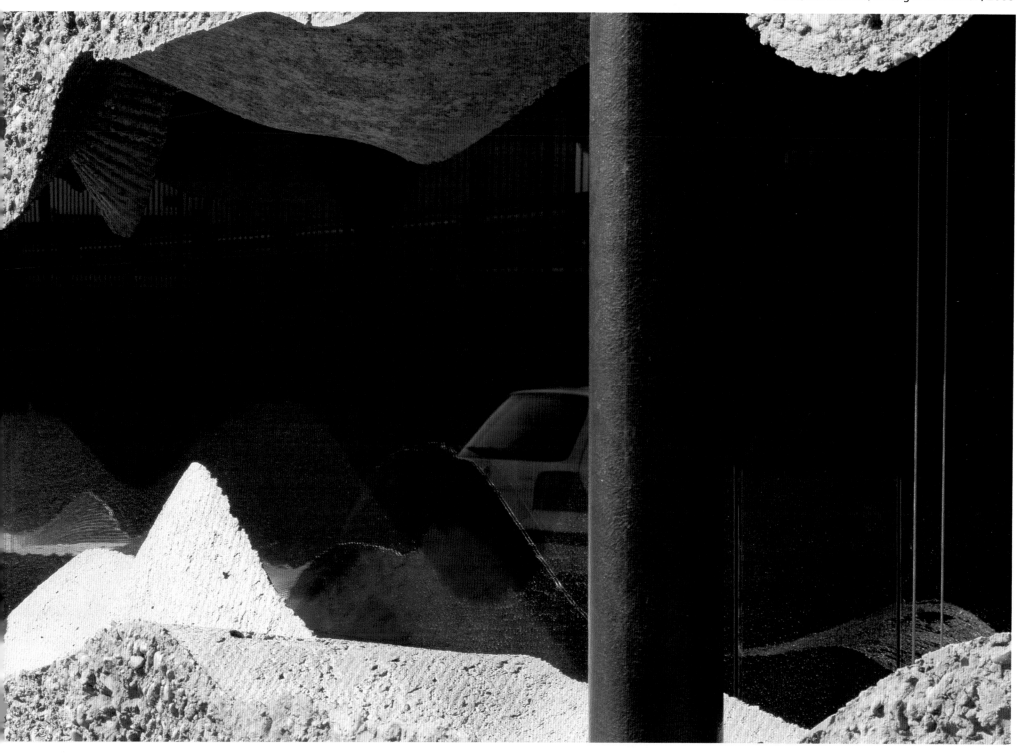

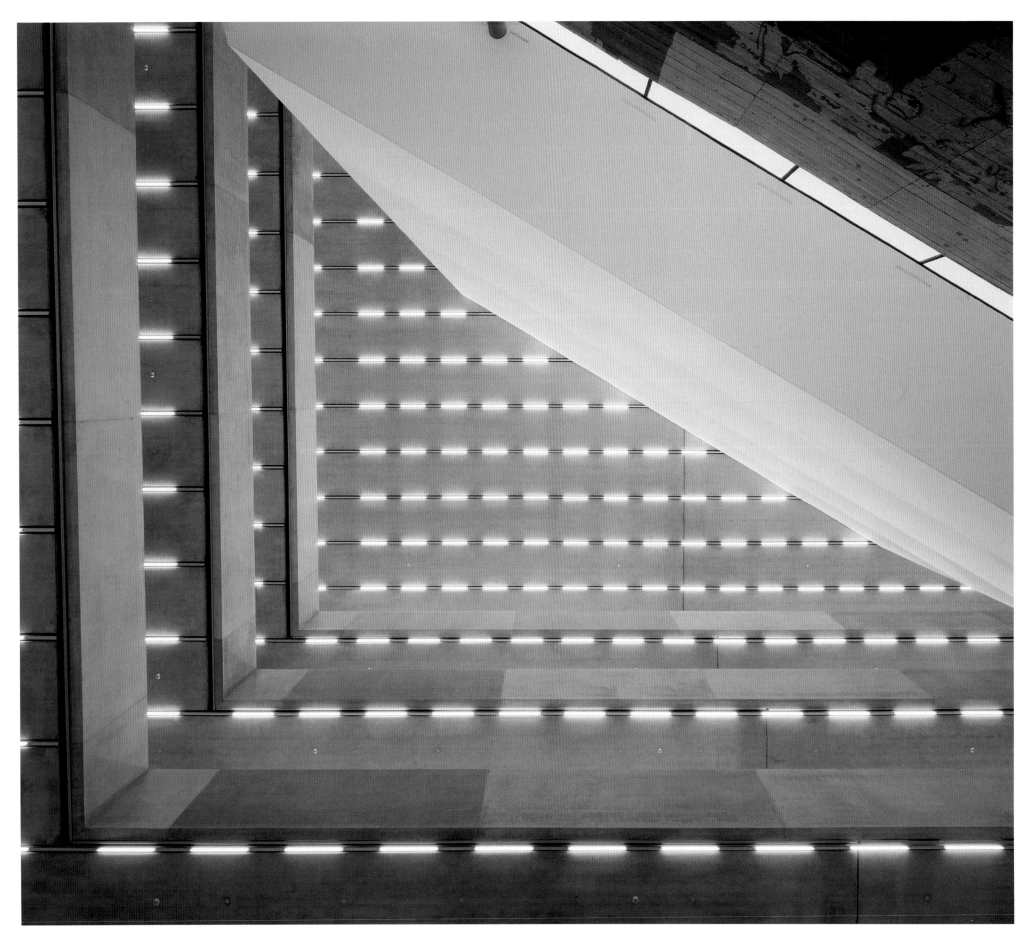

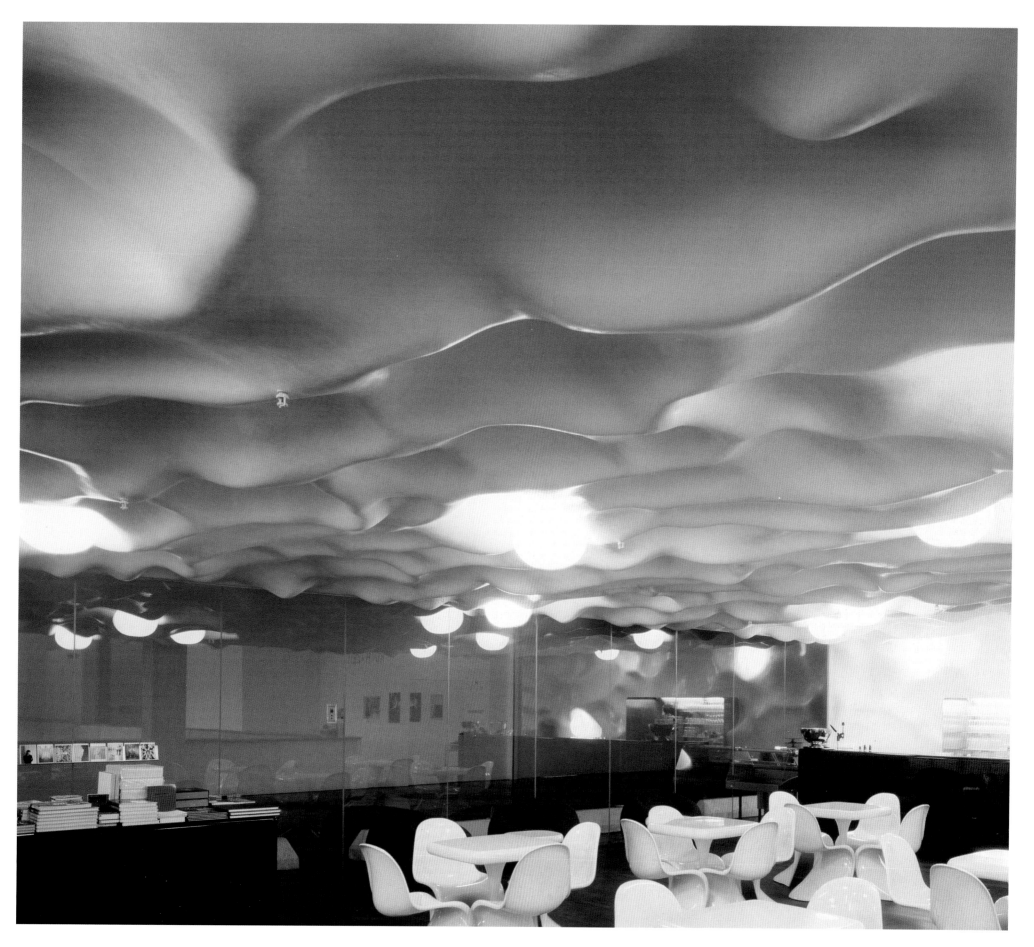

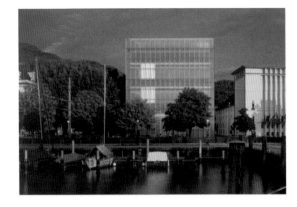

Bregenz, Austria, Peter Zumthor, 1997

The Cube Next Door

Bregenz Art Museum

Any new museum building for contemporary art stands under a certain pressure to pose a stark contrast with its context. This structure achieves that goal through a radical reduction of form. At first sight every design aspect appears to be permeated by a relentless Minimalism. But closer inspection reveals that pure logic and vivid emotion are skillfully played against each other here. The shimmering scales of opaque glass, which enclose the concrete cube, create a surreal, floating quality. Glass panels hung from the ceilings evenly distribute the light from the building edge and let the art on display stand self-aware in the foreground.

Der Würfel nebenan

Kunsthaus Bregenz

Ein neues Haus für zeitgenössische Kunst steht unter einem gewissen Zwang, sich von der historischen Umgebung abzusetzen. Das Kunsthaus scheint auf den ersten Blick von einem nicht mehr zu übertreffenden Minimalismus durchdrungen zu sein. Doch schon die schimmernde Schuppenhaut aus Milchglas verlässt die reine Logik. Sie dient primär dazu, den Kubus irreal erscheinen zu lassen, auch um die eigentlichen Saalwände aus Sichtbeton optisch aufzuweichen. Abgehängte Glaspanele an den Decken verteilen das eingefangene natürliche Licht und lassen die Kunst wie selbstverständlich hervortreten.

Le cube d'à côté

Le musée d'art de Bregenz

Tous les nouveaux musées d'art contemporain sont soumis à une certaine pression pour offrir un net contraste avec leur environnement. Ce bâtiment y parvient par une réduction radicale de la forme. À première vue, chaque aspect de la construction a l'air imprégné d'un minimalisme implacable. Mais un examen plus fouillé révèle la présence d'un dialogue ingénieux entre l'émotion vivante et la logique pure. Les reflets chatoyants du verre opaque, entourant le cube de béton, créent une ambiance fluctuante surréaliste. Des panneaux de verre suspendus au plafond distribuent uniformément la lumière et mettent en valeur les œuvres exposées au premier plan.

El Cubo de al lado

Museo de Arte Bregenz

Cualquier museo nuevo de arte contemporáneo sufre en cierto modo la presión de tener que distanciarse de su entorno histórico. A primera vista, este edificio parece estar caracterizado por un minimalismo difícil de superar. Sin embargo, un análisis más detenido revela una brillante piel escamosa de vidrio opalino que supera toda realidad. Este recubrimiento le da al cubo una apariencia irreal y a las verdaderas paredes de las salas, de hormigón liso, un aspecto reblandecido. Los paneles de cristal suspendidos en los techos distribuyen la luz natural que en ellos se refleja y sitúan el arte en el primer plano de una forma natural.

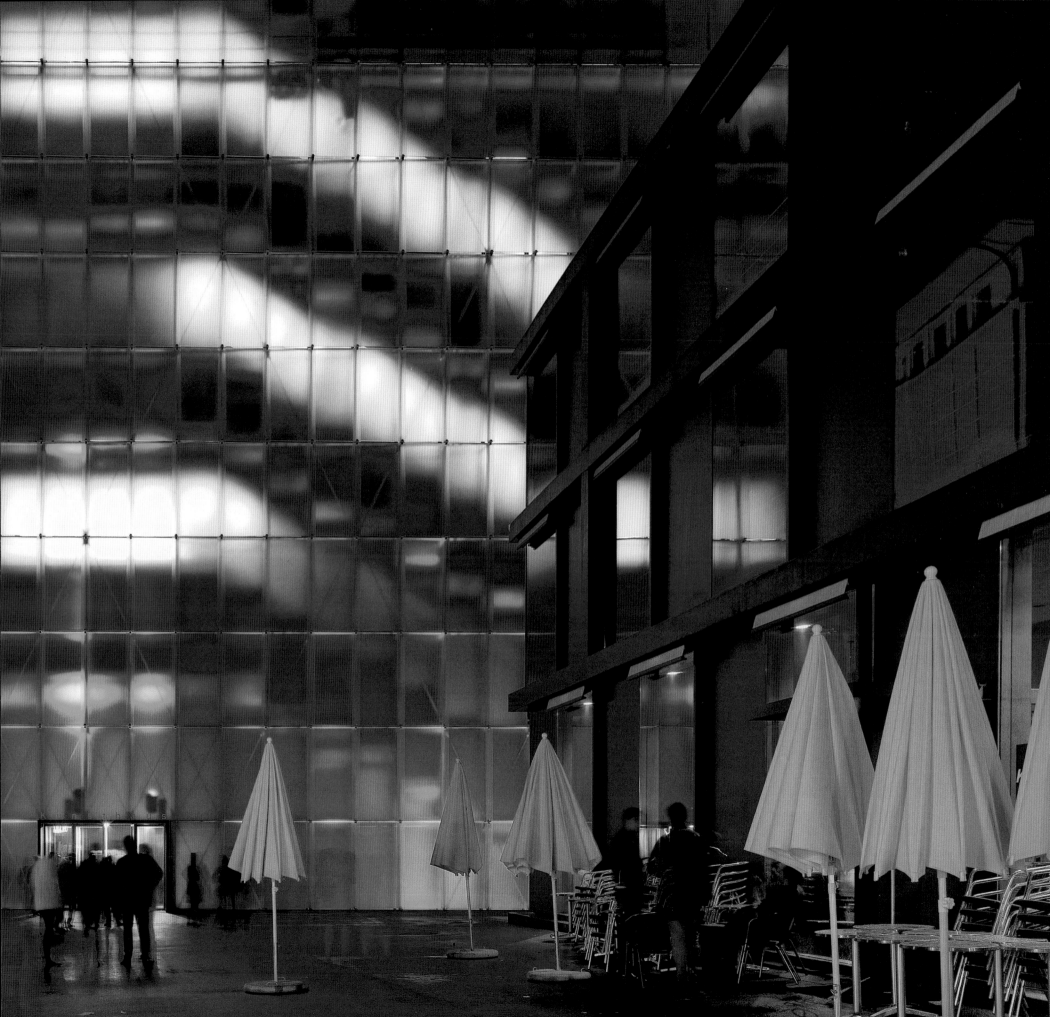

Berlin, Germany,
Dominique Perrault,
APP Architekten, 1997

Extraterrestrial Visit

Velodrome and Swim Center

Lakes outside town led to envisioning the buildings as bodies of water in the midst of the city. Sloping embankments rise to create a generous park plateau. The hovering building masses are embedded in crater-like depressions and seem to hang from the heavens. This ephemeral quality is heightened by the changing light reflections on the metal-net building skin. The entrances are reached through a colonnade that directly accesses a busy commuter train station. The cool ambience is brought inside via the gray color tones of the floor surfaces, the exposed concrete of the galleries and the steel trusses of the cycling arena and swimming stadium.

Extraterrestrischer Besuch

Radsport- und Schwimmhalle

Die Seen rund um die Stadt inspirierten dazu, die Gebäude als glänzende Seen inmitten des Häusermeers aufzufassen. Böschungen lassen eine großzügige Parklandschaft entstehen, in deren kraterartigen Mulden die Bauten schwebend lagern, als wären sie vom Himmel abgehängt. Ein Eindruck von Immaterialität, der durch die changieren den Lichtreflexe auf den mit Metallgewebe verhängten Hüllen verstärkt wird. Die Eingänge erreicht man über eine Kolonnade, die einen direkten Anschluß zum angrenzenden S-Bahnhof herstellt. Das kühle Ambiente setzt sich im Inneren bei dem anthrazitfarbenen Fußboden, dem Beton der Galerien und den Stahlträgern der Hallendächer fort.

Visite extraterrestre

Vélodrome et centre de natation

Des lacs extérieurs à la cité ont mené à concevoir les bâtiments comme des plan d'eau au milieu de la ville. Des talus s'élèvent pour créer un vaste parc en plateau. Les masses des bâtiments, qui semblent suspendues au ciel, sont encastrées dans des dépressions pareilles à des cratères. Cette impression d'éphémère est accentuée par les reflets changeants de la lumière sur le revêtement métallique du bâtiment. Les entrées se font par une colonnade accèdant directement à une gare de banlieue animée. À l'intérieur, l'atmosphère de froideur est créée par les sols gris, le béton exposé des galeries et les armatures en acier du stade de natation et du vélodrome.

Visita Extraterrestre

Velódromo y piscinas cubiertas

Los lagos alrededor de la ciudad inspiraron la construcción de estos edificios como brillantes lagos en medio del mar de casas. Los arbustos se convertirán en un gran parque y en las hondonadas, similares a cráteres, los edificios descansan flotantes como si se hubieran descolgado del cielo. La sensación de inmaterialidad se refuerza con los cambiantes reflejos de la luz sobre la piel metálica de los cuerpos. Una columnata lleva hasta las entradas y, además, es un acceso directo a la cercana parada del tranvía. La fría atmósfera continúa en el interior con los suelos de color antracita, el hormigón de las galerías y la estructura de acero de los techos.

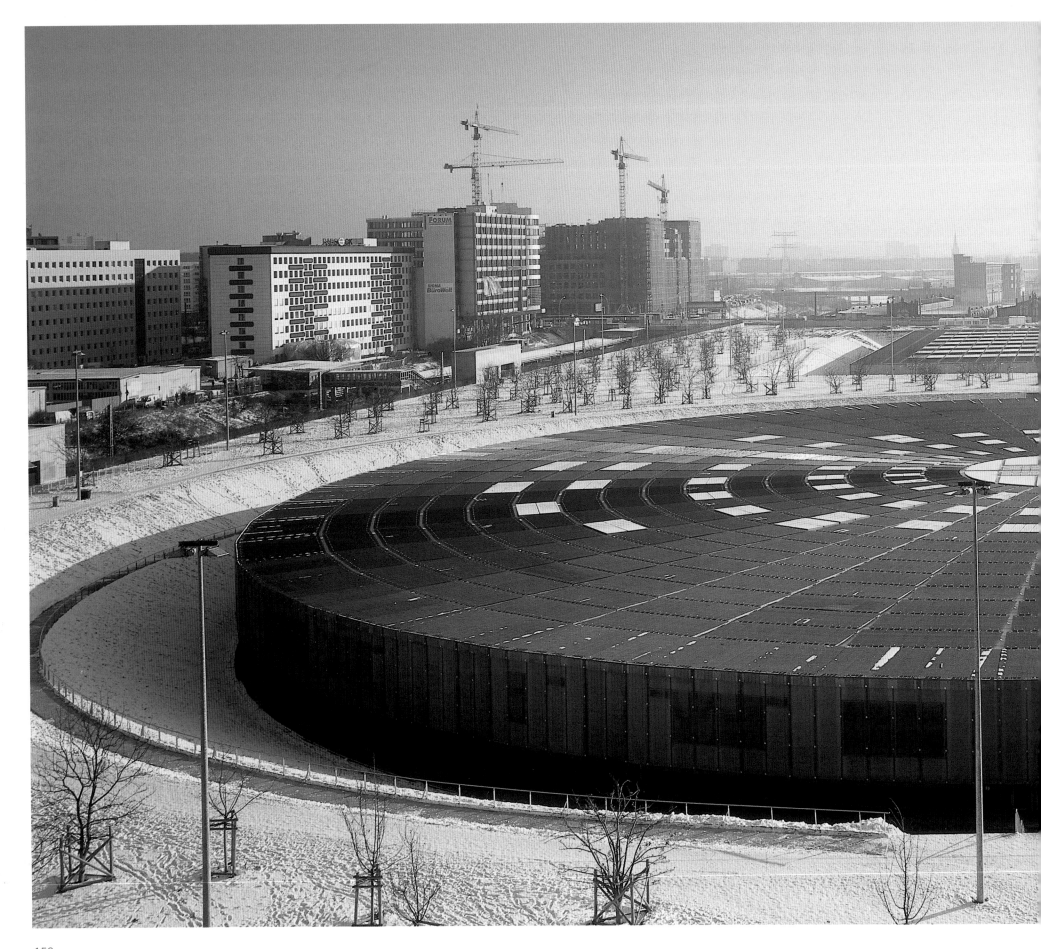

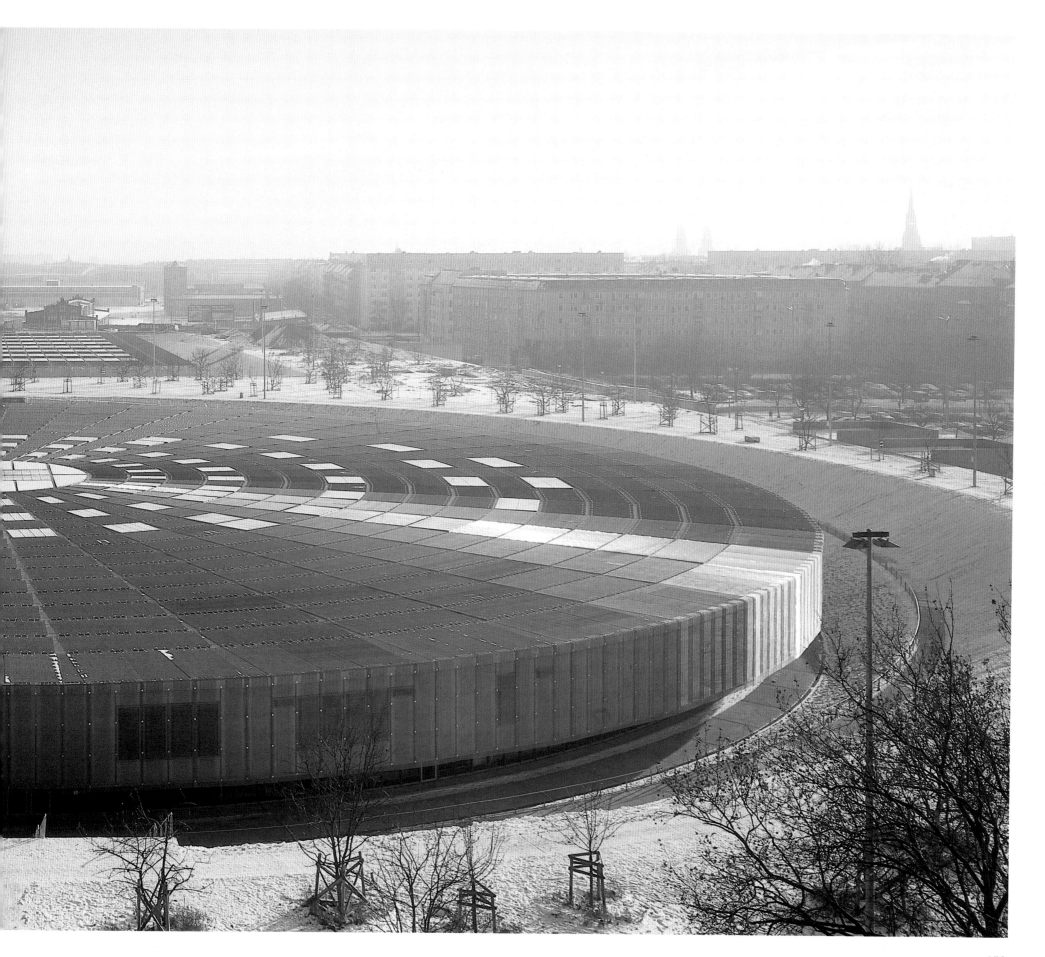

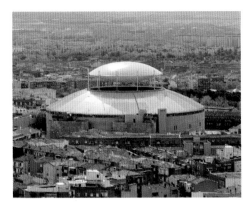

Madrid, Spain, Jaime Pérez, 2000

More than Bullfights

Palacio Vistalegre Arena

This brick-covered arena, located in a lively urban neighborhood, serves as more than Madrid's premier bullfight venue. The 14,000-seat complex also hosts concerts and galas and is home to various sports teams. The circular plan further develops the classic "Plaza de Toros" bullfighting ring design and assures a good view from all seats. Stairs and elevators lead directly from the foyer to the upper levels encircling the arena. The rising concrete bleachers form the last wall of the upper lobbies before one enters the grand arena space. The central dome can be raised to allow natural light and fresh air inside.

Mehr als nur Stierkampf

Arena Palacio Vistalegre

Eingebettet in ein lebendiges Quartier unweit des Stadtkerns dient die in rotem Backstein verkleidete Arena nicht nur als Plaza de Toros. Der 14 000 Zuschauer fassende Komplex wird multi-funktional für Konzerte, Gala- und Sportveranstaltungen genutzt. Die kreisrunde Form in der Typologie historischer Stierkampfarenen ermöglicht eine gute Sicht für alle Zuschauer. Direkt vom Foyer aus führen Treppen und Aufzüge auf die Erschließungsebenen, die radial um die Arena mit Blick auf die ansteigende Unterseite der Tribünen führen. Die linsenförmige Lichtkuppel kann hochgefahren werden, um direktes Licht und frische Außenluft ins Innere zu führen.

Plus que les corridas

Arena Palacio Vistalegre

Cette arène couverte de briques, située dans un quartier urbain animé, n'est pas seulement le premier centre des corridas madrilènes. Ce complexe de 14 000 places accueille aussi des concerts, des galas et des équipes sportives. Le plan circulaire développe au maximum la structure classique de la « Plaza de Toros » et assure une bonne vue de chaque siège. Ascenseurs et escaliers relient directement l'entrée aux niveaux supérieurs autour de l'arène. Les gradins montants en béton forment le dernier mur des halls supérieurs avant l'accès au grand espace de l'arène. Le dôme central peut être levé pour laisser entrer l'air frais et la lumière naturelle.

Más que Corridas de Toros

Plaza de Toros Palacio Vistalegre

Levantada en un animado barrio cerca del centro de la ciudad, esta plaza de ladrillo rojo no es sólo una plaza de toros. El complejo, con cabida para 14.000 espectadores, es multifuncional y se utiliza para conciertos, galas y acontecimientos deportivos. Su forma redondeada siguiendo la tipología clásica de las plazas de toros, posibilita una buena visibilidad desde todos los asientos. Partiendo directamente desde el vestíbulo, las escaleras y los ascensores conducen a los pisos superiores que rodean la arena y llevan a las tribunas. La cúpula de cristal con forma lenticular puede ser elevada para permitir la entrada de la luz natural y del aire fresco de fuera.

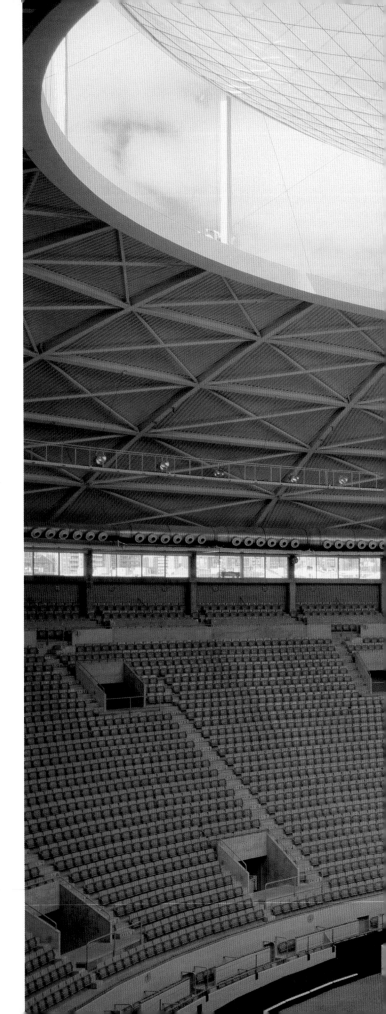

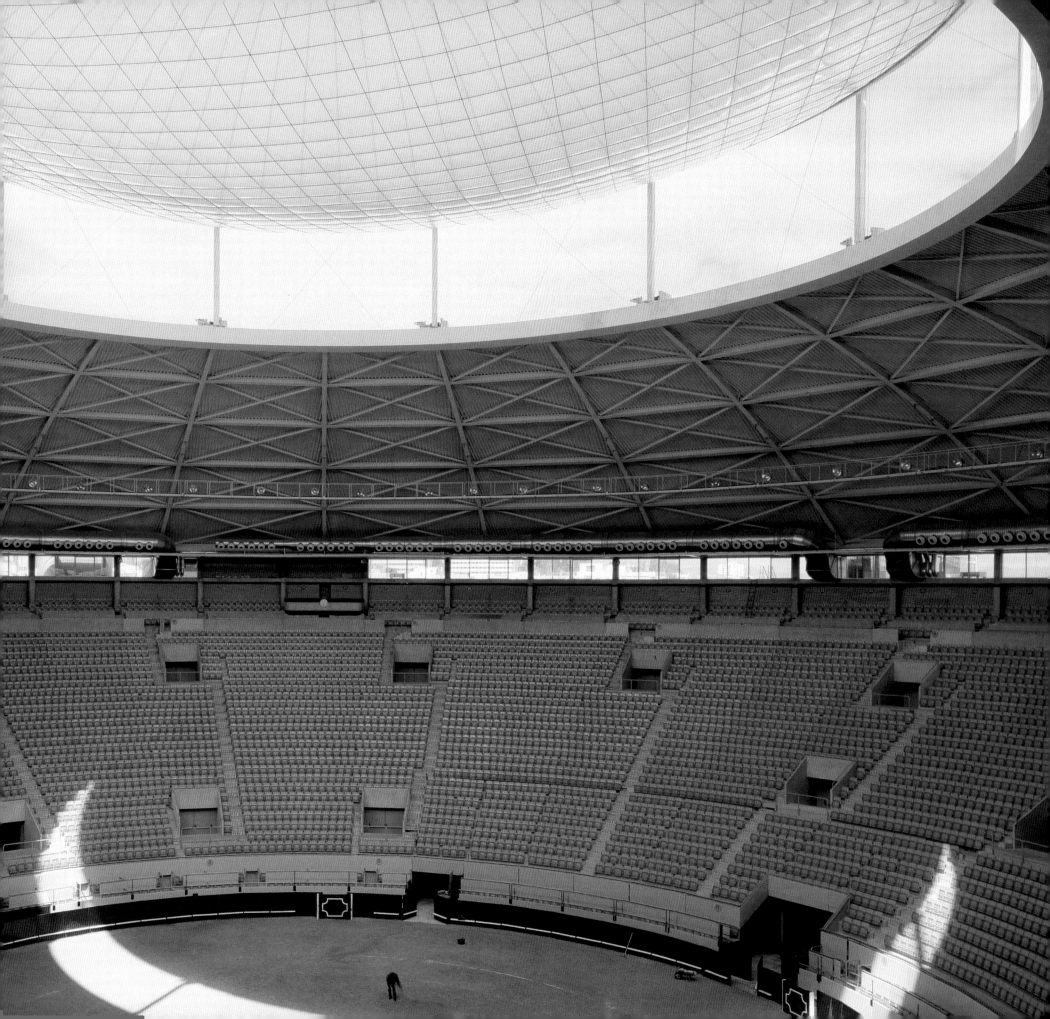

San Sebastián, Spain,
José Rafael Moneo, 1999

Beached Icebergs

Kursaal Convention Center

The once mundane seaside resort was faced with a sharp tourist decline. This daring complex, an active counter-measure against further decay, was composed in antithesis to the old city. The slanting glass blocks translate the nearby mountainous coastline into architecture. The glass facades act as an envelope for the wood paneled concrete structures housing the concert halls. A common plinth connects the two cubes, integrating exhibition spaces, shops and a restaurant into the scheme. The foyer leads up to the main hall, which calls to mind a wooden ship in dry dock and creates a warm contrast to the cooler materials outside.

Gestrandete Eisberge

Kursaal Kongresszentrum

Das einst mondäne Seebad hat mit der Zeit an Glanz verloren. Als Gegenmaßnahme entstand der gewagte Bau aus zwei leicht geneigten, eisblauen Glasblöcken. Als Antithese zur Stadt der Gründerzeit setzt er die Landschafts-typologie der nahen, ins Meer vorspringenden Berge baulich um. Außen und innen verglaste Stahltragwerke bergen die holzverkleideten Betonkörper der beiden Säle. Im Sockelgeschoss befinden sich Ausstellungsräume, Geschäfte und ein Restaurant. Das 22 Meter hohe und 60 Meter tiefe Foyer führt hinauf in den großen Saal, der wie ein Schiff in der Werft aufgestapelt wirkt und ganz in Holz gehaltenen wurde.

Icebergs en bord de plage

Le palais des congrès Kursaal

La station balnéaire jadis assez banale a été confrontée à un fort déclin du tourisme. Contrebalançant activement cette tendance, ce complexe audacieux a été conçu en antithèse de la vieille ville. Les bâtiments penchés rappel-lent, dans leur architecture, le littoral montagneux voisin. Les façades de verre enveloppent des structures en béton lambrissées qui abritent les salles de concert. Un socle commun relie les deux cubes, intégrant un restau-rant, des espaces d'exposition et des boutiques. L'entrée s'élève jusquà la salle principale, qui évoque un navire de bois en cale sèche et crée un chaud contraste avec les matériaux extérieurs plus froids.

Icebergs Varados

Centro de Congresos Kursaal

Con el tiempo, el mundano balneario perdió parte de su esplendor. Para recuperarlo se levantó un atrevido com-plejo compuesto por dos bloques de cristal ladeados y en azul hielo. Como antítesis a la ciudad del Gründerzeit, los bloques transforman el cercano literal montañoso en arquitectura. Las estructuras de acero, encristaladas por fuera y por dentro, albergan los cuerpos de concreto revestidos de madera de las dos salas de conciertos. En la planta baja están las salas de exposiciones, las tiendas y un restaurante. El vestíbulo, de 22 m de altura y 60 de profundidad, conduce a la gran sala, que parece un barco de madera guardado en un astillero.

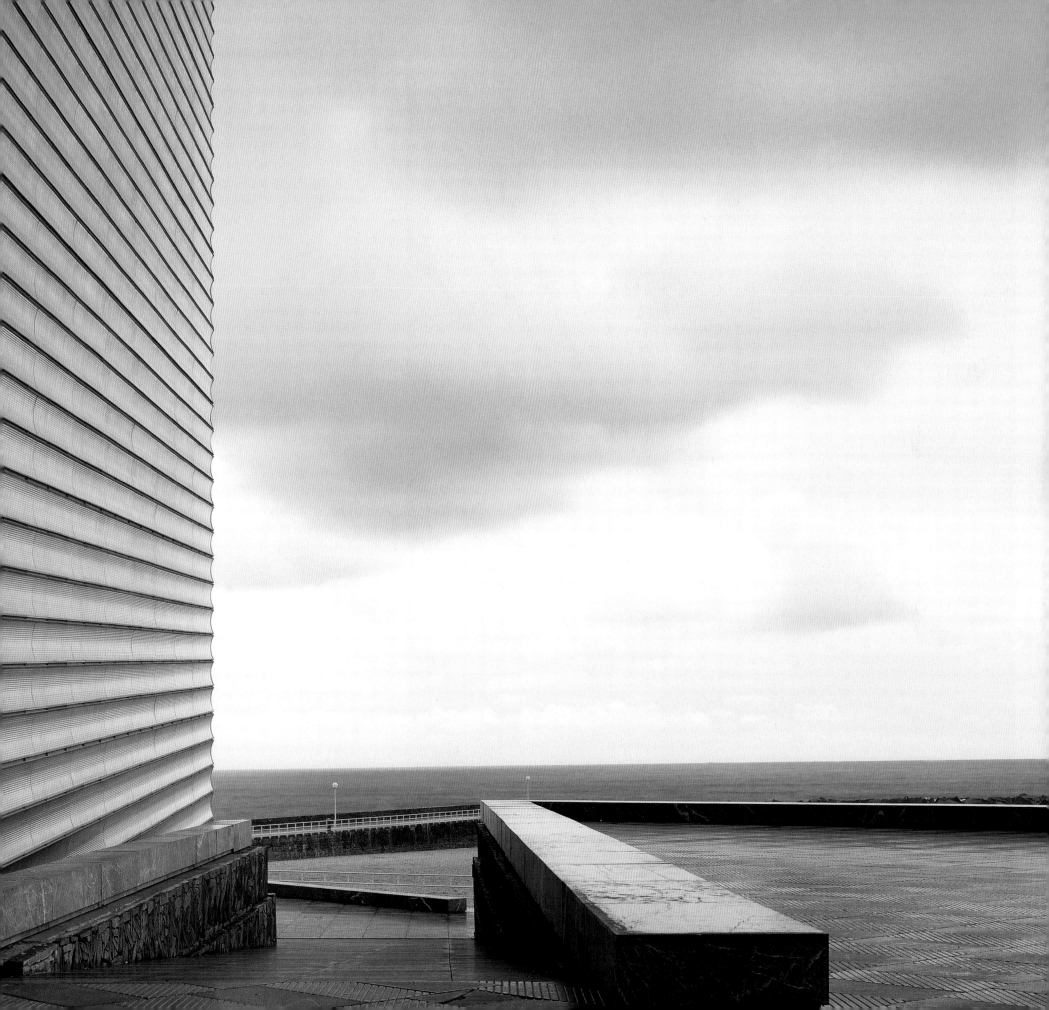

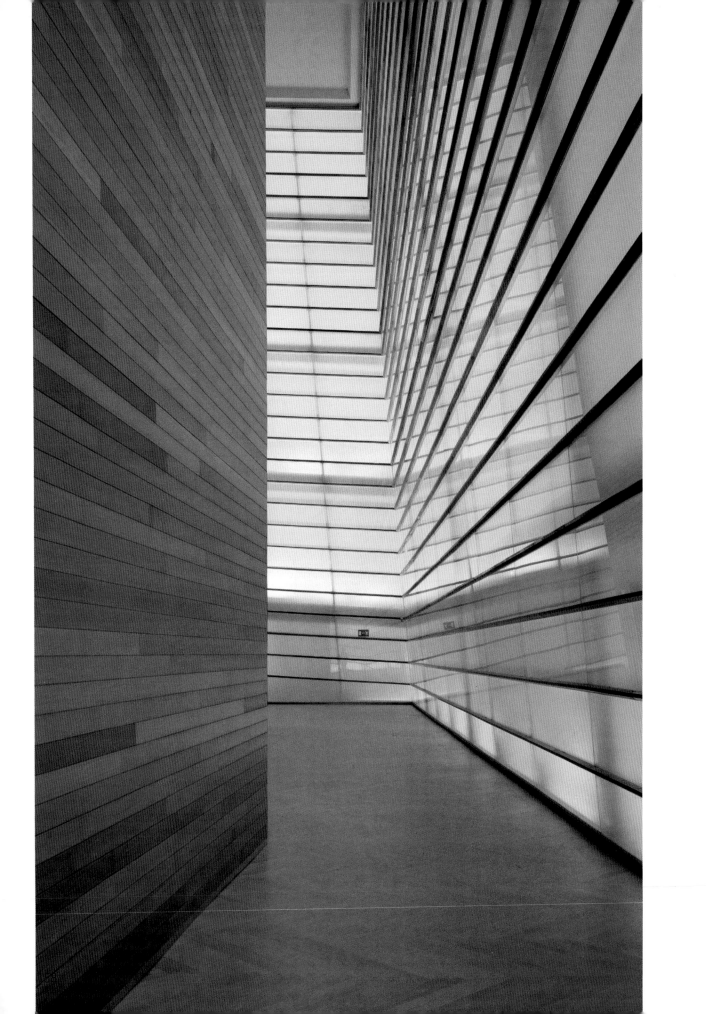

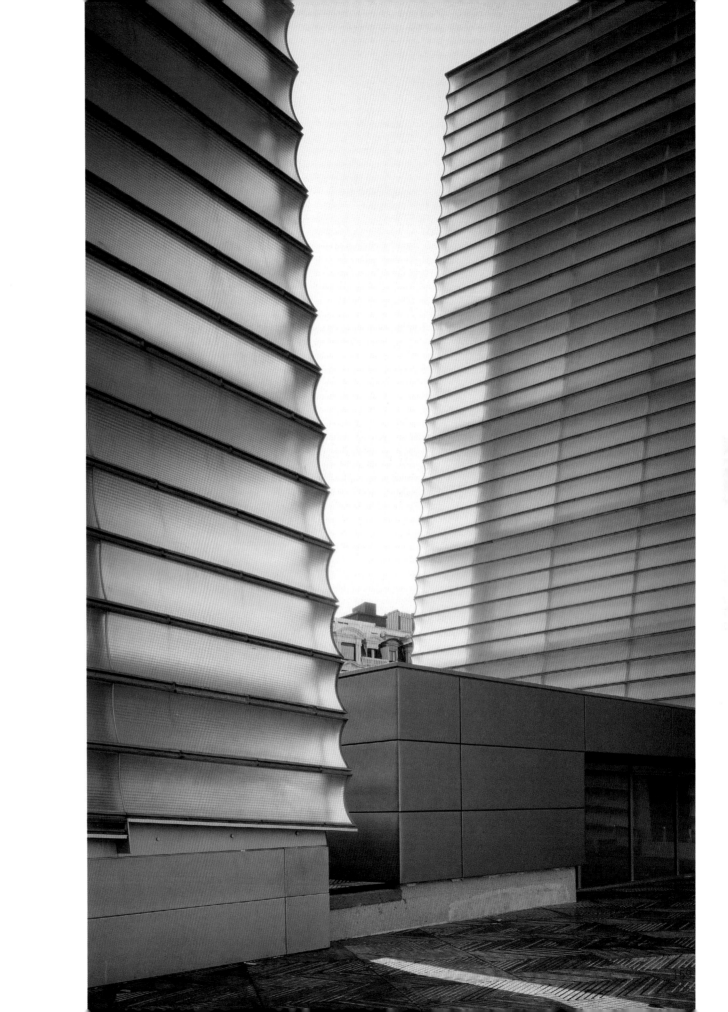

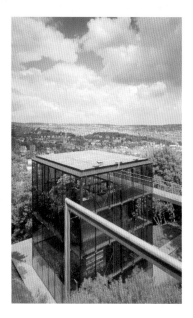

Stuttgart, Germany, Werner Sobek, 2001

More than Modernism

Single Family House R128

This four-story glass cube seems to hover on a steep hillside site above the city. Its open floor-plan features virtually no interior walls and boasts fully glazed outer walls. An elegant steel frame supports the building skin of triple-glazed glass panels. These are filled with a special gas and plastic film used in space technology that allows light to enter, but insulates against both cold and heat. Solar collectors on the roof produce all the electricity required and passive energy systems provide abundant heating without reliance on non-renewable energy sources. Through utilization of prefabricated elements, the structure was completed in a record-breaking 10 weeks.

Eine modernere Moderne

Einfamilienhaus R128

An einem Steilhang erhebt sich der viergeschossige Glaskubus über der Stadt. Die einzelnen Geschosse sind vollständig verglast und ohne Innenwände. Ein geschraubtes Stahlskelett hält die gläserne Hülle aus Dreifachverglasung zusammen. Die mit Edelgas und Kunststofffolien aus der Raumfahrt gefüllten Zwischenräume lassen das Licht ungehindert passieren, Wärme wie Kälte weisen sie dagegen ab. Das Haus produziert die benötigte Elektrizität über Solarzellen auf dem Dach zum großen Teil selbst und kommt ohne zusätzliche Beheizung aus. Durch Verwendung vorgefertigter Teile konnte die Fertigstellung rekordverdächtig in 10 Wochen erfolgen.

Nec plus ultra du modernisme

Maison familiale R128

Ce cube de verre de quatre étages paraît suspendu au-dessus de la ville. Presque dénué de murs intérieurs, il arbore des murs extérieurs entièrement vitrés. Une charpente en acier supporte leurs triples panneaux de verre, contenant une couche de gaz et de plastique employée en technologie spatiale pour laisser entrer la lumière, et isoler du chaud et du froid. Des capteurs solaires sur le toit produisent l'électricité nécessaire et des systèmes d'energie passive chauffent abondamment sans reposer sur des sources d'énergie non renouvelables. À base d'éléments préfabriqués, la construction a été achevée en un temps record de 10 semaines.

Más que Modernismo

Casa Unifamiliar R128

Este cubo de cuatro plantas se levanta sobre la ciudad en una escarpada pendiente. Todos los pisos están encristalados y carecen de paredes interiores. Un esqueleto de acero sostiene la cubierta de cristal, de tres capas. Los espacios interiores entre ellas están rellenos de gas noble y de láminas de plástico utilizado en la astronáutica. Estos elementos permiten la entrada de la luz y aíslan del calor y del frío. La casa produce gran parte de la electricidad que necesita gracias a los paneles solares que hay en el tejado y, además, no necesita calefacción adicional. La utilización de elementos prefabricados hizo posible su construcción en diez semanas.

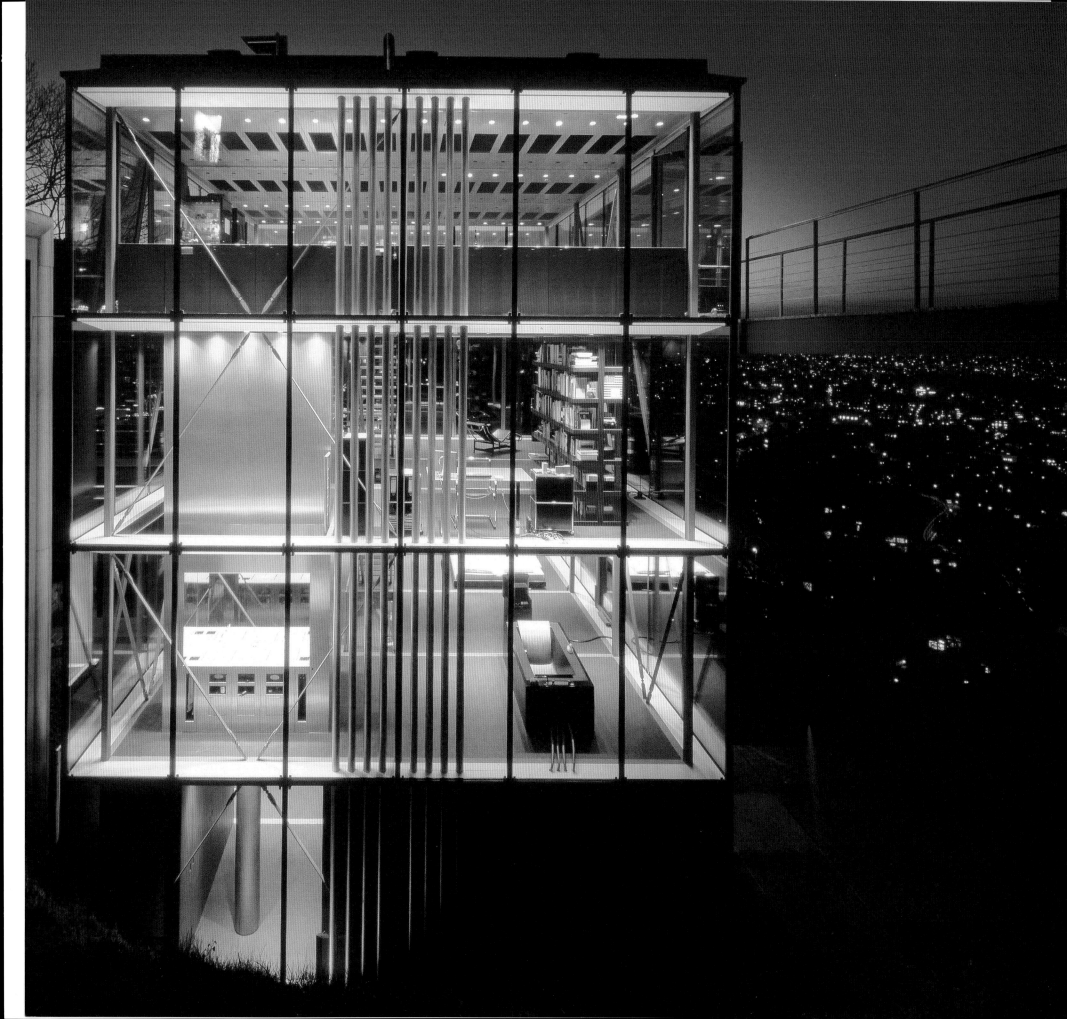

Hamburg, Germany,
Bothe, Richter, Teherani, 2003

Urban Dry Dock

Elbberg Campus

This complex transforms a once rough portside neighborhood with a lively mix of offices and housing. The loft residential units were nestled into the site's steep embankment, allowing creation of a hillside park. The street-side office building is also woven into the network of public spaces. Its urban roof terrace extends the park and offers excellent views of the port. The office building shines in aluminum and glass whereas warmer materials – copper sheathing and wood laths – create a more relaxed atmosphere for the housing units. Massive brick retaining walls emphasize the dramatic topography and anchor the levitating building composition.

Angedockt am Hang

Elbberg Campus

Zwischen alten Lagerhäusern, Hafenanlagen und Industrieflächen gelegen verbindet die Anlage Arbeit, Wohnen und Freizeit. Dem Hangverlauf folgend sind um die neue Parkfläche Büro-, Wohn- und Loftgebäude entstanden. Eingebunden in die öffentlichen Flächen ist auch das Bürogebäude mit seiner Fassade aus Aluminium und Glas. Das Dach seines Sockelbaukörpers dient als öffentliche Stadtterrasse mit Blick über den Hafen. Kupfer, Glas und Holzlamellen kennzeichnen die beiden Loftbauten im ruhigen Park zu Füßen des Steilhangs. Mächtige Stützmauern aus rotem Backstein folgen dem Hang und liefern Halt für die schwebend-dynamische Komposition.

Cale sèche en ville

Elbberg Campus

Ce complexe transforme un quartier portuaire jadis assez rudimentaire en un mélange animé de logements et de bureaux. Les lofts sont nichés sur le site pentu du quai, permettant de créer un parc à flanc de colline. Côté rue, l'immeuble de bureaux est aussi incorporé dans les espaces publics. Son toit en terrasse prolonge le parc et offre de très belles vues sur le port. Contrastant avec cet immeuble rutilant d'aluminium et de verre, des matériaux plus chauds – gaines de cuivre et lattes de bois – créent dans les logements une ambiance plus détendue. De gros murs de soutènement soulignent la topographie spectaculaire et ancrent la composition aérienne du bâtiment.

Atracado en la Ladera

Campus Elbberg

Situada entre viejos almacenes, instalaciones portuarias y superficies industriales, la construcción une el trabajo con la vivienda y el tiempo libre. Los edificios de oficinas, viviendas y lofts se han construido alrededor del parque y siguiendo el trazado de la ladera. El edificio de oficinas, con su fachada de aluminio y cristal, también está unido a las superficies públicas. El tejado es una terraza pública con vistas sobre el puerto. El cobre, el cristal y la madera caracterizan los dos edificios de lofts en el tranquilo parque a los pies de la pendiente. Los gruesos muros de contención, de ladrillo rojo, siguen la pendiente y sirven de apoyo a la composición flotante y dinámica.

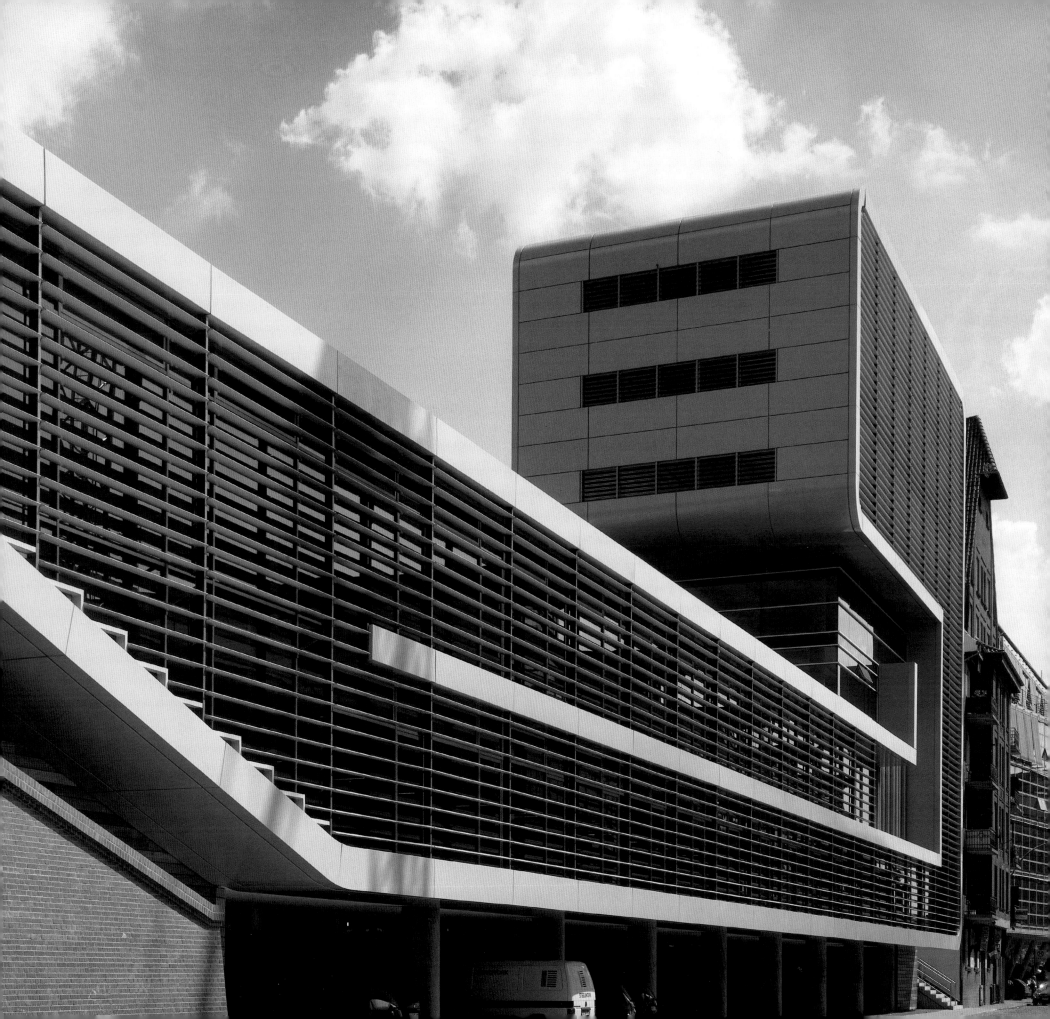

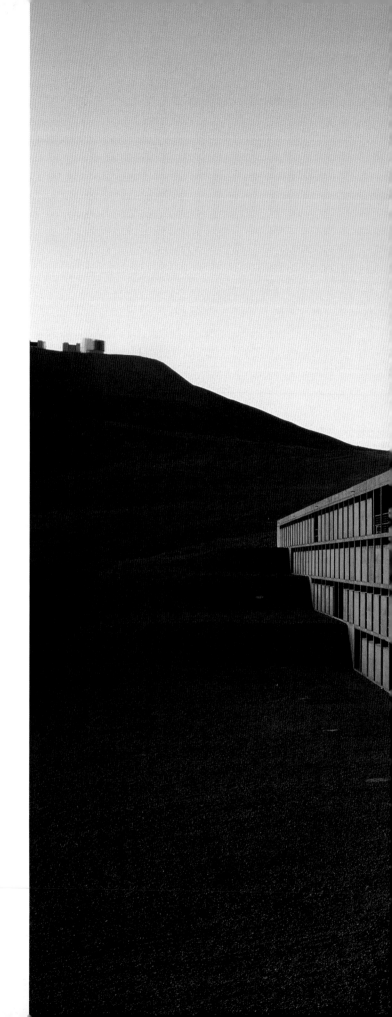

Paranal Mountain, Chile, Auer + Weber, 2002

Star Lodging

European Southern Observatory Hotel

Northern Chile's uninhabited Atacama desert is an ideal site for the ESO's Very Large Telescope. But the scientists conducting research here at 2,600 meters above sea level need a place to regenerate, an oasis in the barren desert. Filling the gap created by two gentle hills, the red concrete building skillfully blends in, and at the same time contrasts, with the site. Respectful of the pristine desert landscape, it creates a sensual place that counters the high-tech world of the telescope facility. The rooms look out to the magnificent view, while the lush oasis vegetation and cooling pool of the dome space provide internal focus.

Sternen-Herberge

Hotel am European Southern Observatory

In der Atacama-Wüste im Norden Chiles befindet sich in 2600 m Höhe das „Very Large Telescope" der ESO. Die hier arbeitenden Wissenschaftler benötigen einen Ort der Regeneration, eine Oase in der unwirtlichen Wüste. Einem Staudamm gleich spannt sich die Anlage zwischen den Flanken einer Geländemulde. Den unverbauten Horizont bis zum Pazifik respektierend erscheint sie als Gegenpol zur hochtechnologischen Welt des Teleskops als sinnlicher Ort, der im Schoß der Erde selbst liegt. Den internen Fokus der aus rotgefärbtem Beton erbauten Anlage bildet die 35 Meter breite, kreisrunde Kuppelhalle mit Oasenpflanzen und kühlendem Pool.

Bercé par les étoiles

Hôtel de l'European Southern Observatory

Le désert de l'Atacam au Nord du Chili est un site idéal pour le très grand téléscope d'ESO. Mais les chercheurs qui y travaillent à 2600 m au-dessus du niveau de la mer ont besoin d'un endroit pour se régénérer, d'une oasis dans le désert. Comblant l'espace entre deux collines, ce bâtiment en béton rouge se fond adroitement dans le site, tout en contrastant avec lui. Respectant le paysage original désertique, il crée un endroit sensuel qui compense le monde high-tech de l'installation du télescope. Les chambres donnent sur une vue magnifique, tandis que la luxuriante végétation de l'oasis et la fraîche piscine de l'espace du dôme attirent l'œil vers l'intérieur de l'hôtel.

El Albergue de las Estrellas

Hotel en el European Southern Observatory

En el desierto de Atacama, al norte de Chile, se encuentra el «Very Large Telescope» de la ESO, a 2.600 metros de altura. Los científicos que trabajan aquí necesitan un lugar para recuperarse, un oasis en el inhóspito desierto. La instalación se levanta entre los lados de una hondonada como una presa en concreto rojo. Respetuoso con el horizonte libre de construcciones hasta el Pacífico, el hotel parece un lugar sensorial, el polo opuesto al mundo altamente tecnológico del telescopio en la planta baja. El centro interior de la instalación tiene 35 metros de ancho y está compuesto por un vestíbulo redondo, con cúpula y plantas, y una refrescante piscina.

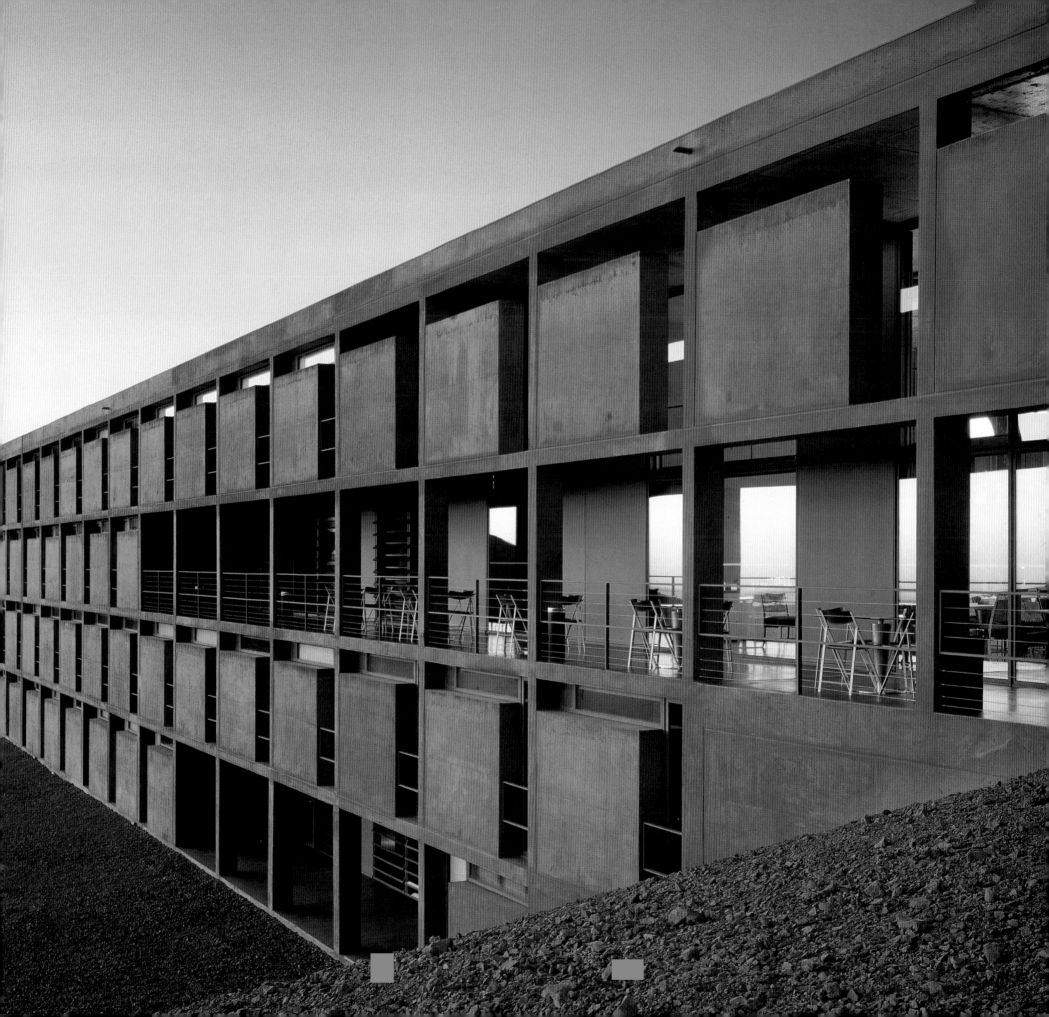

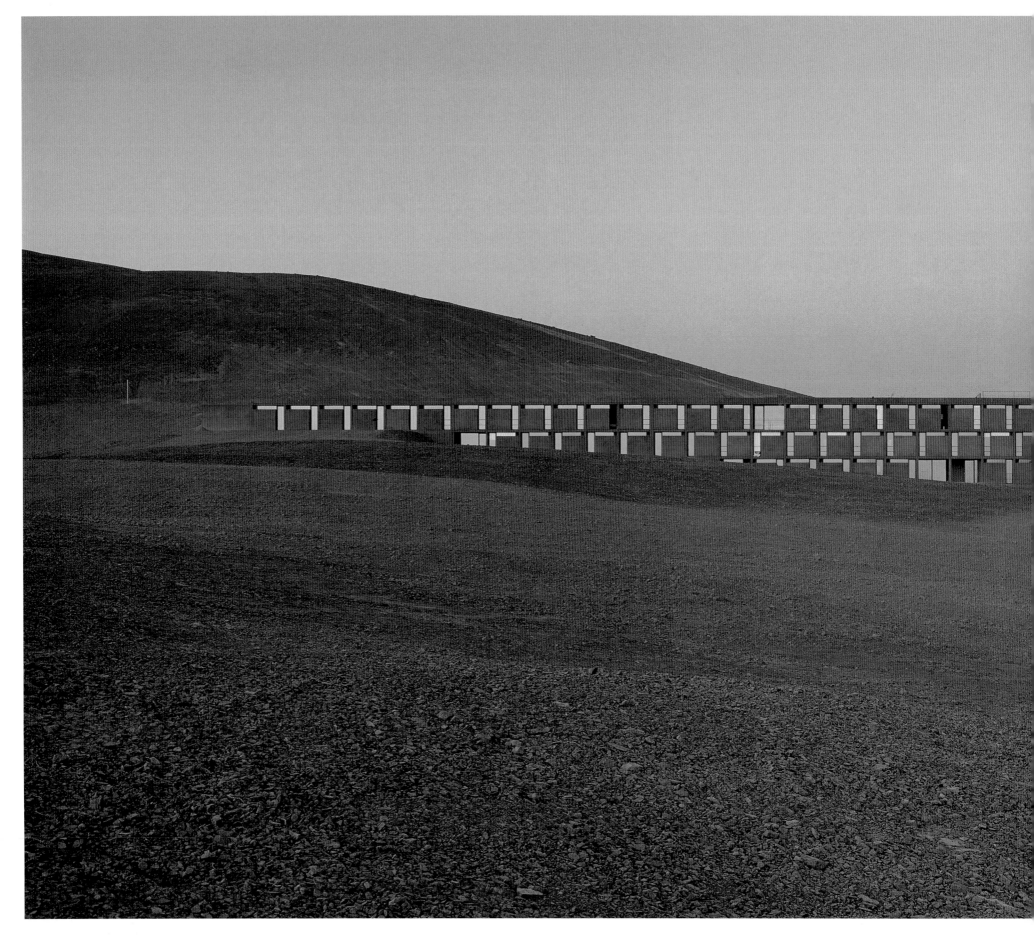

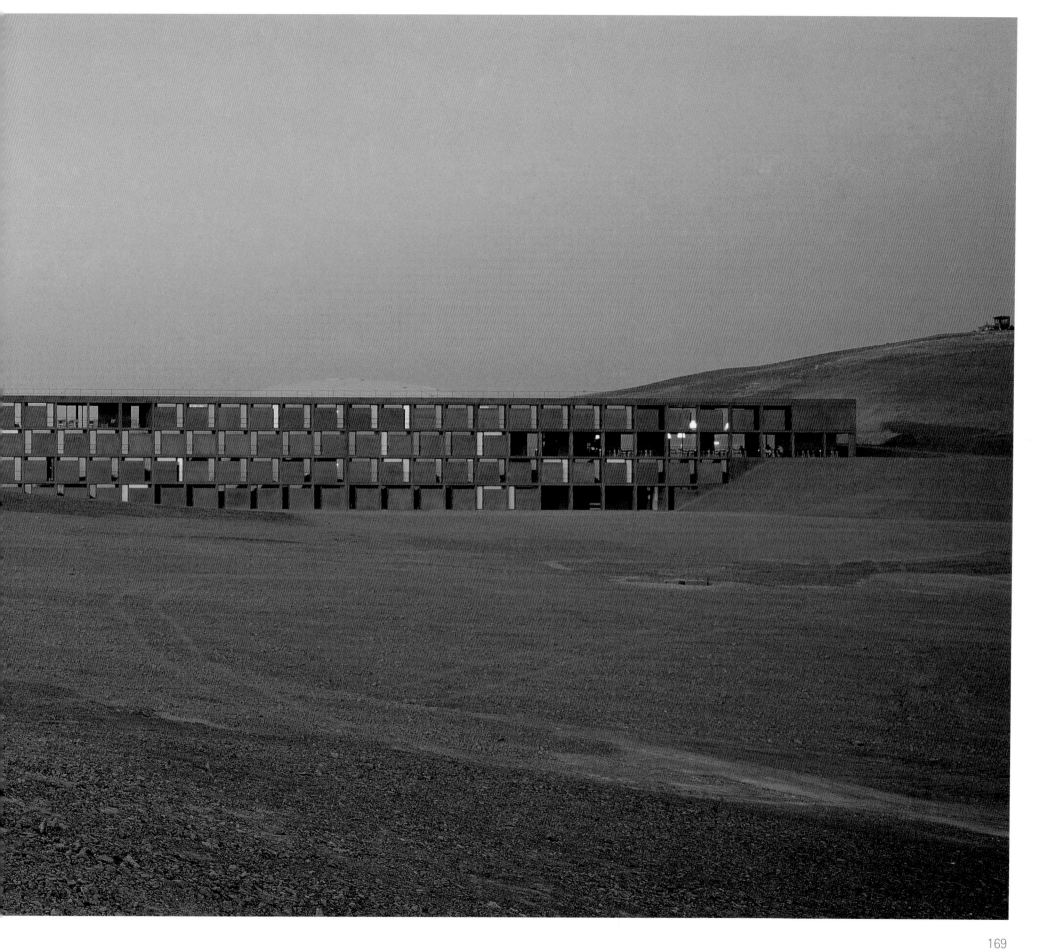

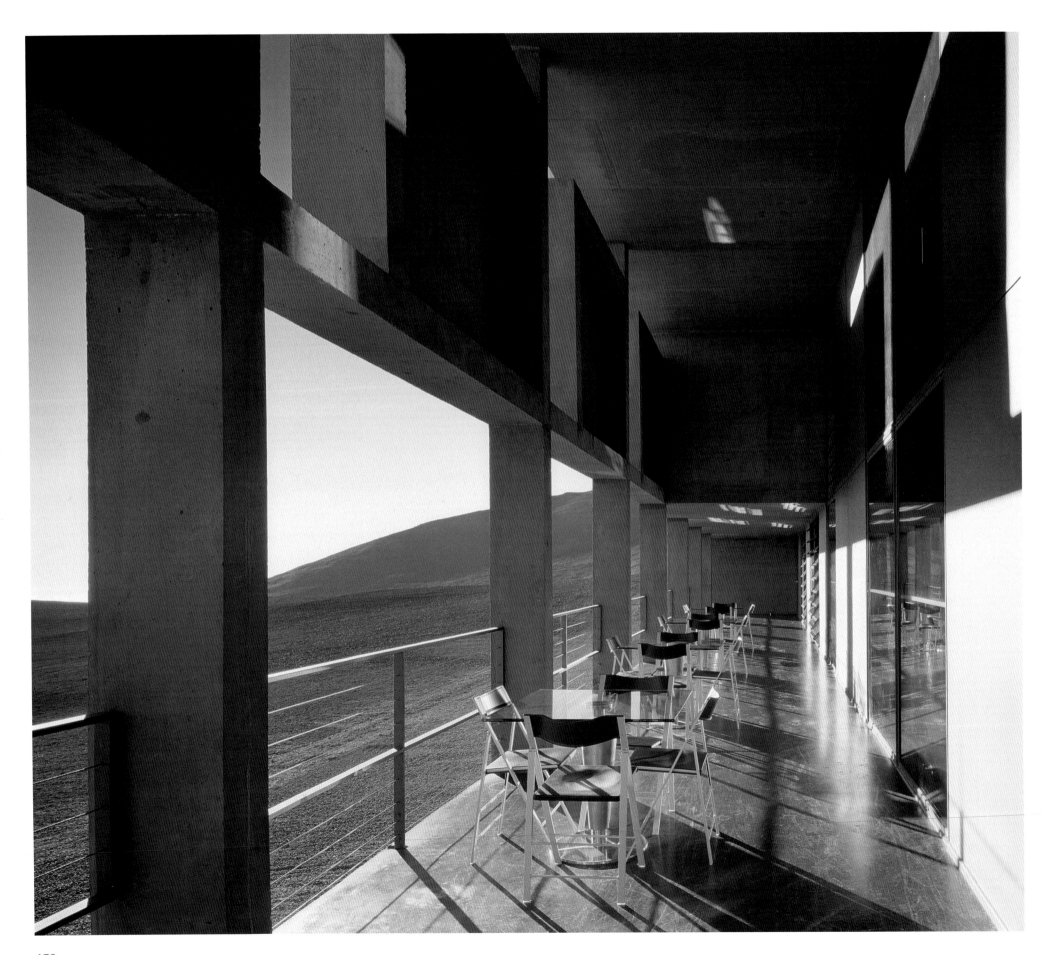

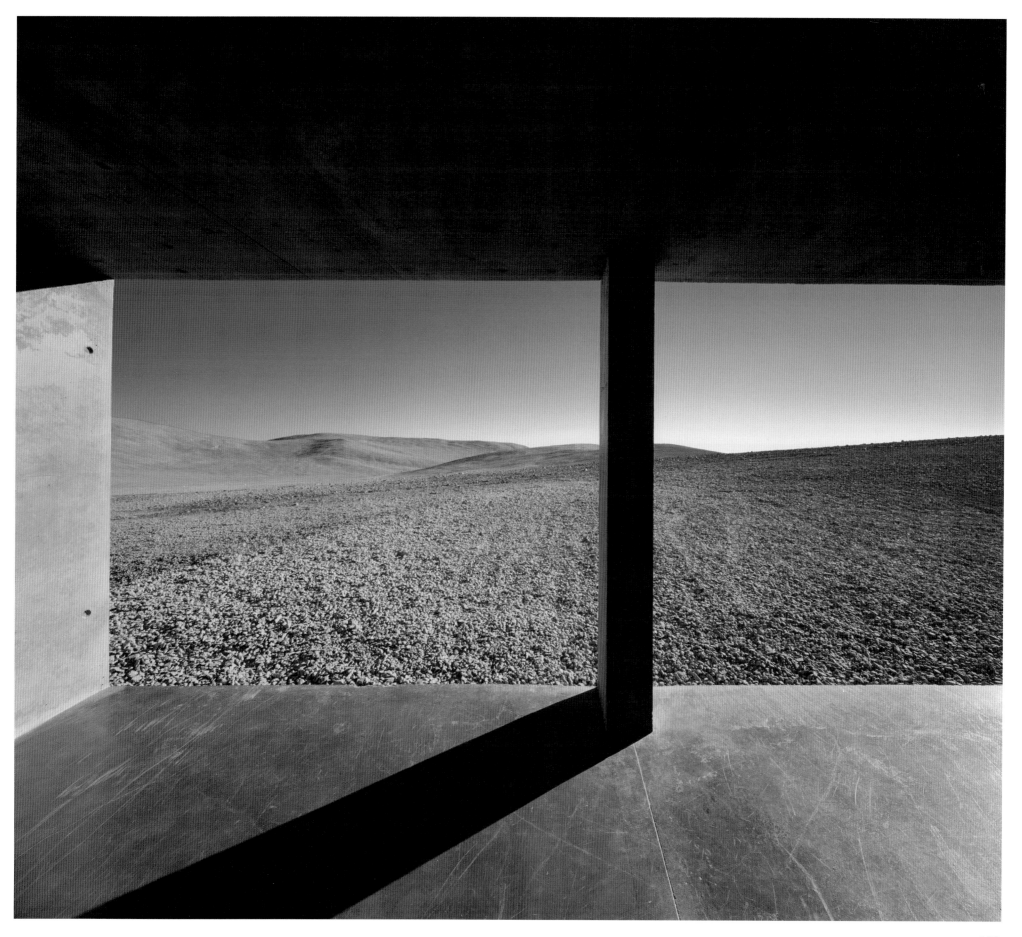

Innsbruck, Austria, Dominique Perrault, 2002

Shock of the New

City Hall, Shopping Center, Hotel

A covered pedestrian street forms the heart of the city hall which also incorporates shops and a hotel. The mix of uses brings vitality into the city center and also supplements limited public funds with private investment. A 37-meter glass tower topped with a public observation deck serves as a new downtown landmark. Transparency is a guiding premise that permeates the entire complex. The resultant open atmosphere can be felt from the public service counter on the ground floor all the way up to the roof-terrace cafe on the top level. It achieves an airy, informal quality rarely encountered in Europe's often stuffy public administration buildings.

Provokation des Neuen

Rathaus, Einkaufszentrum, Hotel

Die Rathaus-Galerie ist als Passage angelegt. Sie erschließt auch die Geschäfte und das Hotel, die integriert werden, um die Baumaßnahme zu finanzieren und die Innenstadt zu beleben. Über der Passage erstreckt sich das Wahrzeichen des Komplexes, der 37 m hohe, gläserne Treppenhausturm, dessen oberstes Geschoss als Aussichtsplattform angelegt ist. Transparenz als Prämisse zieht sich durch den Bau. Vom öffentlichen Servicezentrum in der hellen Passage über den markanten Turm bis zum Dachterrassen-Café spürt man eine Bürgernähe, die in öffentlichen Institutionen eher selten anzutreffen ist.

Le choc de la nouveauté

Mairie, hôtel et centre commercial

Une galerie piétonne forme le cœur de la mairie qui abrite également des boutiques et un hôtel. Le mélange des genres donne de la vitalité au centre ville, complétant les fonds publics limités par des investissements privés. Une tour de verre de 37 m, coiffée d'une terrasse panoramique publique, sert de nouveau repère au centre ville. La transparence est un principe de base qui imprègne tout le complexe, créant une atmosphère ouverte depuis l'accueil administratif au rez-de-chaussée jusqu'au café de la terrasse. Favorisant l'espace et la clarté, elle crée une ambiance décontractée que l'on trouve rarement dans les administrations européennes souvent étouffantes.

La Provocación de lo Nuevo

Ayuntamiento, Centro Comercial, Hotel

El corredor del Ayuntamiento ha sido concebido como una galería comercial. Aquí se encuentran los comercios y el hotel, que han sido incluidos en el proyecto para financiar su construcción y para dar vida al centro de la ciudad. Sobre la galería se levanta lo verdaderamente peculiar del complejo: una torre de cristal de 37 metros de altura terminada en un mirador público. La transparencia está presente en toda la construcción. Por todo el edificio, desde el centro de servicio público en la luminosa galería pasando por la característica torre y la cafetería, se siente la cercanía a los ciudadanos, algo poco común en las instituciones públicas.

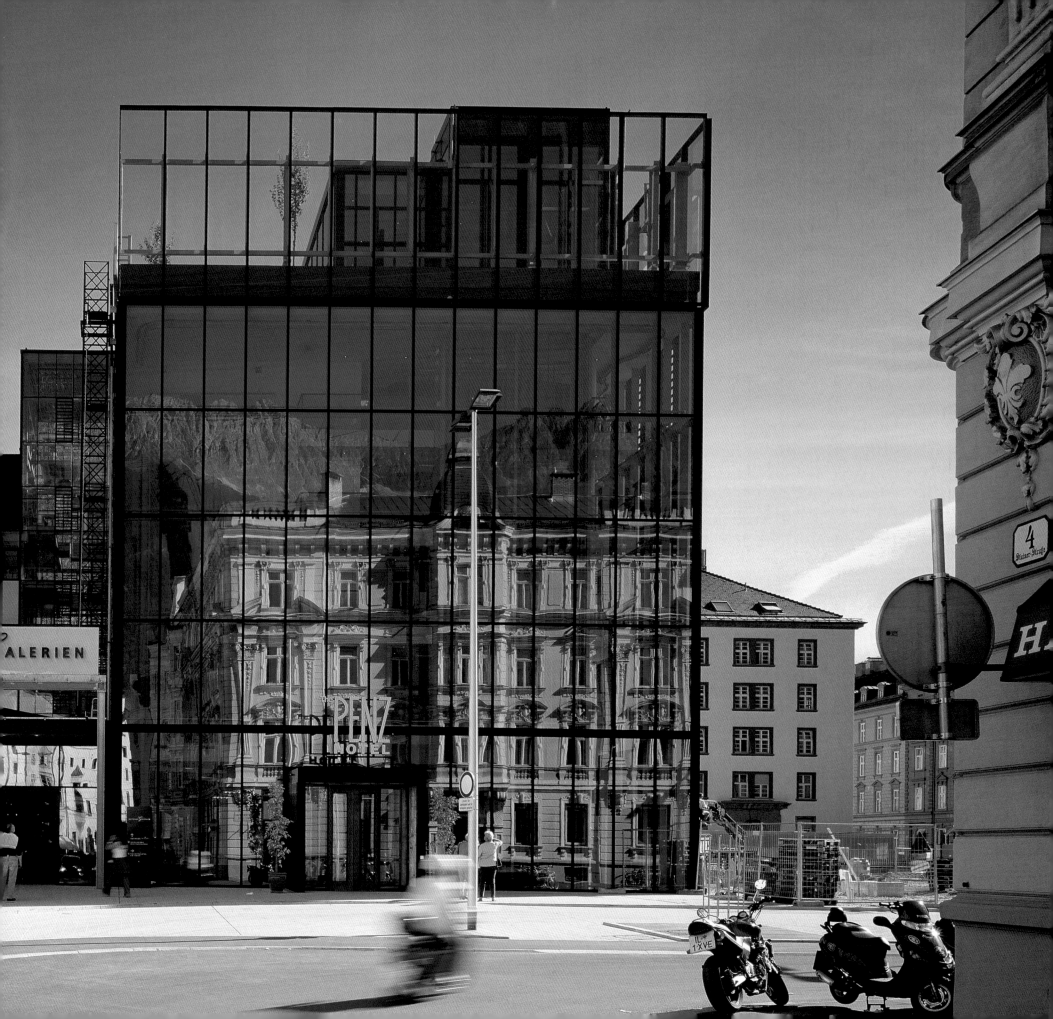

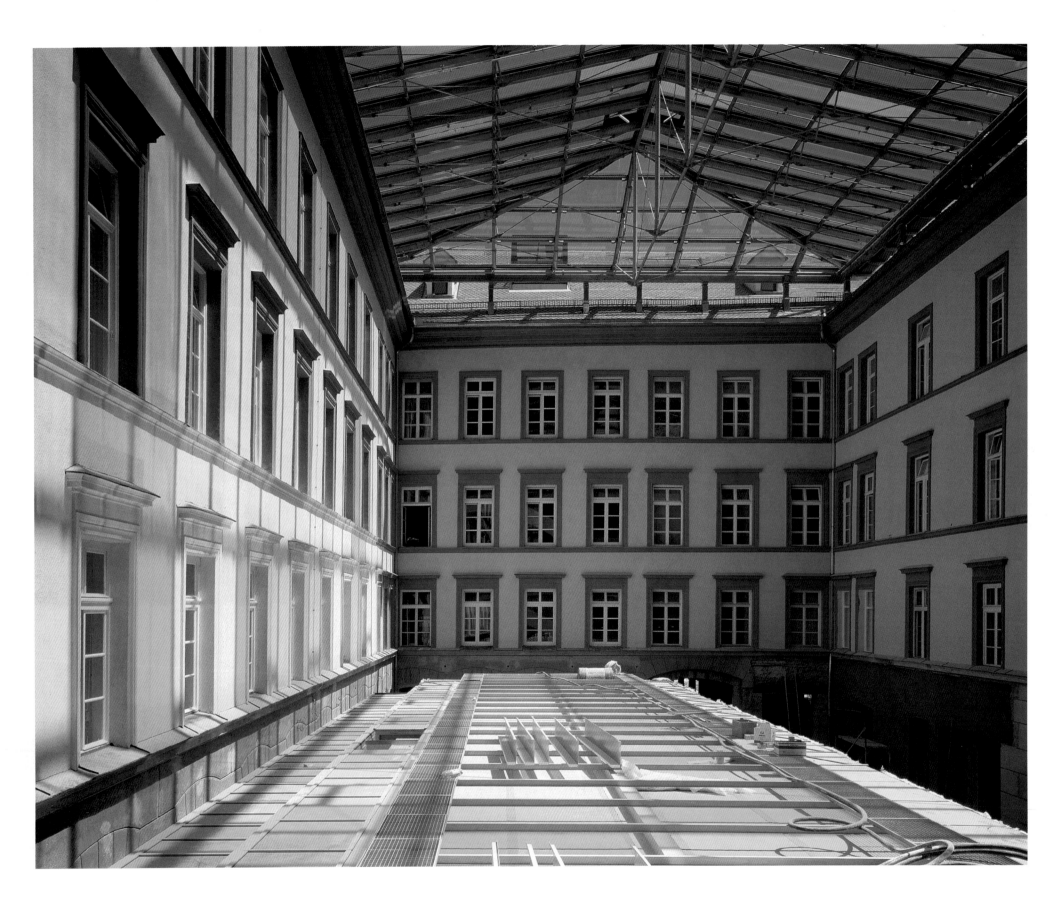

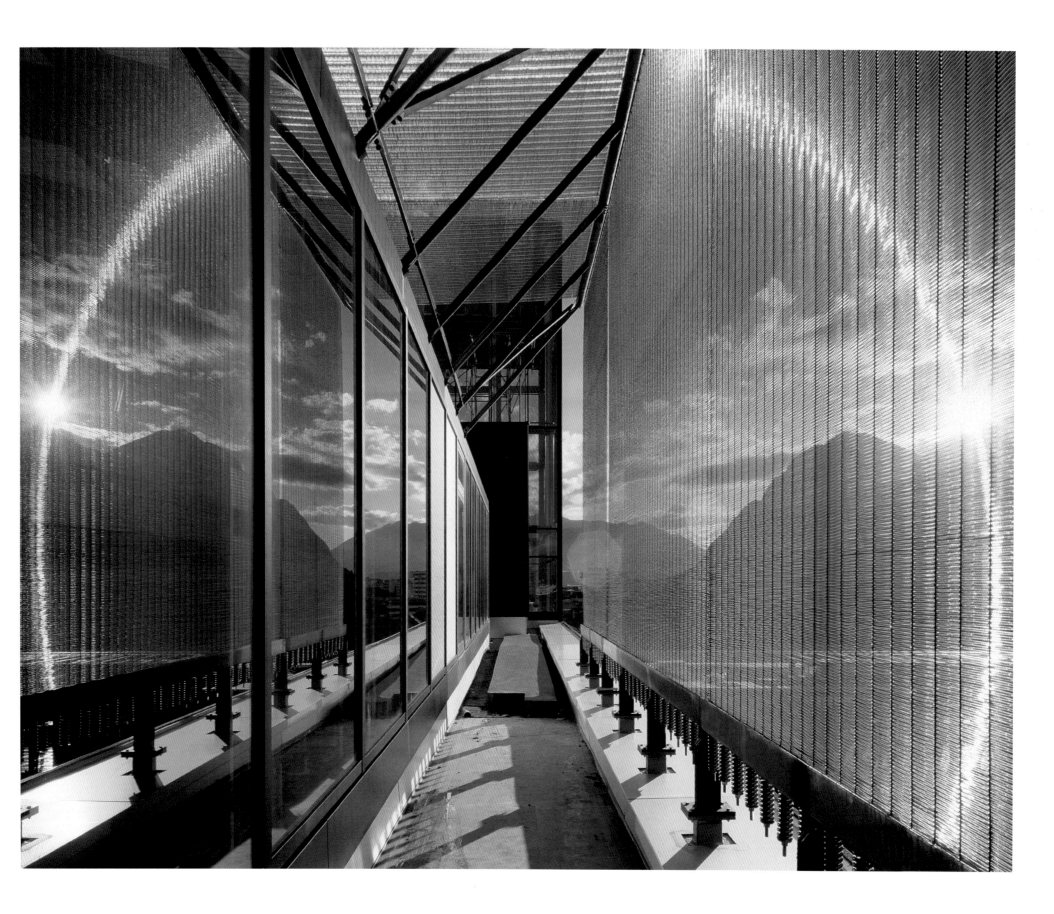

175

Photo credits. Bildnachweis. Crédits photographiques. Créditos fotográficos.

Bier, Philip/VIEW: 108/109

Boegly, Luc: 18/19, 134/135

Boegly, Luc/Archipress: 28/29

Cook, Peter: 76/77

Denancé, Michel: 30–33, 140/141

Frahm, Klaus: 9, 14/15, 50–53, 62/63, 110/111, 164/165

Gasgoigne, Chris/VIEW: 103

Gilbert, Dennis/VIEW: 74/75, 98/99, 120–123

Görner, Reinhard: 12/13, 110

Grimmenstein, Bernadette: 34/35

Hagen, Gerhard: 68/69

Halbe, Roland: 2/3, 6, 8, 16/17, 26, 34, 36/37, 41, 42/43, 48/49, 58/59, 64–67, 70/71, 78–81, 82–85, 86–89, 90–93, 94/95, 104–107, 112–115, 132/133, 136–139, 154/155, 156–159, 160–163, 166–171, 172/173

Helle, Jochen: 38/39, 124/125

Heßmann, Karin: 10/11

Hufton+Crow/VIEW: 58, 60/61

Huthmacher, Werner: 38, 40, 124, 126/127, 150–153

Janzer, Wolfram: 96/97, 116–119, 148/149

Mackinven, Peter/VIEW: 18

Müller-Naumann, Stefan: 100–102, 146

Nikolic, Monika: 22, 24/25, 142–145

Nikolic, Robertino: 29

Raftery, Paul/VIEW: 22/23, 54–57

Riehle, Tomas: 146/147

Smith, Grant/VIEW: 128–131

Sumner, Edmund: 20/21, 27, 44/45

Willock, Nathan/View: 46/47

Winde, Jörg: 72/73

Rights for plans by:

Auer + Weber, Munich: 6/7 (Plans)

Renner Hainke Wirth, Hamburg: 9 (Plan)

Werner Sobek, Stuttgart: 8 (Plan)

Architect. Architekt. Architecte. Arquitecto.

Atelier Hitoshi Abe, Sendai, Japan:
Miyagi Stadium, Sendai, Japan

Auer + Weber, Munich, Germany:
European Southern Observatory Hotel (ESO), Paranal Mountain, Chile

Axel Schultes, Charlotte Frank, Berlin, Germany:
Federal Chancellery, Berlin, Germany

Bothe, Richter, Teherani, Hamburg, Germany:
Elbberg Campus, Hamburg, Germany

Branson Coates Architects, London, Great Britain:
National Center for Pop Music, Sheffield, Great Britain

Cesar Pelli & Associates, New York, USA:
Petronas-Towers, Kuala Lumpur, Malaysia

Daniel Libeskind, Berlin, Germany:
Jewish Museum, Berlin, Germany
Imperial War Museum, Manchester, Great Britain

Denton Corker Marshall, Artist: Robert Owen, Melbourne, Australia:
Webb Bridge, Melbourne, Australia

Dominique Perrault, Paris, France:
City Hall, Innsbruck, Austria
MPreis Supermarket, Wattens, Austria

Dominique Perrault, Paris, France/APP Architekten, Berlin, Germany:
Velodrom and Swim Center, Berlin, Germany

Emilio Tuñón and Luis Moreno Mansilla, Madrid, Spain:
Auditorio de la Ciudad de León, León, Spain

Francisco José Mangado Asociados + Alfonso Alzugaray, Pamplona, Spain:
Navarra Convention Center and Auditorium, Pamplona, Spain

Frank O. Gehry, Los Angeles, USA:
Disney Concert Hall, Los Angeles, USA
Fisher Center for the Performing Arts at Bard College, Annandale, New York, USA
Guggenheim Bilbao, Bilbao, Spain

Future Systems, London, Great Britain:
Selfridges Department Store, Birmingham, Great Britain

Gensler, San Francisco, USA:
Moscone West Convention Center, San Francisco, USA

Herzog & de Meuron, Basel, Switzerland:
Laban Dance Centre, London, Great Britain
Schaulager® – Emanual-Hoffmann-Stiftung, Basel, Switzerland

Jaime Perez, Madrid, Spain:
Palacio Vistalegre Arena, Madrid, Spain

José Rafael Moneo, Madrid, Spain:
Kursaal Convention Center, San Sebastian, Spain
L' Auditori Concert Hall, Barcelona, Spain
Moderna Museet, Stockholm, Sweden
Murcia City Hall, Murcia, Spain
Our Lady of the Angels Cathedral, Los Angeles, USA

Klaus Kada, Graz, Austria:
Concert Hall, St. Pölten, Austria

Mario Botta, Lugano, Switzerland:
Chapel of Santa Maria degli Angeli, Monte Tamaro, Switzerland

Nicholas Grimshaw and Partners, London, Great Britain:
Eden Project, Cornwall, Great Britain

Norman Foster and Partners, London, Great Britain:
London City Hall, London, Great Britain
Swiss Re Headquarters Tower, London, Great Britain
Reichstag Building, Berlin, Germany

Peter Cook, Colin Fournier, London, Great Britain:
Kunsthaus Art Museum Graz, Austria

Peter Zumthor, Haldenstein, Switzerland:
Kunsthaus Bregenz, Bregenz, Austria

Renner Hainke Wirth, Hamburg, Germany:
Lufthansa Reception Building, Hamburg, Germany

Renzo Piano Building Workshop, Genua, Italy/Paris, France:
Hermès Building, Tokio, Japan
NeMo – National Center for Science and Technology, Amsterdam, The Netherlands
Tjibaou Cultural Center, New Caledonia, South Pacific
Auditorium Parco della Musica, Rome, Italy

Richard Meier, New York, USA:
Jubilee Church, Rome, Italy

Richard Rogers Partnership, London, Great Britain:
Millennium Dome, London, Great Britain

Santiago Calatrava, Zürich, Switzerland:
City of Arts and Sciences, Valencia, Spain
Oriente Station, Lisbon, Portugal
Pont de l'Europe, Orléans, France
Tenerife Opera House, Santa Cruz de Tenerife, Spain
Winery Complex Bodegas Ysios, Laguardia, Alava, Spain

Shigeru Ban, Tokyo, Japan mit Frei Otto, Stuttgart, Germany:
Japanese Pavilion Expo 2000, Hanover, Germany

Thomas Klumpp, Bremen, Germany:
Universum® Science Center, Bremen, Germany

Wandel, Höfer, Lorch + Hirsch, Saarbrücken, Germany:
Synagogue Dresden, Germany

Werner Sobek, Stuttgart, Germany:
R128 House, Stuttgart, Germany

Wood Marsh Pty Ltd, Melbourne, Australia:
ACCA – Australian Center for Contemporary Art, Melbourne, Australia

Zaha Hadid, London, Great Britain:
Contemporary Arts Center (CAC), Cincinnati, USA
Interchange Terminal Hoenheim-Nord, Strasbourg, France
LGS Pavilion, Weil am Rhein, Germany
Ski Jump Berg Isel, Innsbruck, Austria